JEWISH ART

Jewish Art

A Modern History

Samantha Baskind and Larry Silver

REAKTION BOOKS

To our children:
Asher and Naomi
Zachary and Laura
Our own precious legacy.

And to all those who have no one to mourn for them.

Published by Reaktion Books Ltd
33 Great Sutton Street
London EC1V ODX

www.reaktionbooks.co.uk

First published 2011
Copyright © Samantha Baskind and Larry Silver 2011

Printed and bound in China by C&C Offset Printing Co., Ltd

British Library Cataloguing in Publication Data
Baskind, Samantha.
 Jewish art : a modern history.
 1. Jewish art – Europe – History.
 2. Jewish art – United States – History.
 3. Jewish art – Israel – History.
 4. Jewish artists – Europe.
 5. Jewish artists – United states.
 6. Jewish artists – Israel.
 I. Title II. Silver, Larry, 1947–
 704'.03924-dc22

ISBN 978 1 86189 802 9

Contents

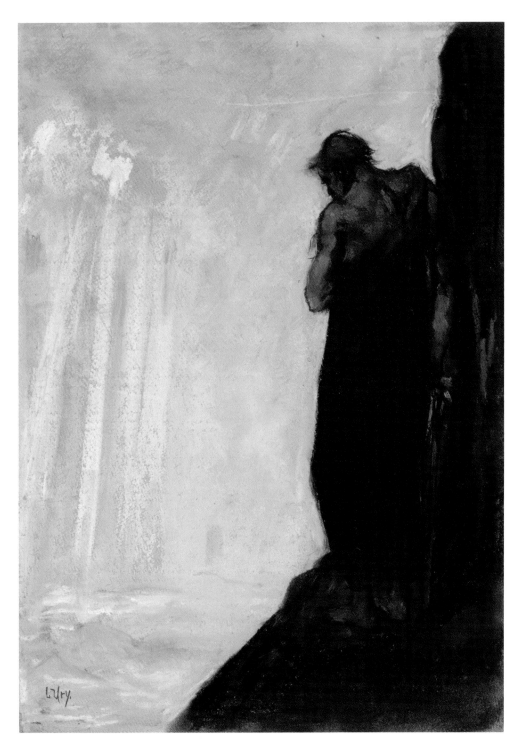

Frontispiece: Lesser Ury, *Moses Sees the Promised Land before his Death*, 1927–8, gouache.

Introduction

What would make an art object Jewish: its so-called subject matter? But, if that is the case, what about a menorah made by a gentile craftsman? Or the religion of the artist? If so, what about a crucifixion scene painted by a Jew?

— STEVEN SCHWARZSCHILD, 1987

I wanted to make tangible artifacts that were Jewish, simply so unmistakably and unapologetically Jewish work would exist in the fine arts.

— ARCHIE RAND, 2006

Consider two paintings: Camille Pissarro's *The Haystack, Pontoise* (1873) and Claude Monet's *Haystack, Morning Snow Effect* (1891). Both paintings were created in late nineteenth-century France, both artists worked in a style known as Impressionism, both painted in oil on canvas and exhibited together in the Impressionist exhibitions in Paris (1874–86). The theme of haystacks interested these artists because Impressionism was concerned with the effect of light and shade on different surfaces but also because life in the French countryside evoked national self-awareness, particularly in the urban cultural capital, Paris. While Pissarro's and Monet's techniques and ambitions were very similar, Pissarro's contemporaries in the Impressionist circle often singled him out as a 'Jewish artist'. What makes Pissarro's depiction of haystacks different from that of his contemporary Monet, a non-Jewish artist? Can we determine what distinguishes Pissarro's painting as an example of 'Jewish art'? This juxtaposition of Pissarro's and Monet's paintings raises the oft-debated topic of defining

modern Jewish art, plus the related query of who makes it. Moreover, is Jewish art even a legitimate genre, worthy of separate interpretation, in modern art? Exploring the work of European, American and Israeli artists, this book presents nearly two centuries of Jewish art in a concise and accessible manner.[1]

Some Jewish art is defined by distinctive subjects and symbols from the tradition, which have been incorporated into art by artists of Jewish descent. Yet Jewish artists have also participated in, and inflected, the main currents of artistic modernism. Jewish art of the more recent past, most notably and egregiously the 'School of Paris', has been excluded from the dominant, often nationalistic, canon of modern art.[2] But in the main, contributions by Jewish artists to modern art need to be examined within their differing settings in Europe, America and Israel and at different moments across the past two centuries. Consideration of the distinctive political, cultural and social conditions in which such art was produced, for example, frequently focuses on immigrant

and diasporic experiences, since Jewish artists repatriated like their co-religionists. At the same time, we remain mindful of the distinctive objecthood of the works we discuss, not simply relegating Jewish art to 'illustrations' or monuments that exist to educate or memorialize.[3]

The crucial question of definition haunts these initial pages. First and foremost, 'What is Jewish art?', and why should it matter in studying painting and sculpture of the modern era? Critics debate whether Jewish art should be limited only to any art made by a Jew, independent of content, or if both the artist and the artwork must be identifiably Jewish, expressly engaging the 'Jewish experience'. In other words, a portrait by Moritz Daniel Oppenheim (chapter Three) of a gentile sitter would be considered a 'Jewish' work of art, just as much as a Holocaust memorial by George Segal (Conclusions) or a landscape of Palestine by Reuven Rubin (chapter Six).

Indeed, in 1984 a group of scholars debated the subject of Jewish art and subsequently agreed that 'Jewish art is art which reflects the Jewish experience'.[4] That group cited art created for purposes of worship, especially ritual art; synagogues; and Hebrew illuminated manuscripts; but they did not address painting or modern art, leaving the question open as to how more contemporary Jewish artists would fit into their definition. Further, what comprises the 'Jewish experience' remained undiscussed. Jewish experience

and history differ in each country or continent, and across each generation. Moreover, Jewish worship itself comprises different denominations and levels of prayer. This general ambiguity concerning the Jewish experience, both religious and cultural, is only magnified by anthologies on Jewish art and survey texts, where the general term 'Jewish art' is used without precision.[5] As this book will show, Jewish art is far from monolithic in style, form and subject, because of the remarkably multifarious Jewish experiences across both geographies and time.

At times Jewish artists make art that does not overtly appear to be Jewish (religious or cultural), but close observation reveals that Jewish identity is encoded in the work.[6] For example, in discussing the paintings of Ben Shahn, Ziva Amishai-Maisels argues that for a period Shahn avoided direct reference to the Holocaust but still expressed his Jewish identity by employing allegorical subjects. She arrived at this conclusion by uncovering Shahn's use of Holocaust photographs as source material for his paintings on other socially conscious topics with implications about the plight of Jews as well.[7] Some artists deliberately deny their Jewish identity as an influence on their work. For much of his life, Raphael Soyer disputed that his art was affected by his Jewish heritage, preferring instead to adopt the moniker 'New York Painter', yet recent scholarship has demonstrated that he

was profoundly shaped by the Jewish American acculturation experience.[8] Helen Frankenthaler, a post-painterly colour field artist, presents a similar case; in 1998 she described her views: 'My concern was and is for good art: not female art, or French art, or black art, or Jewish art, but good art.'[9] Omitting Frankenthaler as a Jewish artist solely on the basis of her personal claims, while including Soyer, seems uncritical. Before Soyer was examined along these new lines, most scholars understood him as having eschewed Jewishness in his art.

In sum, whether Jewish artists should be defined by their sociocultural characteristics or by their subject matter remains an open question. Clearly, no sole definition of Jewish art has universal applicability; indeed, many historians have avoided the topic altogether. As Steven Schwarzschild put it: 'Treatments of Jewish art invariably feel constrained to begin by discussing whether there even is such a thing as "Jewish art", and, if there is, how it is to be defined.'[10] Similarly, Michael Awkward calls attempts to pass tests, identify qualities, or to label, 'border policing'.[11] Rather than employing labels, this book asserts that investigating Jewish art can help to establish elements of artistic identity within the larger analysis of artistic production. Avoiding any reductive classifications or essentialism, we hope instead to consider a neglected, often rejected, element of individual formation in considering the

variety of definitions asserted by artists both for themselves and for their works during the past two centuries.

Western art is typically understood as a product of national 'schools of art', and its imagery created within a dominant Christian society. Moreover, until recently, art – especially from the modern period – has been viewed as progressive, an evolution of one style from or in reaction to the next. Jewish art cannot be understood within this rubric; Jews stand outside Western, Christian-based norms by virtue of their (often marginalized) religion and because of their status as a diasporic people. No doubt, Jewish life, unstable and continually displaced, remains central not only to the prejudices suffered by Jews of the ages, but also to the artistic and cultural development of Jewish art.

While some interpreters focus on the negative consequences of the Jewish exile, others view the diaspora as fostering creativity.[12] To be sure, the themes and art by many Jewish artists described herein were only possible in a diasporic (or immigrant) situation. Those ever-present reminders of one's religiocultural differences under a host culture often enabled Jewish creativity, and exchanges between Jews and non-Jews contributed to the myriad responses to modernity described in this book. As Stuart Hall so eloquently observed: 'Diaspora identities are those which are constantly producing and reproducing

themselves anew, through transformation and difference.'[13]

In any case, how challenging it is to try in vain to define Jewish art when Jews themselves resist classification, variously identified by detractors or internally labelling themselves as a religion, a people or a culture. One would hope that such terms might be exhausted and finally unnecessary after the Holocaust, but the establishment of the Jewish state and the flourishing of a new Israeli art (see chapter Six) to complement an already nationalistic art of Palestine only adds to the complexity of the situation. Thus typical art historical classification cannot easily apply to Jewish art, at once the art of a religion but also of a distinctive culture, variously modified within diverse nationalities. Indeed, for centuries Jews have been seen as a separate nation living within various nation-states, and they were pressured ever since emancipation after the French Revolution to assimilate into the dominant national cultures of Europe.

Thus, one crucial caveat for this book is to clarify that the study of Jewish art cannot be analogized to the study of Christian art. 'Christian art' is often erroneously limited to a specific period – usually the 'medieval' era – in the history of art, but properly understood, 'Christian' can encompass such artistic endeavours as Carolingian manuscripts and Byzantine icons, to a French Gothic church, or famous paintings of the Italian Renaissance, such as

Raphael's *Sistine Madonna* (1513–14) – in other words, all art made for Christian worship.[14] So if we allowed Christian art to provide a model, then Jewish art would mean all art made in the service of the synagogue. In actuality, Jewish art incorporates a wide variety of subjects, including secular images, whereas Christian art is identified primarily by religious iconography.

It is no coincidence that substantial numbers of Jews entered the profession of art precisely at a moment when modernity altered many of the motives and subjects of art. After the French Revolution European artists began to disengage their creations from dedicated religious or political purposes; instead they took an interest in wider culture and worked more frequently without direct commissions from patrons, and increasingly explored subjects of a more personal nature. In short, comparing Judaism to Christianity can be misleading, because of the Jewish people's peculiar, ambiguous and shifting position as both a religion and a culture, an idea that permeates this book.

Jewish art needs to be studied for this very reason: art by a Jew – a person not raised within the dominant majority – is continually shaped by difference. We intend to explore through a range of examples how that differ-ence, both consciously and unconsciously affects the art made by Jews. When marked by gender, race or religion, such Otherness

inevitably colours an individual.[15] For example, when nineteenth-century European Jews emerged from ethnically homogeneous ghettos or shtetls into larger society, suddenly their difference was foregrounded, influencing perceptions, interactions and ultimately personal creations. Some Jews of the modern period submerged their marked identities; others completely renounced their Jewishness, even undergoing conversion. Many tried to find a way to negotiate Jewish life in their new social spaces, and this book will attempt to elucidate how these issues manifest in works of Jewish art.

The sociologist Georg Simmel delineates this situation, which he terms the 'web of group affiliations':

> As the individual leaves his established position within *one* primary group, he comes to stand at a point at which many groups 'intersect.' The individual as a moral personality comes to be circumscribed in an entirely new way, but he also faces new problems. The security and lack of ambiguity in his former position gives way to uncertainty in the conditions of his life . . . external and internal conflicts arise through the multiplicity of group-affiliations, which threaten the individual with psychological tensions.[16]

W.E.B. Du Bois, too, describes the conflict inherent in a marked existence, here for African Americans, as a 'double consciousness, this sense of always looking at oneself through the eyes of others . . . one ever feels his two-ness – an American, a Negro; two souls, two thoughts, two unreconciled strivings; two warring ideals in one dark body.'[17] In relation to the American Jewish experience, such double consciousness has been modified to describe Jews as 'insiders who are also outsiders' – as a people who are 'standing somewhere between the dominant position of the white majority and the marginal position of peoples of colour'.[18] Over a century later Du Bois' observation remains very relevant to both the black and Jewish experience, considering both groups' status as Others within a prevailing host culture. Importantly, African American art is now a recognized area of study. Also akin to the position of black artists and Jewish artists are female artists within a male-dominated, often chauvinistic world; copious current scholarship describes how women articulate and bear witness to their marked experience in art.

A principal reason why students of Jewish culture, from the nineteenth century onwards, have accepted uncritically that Jews did not make art is that they assumed that an obedience to the biblical proscription against 'graven images' in the Ten Commandments perennially denied Jews the opportunity to make conventional religious representations. Interpreted stringently, the Second

Commandment has been understood as prohibiting the creation of any art: 'Thou shalt not make any graven image, or any likeness of any thing that is in the heaven above, or that is in the earth beneath, or that is in the water under the earth' (Exodus 20:4). Deuteronomy repeats and broadens this ban:

[L]est ye deal corruptly, and make you a graven image, even the form of any figure, the likeness of male or female, the likeness of any fowl that flieth in the heaven, the likeness of any beast that is on the face of the earth, the likeness of anything that creepeth on the ground, the likeness of any fish that is in the water under the earth [Deuteronomy 4: 16–18].

A closer reading of the text shows, however, that the commandment was directed against figuration used for idol worship, not other types of artistic expression.[19]

Indeed, Jewish art *was* fabricated in ancient times, but was not visibly transmitted to later visual traditions – likely a result of the Jews' diasporic life and subsequent inability to transport art rather than any literal adherence to the biblical injunction. Clearly, the Second Commandment did not by any means preclude art. Human renderings appear in the third-century synagogue murals of Dura Europos in Syria (see chapter One) along with other significant works made for and

by Jews. Even earlier, in the book of Exodus, Bezalel – the first Jewish artist and the only artist mentioned by name in the Hebrew Bible (Exodus 31:2 and 35:30) – designed the Tabernacle and its holy vessels.[20]

Recently, Kalman Bland deconstructed some myths behind the Second Commandment, demonstrating the belief that Jews are aniconic is a mischaracterization, steeped in anti-Semitic perceptions and modern constructions of Jewish creativity.[21] Nonetheless, to some degree, the heritage of this 'prohibition' still affected Jewish artists. As late as the twentieth century in America, the European-born Maurice Sterne – who, in his own day, was famous enough to command the first one-man exhibition by an American artist at the Museum of Modern Art (in 1933) – recalls being chastised for his love of art at an early age:

[T]he graphic arts had absolutely no place in our lives. Religious Jews took very seriously the Biblical injunction against 'graven images,' and I was punished badly one day by the rabbi of my school for drawing his picture on the ground with a stick. He said that I had broken the Second Commandment.[22]

A seminal figure from the next generation in American art, Jack Levine, began painting biblical works in 1940 in an attempt to augment

Jewish pictorial expression, which he felt was hampered by the prohibition against graven images: 'Because of the Second Commandment, against graven images, there is a relatively sparse pictorial record of Jewish history or the Jewish imagination. I felt the desire to fill this gap.'[23] Archie Rand, whose recent monumental exploration of rabbinic law provides one of the last images in this book, felt a similar imperative to create: 'I realized that one of the rights and obligations of any culture is to manifest a visual exponent of that culture. Judaism had been forced externally and internally to ignore that impulse.'[24]

Chaim Potok's novel *My Name is Asher Lev* (1972), a book that Levine references when talking about the challenges of a child-artist born to observant parents, also addresses this issue.[25] The protagonist Asher, the son of a Hasid, chooses the profession of painter, enduring the condemnation of his family and community because of his rejection of the Second Commandment. Poignantly characterizing himself as an outcast, Asher offers the opening words of the novel in the form of an introduction:

I am Asher Lev, *the* Asher Lev . . . So strong words are being written and spoken about me, myths are being generated: I am a traitor, an apostate, a self-hater, an inflicter of shame upon my people.[26]

Undoubtedly, the Second Commandment's legacy, however inflated, still persisted in some Jewish minds and thus conditioned some of the art described here.

The following pages provide an analytical survey and reconsideration of the richly textured varieties of Jewish art-making in Europe, America and Israel across the past two centuries. Because of space constraints we cannot be comprehensive; instead we have chosen topical or typical works across a wide range of media and by representative artists. Ranging from biblical narratives to modernist experimentations, portraits to synagogue scenes, Holocaust memorials to explorations of diasporic life, from history paintings to genre paintings to landscapes to still-lifes, the art described herein provides the reader with a broad understanding of the issues and ideas influencing modern Jewish artists. Employing both a chronological approach and a regional orientation to create a historical framework, this book describes how aspects of the diverse and complex Jewish experience find expression(s) in modern art.

Since this book focuses on figural art, primarily from the modern era, it necessarily excludes important dimensions of Jewish creativity: the built environment, whether synagogues or other major buildings by Jewish artists; and decorative objects, especially items for ritual use (usually marginalized under the rubric of 'Judaica'). Geographically, some

regions that produced the earliest important Jewish art include areas now described as Sephardic, but our focus on the modern era in Europe, America and Israel will consider artworks by all Jewish artists, irrespective of their subdivisions, whether by region or tradition. First, we must begin to see the larger whole of Jewish art-making. Let future investigators pursue and amplify those important distinctions.

1 A Prequel to Modernity

The conception of Jewish Art may appear to some a contradiction in terms.
— CECIL ROTH, 1961[1]

Judeans nor their forebears possessed any kind of plastic or even mechanical ability . . .
As a matter of fact Israel through the ages has manifested nothing essentially national
in the plastic arts, neither in antiquity, nor through the Middle Ages, nor to-day.
— BERNARD BERENSON, 1948

When the extensive murals of Dura Europos Synagogue were discovered in Syria in 1932, their elaborate imagery and unprecedented range of Jewish subjects arrived with a shock only approximated by the discovery of pre-historic cave paintings in Spain and France in the late nineteenth century.[2] In part, because of the assumed proscription of Jewish imagery enforced by the Second Commandment, people could not believe what they were seeing. Or else they tried to understand these synagogue pictures as an aberration or as a prefiguration of later Christian sanctuary decoration. After all, it was widely believed, Jews were the 'nation without art'.[3] As noted in the Introduction, that canard has been refuted as a slur, one chiefly asserted by German anti-Semites of the late nineteenth century who deemed Jews a people distinguished chiefly by their lack of interest in visual art, occasioned by the prohibitions of their Second Commandment against 'graven images'. Yet, taken to heart by German Jews as a spiritual badge of honour,

this notion still held sway as a cultural given for many Jewish artists and intellectuals into the late twentieth century.[4]

In many respects, the issues of modernity were shaped in the immediate wake of the French Revolution (1789–99), when the question of the status of Jews in the new regime arose shortly after the *Declaration of the Rights of Man* (1789). The autonomy of the Jewish community posed a problem within the otherwise homogeneous citizenry.[5] Uniform, equal civil rights under the new order came with the privatization of religion and its separation from the dominant and conformist secular state. As the French National Assembly put it on 23 December 1789, during a debate on the eligibility of Jews for citizenship:

> The Jews should be denied everything as a nation, but granted everything as individuals . . . They must constitute neither a state, nor a political corps, nor an order. They must individually become citizens.[6]

Confirmed by Napoleon, these views established the persistent problem of Jews within an emerging secular world, a world that officially disestablished any dominant religion and practiced toleration in the wake of Enlightenment values. Yet within their supposedly neutral participation in secular life, Jews remained marked and self-aware, excluded from opportunity by discrimination. Moreover, their picturesque difference, especially for observant Jews, was often singled out with a contrasting vision of Jews as 'Orientals' in the midst of a progressive, European 'West'. Jewish nationhood, always a minority amidst emerging modern nation-states, was defined from the outside, until it was embraced as a goal of self-definition by the Zionist movement at the turn of the twentieth century.

Within such poles of behaviour – the separation of the secular public sphere from a private, personal religiosity – the Jew was compelled to negotiate the process of modernization. This was all the more true for the 'Jewish artist', an unprecedented category of professional aspiration and identity. Thus this book will address the basic story of Jewish history and art from the period of emancipation, the general European cultural Enlightenment as well as the official declaration in France (1791) that Jews could be equal citizens – provided that they renounce their distinctive faith and culture.[7] This tension of identity would continue to haunt Jews even in the modern era: as 'ethnics' by descent, they were yet another 'people' in an era marked by multiple nationalist movements, or they could be understood purely as a religion in an era of uneven but progressive toleration under a Christian majority.

Contrary to suppositions about the Second Commandment, early Jewish imagery, whether in the form of symbols or in religious narratives, had flourished at several historical moments, both ancient and medieval, only to be interrupted by cultural dispossession in the form of either expulsion or persecution. More than any other monument, the Dura Europos synagogue (244–45 CE, illus. 1) provides a unique touchstone for assessing ancient Jewish visual culture at its fullest – and perhaps for imagining what might have been. The site was a Roman provincial boundary settlement, populated with temples of various religions and cults, including a much smaller Christian sanctuary. An overview of the synagogue interior shows a variety of narratives – some 58 episodes in 28 panels – displayed in three superimposed registers alongside and above a projecting shell niche on the western wall in traditional orientation towards Jerusalem, which forms the visual focus of the sanctuary.[8]

Importantly, that niche contains a number of enduring symbols of Judaism: to the left, a menorah (a seven-branched candelabrum); in the centre, a representation of the Temple

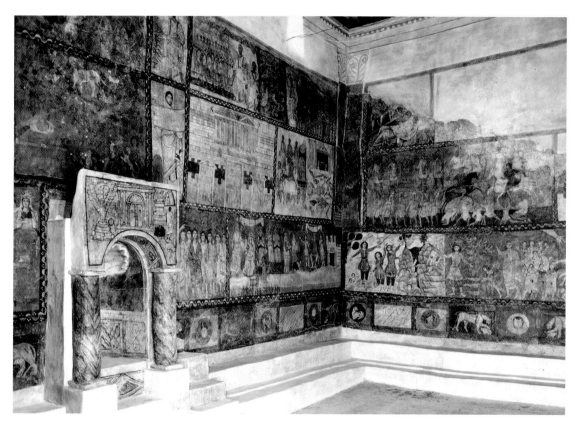

1 *Dura Europos*, Syria, *c.* 245, Synagogue interior, overall view.

facade (destroyed in 70 CE); and to the right, an abbreviated narrative of the binding of Isaac (Akedah; Genesis 22) on Mount Moriah (or Temple Mount as it later became known). That event, a test of commitment on the part of the patriarch of the Jewish people, also reaffirmed the covenant between Jews and their lone God while assuring direct divine intervention in the future for his descendants.[9] At the same spot in Jerusalem, later construction of the Temple provided a true religious centre; twice destroyed, that structure still remained a beacon of hope for future reconstruction and redemption. In the Dura frescoes, the Temple facade representation features a shell in its centre, echoing and reconfirming the significance of the shrine below. Also inserted to the left of the Temple, a *lulav* (palm cluster) and *etrog* (citron) signify the ritual items offered during pilgrimage at the Autumn harvest festival of Sukkot, an ingathering at the Temple. Ultimately all these images recreate

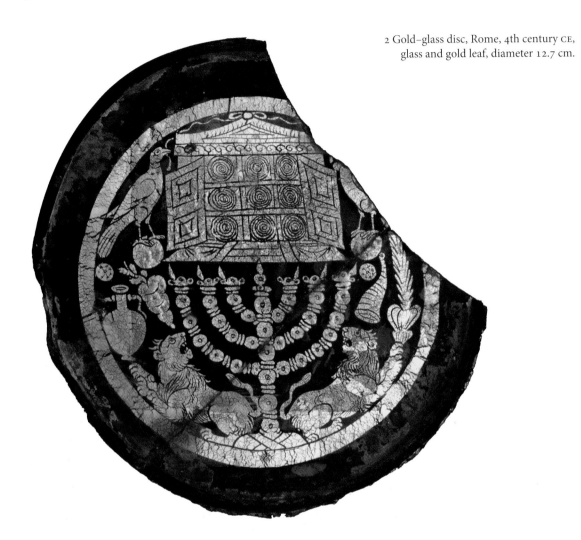

2 Gold–glass disc, Rome, 4th century CE, glass and gold leaf, diameter 12.7 cm.

links within the biblical covenant, stretching from the absolute faith of Abraham up to the building of the Temple, whose future physical re-creation is symbolically performed with this image, even within the decoration of a provincial synagogue.

It is likely that the menorah in the niche depicts the actual object from the Temple, lost in the Roman destruction of the Second Temple 70 CE, as represented in the scene of looted trophies on the Arch of Titus in the Roman Forum (81

CE).[10] Along with the divine intervention in the story of Isaac, these other symbols of centralized Jewish life around Jerusalem indicate a messianic hope for rebuilding the Temple as well as re-establishing Jewish life and culture there.[11] This vocabulary of identity and hope also appears in rare surviving decorative objects, such as a gold glass disk from a Roman catacomb (illus. 2); here the central portion is dominated by a menorah with flanking lions below and an ark of the Law with flanking doves above; the open

ark shows three shelves of rolled Torah scrolls within.[12] These symbols thus refashion even the provincial synagogue into the image of the once and future Temple.

While a number of synagogue mosaics survive with a similar roster of symbols, Dura Europos remains truly unique and challenging in its vast cycle of religious narratives.[13] One prominent story on the top right of the western wall shows Moses, oversized in scale and dressed like a Roman, leading the Hebrews through the Red Sea – the ultimate image of redemption, recounted every year in the household festival of Passover (illus. 3). Scenes around the Torah niche on the same wall chiefly involve the Ark of the Covenant, forerunner of the Temple. To the right, in the lowest register, the saving discovery of the infant Moses anticipates the later water miracle by the adult leader. Above it, the Ark on a mobile cart is shown overthrowing the idols of the Philistine god Dagon in Ashdod (1 Samuel 4–6), reaffirming the supremacy of Judaism within the diverse religions of Dura, a border town. And to the left, the lower scene also depicts the Jewish triumph over Persian threats through the equestrian Triumph of Mordecai (Esther 6:11). Instead of a narrative image, above that register the Consecration of the Tabernacle with the priest Aaron (Exodus 7–8) leads

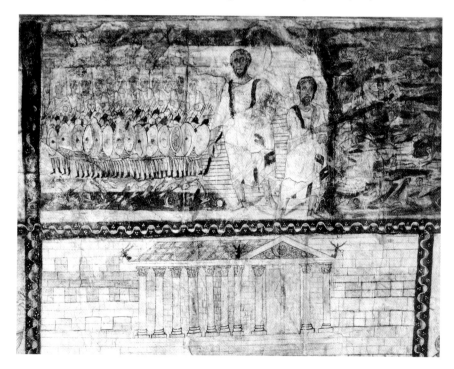

3 Dura Europos, Syria, c. 245, synagogue interior, detail.

across the niche to the image of the Temple itself before the Ark and Dagon. The Tabernacle is not represented as the tent described in the Bible, but rather as a Roman temple, adorned with a central menorah and ark like the Dura niche, reinforcing the symbolic connections seen also on the gold disk. Opposite, on the northern half of the western wall, appears an unpopulated image of the Temple itself, echoing the representation of the earlier Tabernacle and asserting the sacral continuity from tabernacle to Temple to Dura imagery. Above the niche on either side of the scene of the patriarchal Blessing of Jacob two prophets, Isaiah and Jeremiah, provide links between the past, present, and messianic future.

Taken together, Dura Europos exemplifies a synagogue decoration tradition made up by both symbols and stories. While its narrative richness remains unique, later synagogue mosaics extend the constellation of Jewish symbols and their messianic promise. The crossroads hub of Sepphoris (early fifth century), near Nazareth, provides the most detailed mosaic floor decoration (illus. 4) of any synagogue, and is one of several major mosaic ornaments of domestic or public structures in the city.[14] Included among these crisply delineated image bands are several (damaged) biblical scenes – not only the Sacrifice of Isaac but also the annunciation to Abraham that Sarah would bear Isaac, plus Aaron, before the Tabernacle (Exodus 29). In

the centre of the floor stands a zodiac with symbols of the four seasons,[15] a pagan image of the cosmos, around which Temple symbols abound: (in descending order) heraldic lions around a wreath; a Temple facade with incense shovel, flanked by symmetrical menorahs, shofars and Sukkot objects; the Temple offerings of Aaron (Exodus 29); the table of the showbread (Exodus 37) and basket of first fruits (Deuteronomy 26). These latter groups are important as they depict actual Temple services. As Zeev Weiss has explained, this cluster of images presents an image of the covenant with Abraham, a promised offer of future divine redemption for the Jewish people, climaxed by the rebuilding of the Temple.[16] Mira Friedman has suggested further that the imagery of the sun chariot might have raised eschatological associations with personal resurrection and everlasting life for their Jewish viewers, particularly with reference to the biblical ascent by Elijah in a fiery chariot to heaven.[17]

Jewish imagery during the early Christian era also succumbed, along with Byzantine art in Constantinople and Islamic art, to sanctions against figuration, favouring instead the construction of purely geometric floor patterns, and there is evidence of destruction of earlier synagogue imagery, especially in northern Palestine.[18] In effect, this movement might indicate an instance of Jewish pride in aniconism, versus figural representation

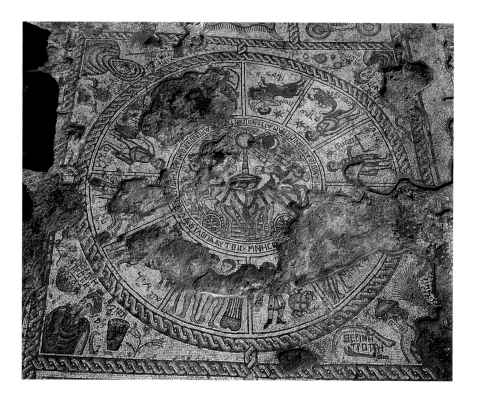

4 Sepphoris synagogue, early 5th-century mosaic.

within the visual culture of dominant Christianity. The eventual dispersal of the Jewish community to form the major division of Ashkenazim (in Northern and Central Europe) and Sephardim (in the Mediterranean and Near East) slowed ancient Jewish visual culture. Some surviving books from the Islamic regions point to important scribal work, ornamented with decorative patterns composed out of fine calligraphy, known as micrography. These books were followed by an even more extensive pictorial tradition, recovered in the late nineteenth century: medieval illuminated Hebrew manuscripts.[19]

A key work, known as the Sarajevo Haggadah (c. 1350), provides the Passover seder service. It was produced in Spain, not under the Islamic rulers who had provided a medieval golden age for Jews in southern Spain, but rather under Christian kings in fourteenth-century Catalonia.[20] The Haggadah's publication in facsimile (in 1898) anticipated the later find of the Dura murals by a full generation. Not only did this impressive work include the first rediscovered medieval Jewish figural imagery, it also featured narrative sequences like contemporary Christian manuscripts, such as Latin Psalters from France and England.

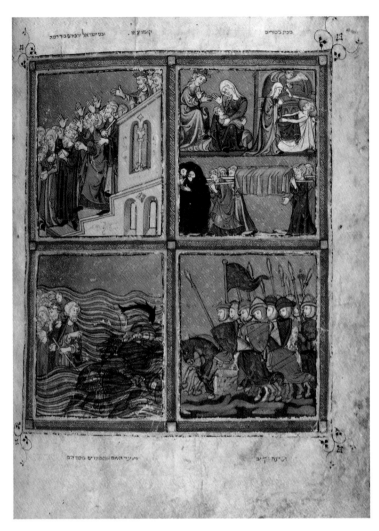

Soon other manuscripts were discovered, revealing that Jewish book illumination also included German and Italian works from the thirteenth to fifteenth centuries. Disruptions in regional Jewish history interrupted these otherwise thriving traditions, especially the widespread Sephardic persecutions of 1391, which effectively stilled production of illuminated Haggadot before Jews were finally expelled from Spain in 1492.

In Spain the burgeoning manuscript tradition provided another assertion of Jewish identity and visual culture; however, unlike the leadership role by Jews *vis-à-vis* emerging Christianity back in the mid-third century at Dura Europos, by this period the roles of the two religions had reversed: these Spanish Jewish images responded to prior, established Christian models. Perhaps the most spectacular of the Sephardic manuscripts, the Golden Haggadah (*c.* 1320–30), features fourteen full-page miniatures. One page (illus. 5, fol. 14v) uses quadrants to present the departure of the Hebrews from Egypt alongside the death of the Egyptian firstborn, above a pair of scenes of the Exodus below. There the Egyptian army,

5 'Scenes from Exodus', *Golden Haggadah*, c. 1320–30, parchment, gouache, burnished and patterned gold.

moving to the left in accord with Hebrew reading habits, pursues the Israelites, only to drown in the Red Sea as Moses turns to confront them. Slender figures with large heads gesticulate emphatically. The book's eponymous gold grounds and geometrical designs, as well as individual figural motifs, stand close to recent Gothic manuscripts, including Old Testament cycles from France, particularly during the later reign of King Louis IX,

whereas individual Genesis scenes have been linked with various Christian models in Italy and France.[21]

The Sarajevo Haggadah originated in nearby Aragon and also utilized French manuscript models, particularly for its alternating use of red and blue borders and background. This layout consistently characterizes its representations of two scenes on a divided full page. For example (illus. 6; fol. 28r), its own version of the Crossing of the Red Sea features a miraculous displacement of dry land, presented as red background between two segments of water that encompass drowning soldiers. This scene is placed above the subsequent dance of rejoicing by Miriam and the women (Exodus 15:20). In both works, this climactic event of the Passover celebration focuses attention on the departing Hebrews, contributing to building up a consciousness as a people through its own image. Indeed, the Golden Haggadah and most Sephardic Haggadot conclude with quotidian images devoted to Passover preparations.[22] Thus within an increasingly intolerant

wider cultural milieu, Jews reinforced their own ceremonies and history through such luxury manuscripts, sometimes used ritually in seder observance but also created in resistance and response to Christian pictorial

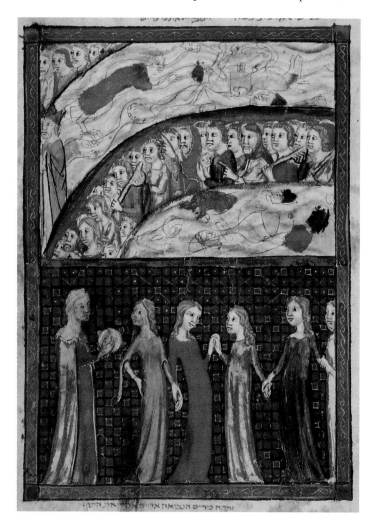

6 'Scenes from Exodus', *Sarajevo Haggadah*, c. 1320–35, ink and colour on vellum.

narratives, especially French thirteenth-century illustrated Bibles.

Contemporary Hebrew Bibles from Spain also received some illustration, though chiefly with traditional symbols featuring messianic overtones – ark, menorah and ritual utensils of the Temple – on facing pages.[23] But the largest, most beautiful of late medieval Jewish manuscripts, known today as the *Rothschild Miscellany*, was lavishly illustrated (illus. 7). Produced in Ferrara, northern Italy, in the third quarter of the fifteenth century, it is closely related to a major school of illumination for the Este court, headed by Borso d'Este, and it was certainly illuminated by several specialist Christian miniaturists, who were also working on a large-scale illuminated Bible for d'Este (1455).[24] Among its varied texts were Psalms, Proverbs, Job, Haggadah, a weekday-Sabbath prayerbook (*siddur*) and a holiday prayer-book (*machzor*). It also included secular material, such as legal and moral treatises. Many of the various texts were penned by a single, unknown scribe, although the patron's name, Moses ben Yekutiel ha-Kohen, is known through a Sabbath healing prayer on his behalf (*mi she-barakh*) inserted into the text. The page illustrated here (fol. 65) appears in the Job section; it displays his redoubled wealth after his tribulations (42:10), which consists of flocks, fields, orchards and extensive land holdings. The convincing naturalism includes an atmospheric landscape with glowing

sunset and also encompasses the animals described in the biblical narrative: sheep, cattle, asses and even camels.

Uneasy relations between medieval Jews and their Christian neighbours continued to erupt periodically in the form of overt perse-cutions, leading up to outright expulsion of the former from Iberia (from Spain in 1492; Portugal in 1497). Outbreaks of the Black Death, beginning in 1348, often were blamed on Jews (because, it was claimed, they had poisoned municipal well water). Even in the Italian Renaissance, an era normally charac-terized as progressive, Jews were depicted as perpetrators of the 'blood libel' (whether it be the desecration of hosts for the Catholic mass or even outright murder of Christian children for their blood), a charge most frequently asserted at Passover/Easter.[25] At such times, the relationship between ritual wine and matzah for Jews was seen as a critical counter-point to the Christian Eucharist and was often linked to traditional accusations of Jews as Christ-killers, renewed with violent pogroms.[26] Jews thus became objects, images, even stereo-types, for vilification in the visual arts in both Christian altarpieces and in histories, such as the *World Chronicle*, compiled in Nuremberg by Hartmann Schedel in 1493. Additional representations in German prints or paintings of the Passion of Jesus frequently stressed hateful torments inflicted by Jewish antagonists with grotesque features.[27]

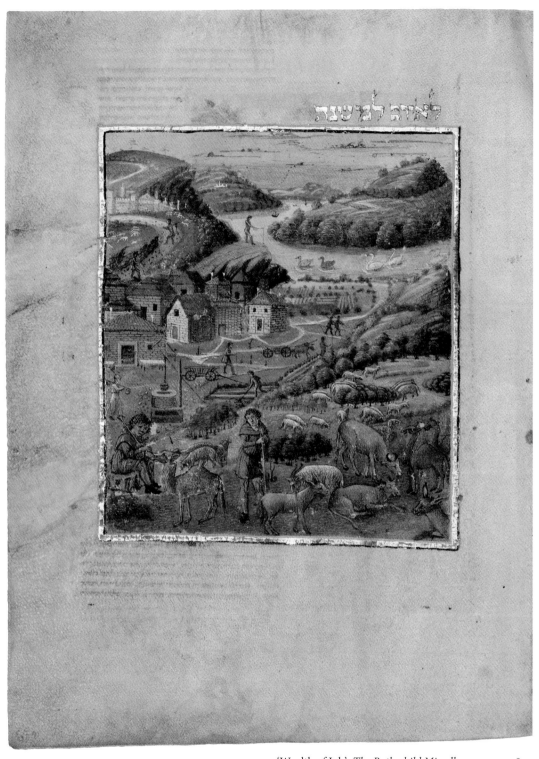

7 'Wealth of Job', *The Rothschild Miscellany*, c. 1450–80, vellum, pen and ink, tempera, gold leaf.

Imagery of Jews created by non-Jews, sometimes with hostile intentions, also became increasingly attentive to ethnographic accuracy. Emblematic of the status of Jews within German-speaking lands is a pair of seemingly documentary small etchings by Albrecht Altdorfer, a Christian artist and member of the city council in Regensburg, Germany.[28] They record both the entrance hall (illus. 8) and the interior of the thirteenth-century synagogue in the artist's home town; however, that building – and its surrounding Jewish community – were about to be razed and the community expelled, to be replaced by a new cult church erected on the spot to honour a venerated local icon of the Virgin Mary, the *Schöne Maria* of Regensburg. The narrow vestibule of the old synagogue is represented by Altdorfer with a couple of elderly congregants entering the door of the structure, which he depicts on an accompanying etching. The interior scene shows a central *bima* (pulpit), situated within a trio of columns that support two vaulted aisles of space. A shadowy ark on the eastern wall stands in the sanctuary rear. In eerie

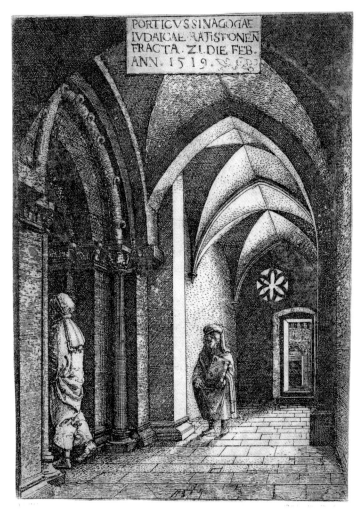

8 Albrecht Altdorfer, *Entrance Hall of Regensburg Synagogue*, 1519, etching.

anticipation of Hitler's proposed museum to the 'vanished race' of Jews in Prague, these etchings bear inscriptions making clear that they are documentary records of a destroyed structure – the microcosm of the entire local

community. Indeed, the pejorative inscriptions read, in translation: 'Portico of the Jewish Synagogue at Regensburg, broken up 21 February 1519' and (for the interior) 'AD 1519 Jewish Synagogue in Regensburg, destroyed by the just judgment of God [*iusto dei iudicio*] from the ground up'.[29] Just as with the artistic contrast between Jesus and his 'Jewish' tormentors or the ritual contrast between supposed Jewish activities and Christian rituals around Passover/Easter, Christians depended for self-definition upon demonizing the Jew as a stereotype and either converting him or extirpating him from their midst. Thus even in Altdorfer's dispassionate recording of a specific Jewish sanctuary, he expressly records its destruction as divine 'righteous judgment'.

After the expulsion of Jews from Spain and then Portugal, these Sephardim migrated either across the Mediterranean to Turkey, to Italy, especially Venice, or else to Holland, especially Amsterdam, arriving around 1595. There those Jews who had been forced to convert to Christianity – yet were suspected of dissembling and labelled as *conversos* or, worse, as *marranos*, or pigs – were finally allowed to practice their religion openly in a country dominated by Calvinist Protestants.[30] Despite having second-class citizenship status, even in Amsterdam, they were spared the persecution of earlier centuries. Some Jews in Holland were able to make considerable fortunes through commercial opportunism,

filling niches in emerging international commodity trade, particularly in tobacco, sugar, spices and coffee, through their connections with the Portuguese overseas trade networks. Jews were allowed to establish their own self-governing communities, the Jewish 'nation' (*Joodsche natie*), which included religious instruction and Hebrew publishing.

The prosperity of the Portuguese Jewish community eventually culminated in the construction of a magnificent synagogue, designed by Elias Bouman; its dedication in 1675 was commemorated in a large-scale etching by a non-Jewish Dutch artist, Romeyn de Hooghe (1645–1708).[31] Like this print imagery, the synagogue itself became a point of interest for visitors of all stripes in Amsterdam. One of the principal contemporary Dutch specialist painters of church interiors, Emanuel de Witte, was commissioned by the community to paint the interior of the synagogue in 1680 (illus. 9).[32] The contrast with Altdorfer's etching could not be greater, even though both works are documentary in purpose. That De Witte's image was commissioned by the Jewish community itself attests to their proud celebration of their (relative) religious freedom and prosperity, embodied in the great structure; moreover, since the artist had already painted interiors of prominent Calvinist and (imaginary) Catholic churches in Holland, to have him paint no fewer than three versions of this subject constituted a kind of

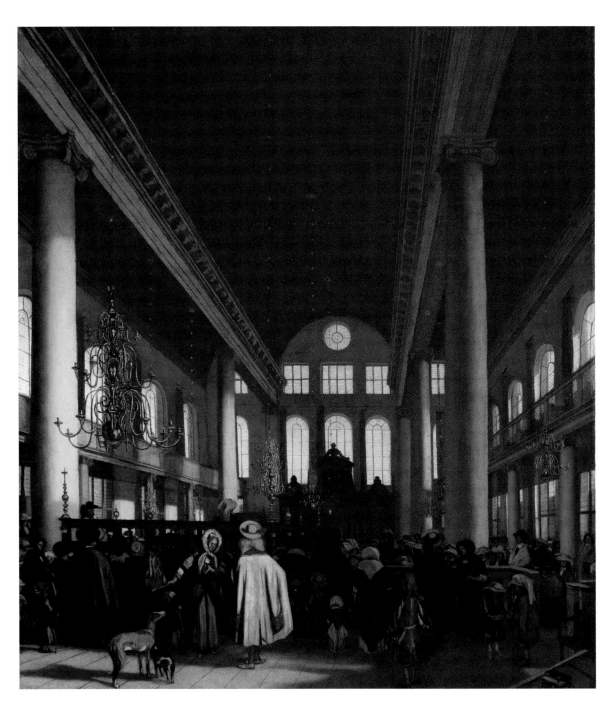

9 Emmanuel de Witte, *Interior of the Portuguese Synagogue*, 1680, oil on canvas.

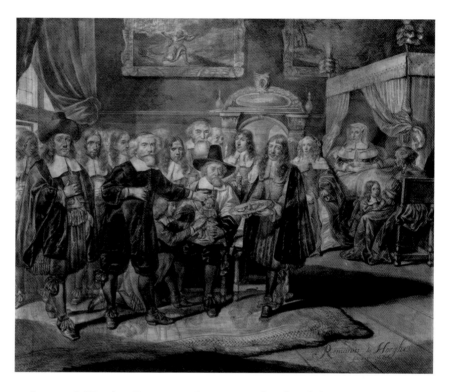

10 Romeyn de Hooghe, *Circumcision Scene*, 1665, ink and wash drawing.

parity with the other leading religious groups. The image features a foreground figure, standing in a pool of light, seen from the back while wearing a bright blue cloak; he is clearly non-Jewish, but unlike Regensburg's Jewish citizens, the costume of Amsterdam's Jews was not parochial, so discriminating the congregants from the larger crowd is difficult here. This synagogue has a high ceiling and large windows, making a bright, spacious interior, within which the ark at the far end is backlit and silhouetted. Furnishings include contemporary brass chandeliers that resemble the domestic lighting in Jan Vermeer's canvases.

Romeyn de Hooghe, although a Christian artist, also made one highly finished, elabo-rately signed drawing that features Jews as subjects, probably also on commission from the Jewish figures who appear in it: *Circumcision Scene* (illus. 10).[33] This distinc-tive Jewish ceremony (*brith milah*) takes place in the home, which here shows signs of pros-perity and culture. Its decorations feature elaborately framed pictures with subjects from the Hebrew Bible: the Vision of Ezekiel (Ezekiel 1:15–21) at left and Elijah Fed by the Raven (1 Kings 17:6). In the centre the new-born son is held on a lap, and the circumciser (*mohel*) gestures a welcome to the viewer, as he points towards his instruments laid out on an elaborate salver. For all its importance in the definition of Jewish life, this image

29

also pictures Dutch respectability, including conventional, contemporary costumes.

Of all the Dutch artists who engaged with Jewish or biblical subjects, including the representation of the Temple in art, the most prominent and the most consistent was Rembrandt van Rijn.[34] Living on the *Jodenbreestraat* ('Jewish' Broad Street), the principal neighbourhood of Amsterdam's Sephardic immigrants from Portugal, it is no wonder that Rembrandt took a deep interest in subjects from the Hebrew Bible. Moreover, the Dutch also maintained a national identification with the ancient Hebrews, seeing their struggle for independence against both the King of Spain and Catholic dominance as a modern equivalent of the Exodus from Egypt and the power of the pharaoh.[35]

The Akedah was a favoured subject for Rembrandt, which he portrayed in oil and print. His final representation of the scene, his etching of *Abraham's Sacrifice* (illus. 11), focuses on the climactic moment. Indeed, Rembrandt uses his characteristically dramatic use of strong tone and graphic vivacity as he employs an angel to represent intervention by the divine, preventing Abraham from slaying his son. This event, as noted above, poses the ultimate test of faith for the monotheistic founder of Judaism, who established the original covenant with God; the site on Mount Moriah (which means, 'The Lord shall provide', according to Genesis 22:14) and would become the eventual site of the Temple

in Jerusalem. Also distinctive for Rembrandt is the shadowed face of a bearded Abraham, who hears and feels the embracing presence of the angel without seeing.

Based on such images as *Abraham's Sacrifice*, it has long been believed that Rembrandt was sympathetic to his Jewish neighbours, perhaps even a 'philo-Semite', which would explain why he used Jewish figures for biblical subjects, from Abraham to Jesus. This claim has been seriously undermined in recent years.[36] However, like his fellow Dutchmen the artist did acknowledge both the importance of the Jewish heritage to the Christian faith and the personal dignity of his Jewish neighbours. Many of Rembrandt's sympathy-inducing, portrait-like images of picturesque old men in vaguely exotic costumes have now been doubted as images of Jews, though they were often considered as such in many early twentieth-century Rembrandt catalogues. Yet several character studies do seem to depict Jews of the Amsterdam community. Two portraits of young men with skullcaps clearly represent Jewish sitters (though even this evidence has been dismissed by recent sceptics).[37] One example (illus. 12) offers a small, loosely painted, and informal bust presentation of a sitter who looks frankly back at the viewer. What is important for Jewish artists, particularly later nineteenth-century painters like Maurycy Gottlieb (see chapter Two), is that

11 Rembrandt van Rijn,
Abraham's Sacrifice, 1655,
etching.

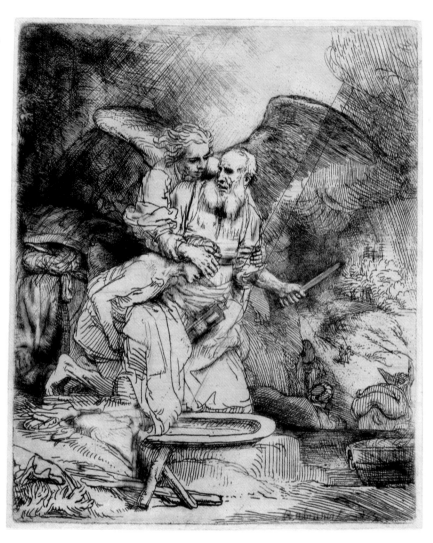

such images were, in Rembrandt's time, sincerely believed to be the artist's personal, sympathetic depictions of his Jewish contemporaries, serving as a precedent for associating Jews with great art, even as subjects worthy of portraiture.

Additionally, Rembrandt is known to have worked with Rabbi Menasseh ben Israel, who then was actively engaged with contemporary Christians in both Holland and England and who even advocated with Oliver Cromwell for the return of the Jews to England (they had

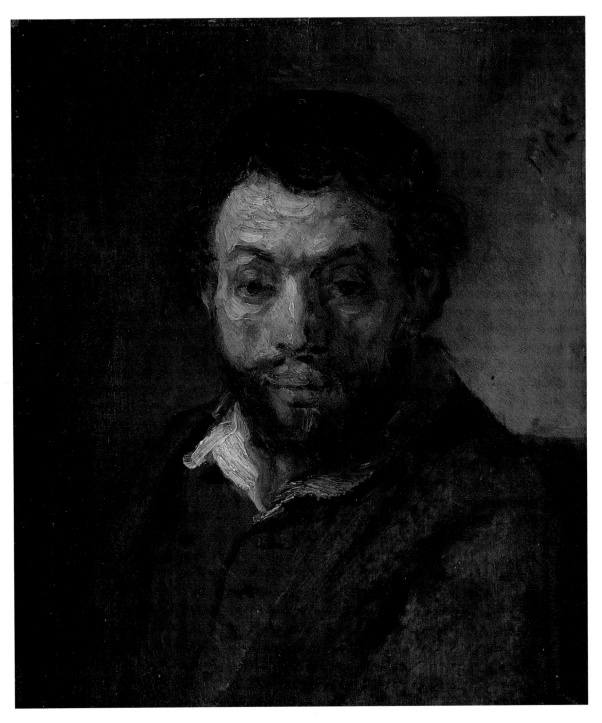

12 Rembrandt van Rijn, *Portrait Study of a Young Jew*, 1648, oil on panel.

been officially expelled in 1290).[38] In fact Rembrandt's 1636 portrait etching of a man in a floppy hat, was long assumed to be a portrait of the rabbi, but its subject has since been rendered anonymous, as it does not resemble the documented likeness of the rabbi made in 1642 by Salom Italia (*c.* 1619–1655), a Jewish engraver and calligrapher living in Amsterdam.[39] Rembrandt did work with Menasseh ben Israel on four etchings to illustrate the rabbi's biblical interpretation of Jewish messianic prophecy, his *Piedra Gloriosa*, published in 1655; however, even in that case Italia intervened with engraved copies, at once more durable than etchings but also containing a correction to Rembrandt's suggestion of the image of God in his rendering of the Vision of Daniel (7:9). Probably with the assistance of Menasseh ben Israel, Rembrandt also managed to make accurate representations of Hebrew words and letters when he used them in his art.[40]

In the wake of the Thirty Years War (1618–48) the situation of Jews improved measurably, as they returned to cities in German lands. Those with wealth or special training, such as doctors, came to occupy positions of influence as 'court Jews' (*Hofjuden*) among regional rulers who needed their financial support.[41] In the process, as in Holland, the study of increasingly visible Jewish ceremonies and settings formed the basis of numerous illustrated texts, especially Bernard Picart's encyclopedic *Cérémonies et coutumes religieuses de tous les peuples du monde* (1723–37, see chapter Two). Such social prominence also soon manifested itself in a legacy of pious donations of ritual objects and art, sometimes referred to as 'Judaica'. Ritual art was commissioned mostly from non-Jewish craftsmen by prominent Jewish patrons for use in the new synagogues.

A good example of such works are *ketubot* (Jewish wedding contracts), often richly decorated but made for a more practical purpose: to outline the rights and responsibilities of a betrothed couple (although, until recently, *ketubot* traditionally only described the bridegroom's obligations). *Ketubot* decoration originated in tenth- to twelfth-century Eretz Israel and Egypt, and styles of *ketubot* typically mirrored the dominant style of the region where the contract was designed. Popular in Spain beginning in the thirteenth century, the tradition of illuminated *ketubot* followed Jews to areas of dispersion when communities were expelled – for example from Spain in 1492 – reaching its pinnacle in seventeenth- and eighteenth-century Italy.[42] A *ketubah* from Modena (illus. 13) comes from this golden age, a pastel watercolour favouring pink, on parchment, with gold paint. The Jewish artist, Judah Frances, signed his name in small letters at the bottom of the document along with a benediction for himself: 'May his rock protect him.'[43] Framed by a columned archway, the elaborate programme features a central shield bearing the betrothed couple's

family crests, held by female angels; buxom, bare-breasted women in antique drapery. An inscription, also held by the angels, offers an abbreviation of the phrase 'With the help of God, may we prosper in what we do'. The angels are accompanied at the bottom of the *ketubah* by putti; classically rendered, small, nude cherubs, which indicate adopted motifs from the host culture and some level of acculturation. Another inscription, within the plaque held by the putti, recalls the biblical predecessor to the bridegroom (a common motif in *ketubot*), his namesake: 'Abraham is to become a great and populous nation and all the nations of the earth are to bless themselves by him' (Genesis 18:18).

Other Jewish artists, such as Italia or the mostly anonymous Venetian designers of Purim *megillot*, or Esther scrolls, produced works for use within the community. Esther scrolls were first decorated in late sixteenth-century Italy, reaching their pinnacle in that country, as well as in the Netherlands and Germany, during the following two centuries. The story of Esther, first recorded in her eponymous book, recalls events in this pivotal biblical heroine's life. In brief, Esther lived in the fourth century BCE and, with her uncle Mordecai, helped rescue the Jews of Persia from the villainous Haman. A central rite during the holiday of Purim, the Feast of Lots, is to read the *megillah*. While including narrative scenes from the life of Esther, the scrolls were also richly embellished

with decorative borders and patterning. Some *megillot* offered Esther's story with biblical figures portrayed in contemporary dress. Other illustrations recalled motifs found in *ketubot*, including allegorical figures and elaborate architectural framing.

Even more intricate ornamentation – expansive floral decorations and animal motifs, along with printed prayers in Hebrew – adorns the wooden walls and ceiling of the German Horb am Main synagogue (built in 1735; now preserved at the Israel Museum, Jerusalem), painted by Eliezer Sussmann (active *c*. 1732–42).[44] At least seven other Bavarian synagogues are thought to be painted by Sussman, who signed his name, as well as his wife's, on the eastern tympanum of this example. This most complete surviving interior by Sussman attests to a stunning tradition of painted wooden synagogues (most of which were destroyed in the Second World War), which originated within the Polish-Lithuanian commonwealth (Sussmann came from Brody, near Lvov, in the Ukraine).

Jacob Moses Speyer, a court Jew in Michael-stadt, and his wife, Gitele, commissioned the Torah decorations for the Frankfurt synagogue in 1784 from a Jewish silversmith (illus. 14).[45] Master craftsman, Johann Jacob Leschhorn (active 1740–1787), created both a shield and finials (*rimmonim*, 'pomegranates') to orna-ment the holy scrolls in the ark. The shield is a recently invented Jewish decorative element,

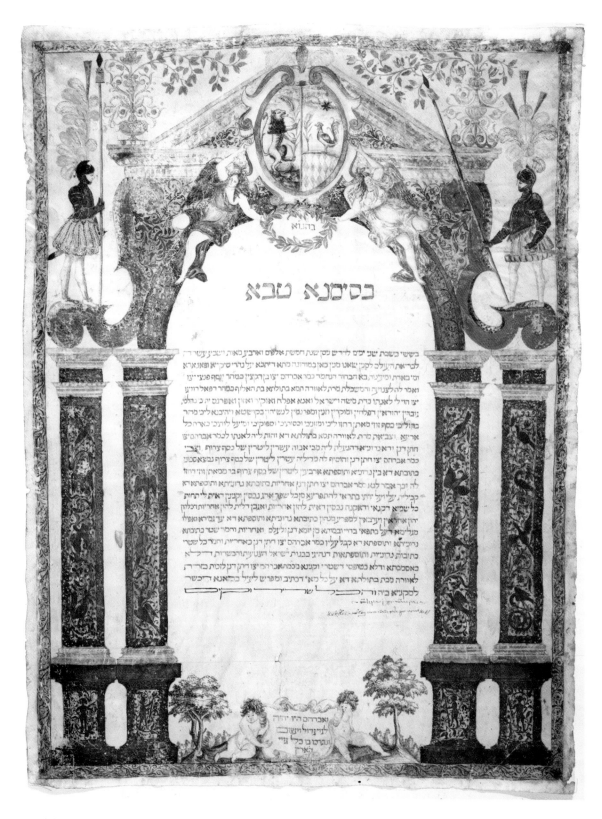

13 Judah Frances, *Ketubah*, 1657, ink, watercolour, and gold paint on parchment.

though Torah finials originated in antiquity. Both objects are enhanced by the presence of pendant bells and delicate surface decoration, including precious gems in this instance. The shield inscription declares just what holiday reading is designated for that particular scroll. Here the attached plaque is framed by pendant lions, symbol of Judah and the Jewish people, above spiral columns that refer back to descriptions of the Temple of Solomon. Such a shield quickly became a visible embellishment – along with elaborate woven and embroidered ark coverings (*parochet*) – and provided an opportunity for pious donation, especially in the eighteenth century. This form of exalting both the religious space and its ceremonial objects offered yet another way to suggest the lost glory of the Temple described in the Bible text (Solomon's Temple: 1 Kings 6–7; vision of a restored Temple: Ezekiel 40–43).

Thus on the eve of the Enlightenment in Europe, Jews had attained a relatively peaceful assimilation into Christian-dominated society. Not yet emancipated nor fully free to pursue any occupation, they nonetheless used their rare privileges to seize the opportunity to worship openly in synagogues of their own making. While Jews sometimes designed ceremonial objects, more often Christians made their Judaica. Jews did not actively create paintings and prints of Jewish life, as they soon would do; rather, Christians depicted Jewish existence, frequently featuring Jews as objects

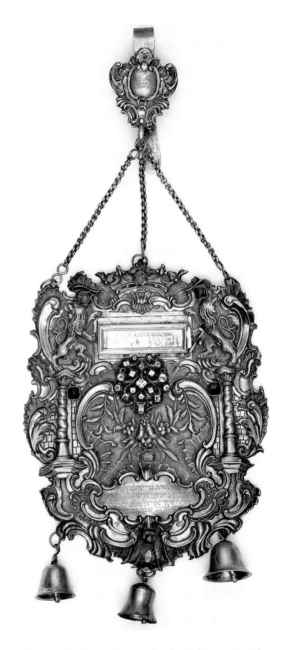

14 Johann Jacob Leschhorn, *Torah shield*, c. 1784, Silver, repoussé and engraved; diamonds; coloured glass.

of fascination, even derision. Unfortunately, the tumultuous history of European Jewry slowed the development of Jewish visual traditions. But with Enlightenment and emancipation at the turn of the nineteenth century, Jews finally took control of their own destiny. They first dared to attend universities in the wake of Moses Mendelssohn, a court Jew in Berlin who participated with German intellectuals in the Jewish Enlightenment, or Haskalah. Soon afterwards they would also pick up palette and brush and dare to pursue the profession of painter.

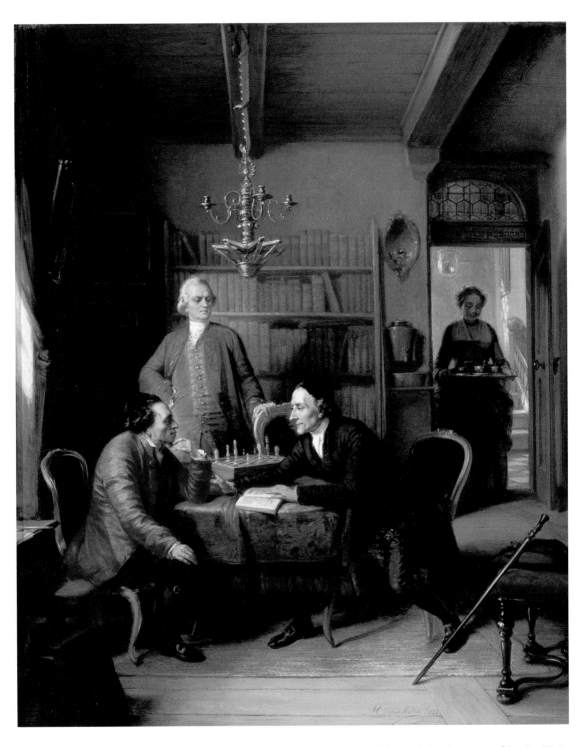

15 Moritz Daniel Oppenheim, *Lavater and Lessing Visit Moses Mendelssohn*, 1856, oil on canvas.

2 Inventing the Jewish Artist in Europe

Baptism was the entrance ticket to European civilisation.
— HEINRICH HEINE, 1825

Because I am a Jew.
— SOLOMON J. SOLOMON, on why he accepted the presidency of the
Royal Society of British Artists, 1918

Over the course of the eighteenth century, the Jews of Europe did have their own version of the Enlightenment. Called the Haskalah, this movement was largely centred in the major intellectual centres of Germany, but it was linked by a network of Jewish publications and correspondence from Amsterdam to Vilna, within what was known more broadly across Europe as 'the republic of letters'.[1] While the Haskalah has been correctly credited with loosening rabbinical authority and promoting reason as a basis of biblical interpretation, these key issues reveal that the movement and its educational aims remained inseparable from the framework of a religious community, despite claims (from those seeing the French Revolution as the end point of the movement) that the Enlightenment ushered in a new era, in which the secular became increasingly separated from the sacred.[2] One crucial contribution of the Haskalah was its production of a new, public intellectual, epitomized by Moses Mendelssohn (1729–1786) in Berlin, who published works chiefly in German but also in Hebrew within

the emerging 'public sphere', including an essay in dialogue with the broader movement, 'What is Enlightenment?' (1784).[3] Mendelssohn, in turn, became the model for a literary figure, the Jewish title character in Gotthold Ephraim Lessing's drama, *Nathan the Wise* (1779), which demonstrates that there is no inherent Christian monopoly on religious truth or wisdom and thus makes a plea for tolerance.

The issue of Jewish social emancipation received serious discussion in Western Europe during the late eighteenth century and also in the shadow of the French Revolution. Despite the universalist aspirations of rationalist philosophers about the equality of all humanity, Jews were viewed and condemned for the insularity of their communities (often imposed, of course, from outside by ghetto regulations) within wider society. When Christian Wilhelm von Dohm, a friend of Mendelssohn in Berlin, issued a tract in 1781, 'On the Civil Improvement of the Jews', he defended the Jews as fellow-citizens.[4] Clearly opposed to anti-Semitism and exclusion of Jews from all rights

of citizenship (except the right to be in public office), Dohm paternalistically advocated tolerance in civil society ('The Jew is more a man than a Jew'), though he allowed for retention of separate Jewish law, whereas Mendelssohn even suggested integrating Jewish law within the larger entity of the state, 'civil admission', even as he opposed Jewish institutional excommunication that compromised liberty of conscience).[5] Dohm also hoped to promote public education and loyalty to the common nation-state. Mendelssohn clearly sounded his personal credo in a subsequent treatise, 'Jerusalem' (1783): 'I recognize no eternal truths other than those that are not merely comprehensible to human reason but can also be demonstrated and verified by human powers.'[6]

That larger idea of civil rights was followed up in France after the Revolution in concurrence with the celebrated *Declaration of the Rights of Man* (1789) for the participation of all citizens; however, Jews initially were only to be accorded those rights of citizenship upon renouncing their communal autonomy. Here, especially, the marked minority status of Jews can be seen as defining them in contrast to the unmarked – and presumably unproblematic – Christian majority culture. And although in 1791 an edict of emancipation was extended to the Jews of France, provided that they 'shall take the civic oath', Jews were to be accorded all individual freedoms but denied any identity 'as a nation' with judges and laws.[7] As Emperor, Napoleon extended this legal definition further in 1806. He briefly attempted to co-opt and govern the Jews by allowing them a representative 'Sanhedrin' and defining their laws of Torah and Talmud as exclusively – and thus separately – religious, but that effort was short-lived.[8]

Within Judaism during the eighteenth century, an equal and opposite reaction formed to the Haskalah. Efforts to reintegrate a Jewish community under the rabbinical leadership were fostered first by Hasidism and later by a Neo-Orthodoxy.[9] Because of the new consciousness of community issues, each movement reasserted Jewish identity and emphasized faith through a revival, not an unbroken continuity. However, for the most part, those Jews we shall examine as artists in Western Europe emerged instead from changes first ushered in by the Haskalah.[10]

The effects of Judaism's increasing diversification included the foundation of the Reform movement by Abraham Geiger in Germany during the second quarter of the nineteenth century.[11] But as another measure of a new Jewish intellectual, German poet Heinrich Heine lived most of his adult life in Paris in ongoing ambivalence, even self-hatred, towards his Jewish heritage. Rejecting religion, including Orthodox and Reform Judaism alike, he relished a cynical role of gadfly, claiming blithely that 'baptism was the entrance ticket to European civilization', and citing Moses

Mendelssohn's composer grandson Felix as the prototype. Heine also asserted, 'There is only one God – Mammon. And Rothschild is his prophet.'[12]

Indeed, emerging Jewish prominence in the modern economic sphere was exemplified by the rise of the international banking firm of the Rothschild family, headed from Frankfurt by the patriarch founder, Mayer Amschel, but at its zenith maintaining major branches in London (under the direction of Nathan Mayer), Paris, Vienna and Naples.[13] Just as in Heine's quote, 'Rothschild' became a modern designation for wealth itself.

While not exclusively responsible for the emergence of the man who can properly be termed the 'first Jewish painter', the Roths-childs and the supportive Jewish culture of Frankfurt helped to sustain the career of that artist, Moritz Daniel Oppenheim 1800–1882).[14] Son of a merchant, Oppenheim received artistic training in the Munich art academy and also followed a number of Christian religious artists (the 'Nazarenes', or *Lukasbund*) to Rome (1821–5). Back in Frankfurt, he followed the current vogue for religious themes by painting subjects from the Hebrew Bible, but he also began early to produce portraits of the Rothschilds, whom he had first encountered in Naples.

Oppenheim's sitters, however, also included renowned Jewish converts to Christianity: Heinrich Heine (illus. 16) and Ludwig Börne,

the latter an author and polemicist who worked for social emancipation of Jews in Germany despite his noted conversion in 1818. While the Heine portrait shows the poet posed upon a chair before a simple, mottled brown background, Börne, painted posthumously from earlier studies, is seated with a newspaper at a desk, dressed in a fur-trimmed scholar's robe. He is busily engaged in reading within a book-lined study, ornamented with portrait busts and sketches of friends and heroes. Behind him on the mantel stands a small bronze of a tyrant slayer, suggesting his advocacy of human dignity and civil rights.

Oppenheim also successfully engaged with the changing role of Jews as citizens within German society. The painter com-memorated the contributions of Moses Mendelssohn almost a century earlier by showing his intellectual leadership during a renowned pamphlet disputation against/with the Christian proselytizer, Swiss clergyman and physiognomist Johann Casper Lavater that took place in the 1760s. Oppenheim staged the scene as a conversation in the home of Mendelssohn (with a Hebrew inscription over the door) in the supportive company of his friend Lessing (illus. 15).[15] To emphasize Jewish contributions to German creative arts, analogous to his own claims for painting, the painter also represented a celebrated musical and cultural encounter in Weimar in 1830 between the aged Goethe and Mendelssohn's

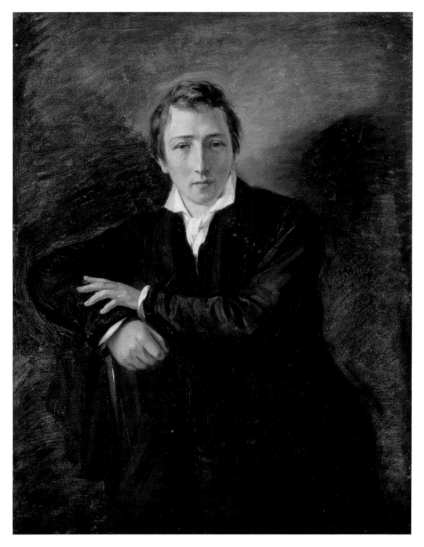

16 Moritz Daniel Oppenheim, *Heinrich Heine*, 1831, oil on canvas, laid down on paper.

opposite: 17 Moritz Daniel Oppenheim, *The Return of the Jewish Volunteer from the Wars of Liberation to his Family Still Living in Accordance with Old Customs*, 1833–4, oil on canvas.

own grandson, the prodigal performer and composer, Felix Mendelssohn (1864). The drawing-room in which the encounter takes place is a well-furnished bourgeois interior, ornamented with the relatively new instrument of a concert grand piano. In addition to the physical presence of Goethe himself, a marble bust of Schiller further underscores the cultural leadership of Weimar for German letters, now

accepting of a Jewish musician (and, by implication, the contribution of a Jewish painter).

More pointedly, Oppenheim's large-scale genre paintings, within the mainstream of bourgeois German drawing-room pictures – known as Biedermeier – also showed Jews as fully vested participants in German life.[16] Like most contemporary works, the subject and meaning of Oppenheim's *The Return of the*

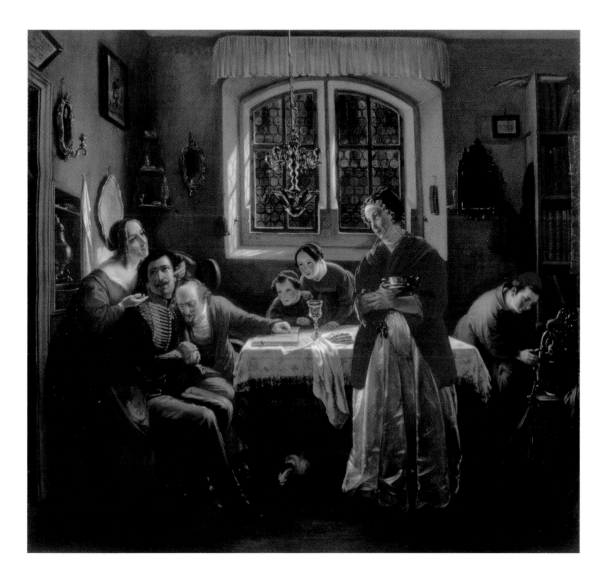

Jewish Volunteer from the Wars of Liberation to his Family Still Living in Accordance with Old Customs (illus. 17) is conveyed by its long title. This painting shows a wounded soldier, wearing his iron cross (at once a sign of military distinction but based on the crucifix) on his uniform; he has returned home after defending Germany against the Napoleonic forces (1813–15). But he has arrived during Sabbath celebrations, apparent by the Kiddush cup and challah on the table, which means that he has travelled on the Sabbath, in violation of Jewish law. Unlike his kin, the soldier's head is uncovered, marking further differences of religious observance between generations, as the title suggests. The overall scene offers testimony to Jewish citizenship and sacrifice for the emerging nation-state of Germany, a

loyalty that came under suspicion after 1815, so the artist was able to reassert Jewish valour and loyalty to the fatherland.[17] At the same time, this painting documents the enduring importance of family and ritual in Jewish life. Within these social tensions of secular state and religious community Oppenheim – and many subsequent Jewish artists – would oscillate.

Indeed, in his later career Oppenheim began to reproduce many of his own genre images that represent the major customs and holidays of the Jewish year or Jewish life-cycle. Beginning in 1865, he reprised them in grisaille (grey tones) for reproduction as prints by a non-Jewish Frankfurt publisher, Heinrich Keller, titled *Scenes from Traditional Jewish Family Life*. In this project he was following the lead, established during the Enlightenment project, of showing religions of the world, especially in the text and engraved images by Bernard Picart, whose publication, *Cérémonies et coutumes religieuses de tous les peoples du monde*, began in 1723 and extended across the eighteenth century, with translations into all major languages of Europe.[18] Jewish customs began the volumes, because Picart understood Judaism as the fountainhead to the other monotheistic religions. Picart's work, in turn, was preceded by Dutch artists interested in Jewish life, notably etcher Romeyn de Hooghe (for example in his drawing, *Circumcision Scene*, illus. 10).

One way to view all these images is as a record of the exotic Other within local Dutch or German culture, as a native form of Orientalism, set in both home and synagogue. Certainly, Oppenheim's works point to that same self-awareness and advocacy by the artist on the part of the Jews of Germany, even as their appeal to tradition still conforms to the cozy family values and descriptive naturalism of Biedermeier. But their main purpose was to educate Christians about Jews.

A representative image of the Oppenheim series, *The Rabbi's Blessing* (illus. 18), comprises one of the twenty finely wrought grisailles for reproduction, which replicates a pair of coloured versions. It combines the family emphasis already seen in *The Return of the Jewish Volunteer* with a carefully rendered religious setting, now relocated within a synagogue, whose details include a massive gilded menorah and an ark with embroidered curtain and eternal light. The painting features a standing observant father, wearing his fur-trimmed Ashkenazi Sabbath hat and holding his prayer book. His young son in the centre bows his head respectfully to receive the benediction of the seated, white-bearded rabbi, whose *tallit* (prayer shawl) drapes over his chair. The only other figure, an old man absorbed in prayer, might be a grandfather.

Other Oppenheim images from the same series even include non-Jewish observers in the scene; for example, *Jarhzeit* (1871) shows a memorial observance (*minyan*) at the Franco-Prussian War front during that same year, with

non-Jews looking on respectfully from the window. In similar fashion, *Sukkot* (1867) depicts the humble but spacious and well-decorated booth of the Tabernacles holiday, used as the site of a festive meal outside the home of a Jewish family, even as they attract the curiosity of a couple of blonde youths. Taken together, Oppenheim's series features rites of passage, including a Bar Mitzvah and wedding, Sabbath celebrations, high holidays and other festivals, such as Passover (described for non-Jews with the title, *Oster-Abend*, 'Easter Eve').

Oppenheim's images offer a rosy, middle-class presentation of both settings and figures, probably more prosperous than the life of most Jews, in order to suggest their smooth, emancipated participation in a presumably tolerant, modern German society. At that very moment large, attractive new synagogues were being built on major streets in most major cities of Central Europe, to announce a new, self-aware Jewish urban presence.[19]

While Oppenheim represents a slightly older way of life with occasional nostalgia or positive references to a former, ghetto-based,

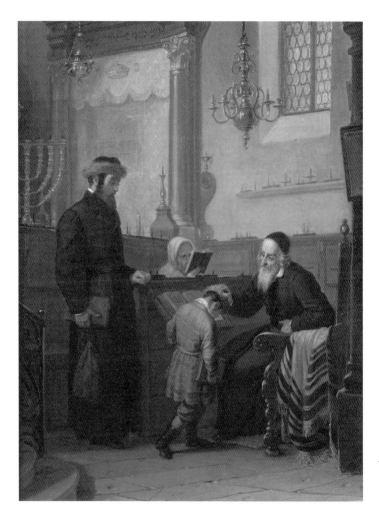

18 Moritz Daniel Oppenheim, *The Rabbi's Blessing*, 1866, oil on canvas.

traditional existence, his art does not fully celebrate what might already be termed a vanishing way of life. That kind of art emerged at the end of the nineteenth century through the work of Isidor Kaufmann (1853–1921) of

Vienna.[20] Kaufmann, too, specialized in genre paintings of picturesque Jewish figures, especially yeshiva boys from Galicia in Austria-Hungary, showing them engaged in prayer and study at home or synagogue. His commitment to display led him to set up a 'Sabbath Room' (1899) in the Jewish Museum of Vienna, whose very identity suggests both cultural awareness as well as distinctness within the majority – Catholic culture – in the capital. Kaufmann clearly declared:

> My intention has always been to praise and glorify the Jewish culture. I wanted to reveal all its beauties and all its nobility, trying to make its traditions and institutions which contain so much devotion and fervor accessible to gentiles as well.[21]

In *Hearken Israel* (illus. 19) Kaufmann shows Hasidim dressed for Sabbath, wearing their fur-lined soft holiday hats (*streimel*) with *tallitot* in synagogue; deep in meditation, they recite the *Shema*, or declaration of faith. The passing of tradition from generation to generation is underscored by the presence of young boys, similarly dressed and already participating. This documentary element of

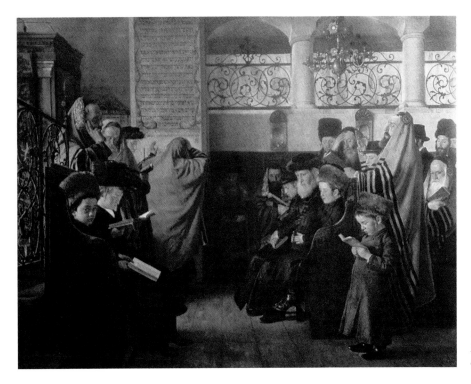

19 Isidor Kaufmann, *Hearken Israel*, 1910–15, oil on canvas.

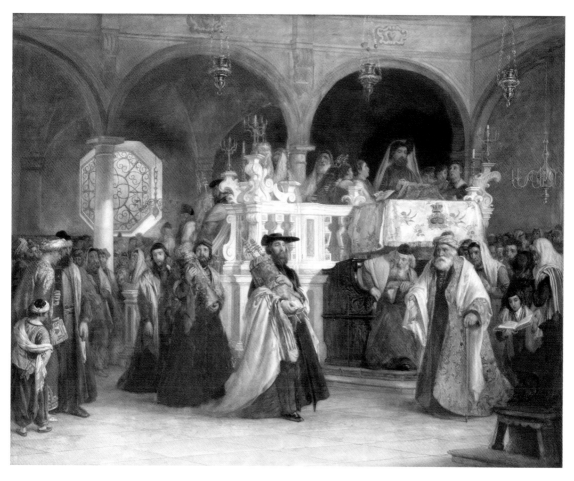

20 Solomon Alexander Hart, *The Feast of the Rejoicing of the Law at the Synagogue in Leghorn, Italy,* 1850, oil on canvas.

Kaufmann's art recalls similar attentions given to other provincial costumes and customs, particularly simple piety, in Bavaria by Wilhelm Leibl of Munich and a variety of other late nineteenth-century German or Austrian artists, so it was not intended exclusively for Jewish clients or audiences.[22]

Religious themes as the subject of Jewish art also appeared in Western European countries. In England Solomon Alexander Hart (1806–1881) became the first Jewish member of the Royal Academy, where he had studied earlier. He painted Jewish worship with the kind of spectacle reserved for contemporary historical or biblical scenes, which he also produced. His best-known work, *The Feast of the Rejoicing of the Law at the Synagogue in Leghorn* (illus. 20), depicts the climactic moment of Simchat Torah in the striking synagogue of Livorno, Italy, when all of the Torahs are carried proudly in procession upon completion of the annual cycle of readings. Brightly coloured, exotic Sephardic costumes of the congregants are matched by the elaborate brocades and silver finials on the Torah scrolls themselves, and the entire scene is staged as pageantry. However, Hart wished not to be identified as a 'Jewish artist', and painted similar imagery of church interiors in Florence

and Venice, while becoming best known for scenes from Shakespeare or Walter Scott, early nineteenth-century gallery favourites.

In contrast, Solomon J. Solomon (1860–1927) remained very comfortable with his dual identity, delineating Jewish material throughout his life along with more mainstream subjects, including portraits of the royal family (for example, *Queen Mary*, 1914).[23] Solomon's Jewish output includes portraits of coreligionists, biblical motifs and genre scenes. *High Tea in the Sukkah* (illus. 21), a work on paper, offers a detailed look at English Jews celebrating Sukkot, a subject explored earlier by Oppenheim in *Scenes from Traditional Jewish Family Life*. Whereas Oppenheim presents a traditional Sukkot celebration, Solomon depicts the adaptation of this ancient holiday to modern British life. Indeed, Herman Adler, then chief rabbi of Great Britain, appears wearing a head covering as well as a long coat while standing in a sukkah among both men and women dressed in contemporary attire. Moreover, along with key elements of the holiday's service – a *lulav* (palm branch) leaning against a table in the foreground and

etrog (citron) hanging from the roof of the booth – the celebrants enjoy high tea. The reciprocal influence of British and Jewish cultures in this intricately rendered work anticipates similar, contemporary modes of acculturation occurring in America (see chapter Four).

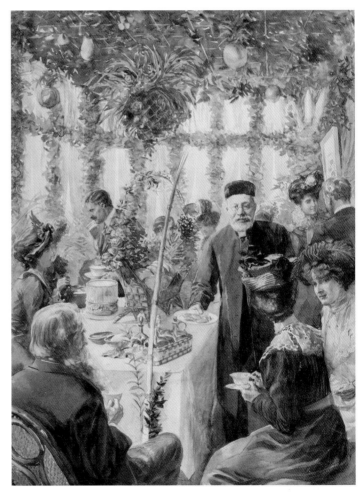

21 Solomon J. Solomon, *High Tea in the Sukkah*, 1906, ink, graphite, and gouache on paper.

Solomon's success was recognized by his peers; he was elected to the Royal Academy in 1906, the second Jew to receive this honour after Solomon Alexander Hart.

The prosperous Solomon family, unrelated to Solomon J. Solomon, sent three children to art school: Abraham (1824–1862), Rebecca (1832–1886) and Simeon (1840–1905).[24] Rebecca Solomon, painter of Victorian moral genre subjects, can surely be considered the first woman of Jewish descent to make a prominent modern career as a painter. Simeon's *Carrying the Scrolls of the Law* (illus. 22) shows a fervent young Orthodox Jew at half-length, embracing the fully decorated Torah with as much intensity as the current imagery of lovelorn romantics in the art of Dante Gabriel Rossetti and other Pre-Raphaelite, Christian artists in Victorian England. Their interest in recreating historic settings also led Simeon to stage religious subjects from the Hebrew Bible with authenticity redolent of contemporary paintings, based in part on research on-site in Palestine, by artist William Holman Hunt. A good example from Simeon's early career is *The Mother of Moses* (illus. 23). Here the artist uses dark-haired 'ethnic' types for authenticity, along with such details as a Middle Eastern lyre

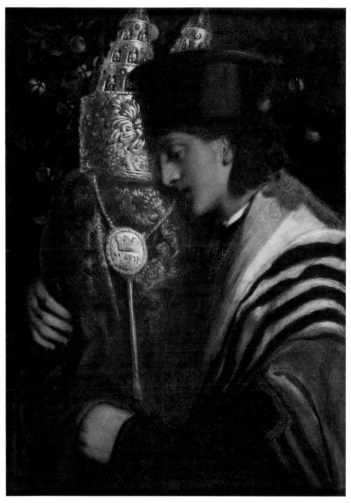

22 Simeon Solomon, *Carrying the Scrolls of the Law*, 1867, watercolour and gouache, varnished.

and simple woven garments and reed basket (soon to be the cradle for the infant on the Nile). The close-up, maternal intimacy of this scene also accords well with Victorian sentiment. Such biblical recreations became a staple of nineteenth-century art (of course more often of New Testament subjects), leading eventually to vivid Hollywood epics from Cecil B. DeMille to Mel Gibson.

In nineteenth-century France the representation of Jews and their customs as exotic

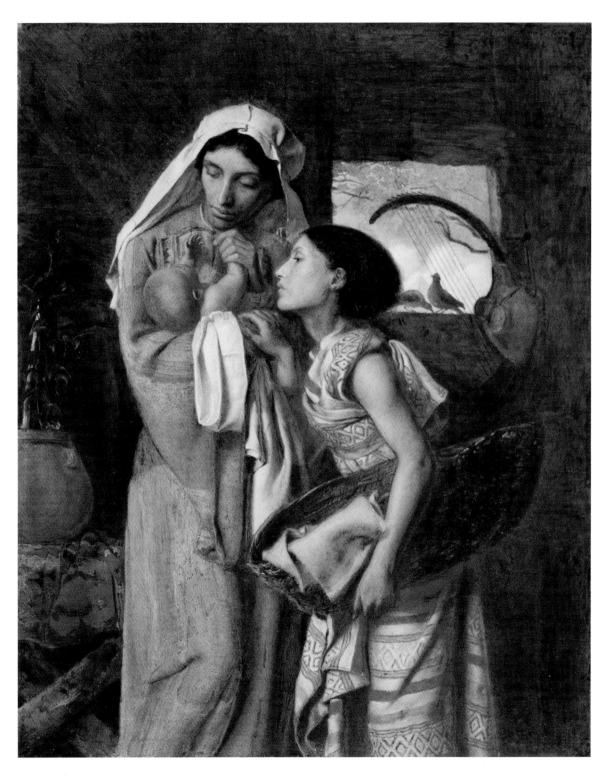

23 Simeon Solomon, *The Mother of Moses,* 1860, oil on canvas.

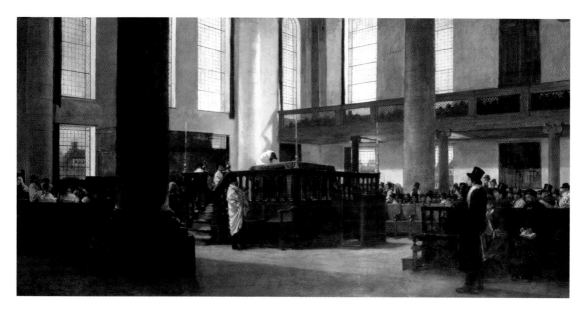

24 Jacques-Émile-Edouard Brandon, *Silent Prayer, Synagogue of Amsterdam, 'The Amidah' ('La Guamida')*, 1897, oil on panel.

persisted (despite it being the country with the greatest emancipation in legal terms).[25] An academic artist of Sephardic background, Jacques-Émile-Edouard Brandon (1831–1897), even exhibited Jewish subjects in the great group Salons in Paris during the 1860s, though he later showed with the first Impressionist group exhibition.[26] Brandon also painted a number of Christian genre subjects, part of France's Second Empire emphasis on authority in both state and religion. Some of his works refer to the great Portuguese Synagogue of Amsterdam, that early haven of immigration for the artist's Sephardic ancestors (see chapter One). Brandon's *Silent Prayer, Synagogue of Amsterdam* (illus. 24) represents the same building as that in De Witte (illus. 9), but here in the new light-filled French idiom. It also captures the local, contemporary Jewish community during the sacred liturgical moment of the silent Amidah prayer. His career demonstrates how simultaneous membership in a religious group as a private person as well as in a nation-state as a public citizen could coexist in nineteenth-century France.

Much more nostalgic as well as provincial, the imagery of the traditional Jews of Alsace formed the main interest of Alphonse Lévy (1843–1918).[27] In a painted work like *Evening Prayer* (illus. 25) or in his woodcuts, he presents a small number of figures clad in their distinctive, ethnic garb, uncompromised by urban modernity in the capital, and busy with activities of prayer or holiday preparations. Their faces display exaggerated features, which in the hands of a non-Jewish artist might well be described as caricatural. In effect, these images of difference, while presented with sentiment

as picturesque, are meant to capture timeless tradition, as if comprising a pictorial version of the anti-modern reaction by Orthodox Jews. Certainly these images, even by a Jewish artist, represent the regional Jews of France as 'exotics' living nearby. They resemble Salon depictions for Parisians by Gustave Courbet or Jean-François Millet of peasant life in remote country locations, or more distant images of truly 'Oriental' Jews within the annexed French colonies of North Africa, exemplified by Eugene Delacroix's *Jewish Wedding in Morocco* (1839).[28]

The situation in Eastern Europe was far more difficult, since Jews were not yet emancipated as citizens; many of the nationalist movements themselves had to take the form of cultural as well as political resistances against the dominant centralized political entities of empires, whether the Austro-Hungarian Empire or Russia. This minority cultural status remained particularly acute in Polish-speaking regions, divided between Russia and Austria-Hungary.[29] For one young aspiring Jewish artist and Polish patriot in Galicia, Maurycy Gottlieb (1856–1879), the search for appropriate artist models and subjects resulted in a diverse output that went well beyond Jews making pictures of their fellow Jews for public consumption.[30] Born in a crossroads city, Drohobycz, then trained in the nearby provincial capital of Lvov (Lemberg), Gottlieb was ambitious to paint historical subjects in the grand style, as

practiced by the leading Polish painter of national events, Jan Matejko, his mentor in Krakow, as well as Karl Piloty in Munich and Hans Makart in Vienna. Colourful period costumes and crowds of figures enacting dramatic gestures characterized Gottlieb's models.

But he also drew inspiration from the biblical representations of Rembrandt (chapter One), who already in the nineteenth century was enjoying a revival, tinged with reports that the Dutchman had used his Jewish neighbours as models.[31] Gottlieb sought subjects that had Jewish resonance as well as universalist inclinations towards religious and cultural reconciliation, including literary subjects such as Shakespeare's Shylock from *The Merchant of Venice*, and a commissioned grisaille series for print reproduction like Oppenheim's *Jewish Life* series, based on Lessing's *Nathan the Wise*.

Gottlieb's ultimate image of religious compatibility emerges from his choice of a New Testament subject, *Jesus Preaching at Capernaum* (illus. 26). This Galilee city became the home of Jesus after Nazareth (Matthew 4:13; Mark 1:21; Luke 4:14–31; John 6:59); there he preached in the synagogue. The model for this work along with orientalizing history pictures of the Levant was Rembrandt, who produced prints of Jesus preaching and teaching. Gottlieb's life-sized painting, left incomplete at his death, shows the historical Jesus, haloed and bearded but also clearly

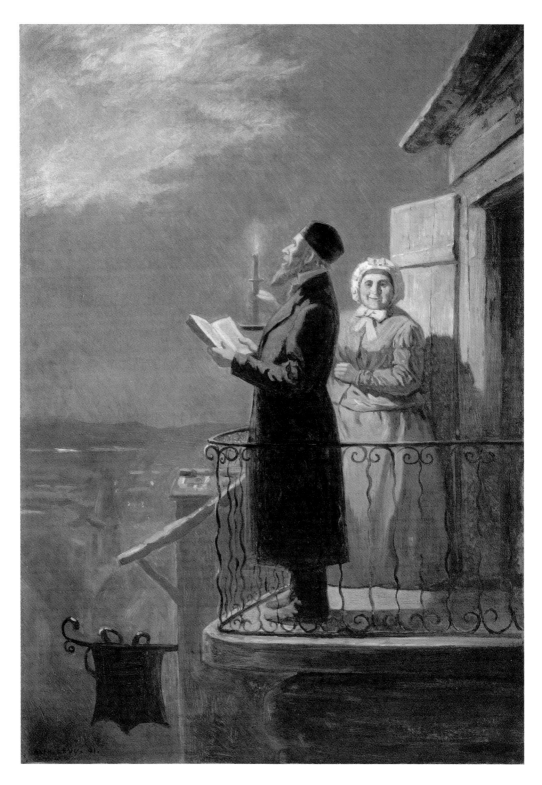

25 Alphonse Lévy, *Evening Prayer*, 1883, oil on canvas.

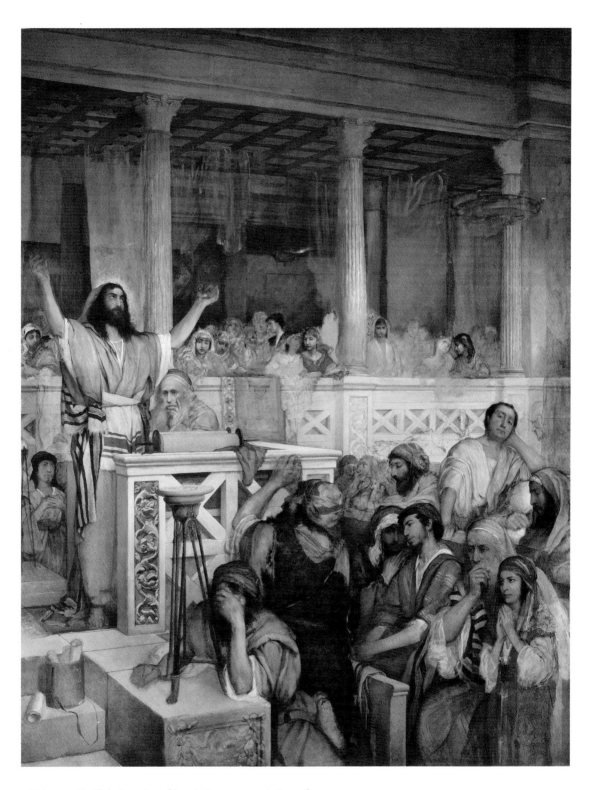

26 Maurycy Gottlieb, *Jesus Preaching at Capernaum*, 1878–9, oil on canvas.

identified as a Jew himself by his *tallit* and covered head, offering a sermon with arms upraised in prayer.[32] A Torah scroll sits before him upon the *bima*. Careful perspective situates the viewer below the steps at left, as if gathered among the listening male congregants, who wear exotic Middle Eastern costumes with turbans. True to Jewish custom, the women occupy their own gallery position behind the preaching Jesus within this columned space of the ancient world. Gottlieb also includes a self-portrait at the lower right. This picture claims that Christianity grows out of Judaism and that Jewish audiences found Jesus a sympathetic teacher, whose words have been warped into anti-Semitism by later centuries.

The young painter wrote to a friend from Rome during a study trip about his desires:

How deeply I wish to eradicate all the prejudices against my people! How avidly I desire to uproot the hatred enveloping the oppressed and tormented nation and to bring peace between the Poles and the Jews, for the history of both people is a chronicle of grief and anguish![33]

Specifically, one of Gottlieb's unrealized projects in the manner of Matejko's Polish history pictures was to have represented the great medieval King Casimir the Great, who granted privileges to the Jews of Krakow (their historic district, Kasimierz, is still named after him).[34]

Gottlieb even produced another large New Testament painting of the Passion, also left incomplete: *Jesus Before his Judges* (1877–9). A crowded confrontation mingles Romans under a canopy on the right with a condemning high priest in his robes, who confronts a distinctly Jewish Jesus, dressed in a *kittel*, or white outer garment, worn both at Yom Kippur and for burial. Gottlieb's source for the life of Jesus within Jewish history was Heinrich Graetz's *History of the Jews*, a multi-volume work in German, published in 1875; Graetz claimed that Caiaphas, high priest of the Sanhedrin, led that religious court to condemn Jesus as heretical, whereas Romans under governor Pontius Pilate carried out the death sentence. By this reading, the condemnation was political as much as religious, an internal authority dispute among the Jews, intended to suppress rebellion. With a shadowy self-portrait beside the shoulder of Jesus, Gottlieb again signals his role as witness and potential sympathizer with Christian as well as Jewish suffering in his identity as a citizen of Catholic Poland.

The artist died young, but he left an epitaph, which includes him proudly participating as a Jew within Jewish practices. In some respects his representation of synagogue services extends the earlier imagery from Picart to Oppenheim, but now it is personalized with several self-portraits and other portraits of family and friends as well. *Jews Praying in the Synagogue on Yom Kippur* (illus. 27) shows the

familiar face of the bearded painter standing beside the Torah scroll, head upon hand in a gesture of thoughtfulness, suggestive of melancholy. Yom Kippur services include memorials for the deceased and assessments of one's own life, so Gottlieb seems to be busy reflecting solemnly upon his omissions and commissions. Nehama Guralnik believes that the youth in the left foreground is a recalled self-portrait as a boy; Gottlieb wears the same medallion on his neck with the 'M. G.' initials. The panel affixed to the Torah contains a Hebrew inscription and date as if in anticipation of the artist's own, early death: 'Donated in memory of the late honored teacher and rabbi Moshe Gottlieb of blessed memory, 1878.' Both the inscription and the self-portrait(s) reaffirm Gottlieb's Jewish identity and his membership in the broader community.

Gottlieb displayed a remarkable propensity to represent himself, often dressed in his self-portraits in costumes of varying times and places, as if acting out roles, though principally characters from Jewish or Polish history. At the same time, for all of his acute self-awareness and temperament, he still enjoyed support

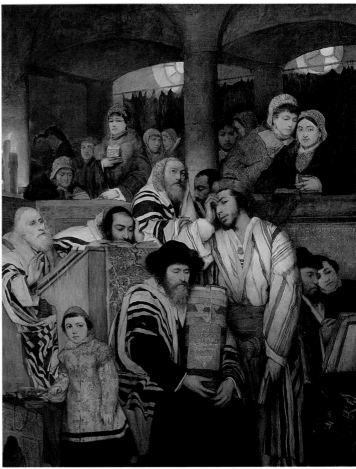

27 Maurycy Gottlieb, *Jews Praying in the Synagogue on Yom Kippur*, 1878, oil on canvas.

from the Jewish community, including Jewish financiers, albeit not on the level of Oppenheim's Rothschild patrons.[35] Given his talent for portraiture, it followed that he also portrayed several of his supporters, leading Jewish political figures who also advocated cultural integration: Ignaz Kuranda (painted in 1878), journalist and president of the Vienna Jewish community; Moritz Wahrmann, Hungarian parliament member, banker and president of the Pest Jewish community (painted in 1878). Further, Gottlieb's work was collected and praised by a

number of Polish literary figures, most of them Jewish, particularly Salomon Lewental, who owned *Jesus Preaching at Capernaum*. His complex but assertive cultural agenda, combining, even integrating, visible Judaism with Polish patriotism, epitomized a new modern liberalism within the emerging nationalism in Eastern Europe.

Younger Eastern European Jewish painters plied their craft within the Pale of Settlement, the territorial ghetto carved out of Poland and Ukraine that was imposed on them by imperial Russia.[36] This generation experienced the increasing persecution of Russian Jews, the largest population in all Europe, especially through local pogroms (notably in 1881, in Warsaw, and 1903 in Kishinev), abetted by increasingly virulent Slavophile chauvinism under Russian tsars from the end of the nineteenth century. Jewish radicals, sparked by a

Social Democrat Jewish *Bund*, worked for political change, including participation in the abortive 1905 Revolution.[37] In Lodz in the Pale of Settlement, Samuel Hirszenberg (1865–1908), who also studied with Matejko in Krakow, responded to the displacement of Jews with works like *The Wandering Jew* (illus. 140), which became a Zionist icon in Jerusalem.

Other explicit imagery of Jewish suffering, such as a lost work of 1904, *Exile*, depicted thinly clad wanderers before a desolate, snowy landscape.[38] In *The Black Banner* (illus. 28), painted in the momentous year of revolutionary struggle, 1905, Hirszenberg features a dense crowd of black-clad Hasidic males of all ages, moving against the grain from right to left across a wide panoramic canvas, topped by looming dark clouds. They carry a black-draped coffin, upon which sits an open book, presumably a holy book. Many of the faces

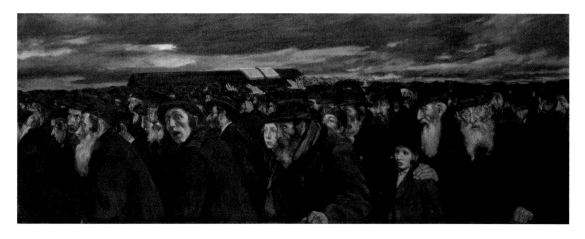

28 Samuel Hirszenberg, *The Black Banner*, 1905, oil on canvas.

29 Samuel Hirszenberg, *The Jewish Cemetery*, 1892, oil on canvas.

turn towards the viewer in expressions of open-mouthed fear and anxiety. This explicitly political image uses an entire composition to mourn and cry out against the persecution of recent pogroms. Already in 1892 Hirszenberg had painted a more generalized but specifically Jewish lament in *The Jewish Cemetery* (illus. 29). Here it is women who grieve, with melodramatic gestures, in the midst of both death and centuries-old tradition, tombstones neglected or even desecrated. For all his distinctly Jewish subject matter, Hirszenberg also exhibited his art in Paris, including his *Wandering Jew* in the 1900 Exposition Universelle (and in seeming echo of France's infamous Dreyfus affair; discussed later in this chapter). Increasingly a number of Jewish painters attained a substantial reputation in that art capital, often with themes that no longer had any strong Jewish resonance.[39]

Also training for a time in Paris, the Dutch painter Jozef Israëls (1824–1911) returned to Holland and remained active in The Hague, a lively regional centre of realistic country landscapes and farmers. There Israëls was known chiefly for his genre images – touching, often sentimental scenes of human suffering or loss, most often through the popular Dutch

figures of peasants, a tradition extending back to Pieter Bruegel.[40] Also within Dutch tradition Israëls used the same dark tonalities and picturesque heads favoured by Rembrandt – offering a pictorial counterpoint to Gottlieb's contemporary turn to the same Dutch master for his biblical subjects. A typical, large Israëls work, *The Last Breath* (illus. 30), shows a sparsely furnished, dimly lit peasant cottage interior, filled with well-observed details. The selective highlights show (to the right) a tender family group, a pair of small children who cling to their seated grandmother; meanwhile (to the left) the barefoot, grief-stricken mother is seen from behind at a bedside, as she prostrates herself upon the corpse of her newly deceased husband. At her feet, the family dog echoes her mourning (like many a Victorian-era painted animal, such as those by Sir Edwin Landseer in England).[41] The strong, implied narrative of family tragedy of this fatherless household also suited contemporary sentiments.

Israëls rarely made explicit reference to his Jewish origins. Yet one of his most popular paintings, a late work also indebted to Rembrandt, denotes Jewish identity in both its title

30 Jozef Israëls, *The Last Breath*, 1872, oil on canvas.

and its character type. *A Son of the Ancient Race* (illus. 31) shows a life-sized, scruffy, urban peddler, presumably from a poor, Jewish quarter (see Amsterdam's Jewish quarter, as painted by Israël's friend, Max Liebermann, illus. 35). His trade also is a traditional Jewish occupation, dealing in secondhand goods. Beside him gold candlesticks and a plate on a table further suggest his religion as well as his occupation. The man's slumping posture and staring gaze convey cumulative fatigue. This painting of dejection came to be associated more generally with Jews. One critic opined:

31 Jozef Israëls, *A Son of the Ancient Race*, c. 1889, oil on canvas.

> It is a sum of that age-old race, whose children dispersed among the peoples like leaves driven along by the storm, but who have not mixed and become one.[42]

But this genre image by Israëls clearly avoids the usual nineteenth-century emphasis by Jewish painters either on biblical subjects or typical religious activities. Perhaps for that very reason Israëls became one of the most successful and frequently exhibited Jewish painters of the era, and he was accorded numerous honours, including a state funeral.

His son, Isaac Israëls (1865–1934), became a successful painter in his own right.[43]

Also in Italy, Jewish artists made careers and integrated relatively easily into the newly unified country of the later nineteenth century.[44] The first Jewish painters of modern Italy, among them Vito D'Ancona (1825–1884), were associated with the Macchiaioli, a movement centred in Florence that featured bold, unmodulated colour areas (*macchia* means 'spot' or 'stain') to render outdoor observations of everyday activities, as if in anticipation of Impressionism in France. Their regional emphasis on the

Tuscan landscape links them to nascent nationalism in Italy. D'Ancona, part of a large and prosperous Sephardic family, specialized more in interior settings and sensuous nudes.

Most accomplished and successful of the Jewish painters of Italy, Vittorio Corcos (1859–1933) from Livorno, also pursued his career in Paris (1880–86), where Goupil & Cie was his dealer, and he associated with a literary circle that included Edmond de Goncourt, Gustave Flaubert and Émile Zola, plus the Impressionists. His striking portraits frequently depict Jewish friends and associates, often literary or artistic, back in Italy (where he converted to Catholicism after marriage in 1886). They offer light-filled, atmospheric presentations but usually are executed in a more meticulous finish than progressive art of Italy or France. Corcos even managed to portray ruler figures and celebrities across Western Europe. One of his most evocative images, titled *Dreams* (illus. 32), depicts his mistress, who pauses on a bench from her reading of a bright yellow, softcover, French work of literature to gaze in reverie outwards at the viewer. Her pose is relaxed and informal, yet brilliantly composed and harmonious in simplified and reduced colour areas.

Unsurprisingly, the greatest social integration of Jewish painters into the progressive art world of nineteenth-century galleries and exhibitions occurred in Paris. Probably the most famous French painter of Jewish origin at the end of the century, Camille Pissarro

(1830–1903) hailed from a French Sephardic family, ultimately linked to Portuguese exiles, in the Caribbean (St Thomas, Virgin Islands, then a Danish possession).[45] Once in Paris in 1855, he associated himself with progressive artists, particularly Paul Cézanne (whose portrait he painted in 1874).[46] His move to the countryside to depict peasant subjects helped to shape the French avant-garde painting agenda from the era of Courbet and Millet through the latter half of the nineteenth century.[47] From his studio in rural Pontoise or Éragny, Pissarro became a founding member and annual contributor to the group known as the Impressionists, who exhibited together between 1874 and 1886 and defied the conventional public taste of the annual Salon. Pissarro also served as the elder statesman of avant-garde painting in Paris, advising and influencing younger protégés, such as Paul Gauguin and Vincent Van Gogh during the 1880s.

A good example of his representation of the countryside beyond Paris shows both his affinities and his contrast with Impressionist settings, led by Claude Monet (see Introduction). In *The River Oise near Pontoise* (illus. 33) the loose brushwork, especially in the grey-blue clouds and foliage, complements a firmly structured composition with a low horizon and a diagonal stream stretching into distance, much like the current paintings made by Monet at exurban, but recreational, Argenteuil. Here, like other Impressionists,

32 Vittorio Corcos, *Dreams*, 1896, oil on canvas.

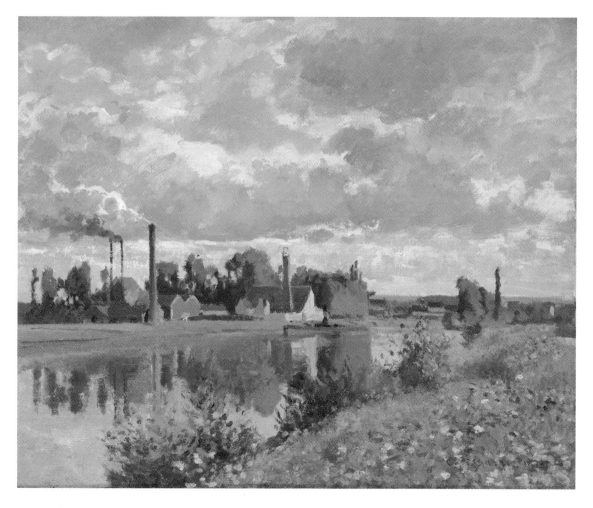

33 Camille Pissarro, *The River Oise near Pontoise*, 1873, oil on canvas.

Pissarro shares goals of suggesting seemingly spontaneous, bold execution and overall atmospheric optical effects to produce momentary sensation, shared by artist and viewer. To these artists such imagery was 'honest', more 'true' in its representation of reality but also more self-consciously produced as a painted picture. At the same time, Pissarro inserts numerous indices of how the countryside has incorporated the modernization process of the Industrial Revolution. A mechanized barge plies the river, part of a new canal network for distant trade, before the towering smokestack of a new local factory, which produced grain alcohol from sugar beets. While Monet and others eagerly embraced the energy of the railroads and their rapid linkage to countryside leisure excursions, Pissarro almost uniquely acknowledged the presence of such modern industry within the countryside,

even as his principal figures in other scenes are country people rather than urban visitors.

Pissarro's politics can be gleaned from his letters. He was a radical, even an anarchist, opposed to all authority, which has led some scholars to read deeper meaning into his representation of factories within his landscapes.[48] His sympathy for rural labour stemmed from a sense of alienated or exploited industrial labour, something that the artist might also have brought to the collective exhibitions of the Impressionist group. In a private album of drawings for his nieces in London, *Turpitude Sociales* (1889), Pissarro suggested how money and privilege, especially by wealthy bankers – many of them Jewish, such as the Rothschilds – could prompt 'the war of the weak against the strong'.[49] If this attitude sounds like classic self-loathing by a Jew, it also represents an intimation of the emerging strong link between Jews and social reform (see chapter Four), already noted for contemporary Eastern Europe.

Pissarro's relation to his Jewish origins was couched in denial, especially of any religious authority. In the Caribbean, Nicholas Mirzoeff notes, minority Jewish culture was seen as racial rather than religious, equivalent to African, slave identity, and he views the move to Paris by the artist as an attempt to work towards fuller emancipation, even assimilation. Pissarro absorbed the increasing secularism of the post-Enlightenment era as a call to view all religion,

Judaism included, as popular superstition, inappropriate to 'our modern philosophy, which is absolutely social, anti-authoritarian and anti-mystical'.[50] For him the Impressionist affirmation of an art of pure sensation was firmly founded on modern, scientific principles instead of 'religious symbolism'. Whether or not as an act of cultural defiance, he married a French Catholic woman (first in common law, then in a civic, not religious ceremony), although he knew that his parents would disapprove. Yet for all of his denial, Pissarro was perceived, even by friends, as a prophet-like figure, down to his white beard, and his conservative Impressionist colleague Pierre-Auguste Renoir stereotyped him as a combination of 'socialist . . . revolutionary . . . Israelite' and a 'mercenary Jew'.[51]

At the end of the nineteenth century Paris was rocked by the ongoing scandal known as the 'Dreyfus Affair'.[52] Alfred Dreyfus, an Alsatian Jew who trained at a military academy for an officer's career in the French army, was falsely accused of treason on behalf of the nation's arch enemy (and victor in the 1871 Franco-Prussian War), Germany. His arrest in 1894 and dismissal in 1895 was appealed in an 1899 retrial, provoking a fervent newspaper defence on his behalf by critic-novelist Zola ('*J'accuse!*') early in 1898. The case served as a lightning rod for widespread anti-Semitic impulses within the powerful rival nationalisms at the end of the century, and while

Dreyfus was eventually exonerated after a renewed court martial of 1899, he was only reinstated in 1905. As for artists in France, Linda Nochlin notes that during the height of the Dreyfus controversy, leading progressive painters split along political lines, which became a kind of culture war: Monet and Pissarro joined Zola in the pro-Dreyfus camp, whereas Cézanne, Mary Cassatt, Edgar Degas, Auguste Rodin and Renoir were anti-Dreyfus.[53] Within such circumstances, we can see how much Pissarro's Jewish identity was sometimes defined in the social judgments of others. Even though he rejected religion, his life, most especially his politics, still remained shaped by contemporary events and the wider culture in France.

In the final decade of his career, however, Pissarro changed subjects dramatically. He followed the lead of Monet, who produced a number of canvas series of the same subject during the 1890s, including haystacks, poplars and the facade of Rouen Cathedral. Prompted by their shared gallery dealer, Paul Durand-Ruel, Pissarro produced several series of his own, but, by contrast, devoted to urban settings.[54] Another analogy is Cézanne's obsessive repetition of favourite themes in still life, landscape or portraiture. Pissarro's own decision came at a time when his infirmities and the personal tragedy of losing one of his sons occasioned his residence in a series of Parisian hotels, permitting painted views from above. Losing himself in work also provided a distraction from the Dreyfus Affair, then at its peak of controversy in the capital. Pissarro's *Place du Théâtre-Français: Rain Effect* (1898, illus. 34) shows the new Parisian space, viewed from his window: the grand boulevard of uniform apartment facades carved out of the old city by Baron Haussmann in the 1860s to lead to the new Opera House, designed by Charles Garnier. This is the very image of modernity, punctuated into depth with a boulevard filled with traffic – the bustle of buses and taxis as well as streets crowded with pedestrians, here carrying umbrellas. This mood and motion evoke the words of poet-critic Charles Baudelaire: 'Modernity is the transient, the fleeting, the contingent . . . '.[55] Such images fulfilled the artist's own goal of 'sincerity' (rather than making art subservient to any illustration of ideas) and his personal striving for beauty itself, in depicting streets that he described as 'often called ugly, but so silvery, so luminous, and so lively . . . it's completely modern'.[56]

Another progressive painter in France at the very end of the nineteenth century, a younger Dutchman, Jacob Meijer de Haan (1852–1895), left Holland and became a close associate of Paul Gauguin in the Pont-Aven group in Brittany in 1889.[57] Known mostly for his own brightly coloured still-lifes around that time, Gauguin made a portrait of De Haan (in 1889) featuring his typical arbitrary

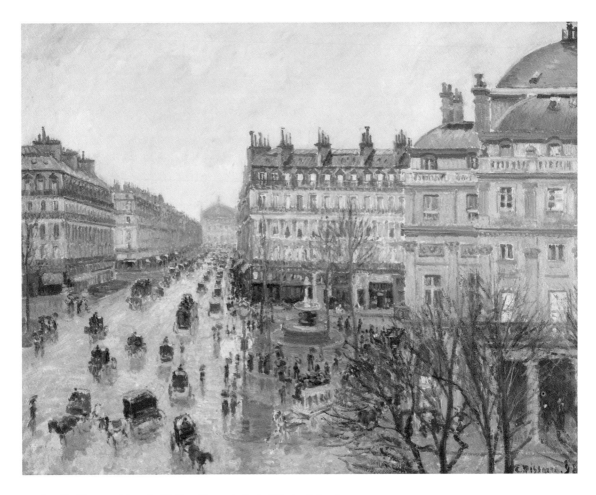

34 Camille Pissarro, *Place du Théâtre Français: Rain Effect*, 1898, oil on canvas.

presentation of colours and compositional shapes but also, disturbingly, presents the Dutch artist with distorted, satyr-like features. De Haan, who paid Gauguin for artistic instruction, was a victim of his mentor's bigotry, unfortunately appearing as a demonic and perhaps even cloven-hoofed fiend. That same year, De Haan made a sympathetic and much more accurate self-portrait influenced by Gauguin's stylistic approach, showing himself in Breton costume. His use of bright colour fields in the background suggests the widespread influence of Japanese prints, whose compositions and flatness of presentation helped provide an alternate contemporary artistic model.

Almost all observers agreed that French art set the tone for progressive painting in the late nineteenth century, so exhibitions of French pictures in Germany, let alone the collecting of French art by curators in German museums, often caused a sensation. Further,

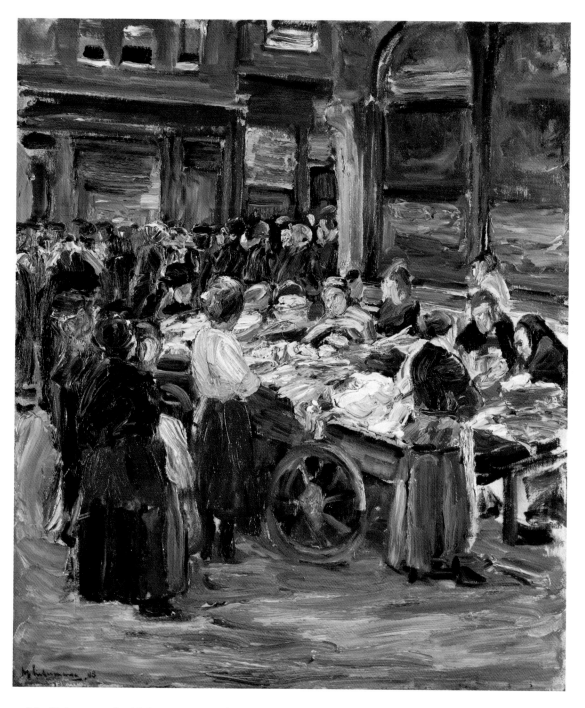

35 Max Liebermann, *Jewish Street in Amsterdam,* 1908, oil on wood.

that collecting of French art frequently set off a powerful chauvinistic reaction in Germany, where the more conservative artistic taste of Kaiser Wilhelm II reinforced his desire for cultural isolation. The very presence of Jews as active collectors of French art, as art publishers and as art dealers (notably the Berlin cousins Bruno and Paul Cassirer) frequently led to a reactionary cultural hostility to foreign art as 'alien', tinged with no small amount of anti-Semitism. Within such ongoing controversy the long and successful career of Max Lieber-mann (1847–1935) nonetheless flourished in Berlin.[58] Eventually he would become president of the Prussian Academy of Arts (1920), receive an honorary doctorate from the University of Berlin, and enjoy retrospective exhibitions in honour of his seventieth and eightieth birth-days. No earlier Jewish artist had ever achieved such acclaim and success.

Liebermann stemmed from a wealthy family and was able to maintain his artistic independence, whether he was criticized for artistic radicalism or conservatism. Like his friend Israëls, he began by painting humble working-class subjects, labouring with dignity and seriousness, often in traditional garb; many of them he observed during frequent visits to Holland (*Flax Spinners in Laren*, 1887). Liebermann's Dutch themes also included the Jewish quarter of Amsterdam, with its historic Portuguese Synagogue (interior detail, 1876; see also illus. 9), but especially its street peddlers

and pushcarts, featured in his series of images, painted in 1905–9, like *Jewish Street in Amster-dam* (illus. 35).[59] While the subject adheres to traditional Dutch urban genre paintings, the bright vegetables on the cart and the darker figures within their crowded urban setting typify Liebermann's own emulation of the lively brushwork and unmodulated colours used by modern French painters, such as Pissarro in his rural market scenes as well as his Parisian streets.

If Liebermann's engagement with a historic Jewish district makes a subtle reference to his ancestry, in general he focused on neutral sub-jects of traditional labour or modern life. In part, this preference might indicate the relative assimilation of his family background, but it also resulted from one of his rare, early attempts – recalling the efforts of Simeon Solomon and, especially, Gottlieb – to depict a Jewish Jesus and suggest the kinship between Jews and Christians. In 1879 Liebermann attempted a traditional biblical subject, *The Twelve-year-old Jesus in the Temple*, which Christians often style as *Christ among the Rabbis* to emphasize the contrasts in the disputation between the precocious youth and his elderly interlocutors. Already using lively brush strokes, Liebermann knowledgeably showed *tallitot* and Hasidic *streimel* for the Jewish costumes, and he omitted the halo and any reference to the divinity of Jesus from his model (originally painted with more ethnic features and red

hair, but reworked). This painting quickly touched off a firestorm of hostile criticism, including from the Crown Prince of Bavaria and the Bavarian parliament, condemning it 'blasphemous' and the work of a painter 'not of the Christian confession'.[60] Liebermann declared that he would never again paint a biblical subject.

In Berlin in 1898 (following Munich, already in 1892, and Vienna in 1897) a break-away movement of artists, calling itself the Secession, defied the Association of German Artists, just as the French Impressionists had shunned the Salon through their independent exhibitions a generation earlier. Even though he had also been elected to membership in the Academy in 1898, Liebermann – the only Jewish artist member – became president the very next year of the Berlin Secession.[61] In 1899 an exhibition at Paul Cassirer's gallery featured works by both Degas and Liebermann, forging the link between French and German progressive art. The Berlin Secession in turn was soon attacked by advocates for a pure, imperial, German culture.[62]

After the turn of the century, Liebermann's art focused on general scenes of prosperous, bourgeois leisure, such as the well-dressed *Man and Woman Riding on the Beach* (1903). Recalling the significant sitters of Oppenheim, Liebermann also began increasingly to paint portraits of important Berlin cultural figures. Many of them were Jewish and/or artists, such

36 Max Liebermann, *Portrait of the Painter Lovis Corinth*, 1899, oil on canvas.

as his deft likeness of fellow Secession artist, Lovis Corinth (illus. 36), denounced not only for his modernism but also for being a Christian married to a Jewish woman, another artist. And Liebermann made numerous self-portraits, both as a practising painter with palette and as a prominent, well-dressed Berliner. Liebermann exemplified his own image as an urbane cosmopolite who led a cultural elite in a world capital.

At the end of the nineteenth century anti-Semitism intensified in Western Europe, spurred on by specific events such as the Dreyfus Affair as well as the larger sharpening of local nationalisms and developing theories of racism, which increasingly began to see Jews as an unassimilated 'alien' nation in their midst.[63] Theodor Herzl (1860–1904), an acculturated Viennese journalist and author from Budapest, who also wrote about the Dreyfus scandal in Paris, led a seemingly inevitable Jewish nationalist movement, known as Zionism, within Western Europe.[64] Acknowledging the failure of emancipation, the new movement received its agenda from Herzl's tract, *The Jew(ish) State* (*Der Judenstaat*, 1896), addressed to the Rothschilds and rapidly translated. It called for Jews to empower themselves by departing to a land of their own, preferably Palestine (then part of the declining Ottoman Empire) to realize a new inner cohesion as a Jewish nation. While German was the language of Herzl and of the Zionist congresses that he headed, beginning in Basel in 1897, Zionism soon called for a revival of Hebrew as a living language for the new movement, a break from the Yiddish of provincial Jews, especially in Eastern Europe. The design of a flag and composition of an anthem, *Hatikvah* ('The Hope', sung to 1878 lyrics by poet Naftali Herz Imber), a song of exile and redemption, marked the new gatherings. On the flag, along with the blue stripes on white like a *tallit*, the use of a

Star of David catapulted that basic design to a new centrality among Jewish symbols, even though – or perhaps precisely because – it had little religiously defined meaning. If song and symbols were included in the earliest Zionist gatherings, visual culture was also deemed important to the new movement. By the Fifth Zionist Congress (1901), an interest group, or party, called the 'Democratic Faction', led by the young Martin Buber and Chaim Weizmann, advocated sponsorship of a press, the *Juedischer Verlag*, founded in 1902 and devoted to disseminating cultural Zionism. Works of Hebrew and Yiddish literature were translated into German, and Jewish art was reproduced for dissemination as part of a call for Jewish national pride and regeneration, a modern 'Jewish Renaissance' to be fulfilled in Palestine.

In his Fifth Congress speech of 1901 Buber declared, 'the most magnificent cultural document will be our art'.[65] Together with a young graphic artist, Ephraim Moses Lilien (1874–1925), Buber organized an art exhibition of contemporary Jewish artists at the Congress Hall in Basel, in which Israëls was featured prominently along with younger artists, including Lilien, Lesser Ury and Hermann Struck. The monthly journal *Ost und West* ('East and West') soon became a major publication of this wider cultural Zionism.

Born in Drohobycz like Gottlieb, Lilien had come to the Zionist movement in Berlin

in 1899, and soon he produced the souvenir card for the Fifth Zionist Congress (illus. 37), a graphic design strongly shaped by the organic linear elegance of Jugendstil, the Central European version of Art Nouveau.[66] It features a strong pictorial contrast: in the lower left an old man with a yarmulke, stooped and white-bearded, leans upon a cane; yet above him the rest of the left corner is filled with the grand, upright, full-feathered figure of an angel, who touches his shoulder consolingly while gesturing outwards towards a brilliant rising sun at right. Towards that sun, a plowman with his team of oxen moves diagonally into the distance of the horizon. Close inspection reveals that the angel's white robes feature a Star of David, echoed in the lower corners of the frame. Binding thorn bushes below the old man contrast with mature wheat stalks in the opposite corner. The large Hebrew inscription that serves as a caption in the lower centre is taken from a principal daily prayer, the

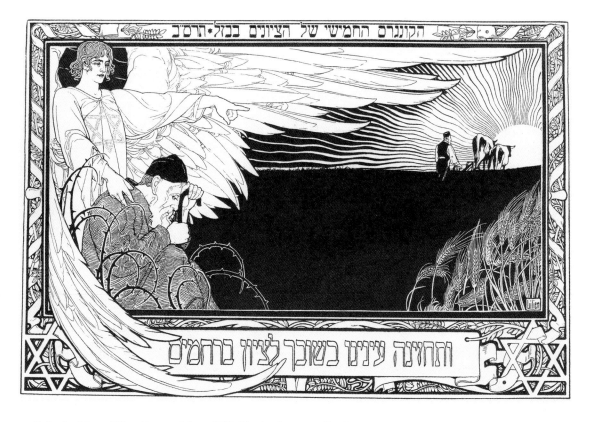

37 Ephraim Moses Lilien, Postcard from Fifth Zionist Congress, Basel, 1901.

Amidah, and reads: 'Let our eyes witness your loving return to Zion.' What Lilien captures so effectively are the multiple strands of Zionism, based in older European Jewish culture but looking towards the future promise of rebirth in Palestine; comprising at once a religious and a secular life, where physical labour and pioneer sacrifice will be used to build the fecund new homeland (see chapter Six). This heroic farmer offers a new image of the modern Zionist Jew, tied to the Promised Land rather than the city.[67] Lilien's postcard represents the figure that Herzl himself had featured in a speech at the first Basel Congress, 'On the day when the plow again rests in the toughened hand of the Jewish farmer, the Jewish Problem will be solved.'[68]

Lilien designed the cover for the inaugural volume of *Ost und West* (1901), the early Zionist publication described above. Here a regal female personification sits before both a Star of David (the repeated pattern on her skirt and the diadem on her brow) and a menorah; though her legs seem bound within more thorn bushes, they sprout flowers by her hand. Lilien also produced a moving graphic memorial to the recent traumatic pogrom of Kishinev, which underscored the need for a Jewish homeland, at least for the large population under Russian rule.[69] It shows a white-bearded, older Jew, standing upright in his *tallit* but bound with ropes as he is being burned at the stake before a nighttime skyline of church steeples. Above

his head the moon is overcast by dark clouds. The frame also features rising flames engulfing thorn branches. Like Rembrandt's *Abraham's Sacrifice* (illus. 11), the martyr is embraced in rescue by an angel, who enfolds him and kisses his brow, while hovering, carrying a Torah scroll within outstretched wings that fill the entire upper portion of the composition.

The ultimate icon of nascent Zionism was the figure of Herzl himself. A memorial, full-length painted portrait, shows Herzl ascending a mountain precipice like Moses while still dressed in a contemporary suit with hat, gloves and walking-stick. It was commissioned by the Eighth Zionist Congress (1907) from Leopold Pilichowski (from Lodz, 1867/69–1931), to be given a place of honour at the front of the next Congress in 1909 in the absence of Herzl. The most often reproduced Herzl likeness, however, was a profile print (illus. 38) by Hermann Struck (1876–1944), based on a sketch from life in Vienna in 1903.[70] Struck, a graphic art specialist, wrote a manual of etching in 1908 and trained many noted modern artists in printmaking: Marc Chagall, Lovis Corinth, Jacob Steinhardt, Ury and even Liebermann. At the time of his Herzl portrait Struck was chiefly noted for his small evocative heads of old Jews, resembling prophet figures and derived from the study head prints by Rembrandt. He described Herzl as 'unforgettable' and possessed of 'superhuman beauty' and 'kingliness' of bearing.[71] He used a profile

format to suggest both permanence and essential features rather than momentary conditions, just like the historic public figures on coins and medals; further, Struck's etching emphasizes Herzl's 'Assyrian' beard and piercing gaze that so impressed contemporaries. Over the course of his career the artist also made commissioned portrait prints of such cultural figures as Henrik Ibsen, Friedrich Nietzsche, Sigmund Freud and Albert Einstein.

Struck's career is instructive. After completing studies at the Berlin Academy, he was banned from teaching there because he was Jewish. Nevertheless he remained both a Zionist and a patriot. He served in 1915 with the German army on the Eastern Front, where he was exposed to the hardships of Jewish life in the Pale. After trips to Palestine, where he etched several portfolios of picturesque landscapes, he finally emigrated, making *aliyah* in 1922 to live in Haifa. He later helped to establish the Tel Aviv Museum of Art, founded in 1932.

For the much older Liebermann back in Berlin, the choices were correspondingly narrower. Even though he lived two years into

38 Hermann Struck, *Theodor Herzl*, 1903, etching.

the regime of Adolf Hitler, he experienced controversy for his Jewish origins already at the turn of the century. His friendship with Israëls made him conscious of the emerging interest in Jews as a 'nation and race', phrases used by Liebermann himself in praise of his peer.[72] In 1909 Richard Dehmel (whose portrait Liebermann painted in that same year) penned a dialogue between a fictional painter and a fictional poet, using the two of them as

his models, to discuss 'Culture and Race'.
Eventually Liebermann would fall victim to
this kind of thinking, and his work was con-
demned as 'degenerate' by Nazi critics. He left
the Academy a mere three months before he
would have been forced out. Invited by the
director of the Tel Aviv Museum to follow
the example of Hirszenberg and emigrate to
Palestine, he showed that his spirit was willing
yet his aged flesh was weak:

> I always stood far from Zionism. Today
> I think otherwise. I have awakened from
> my dream . . . and since I am unfortunately
> such an old tree [86 years old], it is impos-
> sible to transplant me.[73]

During the twentieth century, many other
Jewish artists would face the same dilemma
as either Struck or Liebermann. For some of
them emigration from Europe, whether to
Palestine or to America, became a very real
option, sometimes painfully necessary. Yet at
the same time, even with discrimination and
other hardships, their options at home now
readily included art-making as a viable career.

3 Revolutions in Art and Politics

The weary West, having exhausted all the forms of plastic crafts and sacrificed for the sake of this trade the very ecstasy of vital life emotions, appeals to pure young painters, Jewish painters.
— ISSACHAR RYBACK AND BORIS ARONSON, 1919

Where has this sudden desire to paint come from amongst the descendents of the twelve tribes, this passion for paint and brushes which, in spite of the [biblical] law, everybody seems to tolerate, even amongst the most orthodox?
— FRITZ VANDERPYL, poet and critic, 1925

Early twentieth-century Europe experienced traumatic upheavals, punctuated by the First World War (1914–18) and the Russian Revolution of 1917, whose lasting consequences are still being felt. Jewish history, too, got swept up in this tumult. But the hard-won professional opportunities achieved by artists over the course of the nineteenth century now permitted Jews to participate in artistic modernism, an aesthetic revolution that took shape in major art capitals across Europe. St Petersburg, Paris and Berlin would each receive fresh stimuli from ambitious young Jewish artists. Movements by those painters and sculptors not only into, but also between, those centres led them to form friendship circles and artist colonies in their adopted homes. Modern Jewish artists more frequently and visibly embraced modernity itself in various aesthetic and political movements than they asserted their Jewish heritage, which often still remained a social liability.

For Russian Jewish artists the new century resulted in the most dramatic changes, climaxing in the 1917 Russian Revolution and its political aftermath, in which Jews, including artists, took a very active part.[1] At the end of the nineteenth century the population of Jews in Russia was the largest in the world, but still confined to living in the Pale of Settlement – the territorial remnant of the old Polish-Lithuanian commonwealth. Indeed, Jews remained a separate 'nation' within the diverse, multi-national configuration of Russia, where tsarist government policy oscillated between 'Russification' of Jews to obliterate their differences, or else persecution of Jews through social discrimination and devastating pogroms, such as the infamous Kishinev massacre of 1903 (see chapter Two). When Jews were permitted to enter university, they often succeeded beyond their numbers; during the relatively liberal reign of Tsar Alexander II (1855–1881), who also abolished serfdom in 1861, many Jews embraced Russian language and literature in their education.

Epitomizing this phase of early Jewish contributions to Russian culture, the successful career of Mark Antokolsky (1843–1902), born in

the Pale of Settlement in Vilna, made him the most celebrated Russian sculptor of the nineteenth century. When his work drew the favour of the provincial governor, Antokolsky was allowed to move to St Petersburg and enter the Imperial Academy, which he eventually joined. He worked in both marble and bronze, the classic materials of the Renaissance, and his subjects ranged widely, to include portraits of contemporaries as well as famous figures from Russian history, such as Ivan the Terrible (1868).

Most controversial was Antokolsky's full-length, standing, bound image of *Jesus in the People's Court* (1874).[2] This work, like the paintings by Maurycy Gottlieb and Max Liebermann (chapter Two), stressed distinctly Jewish features of Jesus (probably a self-portrait by the sculptor), including explicit markers like side curls (*payot*) and yarmulke. Scholars have noted the close resemblance of this subject to the vivid naturalism in contemporary religious and Russian history paintings by Ilya Repin (1844–1930), a friend of Antokolsky.[3] Both the sculptor and Repin were initial members of a breakaway group of realist artists, including landscape specialists, known as 'The Wanderers'. Although the *Jesus* was attacked by anti-Semitic critics, it also drew supporters, especially Vladimir Stasov, who joined in a search for an authentic Jewish style to complement the concurrent revival of a native Russian visual heritage. The mocking of Jesus as a subject stemmed from the sculptor's

own sense of persecution as a Jew and epitomized his personal striving for idealistic principles of shared humanity and freedom. His letters to Stasov reveal Antokolsky's view (see Gottlieb) that the teachings of Jesus had been distorted by his followers throughout history.

Perhaps in reaction, especially towards those Jews who chastised him for not representing heroes from Jewish history, Antokolsky also carved the most celebrated Jewish outcast, the seventeenth-century Dutch philosopher, *Spinoza* (illus. 39). Expelled from Amsterdam's Jewish community for his public and heterodox theological-political ideas, Spinoza held the goal of a cultural syncretism, guided solely by rationalism, and would have appealed both to Antokolsky and to many post-Enlightenment Jews. Antokolsky's full-sized marble depiction conforms to the current call for naturalism in historical renderings; it characterizes the great thinker as frail and humble. Spinoza wears a robe as he sits in meditation, head downcast and hands clasped. At his feet an open book marks him as a scholar, but it might also suggest Spinoza's uncompromising intellectual independence, both from Jewish learned tradition and from previous philosophical thought.

After exhibiting and winning a gold medal at the Paris World's Fair of 1878, Antokolsky moved to Paris in 1880, at a time when rising anti-Semitism in Russia climaxed with the assassination of the liberal tsar the following year. That persecution also included crackdowns

39 Mark Antokolsky, *Spinoza*, c. 1882, marble.

on Jews, particularly through strict quotas in university openings in Moscow and St Petersburg. Resistance movements of various kinds arose with Jewish participation, ranging from radical socialism, including the expressly Jewish Bund (founded in Vilna), to Zionism, and even more radical anarchism. This tense political situation continued unabated until the period of revolution, starting with the abortive 1905 uprising and culminating in the Russian Revolution (1917).[4] Consequently, a massive wave of emigration issued from Eastern Europe, principally to America but also to Palestine in two phases, dubbed the First Aliyah (1881–1903) and Second Aliyah (1904–14). At the same time, Jews embraced their own indigenous Yiddish culture, highlighted in literature by the stories of Sholem Aleichem, even as they began to assert a new, ethnically distinctive literature in Hebrew, led in Odessa by Ahad Ha'am (Asher Ginsberg) and Chaim Nachman Bialik. This fervent, intramural language conflict between Yiddish and Hebrew as the dominant Jewish written language would continue far into the new century.[5]

Like Antokolsky, Isaac Levitan (1860–1900) associated with The Wanderers group after 1884. Originally from Lithuania but trained in Moscow, he helped shape The Wanderers' namesake purpose: to produce realistic imagery and to take their art to the people via travelling exhibitions. Levitan became Russia's most celebrated and popular landscape painter. Among his patrons was renowned author Anton Chekhov, whose brother Nikolai was also a painter, yet twice during his career Levitan was forced to leave Moscow during Jewish expulsions. Perhaps to compensate for his own Jewish origins during

40 Isaac Levitan, *Above Eternal Peace*, 1894, oil on canvas.

that intense, late nineteenth-century, nationalistic Russian revival, Levitan's compositions embrace expansive native scenery and often display historic, wooden Orthodox church buildings. Characteristic of Levitan's work, *Above Eternal Peace* (illus. 40) depicts an elevated view to distant water with a foreground traditional timber church, topped with a Russian onion dome and cross. This work shows all the atmosphere and light-filled,

cloudy skies of open-air French painting throughout the nineteenth century, which Levitan had experienced during his recent travels in Western Europe.

Leonid Pasternak (1862–1945) was another Jewish artist associated with The Wanderers after 1888, and he also made trips to Western Europe, where he saw French and German Impressionism. Settled in Moscow, he illustrated Tolstoy's *War and Peace* (1892) and

became a close friend of the author, whose portrait he often painted. Pasternak's successes led to his joining the vanguard 'World of Art' group in St Petersburg, where he was also admitted to the Imperial Academy (1905). Calling himself an Impressionist, Pasternak focused on realistic interior scenes with interactive figures, often portraits of his friends, writers, and artists. For example, his *Meeting of the Council of Art-Teachers of the Moscow School of Painting* (1902), a pastel, depicts a café-like setting to represent the principals in the Russian painting revival. Seated around a table in this atmospheric, crowded space, all of the artists can be identified; for example,

the seated man in profile, sketching, was the leading contemporary portraitist, Valentin Serov. Another Pasternak image shows Semyon An-sky, author of an important Yiddish folkloric play, *The Dybbuk*, reading his work to a patron, Abraham Stiebel (illus. 41). Pasternak survived after the Revolution by making images of Lenin and other leaders. The shifting political fortunes of Russia are further revealed through the career of his more famous son: author Boris Pasternak, who was forced to reject the Nobel Prize by a Cold War Soviet Union.

Levitan and Pasternak remained active chiefly with The Wanderers in Moscow. In St

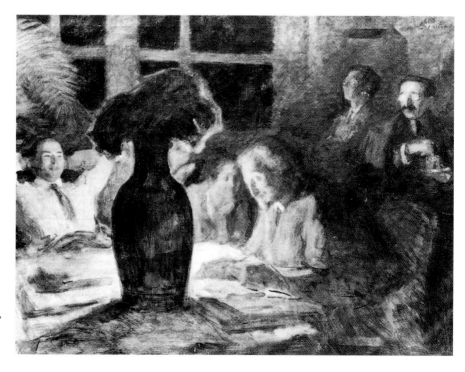

41 Leonid Pasternak, *The Writer An-sky Reading 'The Dybbuk' in the Home of Stiebel*, c. 1919.

Petersburg, the imperial centre, the most important artistic movement after 1898 called itself the World of Art (*Mir iskusstva*), a group that looked westwards with a cosmopolitan interest in Art Nouveau and other international art movements. Léon Bakst (1866–1924), born Lev Rosenberg, became an early leader in World of Art. Though he began his career as a lively portraitist, Bakst's main fame came through theatre design, especially exotic costumes. In 1908 he began work for the Ballets Russes, an international ballet company centred in Paris, where Bakst remained for the rest of his career. There his designs appeared at the very heart of modernist experimentation in both dance and music, by renowned Russian (Igor Stravinsky) and French (Claude-Achille Debussy) composers. Led by Serge Diaghilev, the Ballets Russes featured as principal dancer and choreographer the flamboyant Vaslav Nijinsky. Bakst's brilliant colours and suggestion of dynamic movement are seen most fully in his design for the poster (illus. 42), showing Nijinsky dancing the title role of Debussy's primitivist ballet, 'Afternoon of a Faun'. This ballet emphasized the primal in costume, movement and experimental tones, anticipating Stravinsky's *succés de scandale* in the following year *The Rite of Spring*.

Bakst's career in St Petersburg and then Paris set the tone for other Jewish artists in Russia who followed, especially in the period after 1905, which introduced unprecedented freedom for Russia's Jews. Another *émigré* Jewish artist, Sonia Terk (1885–1979), now known as Sonia Terk Delaunay, also studied in St Petersburg but then defied her Ukrainian family's wishes and arranged a brief marriage of convenience with a gay German art dealer, Wilhelm Uhde, in Paris, in order to pursue her ambitions abroad. Soon remarried, to a non-Jewish Parisian painter, Robert Delaunay, she partnered him in experiments of bright colour juxtapositions, which the couple called 'simultaneous contrast'.[6] Their work, usually credited solely to Robert until recently, was dubbed Orphism in 1912 by their friend, poet Guillaume Apollinaire. Soon their vibrant colour patterns were extended by Terk Delaunay beyond paintings. First she illustrated a poem by Blaise Cendrars (1912) about a journey on the Trans-Siberian railroad, and then moved her colours into abstract geometrical designs for fabrics and textiles, including costumes and set designs for *Cleopatra*, produced by Diaghilev for the Ballets Russes in 1918.

Terk Delaunay's *Electric Prisms* (illus. 43) clearly shows her early experimentation, so admired by Apollinaire and Parisian artists. On the right half of the image two circular, largely white forms suggest light sources from a pair of electric globes, a uniquely modern urban delight in arc lamps on the street and interior lighting.[7] The remainder of the image uses brilliant wedges of prismatic colours to indicate radiant circles of light, which diminish with

distance from brightness to lower values. The image's flat, patchwork composition knowingly engages modern optical theories and colour wheels of contrasting complementaries, derived from late nineteenth-century scientists, chiefly in France: Michel Eugène Chevreul, Charles Blanc and Ogden Rood – and already applied by earlier artists of the 1880s, such as Pissarro and Georges Seurat. Terk Delaunay, like Bakst, ambitiously pursued the latest modernist experiments in the art capital of Paris, suppressing the vestiges of her Russian Jewish identity in the process.

Another Russian Jewish artist who arrived in Paris at the same time to pursue modern pictorial experiments, such as Orphism and the Cubism of Picasso, was Marc Chagall (1887–1985). Born Moise Shagal, he left his native Vitebsk in 1906 and studied briefly in St Petersburg with Bakst, but soon followed him to Paris in 1910.[8] Like Bakst, Chagall would continually engage with theatre production and interior decorations throughout his career,[9] and he too made Paris his adopted home, though he would return briefly and significantly to Russia after the Revolution. In Paris Chagall first lived amidst a crowded group of aspiring artists, many of them Jewish, from all over Eastern Europe, collectively known today as the 'School of Paris'.[10]

Chagall's artistic strategy resembled Stravinsky's musical strategy in *The Firebird*, or the young Wassily Kandinsky's paintings in Munich: namely, to make art out of Russian folk life and folklore while living an urban life abroad. Chagall repeatedly pictured an imaginary Russian village, a shtetl mythologized with a recurrent cast of peasant characters, declaring that 'my homeland exists only in my soul'.[11] Simplified spaces, saturated with arbitrary colour, feature flying figures, both humans and animals. To urbane sophisticates in Paris, this alternative rural world provided as much fantasy as the emerging pure forms of abstraction by the Delaunays. In contrast to the lived agricultural experience of Pissarro's village settings, Chagall offered picturesque sentiment, combining appealing domestic animals (goat, cow, donkey, chicken) along with obviously Jewish imagery. His *Rabbi of Vitebsk*, painted in several versions (1914; best extant version, *The Praying Jew*, 1923, made after his return to Russia), asserted Chagall's Jewish ancestry explicitly. Along with several scenes of Jewish holidays it helped to make him one of today's most famous and beloved Jewish artists. Chagall also frequently rendered oversized, sometimes brightly coloured village violinists; heart of the rural ethnically Jewish klezmer music traditions.

Taking stock of his early career, Chagall's assertive *Self-portrait with Seven Fingers* (illus. 44) shows this dual aspect of his achievement. On the one hand, he presents himself as an urban dandy with flowing curls, who wears an evening jacket, bow tie and boutonnière, even

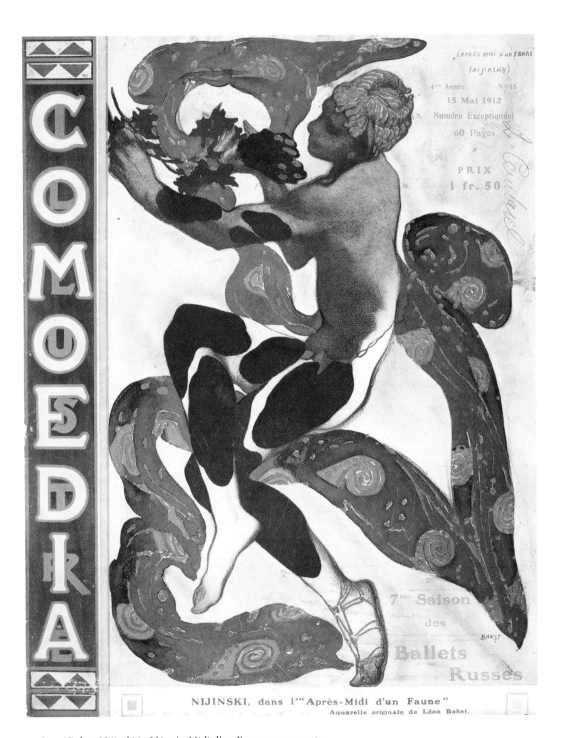

42 Leon Bakst, *Nijinski in L'Après-Midi d'un Faune*, 1912, poster.

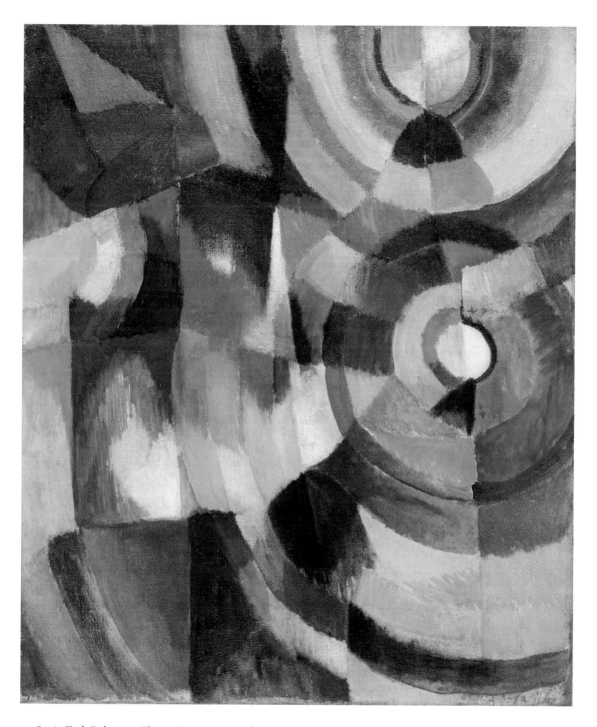

43 Sonia Terk Delaunay, *Electric Prisms*, 1913, oil on canvas.

while he holds a palette with bright colours and brushes in his right hand. His flattened figure with its arbitrary and fantastic excess of digits shows his intensive commitment to his project. But his likeness also comprises a series of angular facets in the fashionable artistic mode of Cubist portraits, tinted lightly with bright primary colours of red and yellow rather than shadows. Yet in progress at his easel sits a typical 'Chagall' canvas, a close replication of *To Russia, Asses and Others* (1911). His depicted village features small houses and an Orthodox church, above which an oversized red cow and peasant woman with a pail fly through the night sky. Within the bright apartment interior, also composed of red walls above a yellow floor, the artist situates the poles of his two worlds. Like a thought balloon of clouds, as a memory or a dream, the Russian shtetl floats above Chagall's easel; still more fantastic is the view out his window, where a white Eiffel Tower, the very emblem of modernity (thus a favourite modernist motif for Cubist-influenced artists, especially Robert Delaunay), appears silhouetted against a night sky.[12] These two sites, respectively, are labelled with Yiddish letters, transliterating 'Russia' and 'Paris' (pronounced as if French).

At the same time, Chagall's picturing of himself with seven fingers derives from aspects of his Jewish heritage, associating the number with the days of creation as well as the three patriarchs and four matriarchs of Judaism.

Equating the number seven with God's own creation of the world, Chagall may be intimating the importance of his own more worldly creations. Chagall may also be referring to the Yiddish phrase 'with all seven fingers', meaning to do something with one's whole being, both rational and irrational.[13]

Unlike Terk Delaunay or Kandinsky, Chagall was unwilling to surrender pictorial legibility – or his Russian Jewish roots – in his version of modernism, but he also clearly staked his claim to affiliate with the most progressive current experimental forms in the art capital of Paris. Significantly, Chagall strove to associate himself with vanguard art, for example in a complex geometrical painting titled *Homage to Apollinaire* (1911–12), or in his Cubist-derived canvas, *The Temptation* (1912), featuring a faceted Adam and Eve in the brilliant colours of Orphism.

Chagall left Paris in 1914 and returned to Russia, where he was stranded by the war. The February Revolution granted Jews civil rights and freedom of movement, and after the October Revolution the new government strove to incorporate its ethnic 'nations', including the Jews, by giving them opportunities for artistic expression. A search for Jewish roots had begun a decade earlier with the Jewish Historical and Ethnographical Society in St Petersburg; it even included folkloric explorations of Jewish culture in the Pale, led by Semyon An-sky (also from Vitebsk,

pictured earlier by Pasternak).[14] As noted above for Kandinsky as well as Chagall, this 'back to the future' revival of a folk heritage became a strong motivating force in progressive art after the turn of the twentieth century. It served in part as a reaction formation to modernity and urban life, but also as an alternate form of imagery (verbal as well as pictorial) to inherited academic norms or conventional realism, which had dominated nineteenth-century art.

The Russian Revolution crystallized the political commitments of all Russian Jews, including artists, some of whom shared the socialist or utopian ideals previously fostered in the Pale of Settlement by the Bund. Many of those who had earlier explored their Yiddish folk roots or else engaged with modern art experiments in Western Europe, now began to apply their art-making to the new society brought about in the wake of the Revolution. Their shift from art as aesthetic experiment to art in the service of a political vanguard required only small adjustments, chiefly in purpose and intended audience. What had previously been a specifically Russian avant-garde art soon became the Soviet avant-garde, often designated as Constructivism. Thus, shortly after the Revolution, the new Bolshevik regime used artists, many of them leading Jewish artists, to stage public spectacles, produce posters and design other agit-prop (agitation and propaganda) imagery. In particular, the first anniversary pageant of the Revolution was mounted outside the Winter Palace in St Petersburg with abstract sculpture and acres of canvas, designed by another Russian Jewish artist: Natan Altman (1889–1970).

Altman's career almost uncannily echoes the trajectory of Chagall, including an intense early period in Paris, where he learned the new artistic vocabulary of Cubism and its cognate embrace of modern urban subjects, Futurism.[15] He had returned to Russia by 1912 before the outbreak of the First World War; there he began to make Cubist-derived portraits of cultural notables, such as poet Anna Akhmatova (1914). Eagerly supporting the Revolution, Altman received the prize commission for the first anniversary commemoration. When the new post of People's Commissar of Education went to Anatoly Lunacharsky, who had seen the young Russian artist in Paris, he appointed Altman as Director of Fine Arts of the People's Commissariat (1921) in the new (1920) capital of Moscow. Lunacharsky helped recruit other modern artists into leadership positions in post-Revolutionary culture. He also appointed Chagall as Art Commissar and director of an art institute in Vitebsk, though Chagall was soon supplanted in the school by another vanguard artist and rival, Kasimir Malevich.

Soon both Altman and Chagall were recruited to work with the emerging Jewish theatre movement, part of the Soviet initiative to promulgate revolutionary ideology through

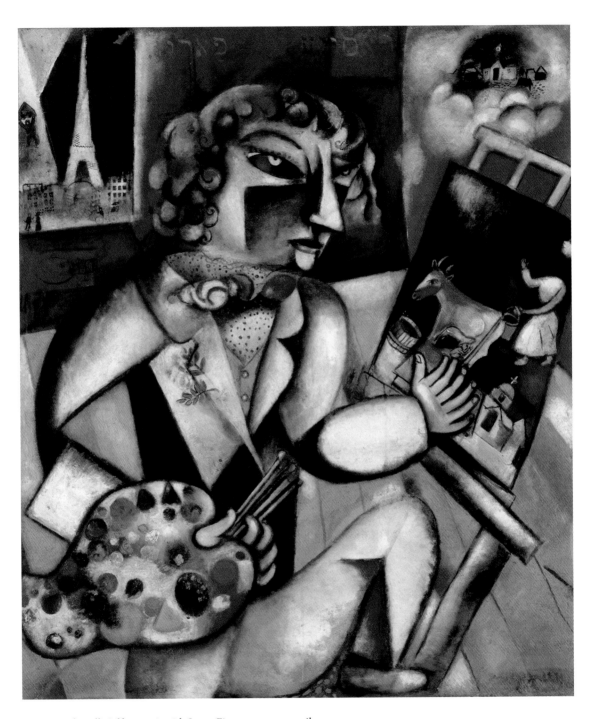

44 Marc Chagall, *Self-portrait with Seven Fingers*, 1913–14, oil on canvas.

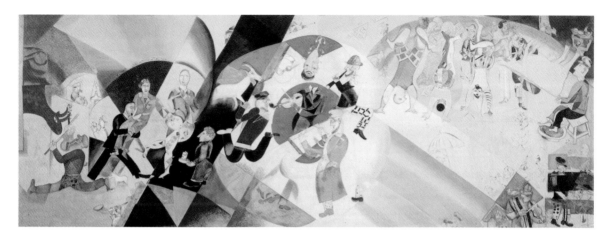

45 Marc Chagall, *Introduction to the Yiddish Theatre*, 1920, tempera, gouache, and opaque white on canvas.

local languages and cultures (an echo of the celebrated contemporary Moscow Art Theatre of Konstantin Stanislavsky). Two major Jewish theatre companies emerged, performing plays, respectively in Yiddish and Hebrew (*Habima*, 'The Stage').[16] Chagall's canvas murals for the State Yiddish Chamber Theatre fully encompassed the walls of their small theatre space. His vast main canvas, *Introduction to the Yiddish Theatre* (illus. 45), provides a summation of his career imagery up to that point, and seems to fulfill the artist's own declaration, 'If I were not a Jew (in the sense I attach to this word), I wouldn't be an artist, or else I would be quite a different artist.'[17]

The image unfolds in three circular portions, further segmented by sharp, angular patches of colour in imitation of the prevailing abstraction of Cubism or Constructivism. But into the pure geometries of artists like Malevich, Chagall's bustling figures intrude. At the far left another typical fantasy cow, coloured green, stands sideways and listens

to the music of a village fiddler, whose 'play' may also refer to the other medium, theatre. In the first circle Chagall himself, wearing a brown suit and carrying a palette, is carried into the picture by a dark-suited, striding figure, the literary director of the company, Abram Efros. Before them the dapper Director of the theatre, Alesksey Granovsky, dances in balletic tights. Their names appear in letters printed above their heads, another strong pictorial element in Russian Constructivist posters, but this time in playful Yiddish. Behind the cow a proletariat audience, uncoloured, stands in workers' caps, whereas behind Chagall on a revolutionary red field appear the Ten Commandments and varied synagogue items. A goat leads into the second circle, where the acrobatic dance of a peasant suggests the lead actor of the company, Solomon Mikhoels. He follows the music of a klezmer clarinetist and cymbalist as well as a violinist in a suit, whose head, wearing a jester's cap, flies off his body – a nod, perhaps, to a Yiddish phrase, 'his

head flew off him', meaning to live in a fantasy or overreach.[18] Finally, the third circle shows three inverted clowns wearing observant religious garb. They, in turn, are observed by another inverted cow and chickens as well as by another peasant. In the lower right corner additional villagers appear: one plays violin in a Jewish cemetery, while a circumcised Jewish boy (wearing a school hat but also clown pants) pees on a pig in front of a village house.[19] Some faces in the upper right background have been associated with Chagall's artist friends and rivals, and many other colloquial references may hide within this complex range of folk motifs. The work sets a perfect tone for the multi-media plays performed by the State Yiddish Chamber Theatre. This principal mural was accompanied by Chagall's four tall, folkloric, figural representations of the additional sister arts, Jewish-style: *Drama* (Wedding Jester), *Dance* (to klezmer), *Music* (Fiddler, on miniature roofs), and *Literature* (Torah Scribe). Chagall also produced costume designs for figures in plays performed by Moscow Yiddish Theatre.

Habima, the first Hebrew theatre, performed such plays as *The Dybbuk* by An-sky (1922, originally 1914; translated from Yiddish into Hebrew by Chaim Bialik), based on folk customs (including exorcism) and legend, this play emphasized wonder-working Hasidic rabbis in a tragic love story and conveyed a serious Jewish message.[20] Habima regarded the rival Yiddish Chamber Theatre as hopelessly mired in shtetl sentimentality and wanted to contrast with them as pointedly as the language rivalry opposed Hebrew to Yiddish.

Habima chose Altman to design both the sets and costumes for *The Dybbuk*, images of village life, including a Beggar's Dance. For these works Altman combined Jewish folk and religious elements with stark geometrical shapes. Specifically, his *Synagogue Interior* (illus. 46) presents a traditional Russian layout but with overlapping planes and a white backdrop. It features a carved ark with regional Jewish decorations, including guardian lions, elevated crown and Decalogue, plus a Star of David on a curtain; in front stands an elevated pulpit (*bima*) with a lectern. Hovering on banners in the air are the Hebrew words of the principal statement of faith, the *Shema* prayer, 'Hear O Israel'. Altman's costume designs feature male Hasidic characters with traditional dark suits and hats, including a few festive Sabbath hats (*streimel*). The rural women wear colourful, full-length dresses. All of the figures show emphatic graphic self-awareness as drawings, flattening the figures and distorting their figures and mask-like faces. In Altman's words, 'The people . . . were tragically broken and twisted, like trees growing on a dry and bare soil. Colours of tragedy were inherent in them.' These designs and others he made for Habima plays accompanied the move of the theatre company, which emigrated to Tel

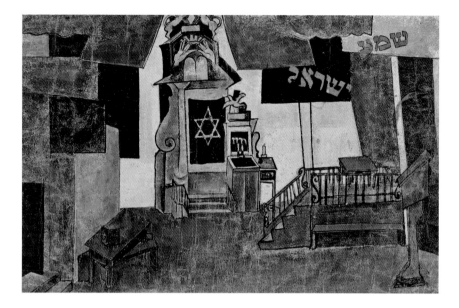

46 Natan Altman, *Synagogue Interior*, set design for *The Dybbuk*, 1922, mixed media.

Aviv in 1926 (now on loan to Tel Aviv Museum of Art). Altman, however, ultimately remained in Russia, to be recognized by the Soviet Union as an Honoured Arts Worker in 1968.

Russian Jewish sculptors also participated in the pictorial experimentation – on the eve of the Revolution as well as in its immediate aftermath. Most notable were the Pevsner brothers, Anton (1886–1962) and Naum (1890–1977), who took the name Naum Gabo to avoid confusion.[21] They were sons of a metal worker. Anton began as a painter, but Gabo started as an engineer in Munich, where he discovered abstract art (via Kandinsky) and then joined his brother in Paris. Gabo's familiarity with metals as well as with engineering led him to produce finely worked three-dimensional, open, geometrical shapes, often with complex or fluid curves, articulated by tension rods. He considered his sculpture to be a presentation of space without mass and dynamic in its extension outward. A good example of his early experimentation is *Constructivist Head no. 1* (1915, reassembled 1985, illus. 47), assembled out of wooden slats. Although formal and impersonal, its reduced and transparent components also suggest structure in architecture, clearly tied to its use of modern, industrial materials, including bronze, plexiglass and even plastic in some other works.

After the Revolution both brothers returned to Russia, where Gabo taught at the 'Higher Technical-Artistic Studios' (vkhutemas) in Moscow, one of several schools (St Petersburg; Vitebsk) run by Lunacharsky's 'Institute of Artistic Culture' (inkhuk). From there Gabo

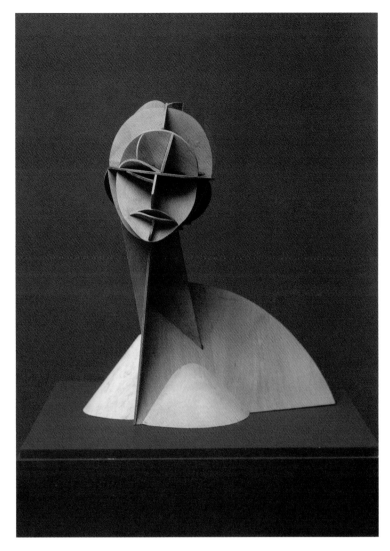

helped foster the new movement of Constructivism, sounding its tenets in his 1920 'Realistic Manifesto', distributed as a poster.[22] He boldly proclaimed that Constructivism surpassed both Cubism and Futurism, recent aesthetic revolutions back in Paris that were unsuited to the new political era. Gabo called for new dynamic spatial forms, to be integrated with life, experienced as the scientific laws of space and time, in the present, 'in the squares and on the streets'. In this spirit, Gabo contributed to open-air exhibitions and agit-prop, and he experimented with kinetic sculptures.

47 Naum Gabo, *Constructivist Head no. 1*, 1915, metal and celluloid.

Up to this point we have seen Russian Jewish artists ambitiously pursuing modernist forms in art, often journeying to Paris to see the latest pictorial experiments. Thereafter many of them returned to Russia to contribute to the post-Revolutionary political reconfiguration, which gave new prominence to artistic design in the public sphere. However, in a pattern that would also be repeated by Chagall and others (again including Kandinsky, who moved to the Bauhaus in Germany), the brothers Gabo and Pevsner both left Russia in 1922. Gabo later settled variously in leading art centres: Berlin and Paris in the 1920s, England in the 1930s and war years (the largest group of Gabo's works is in London, Tate Gallery) and finally in America (where he became a citizen) after the Second World War. Ultimately his sculpture comprised large-scale abstract forms stretched across space, reaffirming the material construction

and energetic shapes of modern sculpture, but with little residue of either a Jewish background or a revolutionary political purpose.

Another significant Russian Jewish artist who stayed home, El (Eliezer) Lissitzky (1890–1941), epitomizes the dynamic pictorial shifts in the visual arts after the Revolution.[23] Raised in Vitebsk (Chagall's home town) and trained as an architect in Moscow, he participated avidly in the folkloric explorations into Jewish culture of the Pale (1915–16; together with Issachar Ryback; see below). Basing his forms on old synagogue paintings (especially Mohilev; now lost) and other flat ornament as well as the calligraphic potential of Hebrew letters, he used his findings to produce graphic illustrations for the Yiddish press, liberated by the Russian Revolution. Signets, cover designs and book illustrations flowed from his pen after 1917, climaxing with his illustrations to the Passover folk song, *Chad Gadya* ('An Only Kid', illus. 48).

Chad Gadya, published by the Kultur-Liga in Kiev, which Lissitzky co-founded, was produced under the influence in 1919 of a shared teaching role with Chagall at the new national art school in Vitebsk. Chagall's model shapes these images, both in the form of the village imagery – with oversized folk figures and the omnipresent figure of a goat, called for in the playful song – as well as with the curvilinear, colourful Cubist planar forms. *Chad Gadya* describes a succession of escalating conflicts, in turn cat,

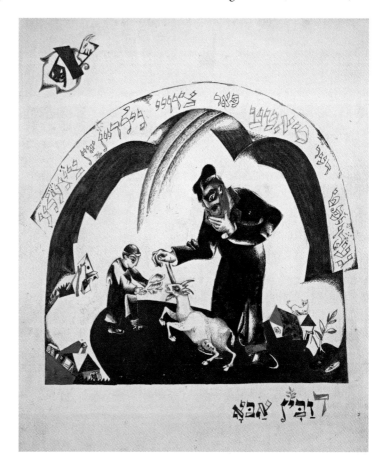

48 El Lissitzky, *Chad Gadya*, illustration 1: 'One Small Goat Papa Bought for Two Zuzim', 1919, gouache on india ink.

dog, stick, fire, water, ox, butcher and then the Angel of Death, before the final victory of the Holy One. God later rescues the situation, initiated when a father lovingly presents his child with 'an only kid'. The verses offer a message of liberation, and the kid is readily identified with the Jewish people, finally redeemed by God. Several scholars have concluded that Lissitzky also saw a potential revolutionary message in the song, fulfilling the call to fuse Soviet ideology with traditional practices of Russian 'nations', such as the Jews.[24] Perhaps the surest element of this message emerges in the first pair of images, where the traditional emphasis on the father as the custodian of the goat is replaced in Lissitzksy's version by a rainbow that lights instead upon the figure of the son, to whom the threatened goat romps. The artist also shows obvious delight in the calligraphic potential of Hebrew letters, repeatedly evident in the successive inscriptions that run along an arch above each figural scene.

However, under the powerful influence of Malevich, who succeeded Chagall at the Vitebsk art school, Lissitzky soon abandoned all figural depictions, even for his *Chad Gadya* dust jacket. Thus Lissitzky would turn to make his main contribution to Constructivism through a series of flat designs that simulate reliefs or other dimensional space. Dubbed Prouns (Project for the Affirmation of the New), they are closely linked to both

Malevich's two-dimensional abstract colour shapes and to 'counter-reliefs', pioneering Constructivist designs (1914–15) by Vladimir Tatlin.[25] *Proun 99* (illus. 49) epitomizes the geometrical shapes and dynamic composition of the series as well as its evocation of a third dimension through overlapping planes, redolent of an architectural plan seen from above. Prouns potentially reshape the world and represent a fresh, utopian vision, sometimes more explicitly suggesting towns or other structural designs, for the new political order.[26]

Related to the Prouns, Lissitsky's political poster, *Beat the Whites with the Red Wedge* (1920), was made earlier for the Administration of the Western Front. It employs the same geometrical shapes, now colour-coded to convey an instant political message celebrating the red of the Revolution. Lissitzky was cheerleading for the Soviets during the civil war that followed in the wake of the Russian Revolution and that soon threatened Vitebsk from the Polish front. Here he graphically represents Soviet military advance with the wedge, and he exploits the background contrast between light and dark to show the moral superiority of the Bolshevik Reds over their enemy Whites.

While Lissitzky spent portions of the early 1920s in Germany, associating with the Bauhaus and the Dutch movement, De Stijl, like Altman he returned permanently to Russia in 1925. There he worked under the Stalin regime to produce propaganda as both a photographer

and graphic designer, and he also designed buildings. Lissitzky declared in 1922: 'Just as we were victorious over religion, so are we fighting with our new accomplishments for victory over art.'[27] Once again the revolutionary political idealism of a modern Jewish artist, even one who had once committed so deeply to reviving the Jewish folk art heritage, triumphed over both his Jewish identity and his use of modern design as a goal in itself.

Unlike the dramatic shift of form and content by Lissitzky, his colleague Issachar Ryback (1897–1935), who studied in Kiev and accompanied him on the ethnographic expedition in 1915–16, retained his commitment to using modern pictorial forms to revive Jewish visual culture in Russia. Praising both Chagall and Altman as his models, Ryback would assert in his essay 'Paths of Jewish Painting' (1919) that the newly liberated Jewish artist must use Jewish folk art to 'absorb the cultural values of his people amassed over the generations'.[28] Ryback also continued to paint traditional Jewish subjects, but he adopted a Cubist style for works such as his *Old Synagogue* (1917), a traditional Russian wooden structure in

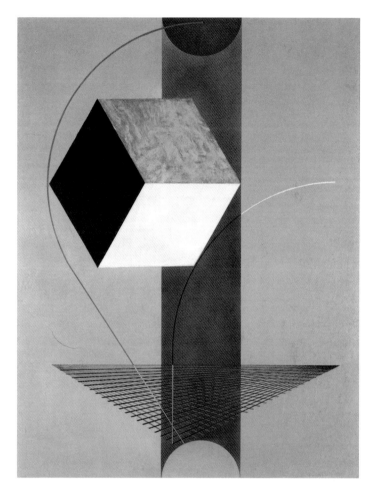

49 El Lissitzky, *Proun 99, c.* 1923, oil on wood.

Dobrovna. This image shows a broad building with two rooflines, a tapering spire and dark silhouette, striving upwards like a peak above the tiny surrounding village. Similarly, Ryback represented an *Old Jew* (1917) as a tall figure rendered in faceted Cubist segments and delicate colour harmonies. He also designed

illustrations: a 'Pogrom' series (1918) and *Shtetl* (1923), the latter of which reprises his *Old Synagogue* in one of its images.[29]

Ryback's *Still-life with Jewish Objects* (illus. 50) shows the artist consolidating his mixture of Jewish subjects and ornament with modern visual imagery, in this case collage assemblages pioneered by Picasso in Paris a decade earlier. While assertively flat, this canvas suggests depth by means of overlapping planes, even as it also simulates literal substances and textures of its still-life components – fruit rind, lace doily and cloth. Several items, including a *lulav* and *etrog*, point to the Autumn holiday celebration of Sukkot (the harvest festival depicted in the previous chapter by Moritz Daniel Oppenheim and Solomon J. Solomon). They accompany the festive prayers in the open, if flattened prayer book. A yellow folk print in the centre of the image offers Hasidim carrying Torah scrolls around the ark on Simchat Torah (celebration of the annual completion of Torah readings and the culmination of Sukkot). Above the print an arched window opens up at the top of the canvas to reveal a view over a characteristic shtetl, rendered in rough strokes and in softened grey tones of distance. Like Chagall and Gabo, Ryback also finally emigrated, spending time in Germany in the early 1920s; eventually he settled in Paris in 1926.

As noted earlier, Chagall returned to Paris definitively in 1924 after making a short stop in Germany. For many Jewish artists from across Eastern Europe as well as other regions during the 1920s Paris became the principal professional destination, along the path already charted by Bakst, Terk, Chagall, Altman and others during the previous decade.[30] In addition to Jewish artists in Paris, the number of Jewish dealers and major collectors there also expanded in this period. Perhaps inevitably a backlash arose among critics, who worried about the Jewish 'invasion' of the French School (*Ecole Française*) of modern art. They distinguished indigenous art from foreigners in the (largely Jewish) 'School of Paris'.

Among the most energetic patrons, two Jewish Americans, Gertrude Stein and her brother Leo, stand out for their patronage of modern artists and writers (famously, Gertrude's portrait had been painted by the then emerging Picasso in 1906). In 1920 another Russian newcomer to Paris, sculptor Jacques Lipchitz (1891–1973), made his own polished bronze portrait, *Gertrude Stein* (illus. 51) in the hopes of securing a sale to his distinguished sitter (the work went eventually to another pair of Jewish American collectors in Paris, the sisters Claribel and Etta Cone).[31] Lipchitz's iconic work (compared by the sculptor to a serene Buddha) remains conservative, yet professional, capturing both Stein's blocky head and signature short hair, while attesting to her stature in the world of Parisian modernism. The simplified overall form of the portrait reveals its sophisticated modernity.

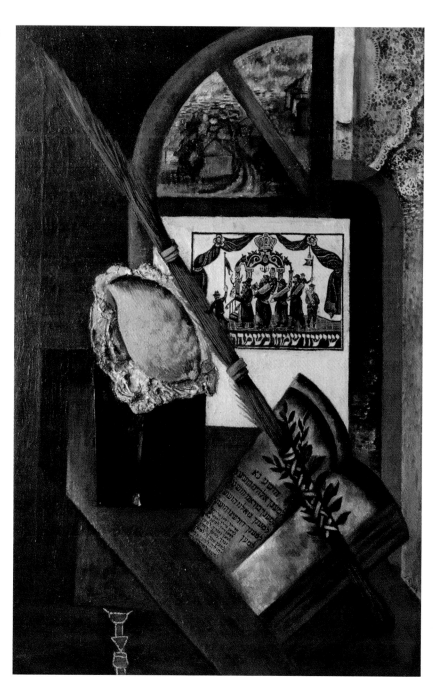

50 Issachar Ryback, *Still-life with Jewish Objects*, 1925, oil and collage on canvas.

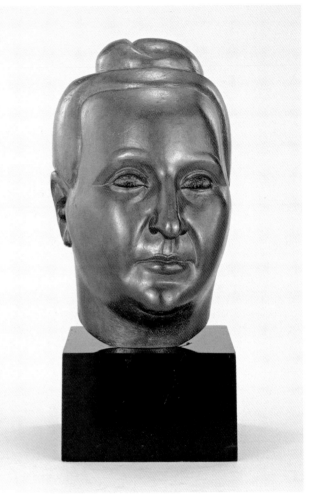

51 Jacques Lipchitz, *Gertrude Stein*, 1920; cast before 1948, bronze.

Lipchitz, however, had been anything but a conservative artist during the previous decade.[32] Born in Lithuania, he arrived in Paris in 1909 for training. His friendship circle with fellow artists expanded in the early teens to include Picasso himself and other Cubist painters, especially Juan Gris. Consequently this decade became a period of intense experimentation, as Lipchitz strove to realize the sculptural equivalent of Cubist painting. In *Bather* (illus. 52) the sculptor shows his complete immersion in the Cubist formal language of faceted segments, now transposed into three dimensions. This small work clearly presents a standing figure, described by Lipchitz as spiralling around its axis and moving in space. Certainly most Cubist works rely upon familiar, inherited artistic traditions, in this case the heritage of the standing female nude statue, only to defy them with challenging new visual forms to underscore both the modernity of the imagery and the very fact that all artworks are artificial and constructed.

This search for alternative pictorial languages, even to depict conventional subjects, led many vanguard artists in Paris to turn to exotic and imported arts, particularly carved masks and figures, from Africa and Oceania.[33] Lipchitz owned a celebrated collection of those artefacts, which helped call him to the attention of both artists and collectors, including Dr Albert Barnes of Philadelphia, who commissioned Lipchitz to design carved reliefs (in 1923) on the facade of his new museum, which housed a collection of modern, largely Parisian, as well as 'primitive' art. At this point in his career Lipchitz was preoccupied with aesthetic innovations, putting his sculpture in dialogue with leading Parisian Cubist painters, most of them close

friends in his artistic community, rather than
drawing upon his Jewish heritage or showing
any political commitments. With the rise of the
Third Reich during the 1930s, Lipchitz increas-
ingly asserted a political perspective in his art
(see chapter Five).

Another Jewish artist in Paris who was
studying such exotic forms for his own, essen-
tially portrait-based art, Amedeo Modigliani
(1884–1920) of Livorno, Italy (Leghorn),
specialized in sculpted and painted heads.[34]
Although he began as a painter, sculpture is
his best-known early medium. Using exotic
sources seen in ancient Egyptian and modern
African carvings, some of Modigliani's sculp-
tures were sold by a dealer he shared with
Lipchitz, Paul Guillaume. After arriving in
Paris in 1906, Modigliani became a close friend
after 1909 with Romanian expatriate sculptor
Constantin Brancusi, who led him to pursue
both the reductive forms of modern abstrac-
tion along with the natural textures of stone
materials in his sculpture. Modigliani's *Head*
(illus. 53) shows facial features reduced to their
essence: symmetrical almond-shaped eyes, an
elongated nose ridge and tiny pursed lips, all
poised on a tall, slender neck above a blocky
cube for a base. This carved head does not
portray a sitter, but it points towards the
exquisitely simplified painted likenesses that
became Modigliani's hallmark during the teens.

Modigliani befriended almost all his
fellow Jewish immigrant artists in Paris, and

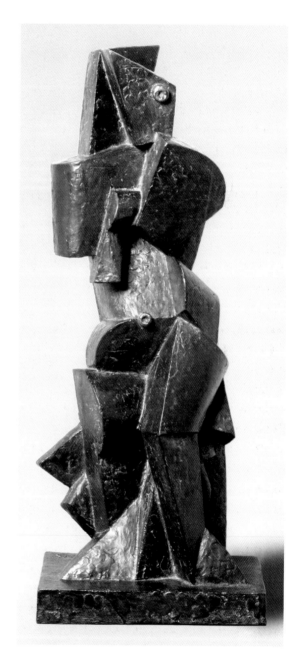

52 Jacques Lipchitz, *Bather*, 1917, bronze, height 80 cm.

97

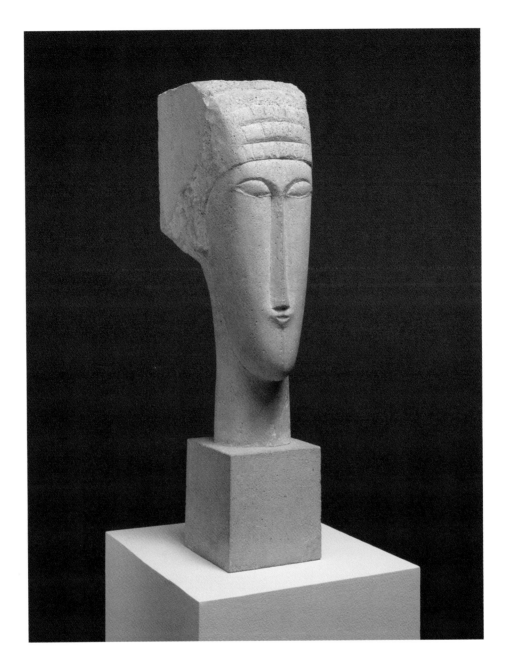

he painted portraits of many of them: close friend, poet Max Jacob (twice), Moïse Kisling (three times), Chaim Soutine and Jacques and Berthe Lipchitz (illus. 54).[35] As part of the reciprocal exchange of portraits among 'artists, friends, and lovers', Modigliani also painted many other artistic leaders of the day, including Picasso, Jean Cocteau, Juan Gris and Paul Guillaume (twice), plus other young painters, such as the Mexican Diego Rivera (twice).[36] He also painted a number of sensuous female nudes, both vertical and horizontal. The double wedding portrait of Lipchitz (who met Modigliani in 1912) and his wife reveals

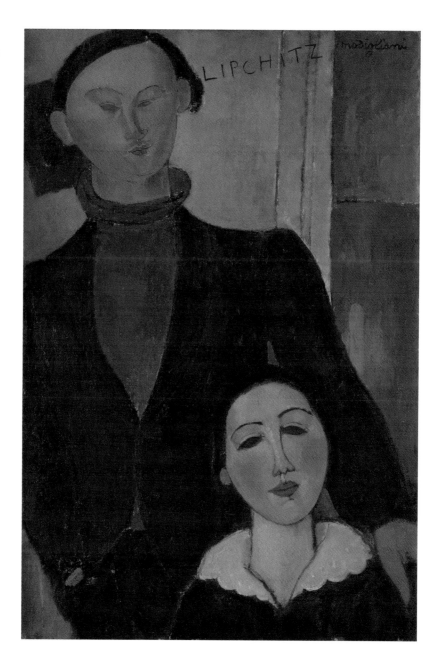

54 Amedeo Modigliani, *Jacques and Berthe Lipchitz*, 1916, oil on canvas.

opposite: 53 Amedeo Modigliani, *Head (Tête)*, 1911–13, limestone, height 71.8 cm.

the characteristic elegant linearity of Modigliani portraits, which hold personal representation and formal simplicity in delicate balance. Planar emphasis, newly self-conscious on canvases in the era of Cubism, is conveyed by simplified colour areas and visible brush strokes (an influential hallmark of Paul Cézanne at the turn of the century) as well by as the addition of lettered captions with the names of the sitters. Yet the same blank, sightless eyes from his earlier stone sculpted heads are consistently retained, now placed asymmetrically as in Picasso's heads. The addition of Berthe Lipchitz in this rare double portrait reveals Modigliani's

characteristic stylization in line, tone and shape of female features, particularly evident in her outlined brows, eyes and nose as well as her long neck. The informal dress and relaxed composition suggests the couple's easy intimacy with both the painter and each other.

Like Lipchitz, Chaim Soutine (1895–1943) also stemmed from Lithuania, and after training in Minsk and Vilna, he arrived in Paris in 1912, where he soon became close friends with Lipchitz and Modigliani.[37] Promoted by the dealer Guillaume, Soutine was patronized early by Dr Barnes, the American collector. Soutine's paintings characteristically employ bold impasto brush strokes to convey gestural presentation of bright colours and thick pigments. While he did produce a number of landscapes, Soutine is best known for two other pictorial genres: figural paintings and still lifes, particularly of slaughtered animals. For the most part Soutine remained unappreciated during his lifetime and was the most vilified of the Jewish artists in the French interwar climate of xenophobic, reactionary criticism.[38] His figures include youthful workers, such as pastry cooks or bellboys, seeming echoes of Soutine's own impoverished upbringing. In offering his personal sense of the importance of a humble trade, Soutine's own status as a working-class immigrant was evident, and he was demeaned for it. Soutine, however, also made portraits of his fellow Jewish artists in Paris, such as *Moïse Kisling*

(illus. 55). In *Kisling*, as in all of his figures, Soutine's heavy brushwork and distortions of facial features, body posture, and oversized hands resemble the portraits of Vincent van Gogh (from the late 1880s), conveying strong emotion and personal vision. The sitter, his face a mass of disparate colours and brush strokes that barely suggest a shadowed half, appears before a heavily worked avocado green background, as he wears a cravat in the complementary colour of bright orange.

Most of the same traits reappear in the still-life paintings by Soutine, which frequently delineate slaughtered fowl, hares and beef carcasses (*Carcass of Beef*, illus. 56). Some interpreters have assumed that the artist deliberately represented foods that lay outside the strict boundaries of *kashrut*, which must be ritually slaughtered under rabbinical supervision. The sheer abundance of flesh summons up varied associations, going back to similar still-life subjects by Rembrandt in seventeenth-century Holland.[39] For many viewers, this image of stilled life also offers a sober presentation of death itself, albeit part of the food chain, at the same time that it gives a tangible sign of abundance and rare feasting, as well as conspicuous consumption, especially of meat (certainly for a seventeenth-century palate but also for a man from a poor village like Soutine). Thus Soutine's imagery forges links to a visual tradition, even as it asserts individual identity through the 'hand' of the artist

in his surface treatment, very much in a modernist idiom. By adopting a visual heritage in the genre of still-lifes, Soutine affirmed his position as an artist in history, using luxury game foodstuffs and French culinary consumption to distance himself from his Orthodox shtetl origins.

As noted, Soutine never denied his Eastern European or Jewish origins – unlike many of his peers, he never changed his name – and he was the most visible target of anti-Jewish French art critics. But he still followed his own independent artistic vision, unafraid of either a dialogue with tradition or else a unique, personal style of impasto and distortion, which sometimes threatens to over-shadow his pictorial subjects.

Perhaps less familiar today but very much a part of the Jewish art community in Paris during the 1920s and afterwards, sculptor Chana Orloff (1888–1968) from Ukraine also spent time in Palestine/Israel at vari-ous moments in her life.[40] Her parents already moved there in 1905 before her career was launched, and she actually came to Paris from Palestine, to which she made numerous visits, especially after the formation of the state of Israel. Her artistic success was more palpable than many of her peers, and she

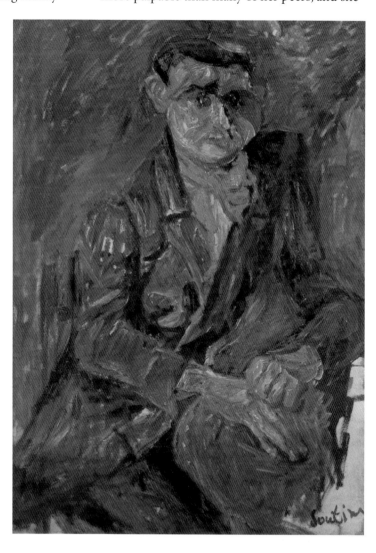

55 Chaim Soutine, *Portrait of Moïse Kisling*, *c.* 1930, oil on cardboard on Masonite.

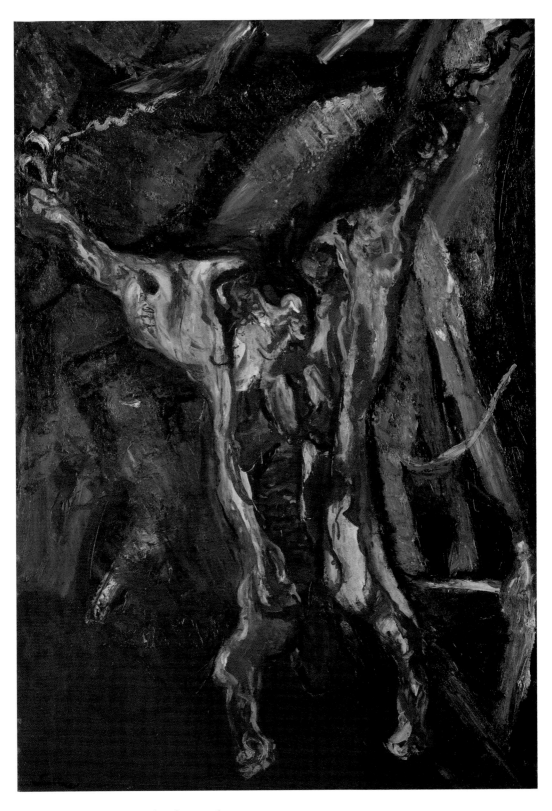

56 Chaim Soutine, *Carcass of Beef*, 1925, oil on canvas.

became a French citizen in 1916, though she had to flee from Paris to neutral Switzerland during the Second World War to escape arrest. Orloff made many portrait busts, including a number of the Jewish artists in Paris. She presents heads at once representational yet elegantly simplified in features, such as her stylized, bronze portrait of Hebrew poet Chaim Nachman Bialik (illus. 57), or her much later image in Israel of the nation's first prime minister, David Ben-Gurion in 1949. Bialik stares forward, sturdily balanced with his arms crossed. His bald pate and shiny skin surfaces provide both the personal character and the modern starkness of form seen in Lipchitz's *Gertrude Stein*.

Orloff also produced elegant bronzes of full-figured genre scenes, whether street musicians, dancers, or mother-child pairs. A good example of her work is *The Dancers (Sailor and Sweetheart)* (1923). Small-scale, stylized and highly polished, this dynamically tilted composition literally fuses its two title figures into an erotic embrace. Their distinctly French *apache*, or counter-culture popular dance, suggests the intimacy of a tango, a novelty practised at dance halls in the Montparnasse neighbourhood, where so many of these Jewish artists lived in Paris.

One other Jewish American artist came to Paris and stayed there for his main output: Man Ray, originally Emmanuel Radnitsky (1890–1976).[41] Born in Philadelphia and raised in New York, Man Ray moved to Paris in 1921

and worked there until the war in 1940. He emphatically changed his name and denied his Jewish identity, already by the time of his marriage. Though he became a successful high fashion photographer, Man Ray also innovated with light-sensitive photograms, which he renamed 'rayograms'; he recorded actual objects on photo paper exposed directly to light without any use of a camera. Those flat, silhouetted compositions often juxtapose unusual objects together, including mechanical parts. Additionally, Man Ray made paintings, sculptures, collages and, notably, participated in the new art form of 'found objects', pioneered in the teens as 'readymades' by Marcel Duchamp in both America (at the Stieglitz Gallery in New York during the First World War) and Paris. Through leading American collectors, the Arensbergs, Man Ray met Duchamp in New York during these war years in Europe. This connection was solidified through Man Ray's photograph of a famous persona of Duchamp as a female, Rrose Sélavy, showing the artist in drag (*c.* 1920).[42] This playful pose by Duchamp constituted an attack on – as well as an exploitation of – the respect accorded to individual artistic personality and subjectivity.

During the teens Duchamp, followed by Man Ray, further challenged art's assumptions, particularly the privilege and the reverence offered to polished workmanship as well as to brilliant invention. Hence, he presented in

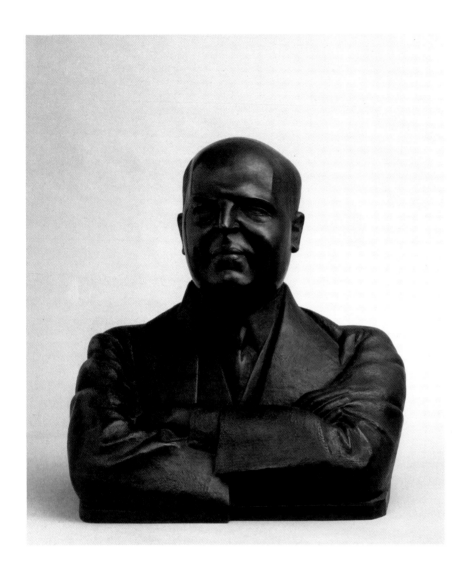

gallery settings such commonplace objects – the readymades – as bottle drying racks, shovels and even an inverted urinal (dubbed 'Fountain' in one of his witty titles). This anarchic send-up of the presuppositions of art was one part of the movement called Dada (after an early childhood word or nonsense sound). One of Man Ray's extensions of these inventions of the teens, a work called *Gift* (1921) was shown in his first Paris exhibition; it comprises a standing flatiron with fourteen attached tacks, suggesting an underlying sadism towards women ('you can tear a dress to ribbons with it', he said). Such subconscious desires, including violence, comprises a new theme of art, partic-ularly after the pioneering work in Paris of André Breton in 1924, which applied the new insights of psychology to works of culture in a movement called Surrealism: 'any discovery that changes the nature or the destination of an object'. The power of Man Ray's *Gift* lies in its inherent contradictions – at once functional as a flat surface, but then undermined by sharp, threatening projections; and an object named

as a gift but with the potential to inflict pain on its recipient.

Man Ray's most significant extension of the Duchamp readymade is preserved in one of his own photographs. Entitled, mysteriously, *The Enigma of Isidore Ducasse* (illus. 58), it is a wrapped object, supposedly a sewing machine, tied with rope. The image conforms to the paradoxical utterance by the poet named in the title, who famously declared in the nineteenth century that beauty emerged from 'the chance encounter of a sewing machine and an umbrella on a dissecting table'.[43] The bulging but unde-fined image conveys a spectral effect that lives up to the 'enigma' of its verbal source as well as its title. Moreover, through the medium of

photography the object itself remains preserved, one step removed from its originating moment, already raising the question (so vexed in our age of photo-manipulation) whether 'seeing is believing'. The sewing machine as object is certainly called for by Ducasse, but it is also explicitly identified with the immigrant Jew in America, as the chief tool of the trade for a tailor, a typical Jewish profession. This seeming coincidence leads Milly Heyd to theorize that suppressing and disguising the sewing machine was a form of repression for May Ray, both of his father's trade and of his own Jewish identi-ty, just like his name change. Even the flatiron in *Gift* can be viewed this way, as a rejection of its proper role for a tailor to treat garments.

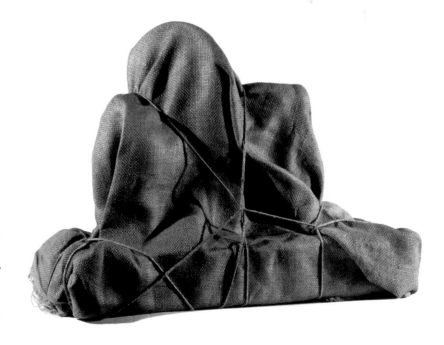

58 Man Ray, *The Enigma of Isidore Ducasse*, assemblage / photograph, 1920 (reconstructed 1970), assemblage: sewing machine, blanket, strings, and wooden base.

Also, Man Ray produced a cloud-like hanging sculpture (akin to the 'mobiles' of his American contemporary – also from Philadelphia – in Paris, Alexander Calder), titled *Obstruction* (1947), composed out of an expanding pyramid of clothes hangers, another derivation of the garment trade, so fully populated by Jews.

Certainly, as the high-priced photographer of couture, May Ray could suppress his humble, Jewish origins and 'pass' as a sophisticated cosmopolite in Paris. But he seems constantly to have been haunted by his Jewish immigrant background. Indeed, the later (1970) recon-struction of the *Enigma* as an object bears the express warning in three languages (German, English and French), 'Do not disturb'.

That trilingual call for aesthetic and social detachment could hardly be sustained during the interwar period, least of all in Germany. In the last chapter, we saw how even the venerable, established career of Max Liebermann became tempest-tossed in the early years of Adolf Hitler's rise to power. In Germany, the First World War had already proved traumatic for artists, resulting in death (Fran Marc), break-down (Ernst Ludwig Kirchner) and lasting psychological scars (Otto Dix) for some of the most important younger painters and printmakers. Even before the First World War, on the eve of its outbreak, German Jewish artists, particularly in Berlin, strove to provide a distinctly Jewish vision, occasionally with biblical subjects, even as some of them seemed particularly sensitive to the potential catastrophe. To be sure, many German Jewish artists defined their own roles as cultural prophets of doom from their positions as citizens of a dynamic new cultural metropolis.

Lesser Ury (1861–1931) in many respects remained an artist of the previous century. He began his Berlin career with evocative suggestions in both paintings and prints of the atmosphere and light of the burgeoning metropolis.[44] In that respect his cityscapes, while focused on Berlin itself, grew more out of the achievements of Max Liebermann and ultimately of the Impressionists in late nine-teenth-century Paris. However, around the turn of the new century, Ury began to focus on Jewish subjects through biblical scenes, represented by small groups of monumental figures. His *Jerusalem* (1896) shows a row of large figures, both sexes and all ages, seated mournfully before an expanse of water, to suggest isolation and exile after the destruction of the Temple, as articulated in Psalm 137. Its atmosphere accords well with the formal figural reductions of Symbolism (for example, the Swiss artist Ferdinand Hodler) at the end of the century, as well as with the contemporary Jewish history and its intensified persecution, from Dreyfus in France to pogroms in Russia. In similar fashion, Ury produced a *Jeremiah* (1897), which showed the prophet of lamenta-tion – and the destruction of Jerusalem – lying prone and alone under the stars. Along with

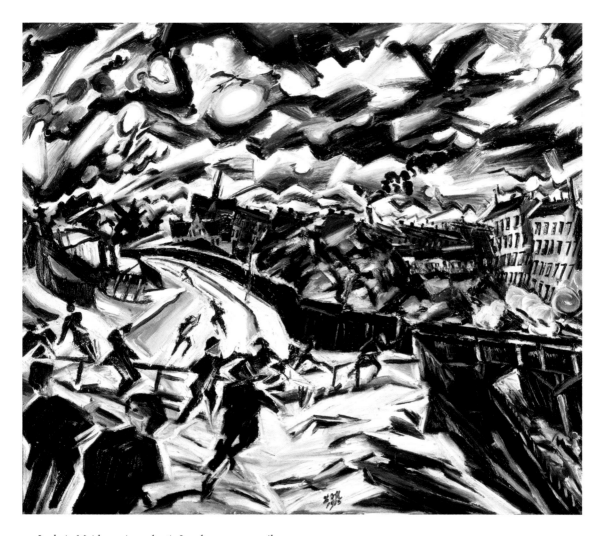

59 Ludwig Meidner, *Apocalyptic Landscape*, 1913, oil on canvas.

other turn-of-the-century artists, such as Jozef Israëls and Ephraim Moses Lilien, Lesser Ury was seen by Martin Buber and young Zionists as a paragon of authentic Jewish artistry and placed on exhibit at the Fifth Zionist Congress in 1901 (see chapter Two).[45]

Ury's powerful, isolated figures culminate three decades later in an image of Jewish tragic heroism, *Moses Sees the Promised Land before his Death* (frontispiece). Like some recent sculpture, such as Boris Schatz's statue of *Moses on Mount Nebo* (1890; see chapter Six), Ury's powerful standing figure embodies the ideal of heroic, if tragic, Jewish leadership in the new era of Zionism (with Herzl often seen as a Moses figure), for Moses was able to see but not to enter the Promised Land (Deuteronomy 3:23–7; 34:1–5). The composition of Ury's gouache is

divided neatly between the dark mountainside with the great man seen in shadow from behind; at the left in bright tones of blue-green, tinged with complementary orange rays descending from heaven, appears the verdant open valley of the Jordan.

Ludwig Meidner (1884–1966), born in Silesia and trained in Breslau, moved to Berlin in 1905, where he became a close friend of a fellow Jewish artist from Poland, Jakob Steinhardt (1887–1968).[46] Meidner worked as a printmaker after training with Herman Struck, but he began in the early teens to paint 'rebellious' images, such as his *Apocalyptic Landscape* (illus. 59). That work echoes a recent poem by Jakob van Hoddis, 'End of the World' ('*Weltende*', 1911): 'The storm is here . . . and trains are falling off the bridges.' In this image of sombre colours (especially the overcast skies), bold brushwork and expansive, if distorted settings, Meidner fantasized urban catastrophe amid an explicitly local, urban site, a Berlin train station. Within a wide panorama, a chasm opens in the lower right corner, and buildings sway in the flickering representation. Dark-clad burghers, small in scale but placed close to the viewer in the left foreground, scramble uncertainly across the space. At this time Meidner assumed the artistic role of a prophet and made a number of stark images, some of them self-portraits, with the theme of a gesticulating, passionate bearded doomsayer (for example in the lithograph *Prophet*, 1918).

His print images appeared in contemporary publications, particularly *Der Sturm*, a vanguard art and literary publication as well as the name of the gallery of Jewish dealer Herwarth Walden (born Georg Lewin), a stalwart supporter of artistic Expressionism in Germany and a founder of the Art Society (*Verein für Kunst*).[47] After the war, Meidner increasingly committed to Orthodox Judaism and largely abandoned art-making in preference for religious observance, except for poems and drawings, sometimes of himself wrapped in a prayer-shawl (*tallit*).[48]

Much the same kind of emphasis filled the current work of Jakob Steinhardt; however, his imagery of doom and destruction was more generalized. His life-sized painting, *The Prophet* (1913), and his earlier print of it (illus. 60), portrays a standing, gesturing, bearded elder, wearing an ancient garment and towering over a frightened, huddled crowd; meanwhile prominently roofed houses above and behind them are devastated by thunderbolts and earthquakes. Both Steinhardt and Meidner, who called themselves the *Pathetiker*, or sufferers, considered that their works conveyed a special trait of Jews, the capacity for personal anguish and suffering as well as a heroic spirituality born out of cultural isolation, like biblical prophets.[49] Both also strongly and mutually engaged with the mystical, religious, late imagery of Spanish old master artist El Greco, who enjoyed a current revival in Germany.

After the First World War the career of Jakob Steinhardt shifted dramatically, part of a growing attention to Jewish identity within Weimar Germany.[50] Also trained by Herman Struck, Steinhardt focused more on his prints, strong, high contrast graphic images in the woodcut medium, though he continued to paint as well. Following the lead of his contemporary Lilien (illus. 37) or of Struck, who resettled in Haifa, Steinhardt increasingly represented explicitly Jewish subjects, both biblical narratives and scenes of traditional observance by Jews of Eastern Europe, whom he personally experienced on the Eastern Front during the war.[51] He issued a milestone illustrated Passover Haggadah in 1923, with references to contemporary hardships in post-war Germany. Finally, in 1933, he emigrated to British Palestine, where he eventually worked at and also directed (from 1953–56) the art school in Jerusalem, Bezalel (chapter Six), while continuing to produce prints, many with Jewish subjects.

As noted for Steinhardt, this period of life in Berlin fostered a new, assertively self-aware Jewish community. Ironically, the culmination of this cultural assertion occurred on 24 January 1933, one week before Adolf Hitler became Chancellor of Germany, when the Jewish Museum of Berlin opened next to the great Oranienburg Synagogue.[52] Two weeks later, old Max Liebermann, honorary chairman of this new museum, resigned his honorary presidency of the Prussian Academy of Arts. Photographs that document the entrance hall of the Jewish Museum show on adjacent walls and surrounded by busts of German Jewish cultural heroes, Moses Mendelssohn and Abraham Geiger, a juxtaposition of Ury's *Jeremiah* with Steinhardt's *Prophet*. Jewish ceremonial objects also were included in the exhibition, but viewed now more as aesthetic objects than as elements of religious ritual. Jewish art in Europe would have received its cultural centre in Berlin were it not for the Nazis, who closed the museum in 1938.

This increasingly fraught situation of modern Jewish artists in Germany vividly crystallized around Hitler's showcase art exhibition in Munich (19 July to 30 November 1937), which he tarred with the slur 'Entartete Kunst' or 'Degenerate art'.[53] 600 works by more than 100 artists were put on unflattering display in a show that toured for four years and had three million visitors. Work in the *Entartete Kunst* deliberately contrasted with a complementary propaganda exhibition at Munich's *Haus der deutschen Kunst* (House of German Art). The favoured aesthetic in the latter show featured classicized ideal bodies in statues and sentimental national stereotypes in painted scenes of family life and rural harmony ('children, kitchen and church' was women's proper gender role in Hitler's formulation). Of course, Jewish artists were by no means the only modernists gathered into this hall of

shame. Such hostile judgements toward foreign art of all kinds readily extended the earlier xenophobic cultural politics of the Kaiser at the turn of the century.

This exhibition reinforced the book burnings of 1933 and other cultural censorship as well as increasingly virulent anti-Jewish laws in Nazi Germany.[54] Further, the very concept of 'degeneracy' still held strong associations with Jews, particularly with neuroses, such as hysteria, often linked to heredity and ethnicity.[55] Racial theories informed the responses to modernist art, which Nazi critics castigated for being 'primitive', 'Negroid' or 'Jewish'.

All European Jewish artists had to find solutions to the danger posed to their very lives, let alone careers, by the Second World War and the increasingly grim reality of the Holocaust. Many of them, such as Chagall and Lipchitz, emigrated to America, the former only temporarily (he never did learn any English), but the latter to enjoy there three more decades of productive creativity.[56] Indeed, such opportunities were fostered by an Emergency Rescue Committee after its foundation in 1940; Lipchitz would declare later that he owed his life to that agency, since 'I did not want to go away from France'.[57] On the occasion of an exhibition at Pierre Matisse Gallery in New York in 1942, 'Artists in Exile', a recently arrived expatriate group of prominent European artists assembled for a famous photograph by George Platt Lynes. Among the Jewish artists from Paris in

this group were Chagall, Lipchitz and sculptor Ossip Zadkine (1890–1967).[58]

Chagall started making images of persecution in the 1910s, including the archetypal Wandering Jew (see Conclusions) and ultimately his well-known crucifixions.[59] Chagall's *White Crucifixion* (illus. 94) identifies Jesus, wearing a loincloth resembling a *tallit*, as a martyred Jew in the midst of Nazi brutality. Lipchitz, too, responded from Paris to widespread fascist political gains in themes of struggle by heroes against overwhelming foes, including David against Goliath (illus. 93) and Prometheus against the Vulture of Zeus (the subject of a monumental sculpture at the 1937 Paris World's Fair alongside Picasso and Miró).[60] His later bronze figures, made both during and immediately after the war, attest to the pain of Jewish wartime loss. *Mother and Child* (1941) universalizes the struggle for survival through a legless and handless imploring parent. To embody the *Kol Nidre* prayer of Yom Kippur, Lipchitz fashioned a *tallit*-clad mourner who performs the *kapparoth*, a ritual sacrifice of a lone rooster on the eve of Yom Kippur as a kind of expiation or scapegoat object to take on the sins of the community (*The Prayer*, 1943; *Sacrifice*, 1947–57).[61]

Other artists who did not emigrate entirely, such as two Germans, Charlotte Salomon and Felix Nussbaum (see chapter Five), sought safety in more remote corners of Europe,

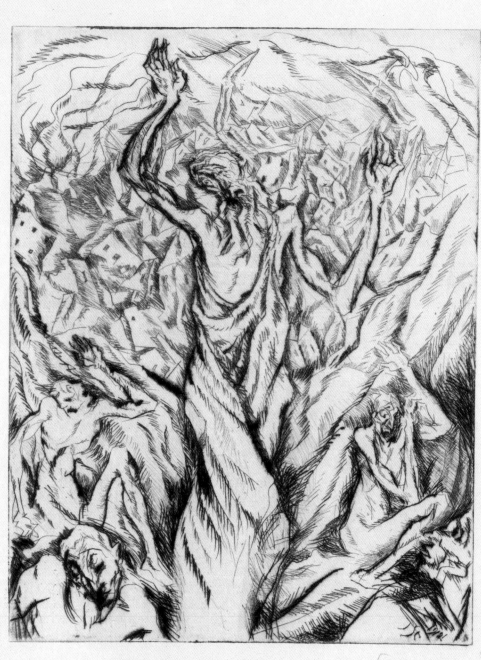

60 Jakob Steinhardt, *The Prophet*, 1912, drypoint and etching.

including Belgium or the Vichy regime of southern France, but they were eventually captured and killed at Auschwitz with so many other Jews of Europe.[62] Effectively, Jewish art traditions across Europe were extirpated by the catastrophic human destruction of the Holocaust. As a final instance – a single part for a much larger whole – of the kind of artistry that was lost to Nazi atrocities, consider Bruno Schulz (1892–1942), another citizen of Drohobycz, the city of Gottlieb and Lilien, two earlier landmark figures in Jewish art history. Schulz was a master of both words and images. As a writer, he is now described as the 'Polish Kafka', with brilliant and unsettling novellas. His wider fame, however, only resulted from posthumous English translations of his publications: *Cinnamon Shops* (English title: *The Street of Crocodiles*, 1934) and *Sanatorium under the Sign of the Hourglass* (1937).

Bruno Schulz was also a serious graphic artist, using both charcoal and ink to produce haunting drawings, some of them originating as illustrations of his prose.[63] His *Self-portrait at an Easel* (illus. 61) not only shows the precocious talent and confident self-awareness of the young artist, but it already sets the tone for many of his disturbing drawn images. Recurrent themes – masochism and complex sexual relations – can be discerned through the large, framed, background scenes as well as the small nude female statue at his feet. Schulz represents male sexual anxieties; some

were compiled into an album with its own evocative title, *The Book of Idolatry*. Many of his images feature dark settings where women, often nude or provocatively undressed, sit enthroned in boudoirs or stand on street corners, dominating smaller, dwarfish men – often with explicit self-portraits of the artist – at their feet. Such acutely confessional frankness with distorted figures echoes the earlier traditions of Francisco Goya and Edvard Munch, but also melds with the harshness of recent German postwar imagery of the 1920s (for example, in Max Beckmann and Otto Dix). Schulz, too, made several drawings of small groups of observant Jews gathered together, showing both his religious distance from them as well as his acute consciousness of his own religious background.

This artistic career, like so many others, whether purely aesthetic or assertively political, was cruelly cut short. The story (already a legend) reports that in November, 1942, over a year after Nazi occupation of Schultz's hometown, one Gestapo officer stationed in Drohobycz shot a Jewish dentist under the protection of another officer. In revenge, the latter Nazi figure allegedly shot Schulz, who had been sheltered by the first officer, while uttering the chilling retort, 'You killed my Jew – now I will kill yours.' Yet one final monument to his artistry was rediscovered like other rare creations during the Holocaust period. Schulz had made painted murals in

61 Bruno Schulz, *Self-portrait at an Easel*, 1919, graphite on paper.

the apartment of his protector, where he was
confined during the war; these were later recov-
ered, restored, then removed surreptitiously by
Yad Vashem Museum in Jerusalem, where they
have recently gone on view (in 2009, on loan
from the Schulz Museum in Drohobycz, today
in Ukraine).[64] These pictures depict fairy tale
figures in old-fashioned costumes – a coachman
self-portrait among them – but with a sardonic
gaze that undermines their romance subjects.
This fragmentary and faded imagery now forms
part of a display, amidst other imagery and
artefacts, of Holocaust memory and memorial
(see chapter Five) – a monument to talent lost
to irreversible trauma.

4 Art, America and Acculturation

Acculturation comprehends those phenomena which result when groups of individuals having different cultures come into continuous first-hand contact, with subsequent changes in the original culture patterns of either or both groups.
— R. REDFIELD, R. LINTON, M. J. HERSKOVITS, 'Memorandum for the Study of Acculturation', 1936

I began to wonder if making paintings that have a Jewish theme was some way of proving that I'm not ashamed of (Judaism) at all. I'm not.
— LARRY RIVERS, born Yizroch Loiza Grossberg, 1965

While Jews arrived in America as early as 1654, they did not participate in the visual arts in a significant way until the beginning of the twentieth century.[1] The liberties accorded Jews in their diasporic Promised Land enabled them to pursue artistic endeavours, but it took time for religious strictures about art making to relax or for an art career to attain respectability. Further, the number of Jews in the United States remained very small up to the nineteenth century, never exceeding more than a few thousand.[2] Ultimately, the loosening of religious observance in America, where Jews were finally freed from pogroms and centuries of anti-Semitism, opened opportunities – whether artistic training or fresh subjects for Jewish art in the New World. Jewish American artists employed a wide range of approaches and subjects, yet a few consistent, often intertwined themes appear in their art from around the early 1900s onwards, when population numbers appreciably expanded and Jews working in the arts became common: a desire first to chronicle and then later to look back nostalgically at the growth of a newly emerged Jewish existence in America, frequently secular and influenced by Yiddish culture. Some artists featured their negotiation of living in two worlds – both as immigrants as well as first-generation Americans – while others attempted to shape topical social and political issues. All of this subject matter manifests the affects of living as a marked minority in the diaspora. For these artists, diasporic living did not impede creativity, but instead provided a springboard for flourishing new material and unprecedented artistic success for its purveyors.

A few eighteenth- and nineteenth-century Jews actively pursued a career making art in America.[3] Some designed ritual objects; for example, Myer Myers (1723–1795), a silversmith, crafted both lay and ceremonial objects for colonial merchants. He created *rimmonim* (Torah ornaments) for several synagogues, including New York's Congregation Shearith Israel and the Yeshuat Israel Congregation in Newport, Rhode Island. Some Jews did paint, most frequently portraits. Solomon Nunes

Carvalho (1815–1897) made likenesses of members of the Jewish community and also painted allegorical portraits, including one of Abraham Lincoln in 1865. Shared style, technique and subject matter suggest that the well-known portraitist Thomas Sully trained Carvalho.[4]

Carvalho also created a few biblical paintings and landscapes, but his fame rests chiefly on his work as a daguerreotypist for John C. Frémont's 1853 exploratory expedition through Kansas, Utah and Colorado, a trip aimed to map a transcontinental railway route between the Mississippi River and the Pacific Coast. Unfortunately, Carvalho's photographs and sketches of the trip were presumed lost in an 1881 fire, although a single, badly damaged picture survived (Library of Congress, Washington).[5] Carvalho's account of the expedition from 1856, the only record of the trip, was widely reprinted, four times before 1860.[6] It discusses both the rigours and discoveries of the journey while also providing Carvalho's personal reflections. The case of the American-born Carvalho, with diverse interests and wide acceptance in the nineteenth century, clearly demonstrates that a Jewish American could succeed as an artist.

Emigrating from Germany at age eight, Henry Mosler (1841–1920) began (like Winslow Homer) as an artist correspondent for *Harper's Weekly* during the Civil War. Without a commission, in 1866 Mosler painted *Plum Street Temple* (illus. 62), a canvas detailing the exterior of Bene Yeshurun in Cincinnati, the new temple erected by pioneering Reform rabbi Isaac Mayer Wise. Setting his picturesque scene against a cloudy sky, Mosler precisely renders the Moorish-style architecture, which dominates the canvas and dwarfs the well-dressed congregants mingling in front of the structure. Portraits commissioned from Mosler by the Jewish community include a precise likeness of Wise's wife, Therese Bloch Wise, from circa 1867. Despite these religious associations, Mosler characterized art as his spiritual connection: 'I am an eternal worshipper of the Creator. When I transfer a beautiful model to the canvas, I am engaged in an act of divine worship.'[7] This belief in art as religion is repeated among a number of later Jewish Americans.

Like many artists of his generation, Mosler travelled to Europe for artistic training. In France he also became a painter of genre scenes, frequently picturing peasant costume and life in Brittany, although in a much more conventional manner than the Dutch Jew Jacob Meijer de Haan and non-Jews, such as Emile Bernard and Paul Gauguin. Mosler's attraction to the traditional, spiritual existence of the Bretons relates to the artist's admiration of their ability to retain time-honoured customs in a rapidly modernizing world.[8] Moreover, by painting Breton life, Mosler could express his attachment to tradition without producing

62 Henry Mosler, *Plum Street Temple*, *c.* 1866, oil on canvas.

images of parochial Jewish subjects, like Jacques-Émile-Edouard Brandon. As Albert Boime observed: 'Mosler solved for himself the problem of participating in a non-Jewish social environment without surrendering his sense of distinctive identity and claims to a harmonious and vigorous ancestral past.'⁹ In short, Mosler's Jewishness influenced his choice of artistic material, whether the theme was obviously Jewish – his painting of a Reform congregation – or else non-Jewish themes about cultural tradition within modernity.

Mosler's modest reputation in his lifetime was largely forgotten until a 1995 retrospective resurrected his name and work. In contrast, Moses Jacob Ezekiel (1844–1917) became the first Jewish American artist to earn international acclaim. Despite recurrent lack of patronage, the Virginia-born Ezekiel persevered, because, as he noted in his posthumously published autobiography:

> [T]he race to which I belong had been oppressed and looked down upon through so many ages, [that] I felt that I had a mission to perform. That mission was to show that, as the only Jew born in America up to that time who had dedicated himself to sculpture, I owed it to myself to succeed in doing something worthy in spite of all the difficulties and trials to which I was subjected.¹⁰

Like many American Jews, Ezekiel felt compelled to succeed, both for personal satisfaction and for the collective perception of his people.

The B'nai B'rith (literally Sons of the Covenant), a Jewish communal group founded in New York in 1843, provided Ezekiel with his first major commission. In 1874 for the upcoming 1876 Centennial Exposition, a world's fair in Philadelphia, Ezekiel carved a marble group, *Religious Liberty* (illus. 63), fully 7.6 m (25 ft) tall. Allegorical in conception, this monument presents the classicized Liberty as a 2.4-m (8-ft) woman, wearing a Phrygian cap with a border of thirteen stars to symbolize the original colonies. In one hand she holds a laurel wreath; she extends the other hand protectively over the idealized young boy at her right, a personification of Faith, who grasps a flaming lamp. At Liberty's feet an eagle, representing America, attacks a serpent, symbolizing intolerance, and Faith steps on the serpent's tail. The group stands on a pedestal bearing the inscription 'Religious Liberty, Dedicated to the People of the United States by the Order B'nai B'rith and Israelites of America'. The statue's message would have been easily recognizable to nineteenth-century viewers, even without an inscription, because Ezekiel made masterful use of a common trope of the moment, Lady Liberty. Thomas Crawford's bronze *Freedom* (1863), a female personification of Liberty, crowns the Capitol

63 Moses Jacob Ezekiel, *Religious Liberty*, 1876, height 7.62 m.

dome in Washington, and Constantino Brumidi's Capitol decorations include *The Apotheosis of Washington* (1865) – an illusionistic fresco showing Washington ascending to heaven, flanked by female allegories, including Liberty – in the cupola of the dome.[11] Ezekiel's *Religious Liberty* is as 'American' a sculpture in style and in theme as one could then find, even as its content provides an essential theme of Jewish American history.

Even though the B'nai B'rith reneged on a portion of its payment because of financial difficulties, Ezekiel continued work on the sculpture, because

> it was the first monument that any Jewish
> body of men had ever wanted to place
> in the world; the matter had been pub-
> lished to the world, I had received the
> commission without ever seeking it, and
> it would have been an eternal disgrace
> upon every Jewish community in America
> if the work had been abandoned.[12]

Once again, Ezekiel's sense of responsibility for his people, a centuries-old idea with biblical roots (for example, Leviticus 26:36–7), obliged him to complete the sculpture.

As the initial Jewish American artist to address seriously his feelings about art and his obligations as a Jew in the field, it is fitting that Ezekiel also frankly discussed his views on Jewish art and the category of 'Jewish artist':

I must acknowledge that the tendency of the Israelites to stamp everything they undertake with such an emphasis [Jewish art] is not sympathetic with my taste. *Artists belong to no country and to no sect – their individual religious opinions are matters of conscience and belong to their households and not to the public* . . . Everybody who knows me knows that I am a Jew – I never wanted it otherwise. But I would prefer as an artist to gain first a name and reputation upon an equal footing with all others in art

119

circles. It is a matter of absolute indifference to the world whether a *good artist* is a Jew or a Gentile and in my career I do not want to be stamped with the title of 'Jewish sculptor.'[13]

While attached to his Jewishness and cognizant of obligations as a Jew, to be categorized as a 'Jewish sculptor' was uncomfortable for Ezekiel – a perspective shared by some later Jewish artists.

Ezekiel's bas-relief *Israel* (1904, usually misdated 1873, illus. 64), with the work's title centrally engraved, represents Israel allegorically four times. At the centre of the panel Israel is shown as Jesus at the crucifixion, arms upraised and feet nailed to a tree stump. Nearly nude, the muscular Jesus appears as a circumcised Jew. To Jesus's right, a seated woman, wearing the crown of Jerusalem, represents Israel's patience. At the feet of Jesus/Israel crucified, Israel in despair bows his head in defeat. Crucially, on his left side a strong, unconquered man symbolizes Israel's hope, and to him Jesus/Israel turns as he suffers on the cross. This figure, Israel resurgent, and Jesus/Israel's attentive connection to him, demonstrates Ezekiel's hope for a future Jewish homeland. *Israel* also provides an important model for Jewish crucifixion

64 Moses Jacob Ezekiel, *Israel*, 1904, bronze cast relief, 111.8 cm x 167.6 cm.

imagery as well as an archetype for Semitic (Jewish) biblical figures, later typified by Larry Rivers (see below).

Jewish artists from this early period worked independently and without knowing each other. Their divergent styles follow the wider creative trends of American art. Not until the twentieth century did Jewish American artists begin interacting and studying art together. At that point Jews became leaders in the art world, innovators of major trends in painting, sculpture and photography, while still retaining personal and professional connections to Judaism.

In the period 1880 to 1920, among the large wave of immigrants to the United States were two and a half million Jews, mostly from poor communities in Eastern Europe.[14] Three theories of assimilation arose: Anglo-conformity, the melting pot and cultural pluralism. Proponents of Anglo-conformity argued that newcomers should emulate the original Anglo-Saxon settlers and immigrant differences should be replaced with traditional American values and customs. Cultural pluralists emphasized the importance of maintaining one's own heritage, because America would benefit from its diversities of cultures. By contrast, the melting pot model posited a consolidated American culture, where those qualities that immigrants brought from the Old Country could blend successfully within a single American culture enriched by elements

of all.[15] Of course, while many Americans advocated a melting pot for immigrants, they excluded themselves from the stew, because as White, Anglo-Saxon Protestants they felt no need to compromise themselves.[16] In reality, most believed that the successful outcome of the melting pot would produce complete conformity to pre-existing American ideals and traditions. For immigrants, however, the goal was not assimilation, replacing one's native culture with an adopted culture, but rather acculturation, reciprocal influence among all parties. Remarkably, the mutual contributions of Jewish artists within American art exemplify acculturation at its best.

Many Jewish artists were schooled at the Educational Alliance, a settlement house on the Lower East Side of New York, where Jewish newcomers learned American manners and customs.[17] Starting in 1895, the Alliance also offered art classes; although temporarily discontinued in 1905, classes resumed in 1917 under the direction (until 1955) of Russian immigrant Abbo Ostrowsky. The Alliance produced a number of artists who later achieved significant success, including sculptors Chaim Gross (1904–1991), Leonard Baskin (1922–2000) and Jo Davidson (1883–1952) and painters Peter Blume (1906–1992), Philip Evergood (1901–1973) and Barnett Newman (1905–1970). Along with the Alliance, several other Jewish venues in New York sponsored art exhibitions. Leading Jewish figures – Rabbi Stephen Wise, Rabbi

Judah Magnes and philanthropist Jacob Schiff – helped sponsor a 1917 art exhibition, in which 300 works by 89 artists were exhibited at the Forverts Building (the Yiddish daily newspaper, the *Forward*); over half of those artists were Jewish. From 1925 to 1927 the Jewish Art Center, directed by artists Jennings Tofel (1891–1959) and Benjamin Kopman (1887–1965), held exhibitions focusing on Yiddish culture. Art exhibitions of the Yiddisher Kultur Farband (YKUF), a Communist organization dedicated to fighting fascism, were also quite popular. Established in September 1937 by the World Alliance for Yiddish Culture, YKUF's first art exhibition in 1938 showed work by 102 artists with both Jewish and non-Jewish material.

In the early decades of the twentieth century some artists, including Abraham Walkowitz (1878–1965), William Meyerowitz (1887–1981) and Jacob Epstein (1880–1959), began their careers by making imagery of the Lower East Side and its familiar Jewish world.[18] Walkowitz, born in Siberia, moved to the Lower East Side in 1893, where his drawings and paintings of figures in traditional Jewish dress were among the first to picture Jews in their new surroundings. *Untitled (East Side Figures)* (illus. 65), an ink drawing, represents the overcrowded Lower East Side. Men with full beards and covered heads are pressed in close quarters along with a few women, one of whom looks out at the viewer from the front of the pack; no background is needed or could possibly be

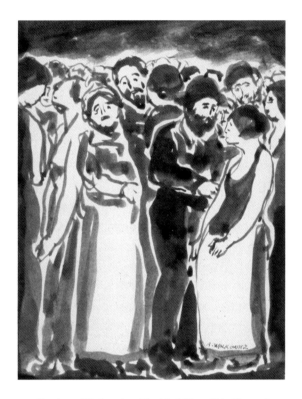

65 Abraham Walkowitz, *Untitled (East Side Figures)*, c. 1904–5, ink on paper.

included. A number of drawings by Walkowitz show immigrant groups or individuals; several were later collected in a book, *Faces from the Ghetto* (1946).

Scenes of Lower East Side life by Russian-born Meyerowitz, who eventually embraced progressive styles of Synchromism and Cubism, remain realistic in subject and conventional in approach. His etching, *The Knife Grinder* (1916), presents a middle-aged Jewish male, already comfortable enough in his new surroundings

to remove his head covering, performing a traditional Jewish trade brought from the old country.[19]

Also a resident of the Lower East Side, Jacob Epstein began his career by drawing his surroundings. In 1902, he made 52 drawings and a cover design for (the non-Jewish) Hutchins Hapgood's *The Spirit of the Ghetto*, a book describing the Jewish world and immigrant life. Illustrating Hapgood's prose, Epstein pictures his brethren in everyday scenes: a rabbi certifying kosher food, pushcart peddlers and Orthodox Jews praying and studying, as well as aspects of Yiddish culture, including the ubiquitous Jewish café (illus. 66). *Yiddish Playwrights Discussing the Drama* illustrates three men in modern attire involved in serious conversation (including a man's profile on the far right,

remarkably close to Hermann Struck's iconic likeness of Theodor Herzl; see illus. 38). Yet these Westernized figures still utilize an ancient language in its American transformation. *Yiddishkayt*, the richly vibrant, shared traditions of Eastern European Jews, offered a secular manifestation of Judaism in America, which included newspapers, poetry, theatre, settlement house activities and even a socialist political bent – all in the Yiddish language.

Hapgood described East Side imagery in *The Spirit of the Ghetto* as typically Jewish and characterized this work as 'ghetto art', naming Epstein as an exemplar of the mode.[20] Some contemporary non-Jewish artists also pictured immigrants in downtown New York. 'Ashcan' artists George Luks and George Bellows recorded life on the Lower East Side, although

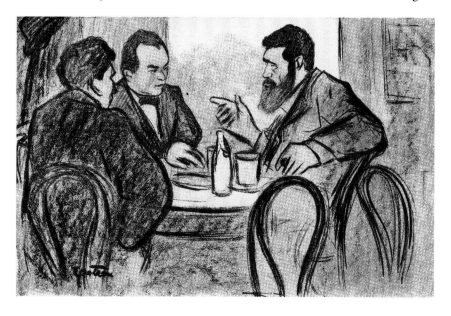

66 Jacob Epstein, *Yiddish Playwrights Discussing the Drama*, 1902, black chalk (from Hutchins Hapgood's *The Spirit of the Ghetto*).

not only the Jewish world. Bellows's canvas *Cliff Dwellers* (1913) renders masses of half-clothed, transplanted New Yorkers swarming the streets on a hot summer day. Luks's more lively, thickly painted canvas, *Hester Street* (1905), presents well-dressed figures bustling about a crowded open-air market, carrying baskets, haggling and conversing, giving the painter a subject tailor-made for his sponta-neous, rapid brush stroke. Years later Epstein recalled this special locale in his autobiography:

> The earnestness and simplicity of the old Polish-Jewish manner of living has much beauty in it, and an artist could make it the theme of very fine works. This life is fast disappearing on contact with American habits, and it is a pity that there is no Rembrandt of today to draw his inspi-ration from it before it is too late.[21]

Ultimately Epstein became an expatriate, settling in London and gaining fame as a groundbreaking and often controversial modernist sculptor; for example, a commis-sion to design Oscar Wilde's tomb in Père Lachaise cemetery in Paris in 1911 resulted in a rectilinear, stone, naked, winged male figure, inspired by Assyrian sculptures that Epstein saw at the British Museum.

Epstein depicted a number of prominent Jewish public figures, including a bust of *Albert Einstein* (1933) modelled in an impressionistic fashion with a heavily textured surface. This frequently recast sculpture is Epstein's roughest portrait, with every touch by the sculptor readily discernible, perhaps as much because of a brief sitting as because of the artist's intent.[22] He also produced many biblical scenes, perhaps due to a desire to be viewed an artist in the grand tradition, but his Jewish heritage likely influenced his attraction to the material as well. His entire body of work, however, is far from 'Jewish'; rather it can most aptly be characterized as avant-garde. Yet viru-lent criticism, often tinged with anti-Semitism, was frequently hurled at him. Further, Epstein even endured some condemnation from the Jewish community for his perceived breaking of the Second Commandment by working with a three-dimensional, lifelike medium. John Betjeman's essay on Epstein in a book on famous Jews, *Twelve Jews* (1934) observes:

> Ever since he first made his public appearance in 1907, Jacob Epstein has been accused of blasphemy, immorality, obscenity, sensationalism, perversion, delighting in ugliness, breaking the Ten Commandments, breaking the conven-tions, incompetence, decadence, adultery, treachery, lack of patriotism, and many others of the major crimes.[23]

Betjeman also noted that Epstein's work derived from Judaism:

Primarily Epstein is a Jew and proud of it. But unlike so many Jews who assimilate the customs and aesthetic standards of the country of their adoption, Epstein has chosen to get his inspiration from Jewry . . . His Jewish blood has stood him in good stead, for his sculpture has an Old Testament quality that is a change from the Graeco-Roman efforts of Royal Academicians. This Biblical quality is, moreover, indigenous to him and his race, a more genuine source of inspiration than could be Greek or Roman sculpture to an Englishman . . . Jewry has made him a poet.[24]

Betjeman's assessment demonstrates how some artists were seen, vaguely, as 'Jewish' and assigned certain 'Jewish' qualities in their work. While Epstein's birthright certainly affected some of his work, such assessments essentialize. Comments like Betjeman's need to be bolstered instead by close analysis of the art and the artist's biography; they serve only to remind us how much artists could be marked as Jewish, whether or not that was their purpose (akin to Pissarro in chapter Two).

Like his coreligionists, Raphael Soyer (1899–1987) pictured his immediate surroundings. His tiny painting, *Dancing Lesson* (illus. 67), has been viewed as a quintessential example of Jewish American art, reproduced in books, art and otherwise, to illustrate the theme of acculturation to the New World.[25] A private scene of Jewish family life, *Dancing Lesson* depicts the artist's sister Rebecca teaching his twin brother Moses how to dance. Soyer's youngest brother Israel plays the harmonica on the sofa, his father and grandmother survey the scene from the couch, and his mother Bella sits on an armchair, holding a copy of the Yiddish daily newspaper *Der Tog*, inscribed with prominent Hebrew lettering. The two main figures in *Dancing Lesson*, Moses and Rebecca, look childlike, unmodulated and flattened. Soyer colours the wall behind the couch a flat, monotone grey and reduces the blush on Moses's cheek to a red splash of paint. Above the couch hangs a portrait of the Soyer grandparents in traditional Jewish clothing. This framed photograph, out of scale with the figures, looms almost as large as Moses's torso. Any photograph that large would have imposed quite a burden on a voyage from Russia to America, which the Soyers took in 1912, when the family's 'Right to Live' permit in the Russian Pale of Settlement was revoked. By enlarging the photograph so substantially in *Dancing Lesson*, Soyer has made it into an icon. Such pronounced emphasis of the photograph reveals its exaggerated importance as a familial sign of the homeland – for Soyer, and for Jewish immigrants in general.

Including ancestral figures in family portraiture became a commonplace convention from the eighteenth century onwards; the

portrait typically served as an extended family lineage (for example, Edgar Degas' *The Bellelli Family*, 1858–60). In contrast, the centrally located portrait in the Soyer's living room, articulating generational continuity, acts to indicate a strong attachment to the family's Jewish past. Certainly, the portrait stands in for a lost generation, but it also provides a reminder of a simpler, more familiar life, of a time with more settled identity. While persecution was far more malignant in Russia than in the United States, the Jewish community there provided some comforts that New York could not, and the Soyers might easily have romanticized memories of the 'Old Country'. The portrait of Raphael's maternal grandparents was taken before the family inhabited two worlds, when Jews lived almost exclusively with other Jews in enclosed ghettos, and where daily rituals and clothes were dictated by Jewishness, not by conscious choice. After a move to democratic America these older conditions could be remembered as a simpler time.

Many Jewish immigrants sought out such familiarity and attempted to replicate the Old Country in America. In 1906, Edward Steiner described his own Jewish immigrant life, recreated in New York: 'To them, Rivington Street is only a suburb of Minsk.'[26] Even Abraham Cahan's fictional protagonist in the classic story of the Jewish immigrant experience, *The Rise of David Levinsky* (1917), pursued the recognizable. When Levinsky

arrived in America, he explored New York until he saw 'a lot of Jewish people where the streets swarmed with Yiddish-speaking immigrants. The signboards were in English and Yiddish, some of them Russian.'[27] Just so, the Hebrew letters on Bella Soyer's newspaper and the family portrait in *Dancing Lesson* served as Raphael Soyer's signs of the familiar. Whether the interior of a small, Bronx apartment or else the larger, Lower East Side locale of Jewish cafés and pushcarts, Jewish artists pictured their New World filled with Jewish signifiers.

Dancing Lesson also documents the 'generation gap between the immigrant parents and their children'.[28] The differing interests of the generations portrayed in *Dancing Lesson* do indicate a growing division – youngsters learning how to dance cheek-to-cheek versus the older generation, uncomfortable with that activity or just more interested in a Yiddish paper than in an American waltz. Jack Levine's first biblical painting, *Planning Solomon's Temple* (illus. 68), provides a statement about that generation gap as well.[29] The first of dozens of biblical images, *Planning Solomon's Temple* offers a scriptural model for Levine's own relationship with his father. As homage to the American-born Levine's recently deceased immigrant father, a man nicknamed by his friends as 'Rabbi Solomon the Wise', *Planning Solomon's Temple* depicts the great art patron King Solomon – who oversaw the building of the Temple and its decorations – talking with

the artisan Hiram about the plans for a temple in Jerusalem. Hebrew labels above the pair's oversized heads identify the expressionistic-ally rendered robed figures. A crowned and turbaned Solomon, 'a symbolic portrait' of Levine's father, holds the temple plan and stands close to Hiram, a figure modelled loosely after the artist himself.[30] Solomon wears the garb of kings: a gold medallion and a deep red turban with a bejewelled crown. A *tallit* (prayer shawl) covers the pious king's shoulders and back. The king presents plans for the temple to the viewer; in Hebrew they denote 'the holy house' that will soon shelter the Ark of the Covenant, the Tablets of the Law, and the Torah of Moses. Modestly dressed in white and painted in profile, Hiram carries his trowel, angle iron and compass, and he steps towards King Solomon.

By picturing his parent as the great King Solomon, a lover of art and supporter of Hiram, and by showing himself in the guise of the young artist, Levine painted a 'Jewish' testimonial to his feelings for his father. The biblical story of Solomon building the Temple served as the perfect prototype to illustrate Jewish patronage of the arts as well as the elder Levine's support of his son's artistic aspirations, even if they conflicted with his own values as an observant Jew. Levine's early biblical works, including *Planning Solomon's Temple*, served as a means, he said, of 'scoring points for my father'.[31]

The homage in *Planning Solomon's Temple* aptly addresses themes of life in the diaspora. To be sure, the American-born offspring of European *émigrés* – like the younger Levine – and immigrant children who did not have strong associations with the Old Country (for example, the Soyer children), assimilated much more easily than their parents. While Orthodox Jews, such as Levine's father, enjoyed the freedom of his adopted country by practicing Judaism openly, his son chose to neglect religiosity, forgoing his Bar Mitzvah. This generational conflict may have prompted Levine's biblical paintings; *Planning Solomon's Temple* was occasioned by his father's death. Like many Jewish American artists, Levine felt strong ties to both his parents and his heritage while also wanting to enter larger society, so he found a way to negotiate this tension in his art, specifically by producing an art of the Bible, thereby honouring his professional aspirations but in the context of Judaism.

Weegee (1899–1968), born in Austria as Usher H. Fellig, was driven from his native land by virulent anti-Semitism.[32] Arriving in America at age eleven, Weegee ultimately made a name for himself as a photographer of sensationalized, lurid, nocturnal tabloid images of death and disaster. Less known are his photographs of Jews on the Lower East Side.[33] For example, *Cafeteria on East Broadway* (illus. 69), which shows five observant Jewish

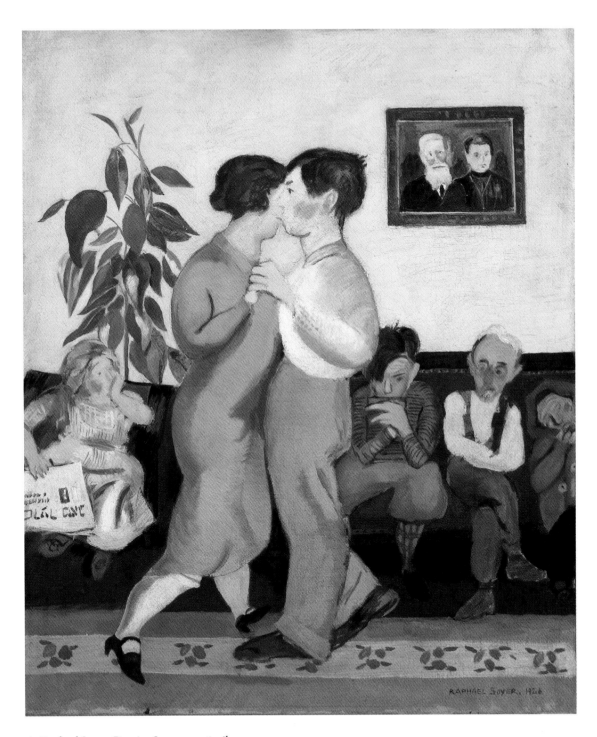

67 Raphael Soyer, *Dancing Lesson*, 1926, oil on canvas.

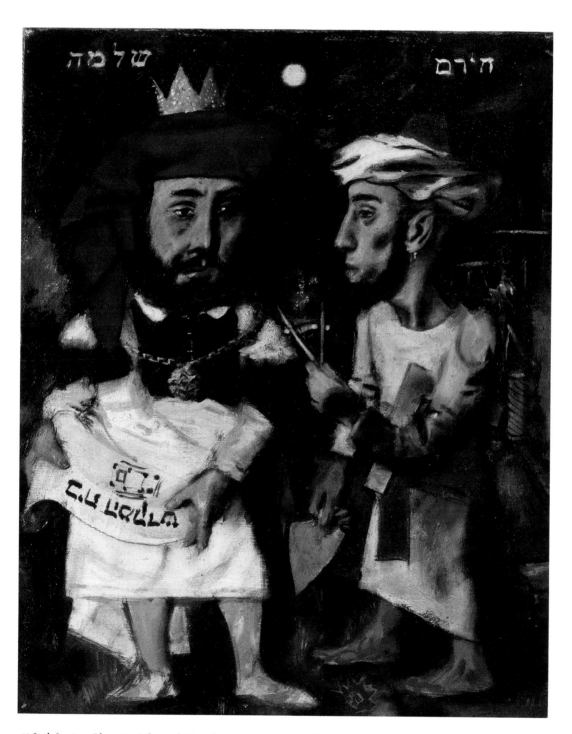

68 Jack Levine, *Planning Solomon's Temple*, 1940, oil on masonite.

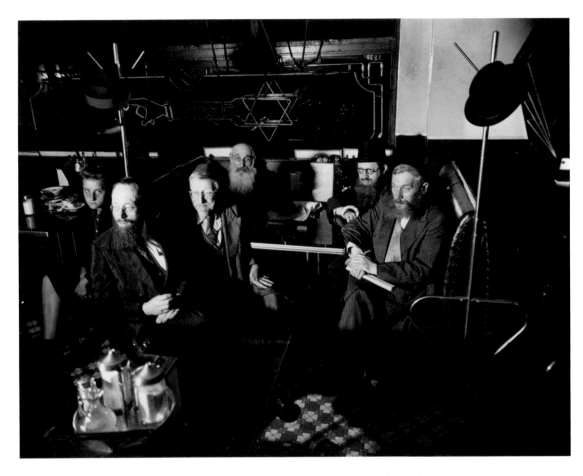

69 Weegee (Arthur Fellig), *Cafeteria on East Broadway*, 12 September 1941, gelatin silver print.

men in a diner with a neon Star of David in the window, provides a paragon of *Yiddish-kayt*, that distinctive Jewish environment created by immigrants on the Lower East Side. At the same time, *Cafeteria on East Broadway* comments on the changeover inherent in the inter-generational scenes of Soyer and Levine. As described, during this period, assimilation became a paramount goal for many Jews (and other immigrants), as religion's central role lessened, frequently creating conflicts between young and old.

Five Orthodox men with long beards and dark suits sit at a booth in the cafeteria. The figure on the far right holds a pad and writing implement, invoking associations of the Jew as scribe or scholar. Sly intrusions of an increasingly modern way of life appear alongside these men in traditional attire. At an adjacent booth in the left background, a young girl directly confronts the camera with her defiant gaze, at home with the camera's presence. On the contrary, four of the religious men focus awkwardly in other directions, as a fifth Jewish

man with a white beard looks through the photographer. The girl's bare leg peeks from underneath her short skirt, clothing prohibited by time-honoured Jewish custom. Her youth, gender and secular clothing differ sharply from the men, who sit close to the girl, yet in so many ways live far away.

Into the composition Weegee incorporates other modern, American elements, including two neon signs: a Star of David above the men's booth and a hand with a finger pointed in the girl's direction. The Star of David clearly demarcates the restaurant as reserved for Jews. Appearing in neon, however, a sign of modern technology, the Star of David hovers incongruously over the anachronistically dressed men. At first, the neon hand seems innocuous, but considering that Jews oppose the direct representation of God and often substitute a solitary hand as a visual indication of the divine presence, for some onlookers it may conjure associations of a higher power. Additionally, that prominent hand directs the eye to the future, suggesting that youth, women and a more worldly lifestyle lie ahead; that cafeterias on East Broadway, where observant Jews gather to converse in Yiddish, would soon fade from the Jewish American legacy. The girl, a sign of the New World, presages the time when religiocultural structures like Jewish cafeterias are to be a reminder of a bygone time, if they will even exist at all. Historian Beth Wenger observes:

In the 1920s and 1930s, as immigrant Jews began to move to more spacious and desirable neighborhoods, they created a new, often nostalgic, relationship with the Lower East Side. The neighborhood helped to frame their collective experiences as American Jews, helped them to make sense of change, and to create a narrative history and a physical context for locating Jewish communal origins.[34]

Concurrently, the hand points to the future by highlighting what may shortly be the past. While directed at the girl, the hand also connects to the hat hung on the rack, which the outstretched finger nearly touches, as if signalling its significance as an article of clothing for Orthodox Jews. Such traditional Jewish attire would eventually be worn by fewer Jews in America, as religious strictures lessened. Soon, Jewish American women will more commonly dress like the girl in Weegee's photo, and men also will adopt American fashions, which do not include covering one's head as a sign of deference to God. In *Cafeteria on East Broadway*, Weegee explores his background and childhood memories, and inserts his own observations – in this case on the evolution of Jewish identity and history in the New World. Weegee devises his photographic observations much more subtly in this photo than his usual shocking tabloid imagery. Although not nostalgic, *Cafeteria on East*

Broadway participates in a larger programme of Lower East Side memory.[35]

A striking parallel can be found in the urban acculturation experience in England and the art it generated.[36] Also primarily congregating in one area around the turn of the century, London's East End, specifically the working-class Whitechapel ghetto, immigrant Eastern European Jews transplanted many customs into their new country, including *Yiddishkayt*. Like Walkowitz, Epstein and Meyerowitz, first-generation Briton William Rothenstein (1872–1945) and Polish immigrant Alfred Wolmark (1872–1961) pictured their coreligionists in Whitechapel. They made genre studies on site and finished by working from mendicant models, costumed in *tallit* and *tefillin*. Rothenstein translated some of these studies onto canvas; the straightforward and richly coloured *Jews Mourning in a Synagogue* (illus. 70) shows eight bearded, grieving Jews wrapped in their *tallitot* (the eighth is barely visible on the far right), each gesturing appropriately, whether a hand pounding a chest, a head bowed in sorrow or a vacant stare.

British-born David Bomberg (1890–1957) and Mark Gertler (1891–1939), along with Jacob Kramer (1892–1962) from the Ukraine, all studied at the Slade School of Art. A scholarship from the Jewish Educational Aid Society allowed Gertler to pursue his artistic interests at the Slade School, where he met other Jews, including Bomberg, also funded by a grant from the Society. All three artists displayed an early attraction to Jewish subjects, with Bomberg – the son of Polish immigrants – pursuing such themes throughout his career. *Ghetto Theatre* (illus. 71) depicts a subject familiar to immigrants in the West, Yiddish theatre life, but Bomberg imbues his painting with a distinctly European stylistic influence as well as an autobiographical theme; the artist enjoyed attending shows at the Pavilion Theatre in Whitechapel, featuring Hamlet and other classics performed in Yiddish. A frequent subject in Bomberg's work, this oil on canvas version of the theatre presents several audience members watching a production on two different levels of the theatre. The steep angle allows the viewer access to a group in the balcony, huddled behind a thin rail atop with several theatre-goers sitting below. Geometrically painted and coloured in several shades of brown, the canvas is clearly influenced by Cubism and Futurism. Bomberg's image of Jewish ghetto life is not romanticized like Epstein's; his figures appear dejected and tired despite the enjoyable entertainment. As Richard Cork, observes, the theatre-goers in this painting appear trapped, literally and figuratively, by the prison-like guardrail of the balcony.[37]

Notably, Bomberg organized the Jewish section of a 1914 exhibition at the Whitechapel Art Gallery, 'Twentieth-Century Art (A Review of Modern Movements)', together with

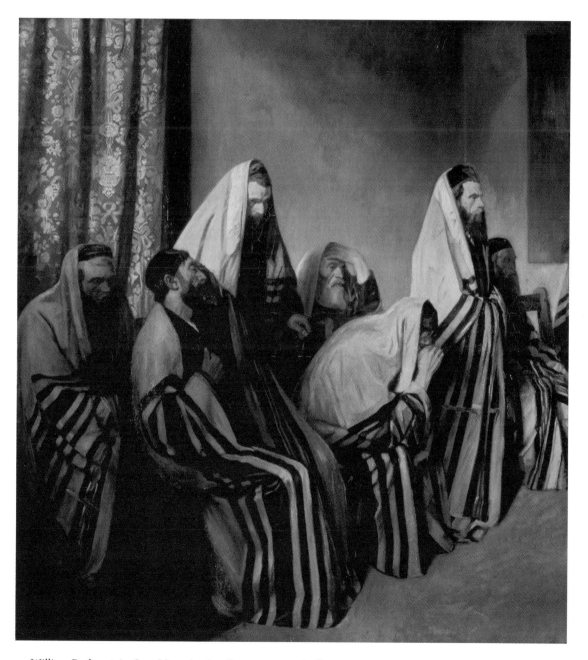

70 William Rothenstein, *Jews Mourning in a Synagogue*, 1906, oil on canvas.

American expatriate Jacob Epstein, whose interests had already turned to sculpture. That art by Jews was isolated in its own room is telling in itself, but more revealing are reviewers' peculiar reactions to the exhibition.[38] Even though only thirteen of 500 works were modern (basically Cubist or Futurist), reviewers focused on the show's modernity, their distaste for modernism and noted the unfortunate 'foreign' influence on English art. Most surprisingly, Jewish artists were singled out as particularly modern, when really only Bomberg fit that category. In the end, Jews and modernism were connected and judged negatively, a stance comparable to the contemporary German art scene (chapter Three), where Jewish artists were also associated with foreign/modern movements, and which presaged the outlook adopted a few decades later by Hitler and his cultural ideologues (chapters Three and Five). A similar underlying tone of anti-Semitism, or at least an intense nativism verging on xenophobia, pervaded discussions of modern art in America. In 1923, conservative critic Royal Cortissoz described modernism as 'Ellis Island art'.[39]

Throughout the early twentieth century in America, Jewish artists consistently figured in the forefront of vanguard artistic developments. Photographer Alfred Stieglitz (1864–1946), born in New Jersey to affluent German immigrants, championed modernism in the 1910s, as both practitioner and patron. *The Steerage* (illus. 72), widely considered Stieglitz's most important photograph, is frequently misunderstood as a scene of immigration to the United States. Instead, *The Steerage* depicts a ship sailing to Europe. Nevertheless, this voyage prompted one of Stieglitz's first 'straight' photographs – the mode he would champion for the remainder of his life – wherein he did not manipulate or crop the negative. According to Stieglitz, the scene appealed to him for its formal qualities rather than its subject:

> The whole scene fascinated me . . .
> A round straw hat, the funnel leaning
> left, the stairway leaning right, the white
> draw-bridge with its railing made of chains
> – white suspenders crossed on the back
> of a man below, round shapes of iron
> machinery, a mast cutting into the sky,
> making a triangular shape. I stood spell-
> bound for a while . . . I saw shapes related
> to each other.[40]

For Stieglitz, here the subject mattered less than the pictorial form. Therefore, it is inconsequential that the woman near the centre wears a shawl that appears (erroneously) to be a *tallit*. On the other hand, one can understand Stieglitz's initial attraction to the scene as related to his Jewishness.

Scholarship scarcely mentions Stieglitz's Jewish roots. Benita Eisler asserts that Stieglitz identified strongly with his German background

in an effort to distance himself from Judaism, which made him uncomfortable.[41] Yet in a definitive text on modern art, published in 1934, Thomas Craven did not describe Stieglitz as a great photographer but as 'a Hoboken Jew without knowledge of, or interest in, the historical American background . . . hardly equipped for the leadership of a genuine American expression'.[42] This kind of commentary supports Eisler's claim, for Stieglitz may very well have worried that anti-Semitism could derail his larger purpose, to be a tireless crusader for photography and modernism. Despite copious surviving writings by Stieglitz, he remained silent on the subject of Judaism. He did feel, however, that his ambitious, intense, sometimes alienating personality issued from his heritage. As Stieglitz himself observed, 'I'm beginning to feel it must be the Jew in me that is after all the key to my impossible make up.'[43]

Considered the father of modern photography and a revolutionary who helped to legitimize photography as a fine art, Stieglitz also introduced modern art to America through his various galleries and writings. Among Stieglitz's vast accomplishments was his founding of the Little Galleries of the Photo-Secession, more popularly known as '291' after its address at 291 Fifth Avenue. Between 1905 and 1917, 82 exhibitions took place at 291, including shows featuring Jewish artists Walkowitz, Max Weber (1881–1961) and

Elie Nadelman (1882–1946), as well as the European avant-garde. Crucially, 291 was the first US venue to exhibit the work of Henri Matisse (1908), Paul Cézanne (1911) and Pablo Picasso (1911), while also promoting contemporary photographers.

Most artists whom Stieglitz supported were not Jewish, although several coreligionists did enjoy his patronage, including painter and sculptor Weber. Born in Bialystok, Russia, to Orthodox, Yiddish-speaking parents, Weber surpassed his humble, foreign origins to become 'the dean of modern art in this country' and 'America's most distinguished painter', as the artist was remembered in his *New York Times* obituary.[44] Weber enjoyed a European artistic education, training in Paris at the Académie Julian and later with Henri Matisse, while viewing the newest art first-hand, including Cézanne's paintings at the 1906 Salon d'Automne. Throughout his career, Weber coupled his modernist interests with personal subjects, including much Jewish material.[45] Around 1918, he began to make images of traditional Jews, most often rabbis studying and praying.

While sometimes similar in subject to Isidor Kaufmann's Jewish genre paintings from Austria, Weber's images display his concern with various progressive styles rather than any attempt to reproduce reality on canvas. *Invocation* (1918), painted in an angular Cubist manner, shows three scholars studying

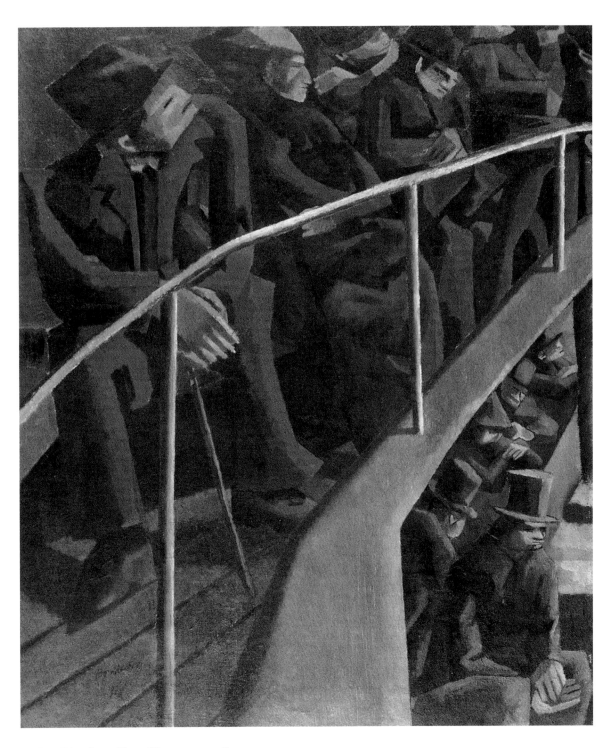

71 David Bomberg, *Ghetto Theatre*, 1920, oil on canvas.

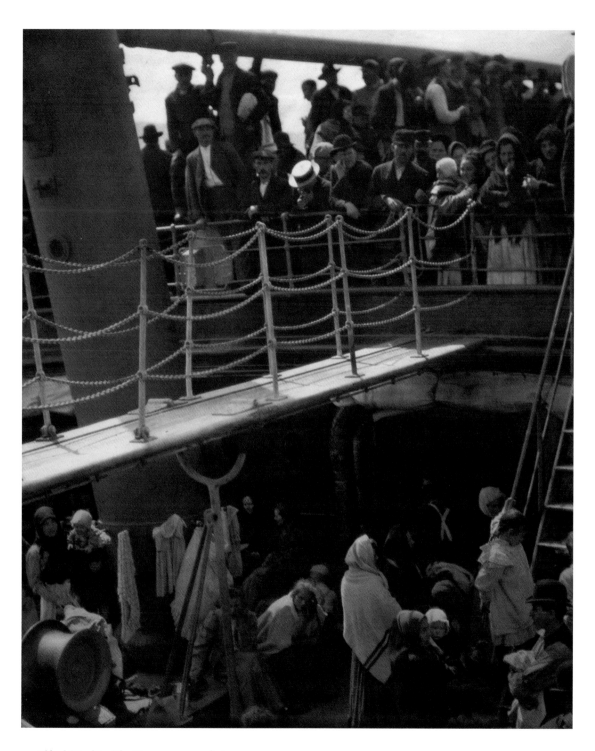

72 Alfred Stieglitz, *The Steerage*, 1907, photogravure.

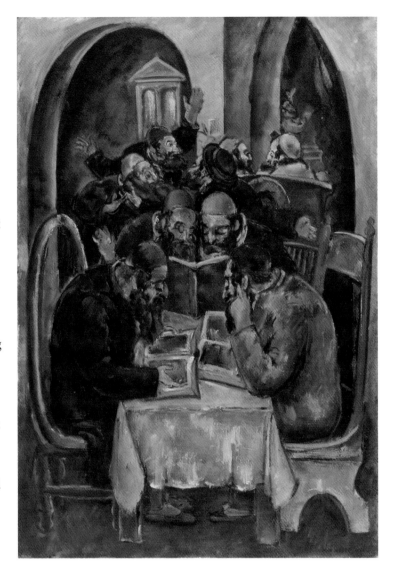

at a table. The large, fully frontal, central figure gestures broadly, beseeching God, eyes upward towards heaven; the figure to his left also looks aloft with an especially elongated face, and a third man at the right either sleeps peacefully or is so immersed in prayer that his eyes are closed. While the mood of this quiet painting coheres with its muted palette, the earthy colours of *The Talmudists* (illus. 73) combine with an emerging expressionist technique, comprised of exaggerated figures and gestures. *The Talmudists* portrays several heavily bearded scholars with noses pressed closely to their books, sitting around a table within a crowded, Gothic-style space, while others con-verse enthusiastically in the

73 Max Weber, *The Talmudists*, 1934, oil on canvas.

background. As Weber moved toward a new style, ironically he created Jewish paintings that recall a great Christian artist: sixteenth-century painter El Greco – also a formative model for other twentieth-century artists in Germany, such as Ernst Ludwig Kirchner, who admired his distorted, elongated figures. Both *Invocation* and *The Talmudists* demonstrate Weber's negotiation of his larger, modern

artistic goals with a continued attachment to his religion.

Following his Cubist experimentations, Weber's paintings became increasingly expres-sionistic, his characteristic style, whether his subjects are still-lifes, Jewish themes or even a brief foray into Social Realist material during the Great Depression. Rendered with restless, energetic lines, *Hasidic Dance* (illus. 74) shows

several men dancing joyously and gesturing emphatically as they convey the ecstatic emotions of their religious fervour; here Weber's style perfectly matches his subject. After 1950 Weber abandoned Jewish scenes, even though he remained kosher throughout his life and regarded himself Orthodox, albeit without consistent synagogue attendance. Instead, Weber avowed, 'my studio is my synagogue'.[46]

Several other Jewish artists from this period experimented with modernism. Known for his non-objective imagery, Ilya Bolotowsky (1907–1981), was influenced by the de Stijl movement in Holland; he was among the first artists in America to paint full abstractions. Louis Lozowick (1892–1973; born Leib) produced Cubist-inspired industrial subjects and views of skyscrapers. Indeed, Lozowick privileged the city in his art, rendering the urban landscape of skyscrapers, factories and mills with a linear, economy of means. From 1919 to 1928 Lozowick made a series of canvases of ten American cities rendered in a precisionist idiom. Lozowick paints city architecture as a grand, geometric, ordered and rational environment devoid of inhabitants in works such as *Minneapolis* (1926–7). In his autobiography, Lozowick recalled his impression of

74 Max Weber, *Hasidic Dance*, 1940, oil on canvas.

New York upon his arrival: 'To a product of the *shtetl*, Manhattan was a phenomenon as fantastic and improbable as Istanbul might have been.'[47] Abraham Rattner (1893–1973) began his career with brightly coloured figural paintings, infused by Cubism and Futurism, after which he adopted a luminously coloured approach to biblical material (see chapter Five). In 1935, nine Jewish artists committed to modernist developments formed a group dubbed 'The Ten'. Among them, Ben-Zion (1897–1987), Ilya Bolotowsky, Adolph Gottlieb (1903–1974), Joseph Solman (1909–2008) and Marcus Rothkowitz (1903–1970; later known as Mark Rothko) exhibited together for four years. Though typically understood as incidental,

critic Henry McBride of the *New York Sun* noticed the artists' immigrant and 'racial' origins in 1938:

> Practically all of the men paint in somber tones and this may be merely a coincidence or it may be racial, for the names of the artists suggest recent acclimatization and it is not always at once that newcomers pass into the glories and joys of living in America.[48]

Like Weber, Ben-Zion's art demonstrates his commitment to Judaism combined with avant-garde modes of artistic communication. Painted with a reduced palette, Ben-Zion's

75 Ben-Zion, *Joseph's Dreams, c.* 1939, oil on canvas.

boldly rendered *Joseph's Dreams* (illus. 75) presents a flatly conceived Joseph with enormous hands and feet, face upturned towards the sky with eyes closed. Quietly communicating with God in his dreams, Joseph is surrounded by a vast sky, filled with a black, outlined, oversized sun, and the moon and stars, some of which appear to touch the ground. The painting indicates the yeshiva-educated, Ukrainian-born Ben-Zion's familiarity with the biblical text, in which Joseph explains that in his dream the sun, moon and stars bowed down to him (Genesis 37:9).

Many artists – especially those with left-wing political leanings – explored political, social and economic issues, particularly during the Great Depression. It has been argued that Jewish traditions of social justice, later characterized as the principle *tikkun olam*, impel Jewish American artists to create imagery in support of the underdog.[49] Indeed, while the term *tikkun olam* did not enter American parlance until the 1970s, the importance of social justice originates in the Bible and has remained a significant Jewish value. *Tikkun* is the Hebrew word for healing, repair and transformation, and *olam* is Hebrew for society or the world. The word *tikkun* appears in Ecclesiastes (1:5, 7:13, 12:9) and translates as 'setting straight' or 'setting in order'. *Tikkun olam* means, in the most universal sense, that Jews are not only responsible for the ethical and material welfare of other Jews, but also for

the ethical and material welfare of society as a whole. Jeremiah (29: 7) iterates this statement: 'And seek the welfare of the city to which I have exiled you and pray to the LORD in its behalf; for in its prosperity you shall prosper.' Jewish ethical philosophy, of which *tikkun olam* is a part, is a way for a Jew to convey Jewishness in a non-parochial way. Maurice Hindus, in a 1927 article titled 'The Jew as a Radical', published in the Jewish periodical *Menorah Journal*, describes the Jew as the heir to radicalism, because

> the old Jewish religion has much in common with modern radicalism. Both exalt the underdog. Both scorn the wrong-doer . . . The ancient writings of the Jews bristle with such pronouncements. The prophets continually hurl threats and curses on the despoilers of the widows and the orphan, the exploiter of the poor and the weak, as does the modern radical.[50]

Working as Social Realists in the 1930s, Raphael Soyer, along with his brothers Moses Soyer (1899–1974) and Isaac Soyer (1902–1981), observed with compassion the mundane details of life during the Great Depression – for example, waiting in an unemployment line. Artists such as Peter Blume (1906–1992) more strongly asserted their political commitments.[51] Visits to Italy in the 1930s, funded by a Guggenheim grant, inspired Blume's best-known

76 Peter Blume, *The Eternal City*, 1934–7 (dated on painting 1937), oil on composition board.

painting: a large anti-fascist canvas, *The Eternal City* (illus. 76). First conceived in sketches and then as a cartoon, Blume portrayed a ruby-lipped Mussolini as an enormous green jack-in-the-box, a conception instigated by a *papier maché* rendering of the leader that protruded from a wall at the Decennial Exposition in Rome, celebrating ten years of fascism. Amid the ruins of the Roman Colosseum, this effigy of Il Duce is accompanied by other symbolic imagery, signifying Italy's decline, including an ailing beggar sitting among fragments of marble. This crisply rendered canvas garnered mixed reviews because of its controversial, propagandistic subject and cacophonous colours. The Corcoran Gallery even excluded the inflammatory painting from its 1939 biennial exhibition, although five years later the Museum of Modern Art purchased the painting for its permanent collection.

Also eager to contest fascism with similar sting, William Gropper (1899–1977) expressed his political sympathies as a cartoonist for left-wing publications, *New Masses* and the Yiddish Communist daily *Morning Freiheit*, thereby reaching a much larger audience.[52] During the war years he made cartoons, war bond posters and pamphlets, often with overt anti-Nazi themes, as well as a few paintings communicating his horror at the news of Nazi barbarism. As early as 1934 Gropper pictured his disgust at Hitler. In a *New Masses* cartoon 'the worker', symbolized by an enormous clenched fist arising from murky water filled with skulls and bones, upsets a rickety raft (illus. 77). On the raft, which flies a tattered flag emblazoned with a swastika, a frantic, gun-toting, distorted

Hitler is accompanied by a well-fed figure, symbolizing capitalism. This didactic image clearly provides the optimistic message that the worker will conquer his oppressors. Later, Gropper's war images focused more particularly on the Jewish experience, including a published portfolio of eight prints, *Your Brother's Blood Cries Out* (1943), which show the battle of subjugated Jews against Nazis.

Lithuanian-born Ben Shahn (1898–1969) tackled issues closer to home in several media, including photography, paintings, murals and prints, many with Jewish themes. Working for the Farm Security Administration (FSA), a government initiative created by President Roosevelt, Shahn made photographs intended to educate and inform the country about

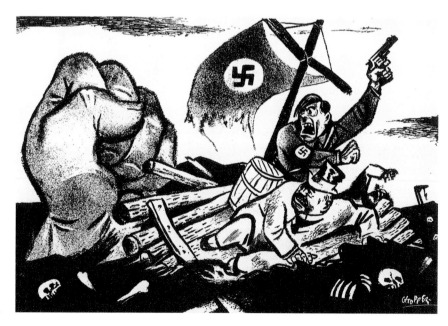

77 William Gropper, untitled illustration, *New Masses* (July 1934).

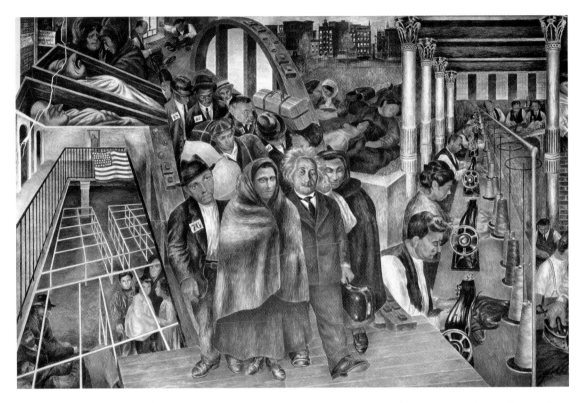

78 Ben Shahn, *Jersey Homesteads Mural* (detail), 1937–8, fresco, Jersey Homesteads Community Center, Roosevelt, New Jersey.

poverty and desperation in Dust Bowl America, the Midwest and the segregated South. Initially, Shahn turned to photography under the influence of Walker Evans, with whom he was sharing a studio, using the medium in conjunction with sketches to capture realistic details and overall milieu as source material for canvases.[53] During three years working for the FSA (from 1935 to 1938), Shahn took over 6,000 photographs, a number of which served as models for later canvases.[54]

Striking Miners, Scotts Run, West Virginia (1935) is one of three FSA photographs that Shahn utilized to create a painting of the same name in 1937. This quiet, black-and-white photograph presents six men milling about in poverty-stricken Scott's Run, where coal once fuelled prosperity before a weakened Depression economy made the town into a poster child for America's misery. Each man stares listlessly in different directions. The town's descent into disrepair and destitution

is indicated by a few simple details, including the abandoned railway car behind the group and barren ground beneath their feet.

Shahn also worked as a muralist under the auspices of the government. His first mural (illus. 78) was made for a recently established New Jersey housing project primarily for Jewish garment workers. Fittingly, it depicts issues relating to the Jewish American experience, including Eastern European immigration, labour conditions and the ultimate reform of labour with the establishment of unions.[55] On the left, a group of immigrants walk diagonally off a ship's gangplank, led by Albert Einstein. As they journey to their new home-land, they pass by disturbing referents: first, the coffins of Nicola Sacco and Bartolomeo Vanzetti, two Italian immigrants who suc-cumbed to discrimination in America and were unfairly put to their deaths for a crime they did not commit. But a different and more personal deterrent for Jews receives promi-nence in this same corner: an anti-Semitic slogan appears on a German sign held by a Nazi, 'Germans, beware; don't buy from Jews'. By including this ominous notice, as well as a plaque reading in German, 'Attention Jews, Visit Forbidden' along with a doctor's name, Shahn provides a major reason for his tale of immigration: recent German persecution and repression. The story unfolds to the right, with immigrants working in sweatshops. The centre scene reveals additional labour problems,

notably picturing the Triangle Shirtwaist Company, home to the infamous 1911 fire that killed 146 young women, mostly Jewish and Italian immigrants. In the right and final section of the mural, the viewer encounters the success of labour reform: orderly planning and additional profits of unionization, including education. This commentary on an important aspect of the Jewish lifestyle, secular and politi-cally committed, took on a personal dimension for the artist; impressed with the community spirit in Roosevelt (then called Jersey Home-steads), in 1939 Shahn moved there, remaining until his death.

Shahn, Gropper, Blume and the Soyer brothers never spoke about how their interest in the oppressed might have accorded with their religion; however, other Jewish artists explicitly connected their art to their heritage of social activism. Harry Sternberg (1904–2002), whose incisive prints explore social ills, relation-ships and human folly, aimed to make art 'an expression of my time, to be of the people and for the people. The people – their struggles, their aspirations – are both the theme of my art and the audience I want to reach.'[56] In his nineties, Sternberg reflected retrospectively on why he believed his art concentrated on social justice issues: 'I think that's part of the Jewish tradition that affected me strongly. Even though I am still not a synagogue-goer.'[57] Characteristic of Sternberg's work, the ironi-cally titled lithograph *Southern Holiday* (illus.

79) appeared in two anti-lynching exhibitions the same year it was made.[58] This scathing commentary on racial intolerance shows a muscular, naked, castrated African-American man tied to a broken column. Behind this disturbing scene stand factories, contrasting modern industrial advances with barbarous acts of lynching and castration.

Similarly, the Jewish American photographer Robert Frank (b. 1924) openly referred to his religiocultural inheritance as a factor shaping his photographs of the disadvantaged. Raised in Zurich, Frank was fifteen when the Second World War began. While safe in neutral Switzerland, Frank later observed that 'being Jewish and living with the threat of Hitler must have been a very big part of my understanding of people that were put down or who were held back'.[59] This observation may help us to understand better the dark photographs that comprise his classic book, *The Americans* (1959). A photograph, such as *Trolley, New Orleans* (1955–6), the cover image of *The Americans*, calls attention to racial inequalities of the period by showing two African Americans, segregated both by the window frames and by their placement at the back of the vehicle.

Among the photographs in *The Americans* is *Yom Kippur – East River, New York City* (1956). Cropped at an odd angle, this image depicts a group of observant, adult Jews from behind, accompanied by a young boy in his *kippah*, shown in profile. At the left side of the quiet

image the viewer sees the top of one man's hat, partially blurred, with additional figures captured crisply and in a bit more detail. During Rosh Hashanah, the Jewish New Year, some Jews perform a propitiatory ritual called *Tashlich*, which entails the recitation of penitential prayers and tossing crumbs into a body of flowing water as a symbolic gesture indicating the casting away of sins. Possibly Frank took the picture on Rosh Hashanah, preceding Yom Kippur, and mislabelled the image.[60] The crucial point is that Frank and Sternberg, like several other Jewish artists described here, were influenced by social ideas first espoused by the biblical prophets and over generations remained an intrinsic value of Judaism, and used art as a vehicle for social change. Although secular in theme, these works were shaped by the Jewish American experience.

Recent scholarship has argued that many early American feminist artists were Jewish, because as perennial outsiders and as the children or grandchildren of radical immigrants, fighting for justice and equality was their heritage.[61] Two Jewish artists initiated the Feminist Art movement. At the height of the Women's Liberation Movement, Judy Chicago (b. 1939) and Miriam Schapiro (b. 1923) jointly founded the Feminist Art Program at the California Institute of the Arts in 1971. Chicago is particularly known for her enormous, groundbreaking multimedia installation, *The Dinner Party: A Symbol of our*

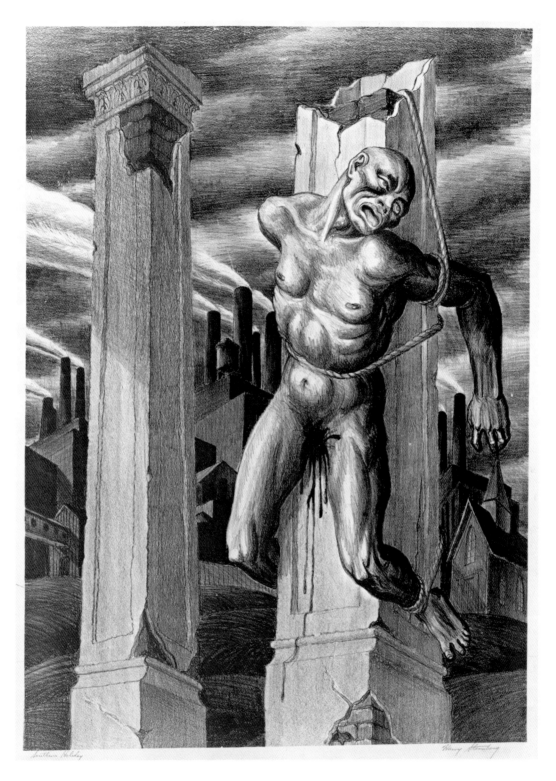

79 Harry Sternberg, *Southern Holiday*, 1935, lithograph.

Heritage (1974–9). Later she produced *Holocaust Project: From Darkness into Light* (1985–93), an installation that focuses on the Holocaust from all perspectives, not just Jewish, and strives to delineate the distinctive female experience (illus. 109).

Schapiro also combines Jewish interests with feminist interests, while demonstrating her affinity for the more worldly, ethno-cultural component of Judaism. Schapiro asserts that she is

> not religious. It is the cultural aspect of Judaism that interests me. In other words – where I came from and how these people lived before me and now. When I am interested to discuss my identity – being Jewish comes to mind and I make a work that reminds me of what it is to be Jewish.[62]

Her art bears out this statement, for Schapiro has transcended her more familiar imagery about women, which responds to the absence of their work in art's history; in her later years she interrogated her Jewish identity. A work on paper in the shape of a house, *My History* (illus. 80) is divided into twenty compartments, within which Jewish symbols appear. Topped by a menorah, Schapiro's compartments include: a Star of David; elements that suggest domestic work by Jewish women, such as a handcrafted *challah* cover; references to Jewish history, such as a photograph of Frida Kahlo (a Mexican artist of purported Jewish descent) and a photograph of the 'Tower of Life' at the United States Holocaust Memorial Museum (Washington, DC).

Photojournalist Richard Avedon (1923–2004) also took pride in his Jewish cultural background. As a child he reserved space in his autograph album for a section, 'Great Jews and Judges', and in a 1995 documentary he asserted: 'I'm such a Jew. But at the same time completely . . . is it agnostic, someone who doesn't believe in anything?'[63] Avedon's interest in Judaism is evident both in his 1972 photograph of comedian Groucho Marx and in subsequent observations about the image. Unflinchingly frank, characteristic of Avedon's work, Marx is shown without his grease-paint mustache, glasses and signature smirk. Tightly framed, he appears as a tired old man with age spots on his balding head. Sharp light in an unidealized, sparse setting serves Avedon, whose purpose is not to present an iconic image of the familiar comedian, but rather to reveal the person behind the performer. Discussing this portrait in a retrospective catalogue of 2002, Maria Morris Hambourg and Mia Fineman describe Avedon as making this photo 'with love in his eye, portraying him [Marx] not as a popular prankster but as a wise elder statesman of Jewish culture'.[64] Evidence indicates that the photographer did view Marx as more than simply a fascinating sitter. In his visual memoir of 1993, Avedon

describes his portrait of Marx 'as a kind of presiding Jewish intellectual, [who] is placed among pictures of my family'.[65] Indeed, Marx's picture appears among images of Avedon's immediate family, indicating that the artist saw himself as part of a continuum of Jews – of a lineage descending from the patriarchs and matriarchs: Abraham, Isaac and Jacob; and Sarah, Rebecca, Rachel and Leah. Viewed in this light, Marx truly *is* a member of Avedon's family.

Even though Jews made up only around three per cent of the US population at mid-century, it is remarkable how many leading Abstract Expressionists were Jewish.[66] Adolph Gottlieb, Phillip Guston (1913–1980), Lee Krasner (1908–1984), Barnett Newman and Mark Rothko all eschewed representation in the late 1940s and early 1950s. The style(s) in which these Jewish artists worked defy generalization, but typically they painted on huge canvases and favoured spontaneity. Although abstract, Newman's paintings have been understood as shaped by his Jewish sensibilities, in part because his titles some-times refer to fundamental figures or ideas in Judaism, such as *Covenant* (1949) or *Eve* (1950). Newman's knowledge of Kabbalah has been associated with his vertical 'zip paintings', and read as symbolic of God and Creation.

The first painting that employed a 'zip' division is *Onement I* (illus. 81), a small canvas upon which a thin, orange, vertical runner separates a reddish-brown surface, causing the otherwise continuous colour field to appear variegated. In contrast, Newman's mature works display larger colour fields that are more solid and flat. Basing his analysis on Kabbalistic interpretations of scripture and other Jewish concepts that Newman knew, Thomas Hess interpreted *Onement I* as

a complex symbol, in the purest sense, of Genesis itself. It is an act of division, a gesture of separation, as God separated light from darkness, with a line drawn in the void. The artist, Newman pointed out, must start, like God, with chaos, the void: with blank color, no forms, textures or details. Newman's first move is an act of division, straight down, creating an image. The image not only re-enacts God's primal gesture, it also presents the gesture itself, the zip, as an independent shape – man – the only animal who walks upright, Adam, virile, erect.[67]

Hess describes the colour field as the earth, because of Newman's hue, and he explains that Adam, the first man created by God, derives from *adamah*, the Hebrew word for earth. In other words, Hess claims that Newman acts as God, the ultimate creator, in his choice of colour and form.

A number of second-generation Abstract Expressionists also were Jewish. Helen Franken-thaler (*b.* 1928) and Morris Louis (1912–1962),

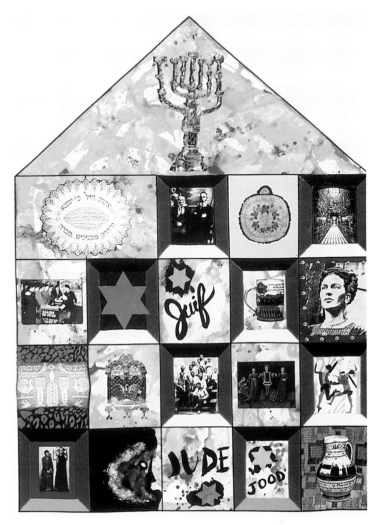

80 Miriam Schapiro, *My History*, 1997, acrylic, fabric and xerox on paper.

born Morris Louis Bernstein to immigrant parents, stained unprimed canvases with thinned colour to create paintings soaked with floating forms. Earlier, however, as Louis first began to experiment with abstraction, he made compositions redolent of Jackson Pollock's drip paintings. A series of seven small black canvases, covered with whirlpools of dripped white paint, the *Charred Journal* paintings (1950–51), and a related image,

Untitled (Jewish Star) (illus. 82), appropriate Pollock's 'allover' technique and Surrealist-automatism. Some calligraphic signs in these early paintings suggest Hebrew letters, characters also explored in drawings from the same period. According to Louis – and indicated by the series title – these paintings refer to Nazi book burnings. Employing abstraction to convey the horrors of the Holocaust was common among artists of the early postwar

81 Barnett Newman,
Onement I, 1948,
oil on canvas.

82 Morris Louis, *Untitled (Jewish Star)*, c. 1951, acrylic on canvas.

period, including Abstract Expressionist sculptor Seymour Lipton (see chapter Five) and painter Mark Rothko. Louis's *Untitled (Jewish Star)* superimposes the Star of David on a heart, a juxtaposition Mira Goldfarb Berkowitz interprets as a transformation of 'the symbol of Jewish sacrifice into one of survival'.[68]

A Holocaust survivor, sculptor Eva Hesse (1936–1970) never made work explicitly about the war, although her experience in Nazi Germany may have influenced her use of unconventional, evocative and ephemeral materials that evoke impermanence and mortality. Born in Hamburg, Hesse and her older sister escaped from Germany in late 1938 on a *kindertransport* (children's train). After the siblings reunited with their parents in Amsterdam, the family moved to New York in 1939 to begin a new life. Tragedy persisted for Hesse; in the mid-1940s her parents divorced, and her mother committed suicide. Hesse only made art professionally for ten years (of which fewer than six were devoted to three-dimensional work) because she died from a brain tumour at age 34. Understandably, Hesse's art is often read in relation to her life – an approach the artist would approve, considering that she was a consummate diarist from her teenage years until her death and spoke about her work in personal terms. Although scholars can too easily get mired in the mythology of her calamities to the detriment of her artistic output, they often describe Hesse as a pioneering feminist sculptor, based on the artist's frequent reflections about her twofold position as both woman and artist. Even her use of fragile, pliant materials has been read as a feminist commitment. Also related may be her Jewish identity, which Hesse discussed at an early age. In 1954, a *Seventeen* magazine

article featured Hesse and included reproductions of five works on paper along with a short personal profile. The author paraphrased Hesse's remarks, explaining that the young artist's interest in transcending superficiality stemmed from her status as a Holocaust survivor: 'She thinks that growing up with people who went through the ordeal of those years makes her look very closely – very seriously – beneath the surface of things.'[69]

In her best-known sculptures, Hesse fused the currently dominant style of Minimalism – typified by detachment – with a personal approach. *Accession II* (illus. 83) recalls Minimalist art in its spare, repeated forms and seemingly unmodified substance, but Hesse was heavily involved with the making of the piece. Weaving rubber tubing through over 30,000 holes that comprise a commercially fabricated, galvanized steel box, Hesse created a work of art rife with her signature contradictions. As Hesse's biographer Lucy Lippard described, 'the bristles are soft, but the associations are thorny, and with its hard exterior, there is an unavoidably defensive quality'.[70]

One of Hesse's favourite materials was latex rubber because of its inherent malleability, thus revealing the artist's presence. Eight vertically oriented lengths of cheesecloth, covered with fibreglass and latex, comprise *Contingent* (1969), which hangs from the ceiling in parallel rows that nearly reach the floor. Installations, or environments, were common for the period, but Hesse's emotive use of scale and repetition revolutionized the art

83 Eva Hesse, *Accession II*, 1967, galvanized steel and rubber tubing, 78.1 × 78.1 × 78.1 cm.

world. Moreover, her translucent, soft materials evoking vulnerability and femininity conveyed qualities antithetical to the more typically assertive strength inherent in standard Minimalist matter.

Some artists who had worked within the mainstream for most of their careers took greater interest in Jewish themes as they aged. While Larry Rivers (1924–2002) had probed Jewish subjects intermittently since the 1950s, in his later years the artist embarked on two significant projects related to his heritage. In 1984, when Rivers illustrated a short story by Isaac Bashevis Singer for the Limited Editions Club, he was also making an enormous three-part painting, cheekily titled *History of Matzah (The Story of the Jews)* (1982–4).[71] Tackling nearly four millennia of Jewish history, *History of Matzah* resembles a collage, with images and stories overlapping on three 2.7 × 4.3 m (9 × 14 ft) canvases, all superimposed on a painted rendering of flat, dry matzah, the unleavened bread of Passover, which resulted from the Jews' haste when fleeing Egypt (Exodus 12:34, 12:39). As a sign of both diaspora and remembering – the core of Rivers's project – yellow, brittle matzah provides an apt background for a series commemorating Jewish history and occasionally offers trenchant commentary on Jewish art. Exploiting parody, a common practice in his entire oeuvre, in *History of Matzah*, Rivers returns the Jew's body to its proper place – the biblical Jewish

figure on whom the artwork is based – rather than repeating the Christianized features of Old Testament biblical types, standard in art history.

Specifically, within the first canvas, *Before the Diaspora* (illus. 84), Michelangelo's Aryanized *David* reappears with a stereotypically Semitic nose and an oversized, circumcised penis. In the top left corner, Rivers recasts the role of Rembrandt's Moses with his cousin Aaron Hochberg, then the oldest living Jewish male in Rivers's family. In the bottom right corner, Jesus in Leonardo's *The Last Supper* also resurfaces with Hochberg's 'Jewish' features. The New Testament gospels imply that Jesus's last meal with his disciples before his crucifixion was a Passover dinner (for example, Luke 22:15), and Rivers stresses this idea in his reworking of Leonardo's fresco. Hochberg occupies Jesus's central place, echoing his pyramidal pose at the table, with matzah placed noticeably on the plate in front of him. By demonstrating the Jewish origins of Jesus's meal, Rivers attempts to reconstruct art history's past, while also making manifest an important Jewish ritual through a cultural icon. Moreover, Rivers also instantiates a theological continuity between Judaism and Christianity. By picturing Jesus (and by extension David and Moses) as expressly Semitic, Rivers repeats a trope already described several times in this book: the Jewish Jesus. Adapting biblical imagery, *History of Matzah* reveals the limitations of much Western art history –

84 Larry Rivers, *History of Matzah (The Story of the Jews), Part 1 – Before the Diaspora*, 1982, acrylic on canvas.

which has excluded the Jew's body from the traditional visual canon.

To tell its story, *History of Matzah* also appropriates a typically 'Christian' art format, the triptych. Within the painting, however, Rivers has imbued both the triptych and a donor portrait with an emphatically Jewish stamp, much like his reconstituted biblical figures. Indeed, in panel two, *European Jewry*

(illus. 85), the group at the centre of the canvas, highlighted by a male Jew holding a Torah, includes portraits of the painting's patrons: Sivia and Jeffrey Loria. The Lorias are shown in a modified version of Maurycy Gottlieb's *Jews Praying in the Synagogue at Yom Kippur* (see illus. 27); their inclusion recalls the tradition of donor portraits in Renaissance altarpieces. Cleverly, Rivers's inclusion of art by a

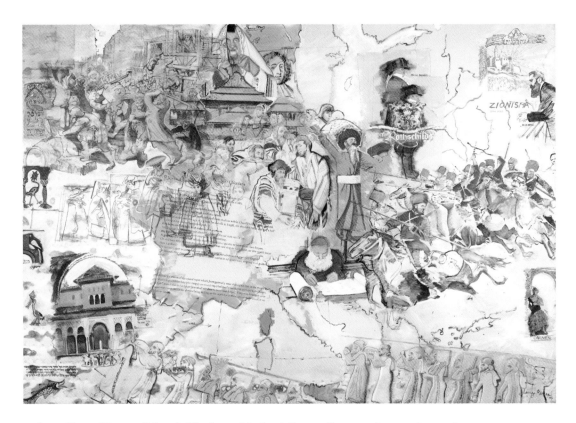

85 Larry Rivers, *History of Matzah (The Story of the Jews), Part 2 – European Jewry*, 1982, acrylic on canvas.

Jew alongside renowned imagery by Christians makes a respectful nod to a neglected Jewish artist, Gottlieb, and to the largely ignored Jewish art tradition. In the process, Rivers clearly claims a place for Gottlieb's painting among canonical artworks.

The third portion of Rivers's triptych, *Immigration to America* (illus. 86), focuses on Jewish immigration to, and settlement in, the United States, up to the First World War. Depicting the many countries and cities from which Jews escaped, a map anchors the work. Immigrants are subjected to compulsory medical exams at a port of entry in the upper left corner. Dressed traditionally, this mass of humanity proceeds downwards on an angle toward the Statue of Liberty, which dominates the lower left corner. Near the centre of the canvas other scenes present typical moments in American Jewish history, including a woman sitting at a sewing machine, an example of the sweatshop experience. A number of additional

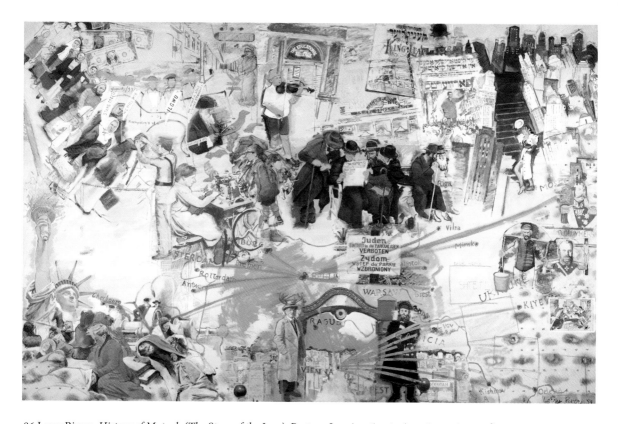

86 Larry Rivers, *History of Matzah (The Story of the Jews), Part 3 – Immigration to America*, 1982, acrylic on canvas.

images demonstrate the proliferation of Jewish culture in the early twentieth-century Jewish American community, including the doorway of the Educational Alliance, which occupies the centre top portion of the canvas. Underneath the Educational Alliance, men in Eastern European clothing read *Der Tog*, a Yiddish daily from the beginning of the century (the same periodical that provided news to Bella Soyer in her son's painting, *Dancing Lesson*). A poster above this group advertises a Yiddish version

of Shakespeare's *King Lear*. For this topic of great personal importance, Rivers carefully planned his placement of imagery and relied less on his characteristic smudges, erasures and diaphanous improvisation. Moreover, by refusing to reinforce a Christian-dominated Western history of art, Rivers inverts and supplements the typical, one-religion view of art history. At the same time, through his parodies of art history's biblical paragons, Rivers subverts the Christian standard and

visually recuperates Jewish history by liberating the Jewish body.

Overtly Jewish social, political and even religious commentary by artists of the generation after Rivers has become a mainstay in the final decades of the twentieth century and up to the present. New York's Jewish Museum initially investigated this phenomenon in two exhibitions, the first in 1982 and the second four years later in 1986. The eighteen living artists in the premier show, 'Jewish Themes/ Contemporary American Artists', and 24 in the subsequent exhibition, 'Jewish Themes/ Contemporary American Artists II', explored, confronted and celebrated diverse aspects of Jewishness in media ranging from video installation to painting.[72] Hebrew text, Jewish literature, religious ritual and examination of the Holocaust are all subjects addressed by these artists, including many described in this book (for example, Art Spiegelman, Audrey Flack and R. B. Kitaj; see chapter Five).

A decade later, the Jewish Museum mounted the exhibition 'Too Jewish? Challenging Traditional Identities'.[73] Paralleling a larger interest in multiethnic difference by other marginalized groups, the eighteen artists in the show investigated Jewish consciousness while testing the viewer's and the art world's (dis)comfort with what was perceived by some as excessively conspicuous Jewishness. These highly assimilated younger artists portray vastly different concerns than their immigrant and first-generation predecessors. Long after Andy Warhol, Deborah Kass (b. 1952) appropriates Pop art techniques and a fascination with celebrity in her portraits of singer-actress Barbra Streisand (illus. 87) and baseball pitcher Sandy Koufax (1994). Subtitling her Streisand silkscreens The Jewish Jackie Series (playing on Warhol's iconic silkscreens of Jackie Kennedy), Kass proffers a profile view of the 'ethnic' star that highlights her nose and subverts American norms of beauty. In fact, several of the 'Too Jewish?' entries focused on noses. Jewish Noses (1993–5), an installation by Dennis Kardon (b. 1950), presents an array of noses sculpted from 49 Jewish models, destabilizing the notion that the Jew can be categorized as a single stereotype.[74] Just as Kardon demonstrates that the Jew's body cannot be homogenized, neither can Jewish American artists.

Paintings by Archie Rand (b. 1949) famously inspired the 'Too Jewish?' exhibition. Indeed, the show was instigated by curator Norman Kleeblatt's visit to Rand's studio in 1989, where he saw the artist's The Chapter Paintings (1989), a series of 54 canvases addressing the weekly chapters of the Torah in a variety of styles, sometimes with literal iconography and at other times in symbolic or abstract formulations. Reacting with 'embarrassment', to use Kleeblatt's words, at the works' 'excessive "Jewishness"', the curator then resolved to examine the upsurge in Jewish subject matter in several artists' work

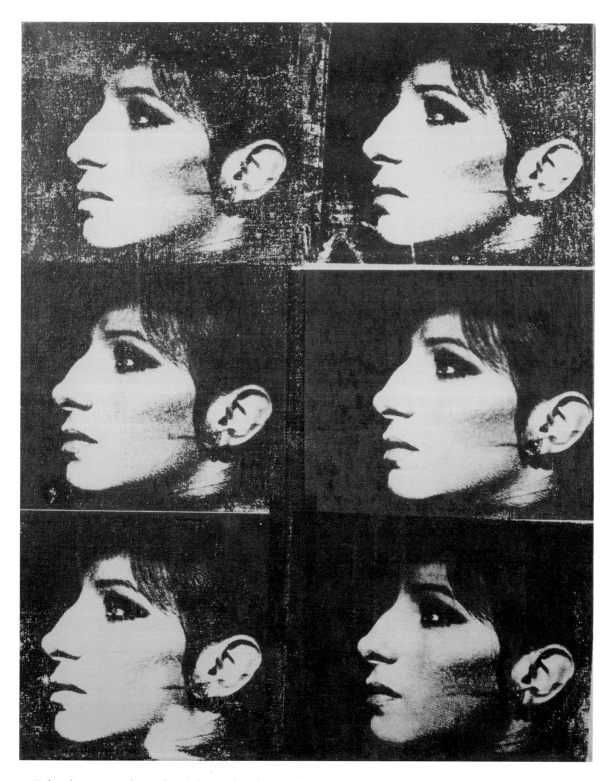

87 Deborah Kass, *Six Blue Barbras (The Jewish Jackie Series)*, 1992, screenprint and acrylic on canvas.

88 Archie Rand, *613 Mitzvot*, 2001–6, acrylic on canvas.

during the 1990s.[75] *The Chapter Paintings* were displayed at the 'Too Jewish?' exhibition, but this series of Jewish imagery was hardly Rand's first to picture aspects of his religion, and many have followed. Rand recently completed an ambitious five-year project: painting an individual canvas for each of the 613 *mitzvot*, the commandments prescribed in the Torah (illus. 88).[76] When installed side-by-side, the paintings cover 518 sq m (1,700 sq ft). Each brightly coloured picture/*mitzvah* on its own 51 × 41-cm (20 × 16-in) canvas is painted in a style reminiscent of 1950s comics and pulp novels and is surrounded by a gold frame with a label at the bottom, indicating the *mitzvah*'s number (illus. 89–92). For example, *Mitzvah* 327 offers a twenty-first-century interpretation of Numbers

5:30: 'Impure persons must not enter the Temple.' A contemporary young man envisions a bikini-clad redhead, rendered as a glamorous pin-up posing within a typical cartoon bubble balloon above his head. Rand's style demonstrates what is likely the first visual manifestation of this commandment in conjunction with the artist's conceptual update: impurity manifests itself in the mind, not the body. For Rand, and the currently growing ranks of Jewishly aware artists, Judaism and Jewishness provide unlimited intellectual material to be explored visually. Such subjects, eschewed earlier and then tentatively considered, now offer many American artists a source of both pride and fascination.

89–92 Archie Rand, *Mitzvah 1: To know there is a God (Ex. 20:2)*; *Mitzvah 53: Destroy idols, their accessories and the places where they were worshipped (Deut. 12:2)*; *Mitzvah 327: Impure persons must not enter the Temple (Num. 5:30)*; *Mitzvah 501: Not to insult or harm anybody with words (Lev. 25:17)*, 2001–6, acrylic on canvas.

93 Jacques Lipchitz, *David and Goliath*, 1933, bronze, height 99.7 cm.

5 Art and the Holocaust, Survival and Remembrance

To write poetry after Auschwitz is barbaric.
— THEODOR ADORNO, 'Cultural Criticism and Society', 1951

Some of us need a post-Auschwitz art even more than a postpainterly art.
— R. B. KITAJ, 1981

In 1951, German philosopher Theodor Adorno famously asserted that there can be no poetry after Auschwitz. Only six years following the full disclosure of human suffering and torture, along with accompanying shock at the barbarity of humanity, Adorno's sentiment is both understandable and appropriate for that moment. Adorno amended his oft-repeated dictum in 1966: 'Perennial suffering has as much right to expression as a tortured man has to scream; hence it may have been wrong to say that after Auschwitz you could no longer write poems.'[1] By that time the Holocaust was a subject repeatedly engaged in the arts, and since then art about the Holocaust has become a major motif among succeeding generations participating in a programme of memory and commemoration. That art builds upon imagery created during the actual years of Nazi power, including work by Jews sequestered in ghettoes, Jews in hiding, concentration camp inmates and artists creating imagery in protest of the war and fascism.[2]

Indeed, European and American artists, Jewish and non-Jewish, made art bemoaning

the rise of fascism and Nazi tyranny (see Gropper, chapter Four). Jacques Lipchitz's 84-cm (33-in) tall *David and Goliath* (illus. 93) constitutes one of the sculptor's many responses to totalitarianism, including several explorations of this biblical theme in addition to mythological metaphors like *Prometheus Strangling the Vulture*, his 9-m (30-ft) plaster cast for the Paris International Exposition in 1937.[3] David's unlikely victory over the giant Goliath (1 Samuel 17:48–51) provided a perfect analogy for Lipchitz's hopeful message. Executed in simplified, blocky shapes, the youthful, Jewish shepherd David, no match for his Philistine opponent in strength or weaponry, embodies the power, though faith, of right over might.

David was used metaphorically in earlier sculpture, most notably in sixteenth-century, republican Florence to embody the power of the populace by Michelangelo. Deviating from the Bible and forgoing the typical representation of David with his slingshot (in the work of Michelangelo and Gianlorenzo Bernini, for

example) or posturing with the dead Philistine's head cut off by his sword (for example, Donatello), Lipchitz's sculpture offers an enormous, arching Goliath, who desperately tries to disengage the rope around his neck, while David sits on the giant's legs, braces himself against the small of his back and pulls with all his might. To underscore the artist's message of good versus evil, a swastika is emblazoned across Goliath's chest. Lipchitz remembered:

During 1933 I had designed a series of maquettes on the theme of David and Goliath that were specifically related to my hatred of fascism and my conviction that the David of freedom would triumph over the Goliath of oppression . . . I wished there to be no doubt about my intent so I placed a swastika on the chest of Goliath.[4]

A plaster version, exhibited at the Salon des Surindépendants in 1934, brought Lipchitz to the attention of German authorities. Fortunately, during the German wartime occupation the sculpture remained safe in the basement of the Musée d'Art Moderne in Paris. Lipchitz, however, was forced to flee soon after the occupation in May 1940, becoming one of many exiled artists.[5] Emigrating to America, the artist initially struggled in his adopted land, making several sculptures about his acculturation experience.[6]

Thus did the Lithuanian-born Lipchitz convey his distress at this moment in history by turning to biblical precedent, a response in keeping with Jewish tradition. Historian David Roskies argues that in moments of catastrophe the Jew links the biblical past to the unthinkable, often secular, present. Roskies explains that the recapitulation of Jewish liturgical thinking is so engrained in the Jewish psyche that 'at that moment of crisis, individuals have the ability and the freedom to reinterpret and radicalize the tradition'.[7] (Similar use of the Sacrifice of Isaac is discussed in the Conclusions.)

One of the most beloved refugee artists, Marc Chagall, repeatedly used Jesus to represent Jewish persecution.[8] The first of several crucifixion paintings, *White Crucifixion* (illus. 94) was painted in the pivotal year 1938, when synagogues in Munich and Nuremberg were destroyed in June and August, respectively, followed by the devastation of *Kristallnacht*, (9–10 November 1938), the 'night of broken glass', when Jewish businesses and synagogues were burned and desecrated by the Gestapo, ss and Hitler Youth. *White Crucifixion* features Jesus on the cross in the central foreground, identified as a Jew by his *tallit* loincloth.[9] Atop the cross the Aramaic inscription identifying him as 'king of the Jews' is rendered in Hebrew letters, making him the epitome of Jewish suffering, the theme carried out in the rest of the picture. Chaos surrounds Jesus. The background depicts a traditional Jewish village, or shtetl, with houses overturned at the left and a synagogue, desecrated and burning on

94 Marc Chagall, *White Crucifixion*, 1938, oil on canvas.

the right. Individual Jewish figures, including an old man wearing an identifying placard (before the sign was overpainted, it read *Ich bin Jude*, 'I am a Jew'), a man grasping a Torah and a wanderer with his small pack, are forced to flee from their homes. Amid this fiery tragedy a Torah scroll burns, and other Judaica litters the ground. An overloaded ship attempts to escape to a safer homeland. At the bottom, right of centre, a woman holds a child – a recurrent, affecting motif used by Chagall to symbolize the fleeing refugee. Especially pervasive after his arrival in the United States, the mother and child pair also conjures the artist's autobiography: soon after his birth Chagall's mother saved her young son by fleeing the family home with him after it caught fire.[10] The tormentor is clearly identified: the synagogue arsonist on the right wears the uniform of a Nazi storm trooper. In addition, before Chagall reworked aspects of the painting, he explicitly indicted the Nazis: a swastika, albeit inverted, appeared on the flag above the burning ark and on the soldier's armband. Why Chagall removed these elements is unclear, but one strong hypothesis is that he overpainted the symbols to protect the politically inflammatory painting from sure destruction by the Nazis.[11] A trio of traditionally dressed figures – one wearing the accoutrements of Jewish prayer, phylacteries and a prayer shawl – hover together with a young girl above Jesus, expressing sorrow at the destruction of land and life.

Two doomed younger, German-born, Jewish artists, hunted by the Nazis, created an enduring testimonial to life. Charlotte Salomon (1917–1943) and Felix Nussbaum (1904–1944) both fled their native country but still did not survive.[12] As Nazi ideology began to take hold in 1933, Nussbaum moved to Belgium, where he lived until 1940, when he was arrested in his apartment and deported to St Cyprien, an internment camp in France. In the detention camp he made drawings of the hideous living conditions, which later informed several paintings. Escaping, Nussbaum went into hiding in Brussels, where he created haunting autobiographical works, including *Self-portrait with Jewish Identity Card* (illus. 95). This starkly realistic canvas shows Nussbaum himself as distraught and hunted, in three-quarter view, his left side in shadow. Warily eyeing the viewer, Nussbaum offers his identity card, stamped *Juif-Jood* ('Jew' in the dual languages of Belgium) in red letters with his photograph affixed. His right hand lifts the collar of his coat to reveal a yellow star. A condemned man, literally backed into a corner, Nussbaum reveals himself as a Jew in the midst of fleeing; he has nowhere left to run – an ominously high wall traps the desperate artist. The predominant colours of the portrait, muted greys, even suffuse Nussbaum's skin tone, unshaven beard and rimmed eyes. Against the predominantly dark, cloudy sky with just a touch of blue, the only other primary colours

in the composition – yellow star and red letters – mark the artist's identity. Yet this evocative self-portrait did not record an actual event – the artist still had some brief time left – but rather expressed his constant fear of being captured. In hiding, Nussbaum did not display either an identity card or a yellow badge. Crucially, however, this 'identity card' reveals further details about Nussbaum: his birthplace, Osnabrück, is nearly illegible, effaced beneath layers of paint. Moreover, for his nationality Nussbaum wrote *sans* ('without', that is, none) with a facsimile of the *Juif-Jood* stamp. According to Emily Bilski, these two changes suggest a deeper meaning for this canvas: because of his religion, Nussbaum was now adrift in the world, without a country, yet he still accepted his Jewish identity.[13]

Self-portrait with Jewish Identity Card is one of many self-portrayals, comprising up to seventeen per cent of Nussbaum's work.[14] Other anxious self-portraits were influenced by Giorgio de Chirico's haunted, ominous cityscapes and James Ensor's macabre figures wearing masks. Underground, Nussbaum survived by constant relocation, assisted by friends, as he eked out a meagre living by selling art under assumed names. Tragically, after living in hiding for over three years, Nussbaum was arrested with his wife in 1944; they both died in Auschwitz. In all, 487 works by the artist are known (many of which are now lost). Many convey his loneliness and despair, but

Nussbaum also made paintings in various genres, ranging from landscapes to still-lifes.

Salomon's work also chronicles her life, although her refugee experience did not form her primary focus.[15] An art student in her early twenties at the Berlin Academy, Salomon was forced to quit because of her Jewish background. She fled Berlin after *Kristallnacht*, which was particularly harsh in Berlin. Salomon emigrated to the South of France, her maternal grandparents' home. As the Second World War erupted, her grandmother committed suicide; soon afterwards Salomon discovered that her mother had also killed herself rather than dying young from influenza. Distraught and worried about her own psychological fate as well as the possible consequences of her Jewish background, especially after her three-week detention at the Gurs camp in the Pyrenees in 1940, Salomon painted ardently for the next eighteen months, creating 769 gouaches accompanied by text and music scores.

Collectively titled *Life? or Theatre?*, these extraordinary autobiographical drawings present Salomon's story, including tales of her friends and family related as pseudonymous characters. The 211 gouaches in the first section of *Life? or Theatre?* are overlaid with tracing paper, on which accompanying dialogue or narrative is provided, whereas on most of the other pictures in the portfolio, text is directly written on the page. With loose brushstrokes and bold colouration, Salomon's

95 Felix Nussbaum, *Self-portrait with Jewish Identity Card*, 1943, oil on canvas.

gouaches demonstrate the stylistic influence of many artists (for example, Vincent van Gogh).

The page opening Act Two of the series depicts a crowd of Nazi soldiers marching triumphantly on the day Hitler was elected Germany's chancellor, with the date (30 January 1933) provided at the centre of the image (illus. 96). This brownish-orange mass of anonymous men fills the picture frame with nearly featureless faces, except for a black line to indicate a mouth that chants allegiance to the *Führer*. A Nazi in front holds a flag aloft, on which – like Chagall – Salomon defiantly renders a swastika reversed, as she does each time she represents the noxious symbol. On the picture's overlay Salomon provided ironic textual commentary:

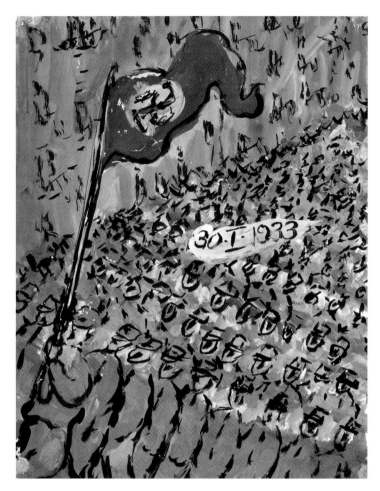

96 Charlotte Salomon, *The Swastika – a Symbol of Hope*, c. 1940–42, gouache on paper.

> The swastika – a symbol bright of hope – The day for freedom and for bread now dawns – Just at this time, many Jews – who, with all their often undesirable efficiency, are perhaps a pushy and insistent race, happened to be occupying government and other senior positions. After the Nazi takeover of power they were all dismissed without notice. Here you see how this affected a number of different souls that were both human and Jewish![16]

Additional images of Nazi humiliations accompany this sheet, including the subsequent picture, perched on a perilous diagonal, of several figures looking at a sign espousing anti-Semitic rhetoric with Nazis marching

behind the group. A later scene illustrates the terror and looting during *Kristallnacht*. Salomon and her husband were arrested in 1943, when Nazis occupied southern France; the couple died at Auschwitz, with Charlotte five months pregnant. Salomon gave her work to a friend for safekeeping, and ultimately her parents received the portfolio.

Art from concentration camps and ghettoes also survived against the odds.[17] The artist inmates of the 'model ghetto' Terezin smuggled out art, providing their own small but 'spiritual resistance', to use an oft-repeated phrase.[18] Most works are tiny, either sketches in ink, pencil or charcoal, or else watercolours made with limited hues. Some ghetto artists created clandestine art showing their grim life, including recurrent camp motifs, such as watch towers, barbed-wire fences, forced labour, deportation, starvation and death. These 'documentary' works – providing an artistic account of the atrocities endured – were typically rendered naturalistically, but some artists did adopt the distortions of an expressionistic style to help convey the extreme emotions and circumstances.[19] Portraits also formed a popular subject and could carry official favour for an artist; more portraiture, including self-portraiture, survives from the camps than any other genre. Nazi administrators would commission artists to make their own portraits, and inmates would also ask artists to make portraits of their loved ones and

themselves – often labelled with a date and the name of both sitter and artist.[20] Morris Wyszogrod (*b.* 1920) survived the Budzyn, Plaszow and Terezin concentration camps by providing valuable artistic services for Nazis, making pornographic drawings, painting coffins for German soldiers and decorating ss living quarters.[21]

Karel Fleischmann (1897–1944) perished at Auschwitz despite his multiple talents. A Czech dermatologist as well as an artist and poet, Fleischmann was first confined in Terezin in 1942, where he treated sick inmates. At the same time, he made drawings of daily living conditions and also wrote poetry, including two volumes that survived the war along with over 600 artworks found hidden at Terezin.[22] *At the Showers* (illus. 97), portrays a crowd of inmates showering *en masse*. Stripped of dignity, they stand under the water trying to cleanse themselves, flesh sagging on their emaciated bodies.

Some artists survived, in part because they were lucky enough to migrate westwards before it was too late. Born in Poland, Jankel Adler (1895–1949) lived and studied in Germany as a young man. Along with his friend Otto Dix, Adler's art was already declared degenerate in 1933. Some of it was destroyed, and other work was removed from German public collections. Four of Adler's paintings were displayed at the infamous 1937 Nazi exhibition, *Entartete Kunst* (Degenerate art).[23]

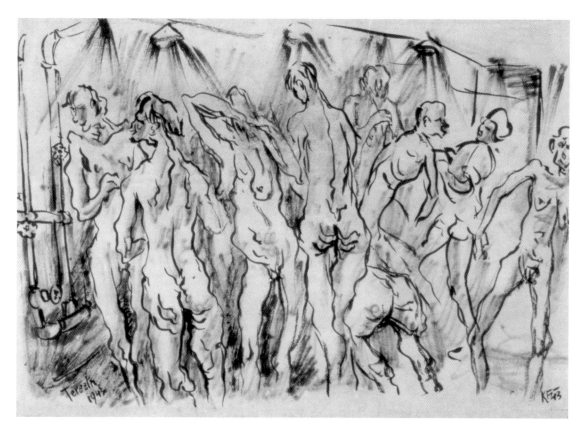

97 Karel Fleischmann, *At the Showers*, 1943, ink on paper.

Initially exiled in Paris in 1933, Adler ultimately settled in England, but not before he returned to his native country to fight in the Polish army during the war. Influenced by Surrealism and abstraction while always interested in figuration, Adler engaged both non-Jewish and Jewish subjects throughout his life, sometimes even printing Hebrew letters on his canvases. In paintings made up of biomorphic forms akin to imagery by his friend Paul Klee

and also influenced by the bird-imagery of Max Ernst, Adler often included a bird-like figure in his work, such as *No Man's Land* (illus. 98). One of many images that explore his anxiety over the war, this canvas is dominated by shades of melancholy blue, punctuated by a small yellow-orange moon burning bright on the left side of the canvas.[24] Its moody theme relates to other contemporary Adler images with similarly evocative titles, *Destruction*

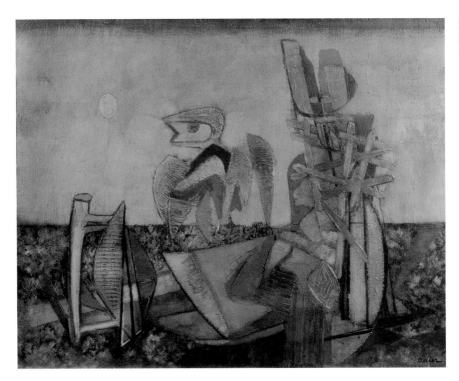

98 Jankel Adler, *No Man's Land*, 1943, oil on canvas.

(1943) and *Beginning of the Revolt* (1943), which culminate in *No Man's Land*. A painting mourning the failure of the brave yet fruitless six-week Jewish revolt in the Warsaw ghetto (19 April–16 May 1943), *No Man's Land* uses a bird to convey the artist's personal despair, considering the bird has been read as a surrogate self-portrait.[25] Mouth slightly open and gazing hopelessly into a desolate, distant land, where men are brutally and senselessly killed, the bird sits on a broken figure, who looks heavenward, mouth also open and crying aloft. Adler's own anguish was warranted, since nine of his brothers and sisters perished in the Holocaust.

As news about the full extent of Nazi brutality seeped into the United States, especially after the liberation of the camps, a number of twentieth-century Jewish American artists expressed their immediate distress, albeit diversely.[26] *Charnel House* (1946), a lithograph by the always socially conscious Leon Golub (1922–2004), was followed later with his *Burnt Man* series (1960–61). Based on newspaper photographs of Holocaust victims, *Charnel House* shows a mass of anguished figures twisting helplessly in ambiguous space. By contrast, the oil painting, *Damaged Man* (1955) from the *Burnt Man* series focuses on

a single victim, flayed and isolated at the centre of the canvas. Golub described the *Burnt Man* series as an attempt 'to visualize what is virtually unrepresentable, the Holocaust . . . what I sought to project in the 1950s, a sense of humans obliterated and surviving under extreme circumstances is still a basic concern of my work' (see illus. 147).[27]

Among many others, Seymour Lipton (1903–1986), Hyman Bloom (1913–2009) and Chaim Gross turned to Holocaust themes at this sensitive period, when feelings about the war were still raw. The events of the Second World War shaped Lipton's subject matter and materials, which evolved from specific representational themes in wood to more timeless abstract comments on the human condition in metal. Figuration seemed inadequate to describe the devastation of war, so in 1942 Lipton began to work non-figuratively in alloys. One of his last representational sculptures responded to news of Nazi persecution of the Jews. Titled *Let My People Go* (1942), based on an utterance by God (Exodus 8:16), Lipton's sculpture portrayed a bust of a pious Jewish male wearing a prayer shawl. By the mid-1940s Lipton was welding suggestive organic forms out of lead, then steel after 1947, and in 1955 rustproof Monel metal. Pointed, geometric elements with spikes and menacingly jutting forms comprise Lipton's lead, horizontal sculpture *Exodus No. 1* (illus. 99), an abstract construction that conveys the artist's feelings

about the Holocaust. The biblical title implies mass departure, most certainly the Jews' exodus from Europe during the war years. Lipton described the cycle:

> The *Exodus* pieces were part of a tragic mood of history and reality that has always concerned me . . . It is possible that Israeli history and emergence entered . . . The underlying mood is tragedy, and the main concern was for a model for an outdoor wall 30 or 40 feet long, a kind of wailing wall monument to human suffering.[28]

By the mid-1940s Bloom (born Melamed, Hebrew for teacher or educator), a Boston-based painter, also explored the Holocaust by painting cadavers and body parts. He had seen them during autopsies at a local hospital, but he was also influenced by Chaim Soutine's painted carcasses (see illus. 56).[29] Bloom's paintings, including *Corpse of a Man* (illus. 100) portray colourful, putrefying, sometimes life-size flesh. Vividly hued, this man appears nude and fully frontal, his stomach flayed and his internal organs a mass of hot pinks, bright reds and other sparkling hues. Lying nude on a table and surrounded by a sheet, this literally visceral depiction both attracts and repels the viewer with its combination of colouristic splendour and morbid bodily decay.

During the Second World War, when Gross became increasingly distraught over news from

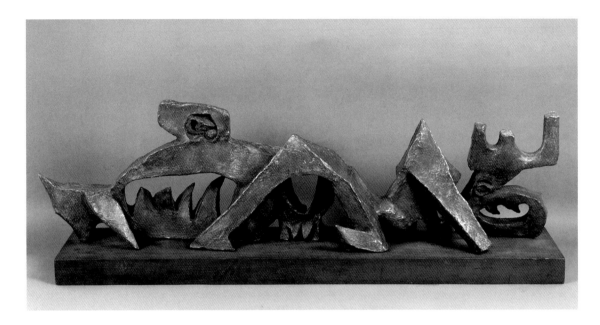

99 Seymour Lipton, *Exodus No. 1*, 1947, lead construction.

Europe, he started his self-termed 'fantasy drawings', subsequently published in a volume.[30] He began these dynamic line drawings without a subject in mind, using his subconscious to guide his hand, and several drawings refer directly to the Holocaust. Some of these, often disturbing, works on paper employ dichotomous iconography, including birds and bound human figures. Gross commented in a 1981 interview that he 'cut them [the Nazis] in pieces'.[31] Following the War, Gross learned of the death of his brother, sister, brother-in-law and niece at Nazi hands, after which his art revisited the heritage he had left behind in Eastern Europe; from this period until his death the artist's sculpture, his favoured medium, consistently explored Jewish themes.

As demonstrated throughout this book, Jesus's crucifixion has served as an indicator of Jewish sorrow and sacrifice on many occasions and in various forms. Distraught by the war, Abraham Rattner responded with a series of Crucifixion paintings in his signature style. *Descent from the Cross* (illus. 101) depicts a Cubist-inspired, dead Jesus being taken down from a bright red cross by two geometrically delineated figures. The segmented men, painted with exaggerated limbs and oversized features, form a colourful contrast to the thick black lines separating the rich hues. Like Chagall, Rattner recognized Jesus as a Jew, a figure who could best embody Jewish martyrdom. After his earlier exploration of progressive styles, with the onset of war Rattner turned toward personal subjects and disavowed abstraction. Rattner characterized his reaction to the Second World War in a 1968 interview:

It [the Second World War] affected me personally very much . . . I had to keep my balance because my emotional response to these feelings that were stirred up in me went back to my anti-semitic [sic] experiences here in America. And I never could get over them because it left an awful mark on me . . . And now Hitler's voice disturbed me . . . And I knew I could not keep on with abstraction, I could not keep on with the intellectual searching after an aesthetic direction, that I had to do something about this emotional thing in me.[32]

Lately, much has been written about the Holocaust response of Abstract Expressionist artists, particularly Barnett Newman's 'Passion' images.[33] Toward the end of his life over an eight-year period, Newman painted *Stations of the Cross: Lema Sabachtani* (1958–66), a series of fourteen, nearly monochrome, canvases, anchored by a narrative title that clearly contextualizes the abstract paintings. Here Jesus's final lament as he bled to death on the cross, 'Lema Sabachtani' or 'Why hast thou forsaken me?' (Psalm 22:2, then Matthew 27:46), asks God in anguish how He could let the Holocaust occur and abandon Eastern European Jewry. The cycle's title occurred to Newman while working on the fourth station (illus. 102), typical of the paintings that make up the series: a raw canvas with white paint and a black line or lines, some frayed, others precise, and all

100 Hyman Bloom, *Corpse of a Man*, 1944–5, oil on canvas.

bisecting the sombre images. Each canvas measures approximately 198 × 152 cm (78 × 60 in), a commanding but not overly daunting size, characterized by Newman as 'a human scale for the human cry'. Newman's postwar consciousness, manifest in *Stations of the Cross*, created a cycle of non-objective paintings that simultaneously engage history, to offer a response without colour or defined form. These elements function symbolically: figuration and colour are nearly eliminated, almost like the Jews. For Newman the intensity of his abstract conception incited him to think of the Passion, which in turn served as a potent,

101 Abraham Rattner, *Descent from the Cross*, 1942, oil on canvas.

shared metaphor of the period before and after the Holocaust.

Indeed, R. B. Kitaj (1932–2007) understood the Holocaust as Jews' 'most pressing memory, our Crucifixion', and made many images about it.[34] Seeking a Jewish symbol akin to the Christian cross, in 1985 Kitaj began to utilize a chimney in reference to the ovens in which Nazis burned Jews. The best known of this series of 'Passion' pictures, as Kitaj provocatively called them, is a canvas of a middle-aged train passenger, titled *The Jewish Rider* (illus. 103). *The Jewish Rider* plays on Kitaj's vast knowledge of art history; the canvas is based partly on *The Polish Rider* (*c.* 1655), a seventeenth-century work long attributed to Rembrandt, one of Kitaj's self-proclaimed twelve favourite painters.[35] Kitaj quotes the rider's pose for his Jewish counter-part and even includes the horse's head and rear behind the passenger. In bright, contrasting colours applied with a painterly brushstroke,

102 Barnett Newman, *The Stations of the Cross: Lema Sabachthani, Fourth Station*, 1960, oil on canvas.

103 R. B. Kitaj,
The Jewish Rider,
1984–5, oil on canvas.

Kitaj presents an uncomfortable traveller
who sits awkwardly in his seat. Here the train
functions as a symbol of the homelessness of
the diaspora Jew. Kitaj layers the painting with
further meaning by converting the setting sun
at the back of the Dutch canvas into a chimney
seen outside the train window in *The Jewish
Rider*. Connecting the chimney to a cross by the
angle of the exiting smoke, Kitaj creates addi-
tional symbolism. As Vivianne Barsky observes,
here Kitaj points 'an accusing finger, suggest
[ing] an unholy alliance between the church
and Nazism'.[36] A conductor in the back aisle

menacingly wields a baton, and the ominous
long corridor further suggests Holocaust
connotations. In fact, Kitaj did paint several
images that include iconography reminiscent
of tunnels to the gas chambers.[37]

Some of Kitaj's 'Passion' images employ
only a chimney, while others picture both a
chimney and a cross. *Passion: Writing* (illus.
104), shows a figure confined inside a chimney,
much as Jews sentenced to extermination
camp deaths were trapped inside crematoria.
A white outline of another shape overlays this
rectangular yellow chimney. Ensnaring the

writing figure, this second area could be read as a coffin with its six-sided configuration. The man's inkwell also mimics the shape of a chimney, complete with a smoke-like emission. Outside the writer's claustrophobic office space appears yet another chimney, this one red and mirroring the inkwell. The actual canvas echoes the rectangular shape of a chimney; the canvas measures an odd, yet evocative 46 × 25 cm (18 × 10 in). Of these 'Passion' images, Kitaj wrote:

> These little PASSION paintings are the closest I've come to the subject of the Shoah which of course I can't do because I wasn't there, nor was God. For better or worse, I thought of the Chimney as an analogue to the Cross in the Christian Passion – both having carried Jewish remains.[38]

Finally, another passion painting, *Passion (1940–45): Landscape/Chamber* (1985), combines all of these Holocaust elements. A truncated cross sits on the far side of the canvas. A deep, ominous tunnel appears at centre, and on the far right a smoking chimney can be found. This painting takes us through the successive stages that led to the Final Solution: Jews, as victims of anti-Semitism by virtue of a long history in which they were blamed for Jesus's death; a tunnel though which they travelled on the way to extermination camps; and then their ultimate, horrific deaths in gas chambers.

For many contemporary American Jews, the Holocaust serves as a major definer of Jewish identity, as indicated by a 1998 survey ranking remembrance higher than synagogue attendance and observing holidays.[39] To that end, American interest in the Holocaust as a subject for art has only increased in the years since artists felt the immediacy of the tragedy. Audrey Flack (*b.* 1931), best known for intensely illusionist, large-scale canvas still-lifes replete with complex symbolic iconography that plumb personal and feminist issues, made other works with Jewish themes. The first of her Vanitas series, based on configurations of objects arranged by Flack in her studio and then photographed, engages Holocaust matter. Titled *World War II (Vanitas)* (illus. 105), the painting incorporates a black-and-white photograph in a magnified, sharply delineated *trompe l'œil* still-life in vivid colours.[40] It combines pretty objects with a reproduction of the iconic, devastating picture of the liberation of the Buchenwald concentration camp, taken in 1945 by *Life* photographer Margaret Bourke-White. Captured in black-and-white, the exhausted, stunned prisoners behind the barbed-wire fence contrast with the rich, glowing colours of the adjoining pastries, displayed on a shiny, embossed silver platter. Among the array of objects in front of Bourke-White's duplicated photograph lie items of both transience and worldly excess: a candle dripping red wax like blood (a motif found in many of Flack's

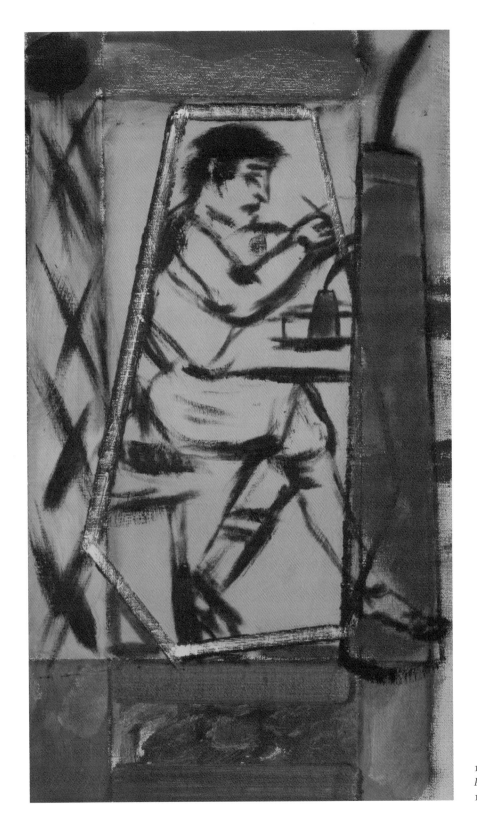

104 R. B. Kitaj,
Passion: Writing,
1985, oil on canvas.

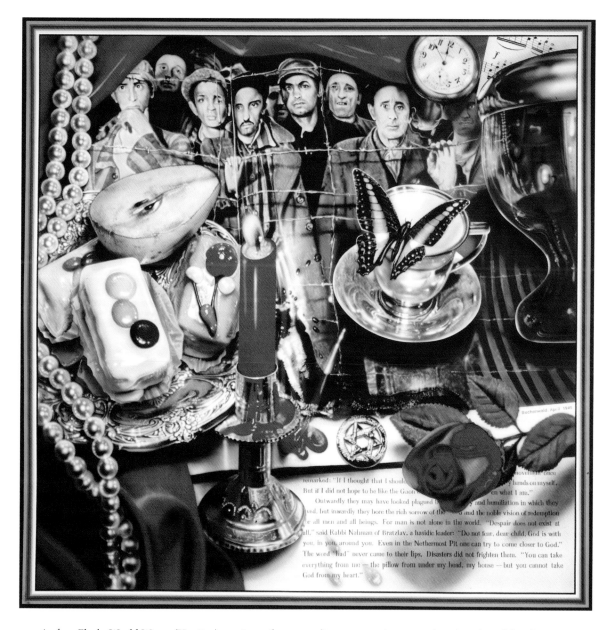

105 Audrey Flack, *World War II (Vanitas)*, 1976–7, oil over acrylic on canvas incorporating a portion of the photograph 'Buchenwald, April 1945' by Margaret Bourke-White.

still-lifes, including the 'Vanitas' series); a red rose; a blue goblet; a strand of shiny pearls (all of which appear in Flack's better known *Marilyn [Vanitas]*); a butterfly lighting on a delicate china cup; a timepiece; and a Star of David from Flack's keychain. Some of these objects sit on an open page of Rabbi Abraham Joshua Heschel's introduction to Roman Vishniac's volume of 31 prewar photographs chronicling the life of Polish Jews. Visible is a passage about faith by the nineteenth-century Hasidic leader Rabbi Nahman of Bratzlav:

Outwardly they may have looked plagued by [the misery – obscured in image] and humiliation in which they lived, but inwardly they bore the rich sorrow of the [world – obscured in image] and the noble vision of redemption for all men and all beings. For man is not alone in this world. 'Despair does not exist at all,' said Rabbi Nahman of Bratzlav, a hasidic leader. 'Do not fear, dear child, God is with you, in you, around you. Even in the Nethermost Pit [sic] one can try to come closer to God.' The word 'bad' never came to their lips. Disasters did not frighten them. 'You can take everything from me – the pillow from under my head, my house – but you cannot take God from my heart.'

Flack explained why she amalgamated such diverse elements: 'My idea was to tell a story, an allegory of war . . . of life . . . the ultimate breakdown of humanity . . . the Nazis . . . to create a work of violent contrasts, of good and evil. Could there be a more violent contrast than that?'[41]

Certainly the contrast between the emaciated prisoners and the luxury goods remains strong in hue and subject, as does the juxtaposition of a *yahrzeit* candle before Bourke-White's survivors, described by Flack as 'a memorial candle to bridge time between 1945 and the present, to burn always in the painting'.[42] But much of the symbolism in the canvas can also be read as conveying a central theme rather than a contrast. *World War II (Vanitas)* focuses on life – on the pleasures of human existence and on the survivors of the camps instead of on the dead: 'I chose specifically not to show blood or injury. Too much blood has been shed already', Flack explains.[43] While the human skull figures in several other still-lifes by Flack, she did not place a skull – a traditional *vanitas* still-life object – in *World War II (Vanitas)*, even though the canvas would be the most appropriate one of her images for it. Nor did Flack admit rotting fruit into her Holocaust memorial, another favourite motif in her other still-lifes and a conventional *vanitas* still-life object. Flack even emphasizes the survival of humanity amid evil by painting a rainbow border around the canvas; the first rainbow was an assertion of God's presence after the Flood – a sign to Noah that life would continue, that God would never again destroy the earth with a flood (Genesis 9:11–15).

In a remark about how she defines Jewish art, Flack provides insight into her canvas, by specifically equating Jewish art with life and contrasting it with a style of art that opposes exuberant, individual expression and social commentary:

I guess Jewish art is specifically religious art like Christian art and like Muslim art. It's a catchy thing because Jews aren't

supposed to make images. Jewish art is probably humanist . . . I think *World War II* is art that has a universal subject – war, death, evil, goodness, morality, and mortality. Jews represent humanism – to life, to life, *l'chaim*. With Jews there's a celebration of life. I think minimalism is the opposite of Jewish art. One green pea on a piece of roast beef.[44]

Less concerned with the means of death and more with the loss of Jewish culture, Shimon Attie (*b*. 1957) created a series of photography installations in Europe collectively called 'Sites Unseen' (1991–6).[45] In several countries, Attie projected photographs onto, or made from, public buildings, in one case on a body of water, all utilizing images from the Second World War. The earliest installation of 'Sites Unseen' was made in Attie's adopted city of Berlin. Struck by the absence of a once vibrant German Jewish community, Attie conceived *The Writing on the Wall* (1991–3) in

response to the discrepancy between what I felt and what I did not see. I wanted to give this invisible past a voice, to bring it to light, if only for some brief moments . . . *The Writing on the Wall* project is my personal response to being in Germany and to my search for a people and culture that I would never know.[46]

Researching images in the city's archives, Attie discovered prewar photographs of Jewish residents of the Scheunenviertel district. After consulting prewar maps of the area, for a year he then projected fragments of those images of everyday life at the original locales where the pictures were taken in the 1920s and '30s, or on sites nearby. *Almstadtstrasse 43* (illus. 106) depicts a superimposed male figure entering the Hebrew bookshop, which is also projected onto the building, bearing a Yiddish sign identifying the shop. The black-and-white projections appear ghostly upon the building's colour and contrast with the contemporary record of the environment, which includes a blue car and a graffiti-defaced door. Later projects devised as part of 'Sites Unseen' include *Trains*, projected photographs of Dresden's Jews on the trains, tracks and walls of the Dresden train station – a site from which many German Jews were deported by the Nazis – installed for two weeks in November of 1993.

The Neighbor Next Door (1995), was installed in Amsterdam for only a week. Here Attie reversed his usual mode and projected images from within buildings. From three apartments on *Prinsengracht*, the street where Anne Frank's family hid, Attie showed short bits of film footage taken during the Nazi occupation, including clips of the Dutch assisting Nazis. He aimed to reveal the point of view of those hidden and to remind the

106 Shimon Attie, *Almstadstrasse 43, Berlin*, 1992, slide projection.

Dutch that many of Holland's Jews perished. In other words, Attie deconstructed the national mythology of Holland as a safe haven during the Holocaust, acknowledging that a considerable number of Dutch Jews were exterminated. Attie also commented on a current problem in Holland: over 100,000 illegal immigrants live in the country today. By projecting images from the past, Attie does not aim to recover history, but to make it tangible for the present. His installations engage the specific sites and histories of the locales he works in, questioning what we remember and what actually occurred. After projecting the installations for a period of time, Attie takes photographs to document the ephemeral events.

Preservation of a vanished Jewish world and recollection of that destroyed culture in Eastern Europe also preoccupy the work of Eleanor Antin (*b.* 1935).[47] Directing under the pseudonym Yevgeny Antinov, Antin made a 98-minute, silent, black-and-white film, *The Man Without a*

World (1991). Antin's rediscovered masterpiece, said to be lost during the Holocaust, *The Man Without a World* tells a nostalgic, melodramatic, even satiric story about shtetl life in Poland before the Second World War (illus. 107). Within a gallery, her related installation, *Vilna Nights* (illus. 108) offers the viewer a glimpse of the cost of Nazi destruction of the life celebrated in *The Man Without a World*. Commissioned by The Jewish Museum, New York, *Vilna Nights* presents a smashed wall that reveals a set of the destroyed Vilna Jewish quarter. Accompanied by audio reproducing sounds of Jewish humanity during the Holocaust, Antin projects several scenes simultaneously to convey the last years in the shtetl. One vignette presents the iconic Jewish tailor sewing by candlelight. While folding garments, the tailor discovers a yarmulke and begins to weep. One can only surmise the sad fate of that *kippah*'s wearer, as the candle symbolically flickers out. Antin's interest in exploring the

107 Eleanor Antin, *The Man Without a World*, 1991, film still.

tragedy of a decimated Yiddish world emerges from a childhood saturated with *Yiddishkayt*.[48]

A growing interest in her Jewish heritage led to Judy Chicago's *Holocaust Project: From Darkness into Light* (1985–93), which debuted in October 1993 at the Spertus Museum in Chicago and subsequently travelled throughout the United States until 2002. This installation culminated eight years of research and exploration, including extensive reading on the subject, visits to concentration camps, archival work on the subject in Eastern Europe and a trip to Israel. While particularly interested in the fate of Jewry, Chicago's project also references other persecuted groups, such as homosexuals and gypsies, and additional subjugated peoples who were largely expunged from the historical record. Moreover, Chicago made a

108 Eleanor Antin, *Vilna Nights*, 1993–7, mixed media installation.

special effort to create imagery that addresses how the female experience differed from that of men. Two stained glass windows and a tapestry, designed by the artist and executed by collaborators, accompany thirteen tableaux blending Chicago's paintings and her husband Donald Woodman's photography on photo-linen (a photosensitive material that enabled the merger of their respective mediums). Information panels and an audiotape guide the viewer through the installation.

First, the viewer encounters the stained-glass logo for the project: a rainbow-coloured triangle based on the different coloured badges Nazis forced concentration camp inhabitants to wear; it is surrounded by flames and soldered with wire to evoke the barbed wire of the camps. As Chicago described the symbol:

> I used the color yellow twice to emphasize the particular suffering of the Jews and as a metaphor for the idea that the Holocaust began with the Jews, but it did not end with them. I intended the design as a memorial to all those persecuted by Hitler and as a symbol of courage and survival.[49]

Next, one sees a 1.4 × 5.5-m (4 ½ × 18-ft) tapestry – titled *The Fall* – conveying the disintegration of rationality through a variety of collage-like images, culminating with victims being forced into camp ovens. Chicago chose tapestry as a principal medium for the work 'to emphasize how the Holocaust grew out of the very fabric of Western civilization'.[50] The tableaux that follow visualize and interpret the events of the Holocaust and also expand to other abuses of power, such as US slavery and the Vietnam War. The project culminates with a stained-glass triptych, titled *Rainbow Shabbat* (illus. 109), which aims to end the viewer's journey on a hopeful note. A yellow star, akin to the compulsory badge worn by Jews, flanks the larger centre panel on both sides. Within those stars, in Yiddish and English, Chicago rephrases a poem by a survivor from Terezin that gives the entire installation its name: 'Heal those broken souls who have no peace and lead us all from darkness into light.' The larger centre panel portrays a Shabbat service. On opposite ends of a table a wife blesses candles, and a husband holds up his Kiddush cup in honour of his spouse – thus incorporating the actual ritual of Shabbat together with Chicago's overriding interest in the female experience. Sitting around the table, peoples from different creeds and races unite with their hands on each other's shoulders, all against a bright rainbow background. Viewed as a whole, Chicago's installation functions aesthetically, instructively and redemptively.

In 1991, Art Spiegelman (*b.* 1948) published *Maus*, a graphic novel that became one of the most celebrated artworks to address the Holocaust and also initiated a Jewish graphic novel craze.[51] Indeed, graphic novels engaging Jewish

subjects have become an explosive cultural phenomenon, with many confronting the Holocaust.[52] *Maus*, which won the Pulitzer Prize in 1992, first appeared as a serial running from 1981 to 1986 in the alternative comic magazine *RAW*, co-edited by Spiegelman and his artist-wife Francoise Mouly. Earlier versions were published in obscure venues in the underground press of the 1970s. A child of Holocaust survivors, Spiegelman recounts his father's story using the unprecedented comic book form, and he also presents the key players in the drama allegorically as animals: Germans are cats, hunting the Jews, who are mice, Poles are pigs, Americans are dogs and French are frogs. In this second-generation account, Spiegelman does not treat his father Vladek with the typical reverence accorded survivors, but rather presents him realistically – which includes Vladek's racist, miserly and misogynistic tendencies.[53]

Interspersed with Vladek's experiences in Poland's ghettos and camps are images of him narrating the story to his son along with Spiegelman's thoughts about creating the graphic novel. Spiegelman's attempt to share his father's tale and make sense of the legacy of the story for his own life, a generation removed from the tragic events, exemplifies the concept of postmemory. According to Marianne Hirsch, who originally developed the principle while reading *Maus*, postmemory

characterizes the experience of those who grew up dominated by narratives that preceded their birth, whose own belated stories are evacuated by the stories of the previous generation shaped by traumatic events that can be neither understood nor recreated.[54]

In the second chapter of volume two of *Maus*, Spiegelman creates a page comprised of five panels, titled 'Time Flies' (illus. 110), a quintessential example of the effects of postmemory. Spiegelman appears wearing a mouse mask, aligning him with both his survivor father and the Jews portrayed in the first volume. Time flies here on two levels: first, insects surround Spiegelman's head – a literal embodiment of flying as well as a consequence of the stinking corpses piled underneath his drawing desk. More poignantly, time flies because of the conflation of time in the word bubbles above the artist's head. Here the exhausted, depressed Spiegelman moves aimlessly between past and present: he and his wife are expecting a baby, for example, at the same time that Spiegelman recounts 'Between May 16, 1944, and May 24, 1944 over 100,000 Hungarian Jews were gassed in Auschwitz . . .' Visually, the large bottom panel brings together past and present; Spiegelman leans on his drawing board dejectedly, conflicted about his success – he has won approbation and financial reward, but by describing the torture

109 Judy Chicago, 'Rainbow Shabbat', 1992, stained glass, fabricated by Bob Gomez and hand painted by Dorothy Maddy from Judy Chicago's design, part of *Holocaust Project*, 1985–93.

and death of Jews. Yet intruding on this modern scene are dead Holocaust victims strewn on the floor, and a watchtower and barbed-wire fence outside the window on the right. For Spiegelman, despite the passage of years, the traumas of the past continue to haunt the present.

Artists in the recently formed state of Israel typically shied away from Holocaust themes, viewing the War as antithetical to the new Jew, celebrated in life and in art (see chapter Six) as a strong, assertive pioneer of the land rather than a weak, passive victim.[55] Within this pervasive cultural programme, by eschewing Holocaust themes, Israeli artists also showed sensitivity to Holocaust survivors and respect for the dead by avoiding the perception that their art was trivializing the catastrophe.[56] Among Israeli artists of that early postwar generation, Mordecai Ardon (1896–1992) – born Mordecai Eliezer Bronstein – did confront the Holocaust, notably in his triptych

Missa Dura (illus. 111). Hailing from Poland and raised Orthodox, later educated at the prestigious Bauhaus by Paul Klee and Wassily Kandinsky, Ardon is widely regarded as one of Israel's most important artists. Ardon was already 37 when he arrived in Palestine, fleeing Germany in 1933 when the Nazis rose to power. By 1935, Ardon had lived on a kibbutz and was teaching courses at the recently reopened Bezalel School of Arts and Crafts (see chapter Six), where he eventually served as director from 1940 to 1952.

Missa Dura, which means 'hard mass' (ambiguously hovering between the Christian mass, or Eucharist ritual, and physical materiality) is a three-part painting, or triptych, with each panel titled separately. In brilliant, glowing colours, Ardon creates a brief history of Nazi evil and destruction through delicately rendered signs and allusions. The left canvas, *The Knight*, refers to Hitler, who saw himself as a knight of

110 Art Spiegelman, from *Maus II: A Survivor's Tale/And Here My Troubles Began*, 1991.

the Third Reich. Ardon juxtaposes varied objects, symbols and shapes. In the centre, a tiny knight wearing armour lies with his legs splayed and arms behind his head, specifically identified as Hitler by his signature tiny black mustache and haircut. Forms and objects float chaotically around him, including a Nazi flag with a sign similar to a swastika, and at the bottom of the canvas stand several houses, one with a broken wall. Above the houses a newspaper, splattered with blood, publishes decrees denouncing Jews. Ardon strews crosses throughout – in circles, on the chest of the knight's uniform, and atop the church at left. Christian piety, however, runs amok; the cross dissolves into a swastika and becomes a sign of

hate, not piety. Notably, only on the far left of this first canvas is the sky blue, but by the time the viewer's eyes sweep to the right side, the sky has blackened, and remains dark throughout the two other canvases. Darkness and evil pervade Ardon's world, as demonstrated by this sinister hue as well as the black Roman numeral xii barely discernable at the centre of the middle image – a number that indicates midnight, the witching hour (and might also refer to the current pope, Pius xii, whose accommodation with Hitler has been condemned by many postwar historians).[57]

Larger than the side images and titled *Kristallnacht*, Ardon's centre canvas symbolically portrays the destruction wrought by the knight's ideas. On the left, Psalm 69 appears in Hebrew on parchment, punctured by six bullet holes for the six million dead. A lamentation psalm, it begins 'Save me, O God; for the waters are come in even unto the soul'. God did not save the many Jews lost in the Holocaust, the theme that pervades this image, conveyed in part through biblical imagery. Near the left upper corner appear two hands, those of Adam and God, akin to Michelangelo's famous rendering on the Sistine Chapel ceiling. But they do not touch and create life; instead, strings bind each hand. Underneath the hands appears the head of Michelangelo's Adam, but it is double-sided – Janus-like – one side white and thus good, contrasted with black, again indicative of the evil that allowed the

destruction wrought by Hitler and his minions. The last biblical reference is the most devastating; at the bottom of the canvas, just right of centre, the top rung of Jacob's ladder peaks onto the canvas. In the Bible, Jacob's ladder reaches to heaven and God, but here the ladder barely even appears on the canvas, highlighting God's absence. The strings dangling from Adam and God's hands connect to various other signs: a series of cards on the left present letters that partially make up Hitler's name and a portion of a swastika; three centre cards depict Hitler's open mouth to indicate his angry rhetoric; and the three smallest cards depict Hitler's distinctive moustache. Finally, the strings reach bowling pins, one with a yellow badge and all set against a blood red background, falling over as symbols of slaughtered Jews.

The right canvas, *House No. 5*, shows an abstracted house from a concentration camp, the culmination of the knight's plans and the final destination of so many Jews, looted and terrorized at *Kristallnacht*. A featureless figure stares out a window of the house, her only identifying attribute a prisoner number on her arm, 167345. Yet one sign provides hope: on her chest in yellow appears not the expected dreaded yellow Star of David badge, but an ancient kabbalistic sign denoting the divine *Sefirot*. A fundamental concept of Kabbala, *Sefirot* channel life and sustain the universe. The pink, transparent house – linked by hue to the house on the left canvas – reveals a

crematorium. Its open window also shows two candles, whose flames hover above, displaced from their source. These candles may imply the loss of the Jewish Sabbath, when candles are kindled, and also refer to the ritual commemoration of the dead, an annual lighting of a *yahrzeit* candle. This latter reading is affirmed by the six flames in the lower corner, symbolic of the six million Jews murdered in the Holocaust. On the far right corner of this final wing a lone creature escapes, a mouse, referring to Jews hidden in cellars and sewers. Ardon provided a short note, resembling a poem, to accompany the painting, which begins: 'In the beginning were Knight, Newspaper and Decree', referring to Hitler, written propaganda, and then Nazi laws.[58] Notice that Ardon's verse starts with the initial words of Genesis, describing the creation of humanity, yet in this case his words articulate the destruction of civilization itself.

Samuel Bak (*b.* 1933) has made a career exploring themes related to the Second World War, examining the Holocaust in a meticulous figurative style reminiscent of Italian Renaissance art but infused with Surrealistic elements. One of the few survivors of the German-occupied Vilna ghetto, Bak was deported to a forced labour camp in 1943, at age ten. After the war, Bak studied art in Germany, emigrating to Israel in 1948. A student first at the Bezalel School and then in Paris and Rome, Bak has continued to live a peripatetic life, settling at various times in

Israel, Europe and the United States, where he presently resides in Boston. Bak presents metaphorical, precisely rendered art in painted series drawing on iconic Jewish symbols and canonical old masters. From his 'Landscapes of Jewish Experience' series (1990–96), the stone wreckage in *Shema Yisrael* (illus. 112) offers ruins devoid of human form.[59] Atop the mountain of rubble sit the Tablets of the Law, functioning as much as gravestones as laws for the Jewish people to live by. These tablets convey none of the commandments, but remain blank except for two yods, the Hebrew letters that signal God. Directly below the upright tablets are piles of stone, alternative shattered tablets. Most notably, a broken stone with the number six peeks out of the wreckage, a number indicating a commandment brazenly broken by the Nazis – thou shalt not kill – and also a number redolent of the six million Jews murdered. Spelled out in Hebrew at the foot of the mountain is a cracked and damaged stone rendering of 'Shema Yisrael', the profession of faith in all Jewish services, the start of the verse that affirms a monotheistic God (Deuteronomy 6:4). As witness to trauma and destruction, in this descriptive and grim canvas Bak does not (perhaps cannot) affirm his faith in God after enduring the Holocaust. Rather, he presents a cold, aloof terrain suffused with shades of grey and purple, the predominant hues of his despairing topography.

111 Mordecai Ardon, *Missa Dura*, 1958–60, oil on canvas.

Beginning in the 1980s, the Holocaust emerged with some consistency in Israeli visual arts, notably in the work of Moshe Gershuni (*b.* 1936), who included a swastika and Star of David in several images. For *In My Heart's Blood*, a 1980 installation at the Tel Aviv Museum of Art, Gershuni arranged 150 bloodstained dishes on the floor in the shape of a swastika, accompanied by a label, 'My wonderful red is your precious blood'. Lately, the politics of Holocaust memory in Israel has become much more complicated. Two Israeli artists, Roee Rosen (*b.* 1963) and Boaz Arad (*b.* 1956), recently created installations wherein Hitler – previously the elephant in the living room in Israeli art – returns through shocking imagery and effects.[60] The son of a Holocaust survivor, Rosen created *Live and Die as Eva Braun* (1995), exhibited in Israel two years later, marking the first time Hitler appeared in an Israeli museum. Through ten stations of 60 black-and-white images, in *Live and Die as Eva Braun* the viewer adopts the role and

viewpoint of Hitler's mistress, Eva Braun. Across the installation, Braun and Hitler become intimate shortly before they commit double suicide. Hitler, however, never appears literally, but rather as a small black mark – his iconic mustache – and dark, precisely parted hair. Full text murals accompany each station, describing to the viewer/Braun how 'she' feels.[61] Rosen's work invites the viewer, placed in a repulsive position, to identify with the perpetrator. The purpose of such identification, Ernst Van Alphen argues, is to clarify how easily one can 'slide into a measure of complicity'. Thus art like Rosen's idealistically aims to prevent horrors such as the Holocaust from happening again, rather than relying on art that focuses on victims.[62]

Three years later, Boaz Arad debuted a series of videos featuring Hitler, including a shocking twelve-second short, *Hebrew Lesson* (2000). Here Arad manipulates historical footage and Hitler's voice so that the despised architect of the death camps appears to be speaking

112 Samuel Bak, *Shema Yisrael*, 1991, oil on canvas.

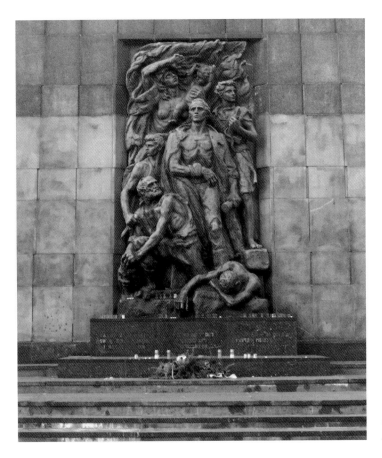

113 Nathan Rapoport, *Warsaw Ghetto Monument*, western wall, 1948, Warsaw.

Hebrew, the language of the people he hated so much. Even more, the spliced audio puts a short yet entirely surprising sentiment in Hitler's mouth, uttering the Hebrew words '*Shalom Yerushalayim, Ani mitnatzel*' or 'Greetings, Jerusalem. I am sorry.' In Arad's 27-second video, *Marcel Marcel* (2000), Hitler orates again, this time in German, using the historical footage chiefly to manipulate Hitler's moustache. Rendered in animation with two lines as if marked by a felt-tip pen, that metonymic moustache flits about and grows – from the iconic, thin mark above his lip into curls, then ultimately transforming into a full beard –

startlingly, one resembling that of Theodore Herzl, the father of Zionism (see chapter Two). Then all facial hair disappears, leaving Hitler exposed. The nakedness of his physiognomy, marked so iconically with facial hair, might be disturbing enough, but the previous, cartoonish animation further reduces Hitler to pure farce. The delicate issue of how to represent (or not represent) the Holocaust was officially exploded in Israel.

Architectural memorials recalling different aspects of the Holocaust – from resistance to those murdered – have been erected in Europe, Israel and the United States, in many different

styles, ranging from abstract to representational, and with varied iconography (for example, religious symbols and biblical imagery, Jewish figures, political signs).[63] While the question of how to memorialize a trauma that nearly erased centuries of civilization remains complex, remembrance itself – an important imperative in Jewish life – has been a constant in the Holocaust's aftermath. To be sure, the Hebrew verb *zachor* ('to remember') is deeply engrained throughout biblical and rabbinic literature.[64] The blessing *Zichronot* provides a foundational element in the Rosh Hashanah liturgy. To that end, the mantra of the Holocaust aftermath, 'Never Forget', resonates on several levels. Nonetheless, motivations for Holocaust monuments vary. Certainly the Jewish obligation to remember encouraged many important memorials, but some also exist – often simultaneously with other objectives – to educate succeeding generations, to assuage guilt, and even to attract tourists.

Nathan Rapoport (1911–1987) created several Holocaust memorials, notably the *Warsaw Ghetto Monument* (illus. 113–14), the first to mark the event at the site-specific location of the uprising (a modified replica stands at Yad Vashem, Israel's Holocaust Museum in Jerusalem).[65] Unveiled on the fifth anniversary of the day the revolt began, this 9.5-m-tall (31-ft-tall) figurative commemorative sculpture bears a dedication at bottom in Yiddish, Hebrew and Polish: 'To the Jewish people – its

heroes and its martyrs.' Classically rendered heroes appear on the front side of this double-sided wall, symbolizing the 30 miles of walls surrounding the ghetto by ss decree, while also suggestive of a gravestone. Posed dramatically, the powerful, surging figures vary in age, and each clutches the kind of makeshift weapon one would find in the ghetto – a rock, a dagger and a homemade grenade, for instance, the latter notably in the hands of the central figure of Mordechai Anielewicz, a leader of the uprising.

This dynamic, muscular grouping contrasts with the bas relief on the reverse side of twelve doomed Jews, referring to the twelve tribes of Israel. Rapoport modelled this horizontal parade of weary figures on the sack of the Second Temple, depicted on the inside wall of the Arch of Titus (81 CE) in Rome. Trudging forward towards the death camps, herded along by Nazis, indicated only by tips of bayonets and three Nazi helmets, the figures comprise all ages. All eyes are downcast except for a rabbi carrying a Torah, who looks plaintively up to heaven. Celebrated for its monumental drama and criticized for its literalness and use of stereotypes (for example, the Wandering Jew; see Conclusions), to this day the memorial serves as a pilgrimage site for Jews around the world, to recall and commemorate the Holocaust, and for non-Jews, especially dissident groups, who gather nearby to protest. The entire memorial sits on the ruins of the lost Jewish ghetto, with its granite

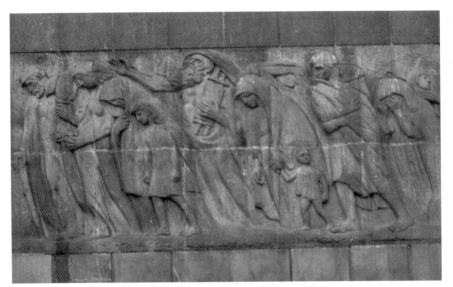

114 Nathan Rapoport, *Warsaw Ghetto Monument*, eastern wall, 1948, Warsaw.

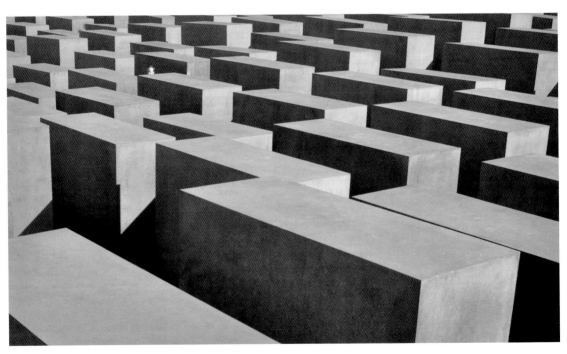

115 Peter Eisenman, *Memorial to the Murdered Jews of Europe*, 2004, Berlin.

retaining wall composed, fittingly, of blocks originally set aside by Nazi sculptor Arno Becker for Hitler's proposed victory monument after the war. On either side of the memorial stands a menorah, symbolic of Jewish resistance during the second-century BCE Maccabean Revolt, celebrated annually during Chanukah.

Memorial to the Murdered Jews of Europe (illus. 115), designed by American architect Peter Eisenman (*b.* 1932), offers a strong contrast to Rapoport's monument.[66] Devoid of figuration or symbolism, Eisenman's memorial consists of 2711 rectangular stones covering 19,000 sq m (205,000 sq ft). Placed in the middle of Berlin near the Brandenburg Gate, the massive concrete slabs, compared by some to tombstones and coffins, are placed on irregular ground, thus creating an undulating, sometimes steep traffic pattern for walking through the memorial. One can easily get lost amid the labyrinth, an uneven field of grey *stelae* causing visitors to feel disoriented and claustrophobic, a purposeful effect designed to simulate the confusion of Jews during the Holocaust. No plaques or inscriptions guide the viewer within the stark memorial, although the names of all the victims are housed in an adjacent underground information site. Eisenman explained that victims' names do not appear, because the *stelae* are not gravestones and because he

wanted visitors to have an experience almost impossible to associate; I wanted them to go to an alien place and relate to it just by being there. I wanted it to be as unassimilatable, as un-nameable, unspeakable and unthinkable as the Holocaust itself.[67]

The memorial stands in Berlin near the former site of Goebbels's bunker and villa, and it was commissioned by the perpetrators of the crime – as opposed to most monuments (like Rapoport's) that were sponsored by the victims. *Memorial to the Murdered Jews of Europe* was designed not only for Jews but also for Germans. As Eisenman put it:

I wanted in some way to begin to normalize the German relationship to the past, if such a thing is possible, to bring it into everyday life. Without that, there can never be an integrated Jewish community in Berlin or in Germany.[68]

While aiming to normalize Jewishness in Germany – so that distinctions between Germans/Jews and non-Jews/Jews can finally be dismissed – Eisenman found that the project also brought him closer to his own Jewishness.[69]

Initially Richard Serra (*b.* 1939) worked with Eisenman on the plans for *Memorial to the Murdered Jews of Europe*, but when the German commissioning agency began to place restrictions on elements of the design, Serra

116 Richard Serra, *Gravity*, 1991, steel.

pulled out of the project. During the past two decades, however, Serra has created several sculptures related to Holocaust remembrance, all in his typical style: massive, minimalist site-specific structures. Installed next to the Berlin Philharmonic, the abstract, two slab, Cor-ten steel *Berlin Junction* (1987) memorializes those who lost their lives at the hands of the Nazis. *Gravity* (illus. 116), a 25-cm-thick slab of standing Cor-ten steel, was made on commission for the Hall of Witnesses at the United States Holocaust Memorial Museum in Washington. The title has multiple implications: the gravity of the evils perpetuated by the Nazis, the gravitational forms that keep the large piece erect, and the derivation of the word 'grave', in evocation of the mass burials of Holocaust victims.

Among other works associated with the Holocaust, Serra made two sculptures referring to survivor Primo Levi, one titled after Levi and the other called *The Drowned and the Saved* (1992) after a chapter in *Survival in Auschwitz*, Levi's memoir about his Holocaust experience. The former sculpture was exhibited at the 1995 Whitney Biennial, and the latter originally appeared in the abandoned Synagogue Stommeln in Pulheim, Germany, a locale where Sol LeWitt (1928–2007) also designed a Holocaust remembrance. Both of Serra's sculptures comprised two conjoined steel L-beams that together look like an upside-down 'U' or a bridge. Critic Hal Foster reads the sculpture as

an icon of spanning and passing, and both kinds of movements are intimated here.

There are those who span the bridge, who pass over it, the saved, and those who do not span the bridge, who pass under it, the drowned. These two passages, these two fates, are opposed, but they come together as the two beams come together, in support.[70]

The sculpture's placement also provides evocative commentary: its shape suggests a *bima* (the platform where Torah is read), and its frontal placement, provocatively near the synagogue's original site of the ark, implies the absence of the Torah, its readers, and once-central purpose of the structure.

A very different memorial, George Segal's *The Holocaust* (illus. 117) employs both figuration and allegory. As a first generation Jew whose family was nearly annihilated in the Holocaust – his father arrived in America in 1922, one of seven brothers and the only sibling to leave Europe and subsequently survive – Segal (1924–2000) was an apt choice to sculpt this lament for the destruction of European Jewry. Overlooking the Pacific Ocean from the vantage of San Francisco's Palace of the Legion of Honor (the plaster model for the tableau is on display at New York's Jewish Museum), *The Holocaust* draws on Segal's signature style: stark plaster sculptural figures placed in real environments. Based on photographs of concentration camp victims, including the same photograph of Buchenwald's liberation by Margaret Bourke-White that appears in Flack's

Second World War painting, the memorial comprises ten corpses cast in bronze and then covered in a permanent plaster white patina. Behind a barbed-wire fence, the bodies lie piled on the ground. Some are clothed and some naked. A lone living figure stands as witness – modelled from Martin Weyl, a Holocaust survivor and later the Director of the Israel Museum in Jerusalem. Arranged in a position that can be interpreted as either a star or a cross, the memorial also incorporates three biblical references: the Expulsion, the Binding of Isaac and the Crucifixion. One woman, whose head lies on the ribs of a man, holds a partially eaten apple to suggest Eve with Adam. An older man lying beside a young boy refers to Abraham and Isaac. Abraham covers Isaac's eyes, shielding him from his gruesome fate, a gesture shared by Rembrandt in his moving late etching of the story (illus. 11).[71] Finally, with his first and only foray into New Testament imagery, Segal includes a lone figure with his arms outstretched, evoking Jesus crucified. Like other Jewish artists, some described here, Segal used Jesus to signify the martyred Jew. Segal explained that his models for the memorial were 'playing dead, but also acting out a collapsed version of ancient Hebrew Bible stories'.[72] Certainly an apt word, 'collapsed' functions in a twofold manner: the figures enacting the stories are literally collapsed, as the promise of the Hebrew Bible nearly collapsed under the enormity of Jewish

death in the Holocaust. At the installation of the memorial, Segal remarked: 'We stack cans in our grocery stores with more order and love than the way the Germans dumped these bodies.'[73] Even more poignant is the location of Segal's memorial – situated at the tip of Western civilization – the social code of which the Third Reich denied, to cruel and horrifying ends.

As this chapter has shown, artists have responded to the Holocaust with diverse subjects, styles and media. An irreversible chapter in history for many reasons, with the brutality of man and the loss of one-third of the world's Jewry being paramount, the immediate and long-term effects of the war changed all the rules about Jewish identity (that is, those who thought that they were Germans or cosmopolites still were rounded up) and made the case for a Jewish homeland urgent and international, instead of the dream of a few zealots or partisans. For the art world, much changed as well. The war led to a sudden alteration of artistic agenda, concerning a dual dilemma of response: artists' need and desire to respond but simultaneously realizing the awesome magnitude of what could not be represented. That is why artists who otherwise appear with a kind of consistency or predictable development in their 'proper', nationally oriented chapters might appear here as well (for example, Gershuni, Newman), or even only here because of work that focused particularly on the Holocaust (for example, Bak, Rapoport). Indelibly etched in our collective memory, the Holocaust continues to instigate diverse and compelling aesthetic explorations of survival and remembrance, and has offered, to date, the most consistent theme by modern Jewish artists.

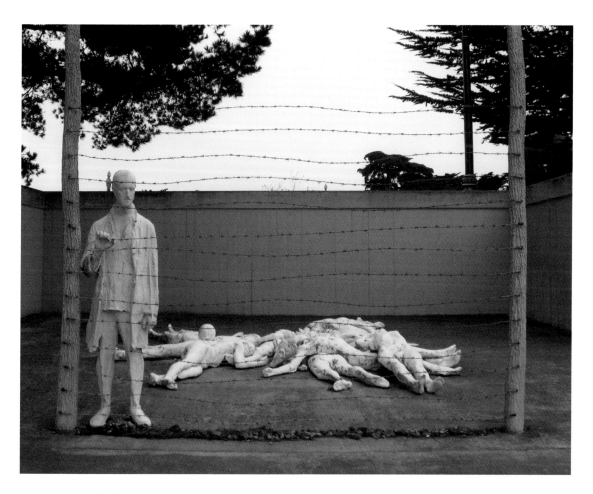

117 George Segal, *The Holocaust*, 1982, 55m² (600 sq ft) site, Palace of the Legion of Honor, San Francisco.

118 Boris Schatz,
Mattathias, 1894 (lost).

6 Home to Israel

It's exile everywhere, there's no distinction.
— YOSEF HAYIM BRENNER, *From Here and There*, 1910

We should not aim towards Israeli painting; we should want painting in Israel.
— YOSEF ZARITSKY

Almost all nations formed during the twentieth century emerged out of dissolving empires, when territories were redefined into new states. Israel, too, emerged from the ruins of the Ottoman Empire and its British successor, which administered the region after the First World War. Yet Israel holds a special place within the family of nations, for as the Jewish homeland it constitutes a country with a complex, dual ancestry. On one hand, it provides an autonomous locality for a people that increasingly defined itself as a nation within late nineteenth-century nationalist movements; the Zionist call of Theodore Herzl was couched in secular terms and confirmed as such by the self-determination promised by Britain's Balfour Declaration in 1917. But it also provides a sacred religious centre, sanctioned by a biblical pedigree and promised in a divine covenant made with the patriarch Abraham. Thus new immigrants came to Palestine, even while it was still controlled by the Ottomans, for both reasons. Many sought relief from oppression and discrimination as a Jewish minority in European countries, especially in Russia's Pale of Settlement. But others, religiously observant, saw their ascent (the literal meaning of the term, *aliyah*) as a form of spiritual fulfillment, an ingathering of the religious community in its historic homeland. Moreover, Israel's declaration of independence in May 1948, followed hard upon the horrific trauma of the Holocaust in Europe, so the new country offered fresh hope and a safe haven for survivors.

Nobel laureate S. Y. Agnon's novel, *Only Yesterday* (1945), presents Palestine from the immigrant's point of view during the so-called Second Aliyah before the First World War. Its dual focus contrasts the secular, sun-baked Mediterranean port of ancient Jaffa with the religious, even anti-Zionist hills of Jerusalem. Next to Arab Jaffa the new city of Tel Aviv was only founded in 1909, whereas Jerusalem remains the city of venerable biblical ancestry and treasured sites, especially the Western Wall and the Tower of David, used even by Marc Chagall in his late religious paintings as the

119 Boris Schatz, *Self–portrait*, *c.* 1930, oil and resin on panel in a repoussé brass frame.

symbol of Zion.[1] Almost from the beginning, in the Land of Israel (*Eretz Yisrael*), even while still called Palestine, art production would oscillate between these two poles: modernist Tel Aviv and traditionalist Jerusalem.

Early initiatives to make art for the region began in Jerusalem after the turn of the twentieth century. The practitioners were recent immigrants, chiefly Zionists from Eastern and Central Europe, who necessarily imported their current visual culture from Europe.[2] In a first concerted effort they established a teaching centre to produce new artists for the future Land of Israel and for display of Jewish art in Palestine: the Bezalel School, founded in 1906 in Jerusalem.[3] It was named after the lone artist of the Hebrew Bible to be designated by name (Exodus 31:1–6), who was described as 'filled with the spirit of God, with ability and intelligence, with knowledge and all craftsmanship'.

Bezalel's founder, Boris (born Baruch) Schatz (illus. 119), had just arrived in Palestine in 1906. Born in late 1867 in the Russian Pale of Settlement, he studied art in nearby Vilna in Lithuania, major centre of the Zionist movement. Soon afterwards he spent time in Paris (1889–95), mentored by celebrated Russian Jewish sculptor Mark Antokolosky (see illus. 39); there he absorbed an artistic outlook that stressed traditional academic training. Before emigrating to the Land of Israel, Schatz spent a decade in Sofia, Bulgaria, newly independent

from Ottoman rule, where he worked to promote art's role in constructing or 'restoring' a national identity through public monuments. This vision of art making derived from a widespread late nineteenth-century notion of national schools, using art to promote solidarity and realize a programme of moral and social influence. Consequently, Schatz believed that truly 'Jewish' art could forge a national consciousness in the Land of Israel and also galvanize collective religious identity and education, akin to Christian art.[4]

Seeking powerful figures from Jewish history, already in Paris Schatz developed sculptural projects around biblical leaders: Moses and Mattathias, leader of the Maccabee Revolt. Most of his early works from this early period, such as *Moses on Mount Nebo* (1890) and *Mattathias* (illus. 118), have been lost and are known only from photographs. *Mattathias*, his most celebrated large sculpture, appeared the same year as the Dreyfus trial (see chapter Two), and later it became a much-reproduced symbol for burgeoning Zionist sentiment. Cast in bronze, it shows the old patriarch trampling the body of a Greek soldier and upraising his arms to display a knife and issue a clarion call to arms.

Mobilized like many Jews throughout Europe by the horrors of the 1903 Kishinev pogrom, Schatz returned to Jewish subjects, presenting stereotyped Jewish figures in terra-cotta reliefs with Hebrew inscriptions and

sentimental titles (*One of the People of the Book*, 1904, *The First Mitzvah*, 1904). Schatz's concept of art as a key element in Jewish culture was influenced by writer Ahad Ha'am (Asher Ginsberg), who promoted the idea of building 'cultural Zionism' through spoken Hebrew in the diaspora.[5] Ahad Ha'am's most famous essay at this moment, 'Zionism and Jewish Culture', was published in the new Zionist journal *Ost und West* in 1902.[6] Schatz first met Theodor Herzl at the Fifth Zionist Congress in Basel in 1901, an occasion also celebrated for its special exhibition of Jewish art, organized by Martin Buber, which explicitly aimed to identify and define Jewish elements in visual art.[7] From this inspiration Schatz determined to make *aliyah* to Palestine and establish the art school Bezalel. In 1904 he marked his intention with a memorial relief of Herzl's already famous profile, combined with a small replica of Schatz's own image of *Moses on Mount Nebo* for, like Moses, Herzl never got to visit the Promised Land. During a fateful year of 1905 Schatz lived in Berlin and met such important Zionist figures as Otto Warburg, later President of the World Zionist Organization, as well as Ephraim Moses Lilien, accomplished printmaker and Zionist illustrator (see illus. 37). Together they founded Bezalel on 8 October 1905.

From its inception Bezalel was a school devoted as much to crafts as to fine arts, partly because of the traditional importance of crafts in the Jewish art tradition. But crafts also gained prominence within a general reassertion of the decorative arts across Europe at the end of the nineteenth century, particularly under the influence of the Arts and Crafts movement in England and the Jugendstil in Vienna, which played so large a role in the organic forms employed by Lilien.[8] Thus, Bezalel encompassed carpet weaving (because of the importance of rugs in the Middle East), as well as metalwork (based on Yemenite skills), plus woodcarving, basketry, graphic arts (including lithography) and photography. Some of its finest products showed progressive, Central European design, led by illustrations by Lilien and impressive posters and graphic designs by Ze'ev Raban (1890–1970).[9]

In 1908 the Bezalel building opened, and the school became an early advocate of Hebrew, still relatively unfamiliar in Jerusalem. Soon, however, conflicts over Bezalel's mission led to disagreement between Schatz and his Berlin board of directors, whose more practical, commercial notion of marketable art favoured a self-sustaining institution. But the crafts industry revival in Europe had no local tradition in Palestine; nevertheless, Schatz maintained his utopian dream of providing a spiritual centre for new, 'Hebrew' artists, producing works with Jewish content. He spoke of the artist as a free worker in crafts 'that can express his spirit and personal taste, crafts that require a new, attractive look, with

their own special Hebrew, Land of Israel style'.[10] Schatz continued his belief in a traditional art academy with an accompanying museum (which eventually formed the nucleus of the new Israel Museum in Jerusalem after 1965), but his stern authority limited the range of art influences tolerated at Bezalel. Certainly, modernism in its various guises was forbidden, as Schatz put it:

> 'Modernist art' is a mixture of feigned innocence, veiled cynicism, hints of stupidity, superannuated romanticism, prosaic inclinations, infantile incompetence, crude lack of culture, a flood of phraseology, and shameless *chutzpah*.[11]

Bezalel's finest products remained decorative works, conceived like the works of the Wiener Werkstätte at the turn of the century, products of refined design, realized in expensive, well-crafted materials. Often these Bezalel works were conceived for placement in synagogues. One extravagant case, a Torah ark, was begun in 1915 and completed in 1923, with the input of 100 students.[12] Another masterwork, *Elijah's Chair* (illus. 120), was designed by Polish-born Raban (born Wolf Rawicki) in 1916 and only completed in 1925, around the time of the Tower of David exhibition in 1925. Fulfilling the requirement of a space reserved for the prophet Elijah in every ritual circumcision, it provides unusual luxury in its use of exquisite woods, metal, ivory and mother of pearl for its delicately carved reliefs as well as armrests shaped into the lions of Judah.

The year 1929 brought not only a worldwide Depression but also disturbing Arab riots throughout Palestine (especially in Jerusalem and Hebron). The Bezalel School of Arts and Crafts temporarily closed its doors, and the new Jewish Artists Association (*agudat ha-amanut ha-ivrit*), founded mainly by Bezalel artists in October 1920 in Jerusalem 'to instill the taste for beauty in the Jewish spirit', moved definitively to Tel Aviv.[13] Schatz died in 1932 while in America on a fundraising tour. The initial impetus of Bezalel ended.

Pioneering art-making in Eretz Israel would have to find other outlets. The historical break is easy to mark. In April of 1921 an international exhibition of arts and crafts was opened at the historic Tower of David, converted into a gallery to display works chiefly by teachers at Bezalel. But in 1922 at the very next Tower of David exhibition, several former students, including Reuven Rubin (1893–1974) from Romania, who had dropped out of Bezalel a decade earlier and moved to Paris because of Schatz's dictatorial taste-making, received public acclaim, precisely because of their rebellion against the academic, conservative imagery. Russian-born but raised in Tel Aviv, Nahum Gutman (1898–1980) was another Bezalel student, although he also trained in Vienna, Paris and Berlin. Gutman would recall in his memoirs:

120 Ze'ev Raban, *Elijah's Chair*, 1916–25, walnut wood, leather, woollen carpet, embroidery on silk and velvet, ivory, shell, cameo, silver filigree, enamel, brass repoussé.

We didn't just want to paint solemn Jews in synagogues or at the Western Wall. We wished to depict the country's landscapes and their different hues . . . We sensed that only one thing would bind us together . . . a love of the landscape . . . Painting landscapes in sharp, frothy colors.[14]

As Gutman's harsh critique of Bezalel's outmoded dominance suggests, these younger artists, recently arrived or returned from Europe in the 1920s, began to make their mark as independents. Consequently, the third Tower of David exhibit in 1924 showed the two groups in separate rooms, divided between 'old' and 'new'.[15] Unsurprisingly, the young avant-garde soon settled in rapidly growing Tel Aviv, dubbed by Zionists 'the first Hebrew city in the world'. In 1928 after the seventh exhibition, the energy of the Jewish Artists Association had shifted, together with their leadership committee, to Tel Aviv, so the burgeoning city became the region's cultural centre, also home to the newspaper *Ha'aretz* and the new *Ohel* Theatre.[16] That theatre would host an 'Exhibition of Modern Artists' in January 1926, the first sign of a developing and lively art scene, which still thrives in Tel Aviv.

Gutman's quote also signals characteristics of progressive art in Eretz Israel. Many Tel Aviv artists did in fact depict the country's landscapes, such as the views of both Jaffa and Jerusalem painted by Reuven Rubin, still

considered the epitome of the new generation of painters who emerged in the 1920s.[17] Rubin had spent a year at Bezalel in 1912, and his 1915 title page for the Romanian Zionist journal *Hatikvah* (illus. 121) extends the European design of Lilien. It already presents flanking dual figures who would dominate myths of the Land of Israel in the twentieth century. At the right, beneath bending cypresses, the quintessential Mediterranean tree often associated with cemeteries and memory, stands a timeless bearded patriarch with his youthful guide, whose pointing gesture leads the gaze to an emerging future in Zion. The journal's Hebrew title, placed within a Star of David, or six-pointed star, appears in the centre of the image.[18] Opposite on the left, under a palm tree stands a pioneer, shading his eyes from the brilliant sun as he rests upon a spade in the midst of his labours of planting

121 Reuven Rubin, *Hatikvah* title page, 1915.

new trees. Pioneers and patriarchs, both rooted in the land.

After studying at Bezalel, in 1913 Rubin spent a year in Paris, then a decade in Romania and even in New York, where he caught the notice of Alfred Stieglitz. Shortly after his return to Palestine in 1923, he mounted one-man exhibitions at the Tower of David in Jerusalem and the Gymnasium Herzliya in Tel Aviv. His painted countryside views also included current inhabitants, presenting their exotic and oriental aspects, whether in the Arab village of Ein Kerem or the Hasidic population of historic Safed, while also painting both historical Jaffa and modern Tel Aviv. Yet Rubin's images of Jerusalem emphasize the Temple Mount and the ancient walls, a timeless vision rooted in the past rather than a living modern city familiar to the former Bezalel student. Like depictions of the American Indian as the literal, autochthonous embodiment of the 'native' in the land, Rubin represents Arabs with their donkeys or goats, or alternatively, he shows Orthodox figures in Safed, cradle of Jewish mysticism in the Galilee.

In truth, retrospective art historical claims of 'modernism' for the forms of Rubin and his peers seem exaggerated, except as a contrast to most Bezalel artists; however, Rubin's bright colours and simplified forms have been justly compared to Parisian art of the teens and 1920s, by such Mediterranean-oriented painters as Henri Matisse.[19] For a century in European and American painting, landscape had been a principal subject for pictorial experiment by a painter through representational means. Certainly this new engagement with the physical setting of Palestine or with its principal sites as settlements on that land marked a major departure from Bezalel's more religious form of nostalgic Zionism.

As part of this discussion of early landscape in the Land of Israel, one should also emphasize the importance of graphic arts within the immigrated Germanic artistic community – particularly their specialization in elaborate landscape drawings. One celebrated figure, Anna Ticho (1894–1980), had arrived from Austria in 1912 during the Zionist wave of the Second Aliyah. Her home outside the old city walls of Jerusalem still remains a major cultural centre and houses many of her works: dense charcoals, produced over the entire course of her career. Ticho depicts empty, uninhabited panoramas of the Judaean hills beneath extraordinarily high horizons (illus. 122); her deliberately calibrated contrasts convey the whiteness of Jerusalem stone, accented with dark patches of scrub brush with a rich variety of strokes, redolent of the varied penwork of Vincent van Gogh. Another Austrian artist, also a major architect who worked in the International Style, Leopold Krakauer (1890–1954) arrived from Vienna in 1924 and like Ticho chiefly worked in charcoals to depict his signature thistles and craggy olive trees on

122 Anna Ticho, *Jerusalem*, 1969, charcoal on paper.

otherwise empty sheets. These motifs provide meaningful and picturesque still-life symbols of the land, akin to the prickly-pear cactus, whose Hebrew name, *sabra*, came to be a namesake for native-born Israelis. Cacti suggest the harshness of the climate and the attendant suffering but also reveal an adaptabilty, complemented by surprising internal sweetness.

Much early art in the Land of Israel was figural, loosely characterized as a modern form of Orientalism, or sentimentalized stereotyping of Middle-Eastern dwellers as sensual and natural, if less civilized figures. Arab labourers are portrayed as the human embodiment of the land itself, suggesting a different, regional model for the new 'Hebrew' settler (rather than a traditional, religious Jew of Europe) to become a pioneer (*chalutz*) in the region, like Lilien's Zionist Congress figure (see illus. 37) or Rubin's *Hatikvah* image. This visual ideology

was characterized at mid-century by Israeli art critic and one-time director of the Tel Aviv Museum, Haim Gamzu:

> We await the expression of the sensations of the new man in Israel. Our movement of renewal is connected, so it has turned out, with land, with working the soil, with a nature which does not easily submit to authority, a nature that frequently rebels and longs for the desert of yore . . . It is in this atmosphere of blending the present with the past that man in Israel lives; it is in this atmosphere that the artist in Israel lives.[20]

Epitomizing the natives-in-the-land theme by Reuven Rubin is his ambitious triptych of 1923, *First Fruits* (4 m/13 ft in total width, illus. 123).[21] Against a simplified, barren, but bright landscape backdrop, heroically large figures stand as archetypes of regional activities. Arabs in the side panels present a desert pastoral: on the left panel, *The Shepherd*, a flautist tends his flocks of sheep before a lone cypress; on the right, *Serenity*, a Bedouin sleeps before the *sabra* cactus, while in the lower corner his large dromedary echoes his curving silhouette. Both figures wear the long robes, *jelabiyas*, of the Middle East. In the centre, *Fruit of the Land*, a tighter group at left wears distinctive costumes, usually identified as Yemenite and holds a characteristic fruit of the region, a

pomegranate, standard image of fertility, which reinforces the presence of the child on its mother's shoulder. For the other woman, the identification with the land is even stronger, since she and her male companion form a pioneer European couple: a strong, shirtless, tanned man seen from the back and a paler, full-breasted female companion. They represent a continuing Jewish presence in the region as the principal focus of the artist, and their labours as farmers have been rewarded by the eponymous fruits: a basket of oranges (still the Israeli produce *par excellence*) on the ground beside the kneeling woman; and the combination of a large melon and a bunch of bananas, both borne by the muscular male. But these figures do not wear the typical costumes of farmers; rather, their gender opposition and complementary poses suggest an even greater archetypal significance, as if a first couple in a Paradise Regained. Indeed, their bodies provide sexual paragons – buxom female identification with nature itself and muscular masculinity releasing that inherent fertility. His powerful physique exemplifies the new ideal of a 'muscular Judaism', whose firm national foundation will result from physical strength and labour on the land.[22] Yet this paradise is of their own making. Their produce reveals the fecundity of this otherwise barren land, the cliché of the desert made to bloom through their efforts, understood in an entirely positive sense (and, by implication, not fostered

123 Reuven Rubin, *First Fruits*, 1923, oil on canvas.

by the efforts of Arab shepherds or Bedouins). Behind them, a strip of farmland shows the sprouts of promising future harvests.

A few years later, Rubin declared in prose the sentiments that he painted into *First Fruits* in his article about the fulfillment he found in Palestine, 'I Find Myself':

Here in Jerusalem and Tel Aviv and Haifa and Tiberias, I feel myself reborn; here, life and nature are mine; the grey clouds of Europe have disappeared; my sufferings, and the war, too, are ended. All is sunshine, clear light, and happy creative work. As the desert revives and blooms under the hands of the pioneers, so do I feel awakening in me all my latent energies. I live with simple people . . . with milkmen and farmers . . . The men here are simple dreamers; life is full of surprises for them; everything is new and their wide open eyes regard the world with wonderment. I have pitched my tent on these ancient hills, and my desire is to tie together the ends of the thread that history has broken.[23]

The forms used by Rubin certainly evoke the contemporary French artistic 'call to order', mentioned earlier, but his Orientalist vision of the country really does not differ greatly from the Jugendstil sensuality of the countryside encapsulated in Ze'ev Raban's idyllic poster of 1929, *Come to Palestine* (illus. 124), designed for the Society for the Promotion of Travel in the Holy Land. Under a fruitful palm and beside a flowering fruit tree a pair of biblical-type figures with their goats overlooks an Arab settlement from a hillside with flowing streams before the wide Sea of Galilee at Tiberias. In a painted stone frame underneath the scene is a verse from Song of Songs (2:11–12) exalting the Land. By combining Zionist themes with

biblical matter, Raban aimed to reinforce the Jewish-Israel connection, typical of many Bezalel artists.[24]

European sources for Rubin's powerful figures have been evoked in the stark, colourful presentation of large Tahitian exotics by Paul Gauguin or the Symbolist allegorical figures by Swiss artist Ferdinand Hodler; however, Rubin's figures, with their suggestions of indigenous links to the land itself recall even more strongly the contemporary murals for Mexico devised by Diego Rivera, which were likewise intended to display the roots of national identity and regional tradition for the new Mexican state, established by revolution in the early 1920s.[25]

Rubin was not alone in his vision of figures inhabiting but also embodying the natural setting of Palestine. Gutman in particular uses the same stereotypes to evoke equivalent senti-ments. His *Siesta* (1926) shows a full-bodied Arab couple resting in the field during a harvest; their own rounded forms echo the brown hills of the setting, complemented by golden mounds of wheat and a fertile green patch of farmland. Dressed in primary colours, this well-earned rest in the heat of the Medi-terranean day recalls peasant images by Pieter Bruegel and by French nineteenth-century painters, such as Jean-Francois Millet, but also by contemporary French artists. Another image of indigenous Arabs by Gutman, a pair of large, complementary pendants (illus. 125–6), shows a male goatherd and female harvester.[26]

Again we see the two main agricultural activities practiced by Palestinian Arabs: Bedouin herding and *fellahin* wheat-growing. This juxtaposition also returns to the primal professions of biblical times: Cain the grower versus Abel the shepherd. Gutman's sturdy female figure shows the paradigmatic strength of an ancient Greek caryatid figure as she carries her sheaves. Additionally, her large water jug recalls biblical episodes like Rebecca at the well, but also more primal images equating women themselves with 'the source' (for example, Jean-Auguste-Dominique Ingres; Pablo Picasso); moreover, women, often shown nude, are traditionally associated with water, partly because of their humoural characteri-zation as moist and cool.[27] Thus this Arab woman in her labours on the land comes to stand for the land itself, natural as well as primal.

Her male counterpart wears a red fez and wide belt; he stands on a hill above the view of an Arab village by the seashore. His striding posture, emphatically archaic, derives from ancient reliefs from Egypt and Assyria, which show a frontal torso and profile head and hips. In contrast to Rubin's somnolent Arab shepherd with his flute, Gutman's herder presents an ideal of sturdy, strong masculinity for his type of the indigenous Arab male.[28] Such a sentimental, positive view would disappear not only with longer exposure to the natives of the Land of Israel on the part of its immigrant

124 Ze'ev Raban, *Come to Palestine*, 1929, lithograph.

125 Nachum Gutman, *Goatherd*, 1926, oil on canvas.

126 Nachum Gutman, *Bearer of Sheaves*, 1927, oil on canvas mounted on cardboard.

artists, but would be rudely shattered by the bloody Arab riots across Palestine in 1929, a disturbing watershed in regional relations.

A younger generation of artists, many of them born in the region, began to devise a new nationalist ideology in the 1930s, emphasizing the 'New Jew' in contrast to the perceived, weaker diaspora immigrant of the past. Now the Middle East with its ancient traditions was favoured at the expense of the art traditions of Europe, seen as an old culture in decline.[29] This viewpoint reinforced the growing cultural resistance to British occupation amidst heightened tension with neighbouring Arab communities. Thus younger artists, including a number of writers, in the Land of Israel celebrated their own roots in both antiquity and myth of the region, stressing their distinctiveness from the religious motivations of Aliyah Zionists. Calling themselves 'Canaanites', they claimed that the religion of Judaism had been forged in the Babylonian exile and conditions of diaspora after the fall of the biblical Kingdom of Judah. As a result, they embraced coexistence with pagan religions and emphasized archaic forms as authentic recovery of their primitive past.

The hallmark image of this movement was a sculpture: *Nimrod* (illus. 127) by Yitzhak Danziger (1916–1977), whose family had arrived in Palestine from Germany but who later studied in London before his ultimate *aliyah* in 1937. That simplified figure in half-length resembles an archaeological fragment; its schematic eyes

and reduced body modelling align this work with modernist emphasis on the 'primitive' (an idea influential on other Jewish artists, including Jacob Epstein and Amedeo Modigliani). This uncircumcised nude points to a pagan past and accords closely with the stone carvings of Egypt. Danziger chose to carve in Nubian sandstone imported from Petra, both for its regional resonance as well as for its rejection of the materials of marble and bronze prized in the Renaissance tradition. According to Genesis (10:9–9), Nimrod was the son of Cush, 'a mighty hunter before the Lord'. His role as hunter is reinforced by the presence of a hawk on his left shoulder. Thus, as with Rubin's and Gutman's figures, Nimrod's physical strength in living off the land provides another indigenous role model. Moreover, his primordial presence in the land is attested in the biblical text.

At this point, the artistic and cultural battle lines of what constituted authenticity in regional art had been clearly drawn. To some extent the linguistic contrast between European Yiddish or Ashkenazi culture, imported with immigrants from the diaspora, contrasted with a desire to construct a new homeland, a Hebrew culture of *sabras*, 'New' or 'muscular' Jews, working the land as pioneers to make the desert bloom.[30] We have already seen this division played out through the contrasting artistic centres – religious Jerusalem versus modernist Tel Aviv. However, many social

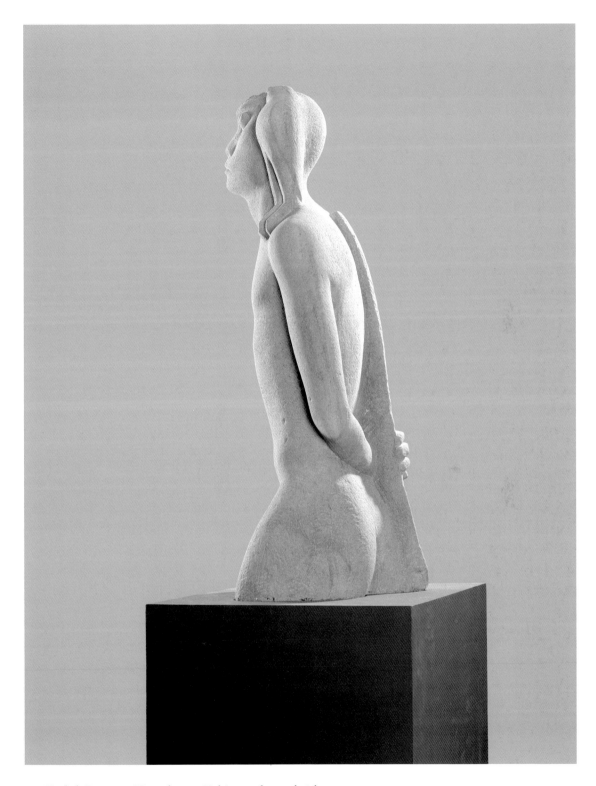

127 Yitzhak Danziger, *Nimrod*, 1939, Nubian sandstone, height 90 cm.

tensions in the emerging Jewish state, which achieved independence in 1948, were elided by this reduction to Hebrew versus Jewish or homeland versus religion.

In Eretz Israel the suffering endured during early pogroms in Europe held only a limited visibility, manifest particularly in the paintings of Samuel Hirszenberg, notably *Wandering Jew* (illus. 140), a featured work at Bezalel, where the artist came to teach.[31] Such suffering and exile, magnified many times over by Holocaust trauma, were largely denied culturally within art of the region after the Second World War, despite the influx of survivors (see chapter Five; with some exceptions, for example, Samuel Bak and Mordecai Ardon). Of course, the founding ideal of muscular Judaism later came to assume the form of national military defence, providing for 'security' against aggressions by neighbouring Arab countries (see below).

This more complex society and ideology of the new nation of Israel are conveyed best during the period right after independence.[32] During these years, many Israeli painters strove to paint large, Israel-inflected variations on Pablo Picasso's 1937 canvas depicting the tragedies of the Spanish Civil War, *Guernica*.[33] A good example is Marcel Janco's (1895–1984) monumental *Death of the Soldier* (1949), a theme he addressed many times from 1948 to 1952. Painted in the blue national colour but with Picasso's same jagged facets and broad gestures of suffering, Janco transposes the idiom of *Guernica* to depict Israeli troops, martyred in the defence of the new nation in the war of independence. Janco, a Romanian veteran of the radical art movement Dada in Zurich during the First World War, had fled from the Nazis and immigrated in 1941. His energetic imagery is filled with patriotism, which infuses another work of the same moment, *Genocide* (1945), an expression of the painter's grief and outrage at Nazi atrocities. Janco also represented the harsh life of a refugee camp, so basic to the new immigrant experience in the years right after the Second World War, by showing an angular tent city within a bright landscape, (*Ma'abara*, 1949). To promote a new, communal setting for truly Israeli art, in 1953 he founded Ein Hod, a hillside artists' colony in the Carmel range near Haifa, which still continues.

One powerful new artistic agenda emerged from the workers' movement in the independent country, through figural paintings made in the nation's third major city: 'red' Haifa, an industrial and shipping centre. There a group of artists formed a Circle of Realist Painters with a Marxist ideal of societal critique (but without the hackneyed forms of Socialist Realism). They sought to produce mural projects, like Diego Rivera in Mexico or Ben Shahn in the USA during the New Deal. Shimon Tzabar, an artist in the group, declared:

In speaking of the popular masses, and of social art, we are obliged first of all to see

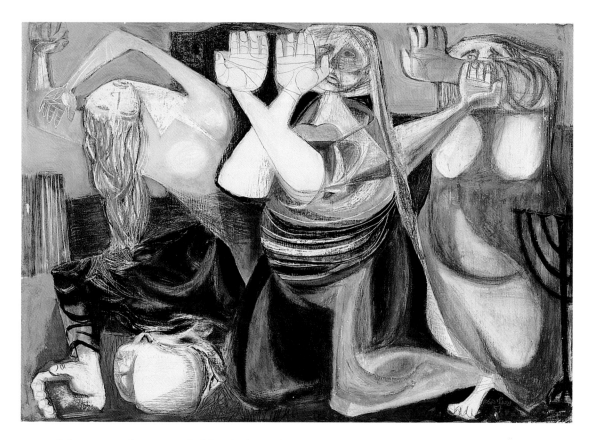

128 Naftali Bezem, *In the Courtyard of the Third Temple*, 1957, gouache on cardboard.

as art's subject and object all the inhabitants of this country – the new immigrant, the Arab worker and peasant, the young man locally born.[34]

Naftali Bezem (*b*. 1924), another youthful refugee from Nazi Germany, forthrightly presented the horrors of the Holocaust in visceral paintings of the same period with such titles as *Mass Grave* (1955) and *Pieta* (early 1950s). Later he designed sculpted reliefs for Yad Vashem, the Jerusalem Holocaust memorial, entitled *From Holocaust to Rebirth*.[35] But Bezem also

painted a still more confrontational subject, the massacre of Arabs at the village of Kafr Qasim, his *In the Courtyard of the Third Temple* (illus. 128).[36] This large image in gouache was a design intended for a mural. Silhouetted against a blue sky, three lamenting women are featured, kneeling and keening with expressive gestures of grief; beneath them in the lower left corner lies a foreshortened prostrate bald, older man, who still clings vainly to his Israel identity card. By placing Arab mourners rather than Jewish Israelis as the subjects of his image, Bezem accords them

status within the new nation, yet he also includes in the lower right corner an empty menorah, the national symbol but also a reference to the destroyed Second Temple of Herod. In a 1982 interview Bezem declared:

> There can also be an Israeli-Arab art. After all, there are Israeli Arabs, and I would welcome it if there were a development of Arab painting of a high standard, with an artistic Arab framework, which would express the feelings of the Arabs.[37]

While Bezem and others were focused on socially conscious creations, another, more influential artistic movement, collectively known as 'New Horizons' (*Ofakim Hadshim*; 1948–63), set out its own redefinition of painting in the new nation of Israel. Interested more in (usually abstract) form than subject, New Horizons artists aimed to make paintings that would rival progressive work in Europe and New York. Janco's geometric, figural, Cubist-influenced imagery initially exemplified one pole of the New Horizons group, but the other, longer-lasting ambition comprised atmospheric lyricism, epitomized by the work of Yosef Zaritsky (1891–1985). Initially Zaritsky, a dominant figure for modern Israeli artists, specialized in watercolour landscapes emphasizing bright Mediterranean light, chiefly around Jerusalem. Indeed, New Horizons artists, despite their cosmopolitan

and universal ambitions, still retained a close connection to the Land, even as they rejected all other anecdotal and narrative connections – especially the pervasive naive Orientalizing of Rubin and his contemporaries.

Zaritsky's personal evolution has come to provide the standard account in microcosm for the general development of Israeli art.[38] Trained in Kiev, he first immigrated to Jerusalem in 1923 before he resettled in Tel Aviv in 1927; eventually his sense of progressive art-making led him to adopt abstraction after mid-century, based upon Tel Aviv's landscapes as viewed from apartment rooftops. Around the mid-1940s Zaritsky adopted an approach subsequently dubbed 'lyric abstraction', which influenced other Israeli artists, including Avigdor Stematsky (1908–1989) and Yehezkel Streichman (1906–1993). One of Zaritsky's numerous renderings of Kibbutz Yehiam, painted from 1949–51 (illus. 129), exemplifies his interest in local light within an abstract pictorial space, conveyed through layered painterly strokes and subdued colours, keyed to grey-greens and earth tones.

An acclaimed second generation of New Horizons artists continued to practice abstraction, often in more austere forms. Polish-born Moshe Kupferman (*b*. 1926), for example, worked at times in a minimalist, nearly monochromatic style, within a system of ruled grids. This structure has been interpreted by some as recalling concentration

camp barbed wires (he was the only member of his family to survive the Holocaust), by others as the scaffolding of Kibbutz houses he helped build.[39] Simultaneously, a number of successful Israeli artists rebelled against New Horizons, including Raffi Lavie (*b*. 1937), who rejected traditional oil panting. Influenced by current American art, especially Robert Rauschenberg's collages, Lavie fused elements of the international avant-garde with local Israeli interests. Lavie also founded the group 'Ten Plus', which held influential exhibitions that invigorated the Israeli art scene with new work, particularly affected by Pop artists Rauschenberg, Larry Rivers and Jim Dine.

Lavie's contemporary, Igael Tumarkin (born in Berlin, 1933) produced a powerful, often three-dimensional fusion of abstraction imbued with a socially critical message. He fashioned one of the foremost monument projects in Israel, Tel Aviv's Holocaust memorial (1974–5), a controversial rusted iron and glass, inverted pyramid in Rabin Square. Tumarkin's materials and medium vary greatly according to the project. *He Walked in the Fields* presents a life-size bronze sculpture of a soldier, whose partially naked body is penetrated by weapons (illus. 130). Made in 1967, immediately after the Six Day War, a triumphant victory for the Israeli army, this sculpture expressly aims to explode a foundational myth of Tumarkin's country – the heroic soldier.[40] The title parodies Moshe Shamir's iconic Zionist novel *He Walked*

in the Fields (1947), also made into a movie, which offers a celebratory tale of a *sabra* soldier. Tumarkin's sculpture, on the other hand, presents anything but a heroic warrior. Humiliated, stripped of clothes from the waist up, the soldier stands in his army fatigues and boots, his penis revealed and limply hanging. His maimed body is ripped to shreds, a helmet appears lodged in the his stomach, and both his tongue and trachea are visible, painted bloody red.

Numerous immigrants from Germany and Austria also gathered in Jerusalem during the rise of Nazi power to form a new artistic community. Mordecai Ardon, described in depth in the previous chapter, arrived in Jerusalem in 1933 as a Galician-born *émigré* from the Bauhaus of Weimar Germany. Trained by Paul Klee and Wassily Kandinsky, among others, Ardon taught at, and eventually became director (1940–52) of a revived Bezalel, which reopened in 1935 and was dubbed the 'new Bezalel' (led by Josef Budko from 1935–40). Ardon's background in the practical and modernist nature of Bauhaus art certainly pervaded the 'new Bezalel', while he emphasized colour in his own work. His early landscapes demonstrate his preference for glowing colouration (illus. 131), partially indebted to his idol, Rembrandt. Later, Ardon incorporated recurrent symbols suffused with spirituality and mystical ideas derived from Kabbala to create complex, jewel-like imagery.

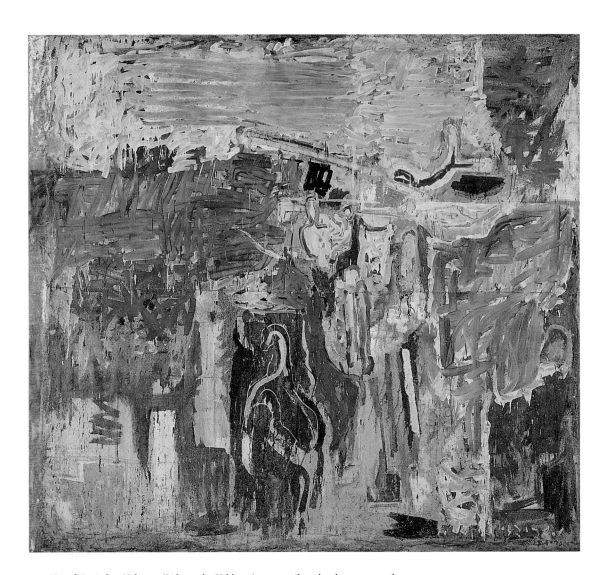

129 Yosef Zaritsky, *Yehiam (Life on the Kibbutz)*, 1951, oil on burlap mounted on canvas.

130 Igael Tumarkin, *He Walked in the Fields*, 1967, bronze and paint, height 175 cm.

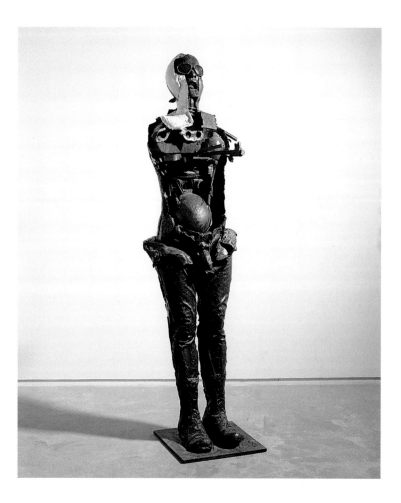

Avraham Ofek (1935–1990), an immigrant from Bulgaria in 1949 and the youngest of these artists active right after independence, worked alternately between Jerusalem and Haifa. His early *Cemetery in Jaffa* (1955) uses an empty landscape to contrast man-made, white, Muslim gravesites with the native green *sabra* cactus, which grows tall and expands beyond the confines of the picture. This juxtaposition symbolically enacts the conflict for space and dominance in the Land of Israel between the Jaffa Arabs and the increasing Jewish population.

But for a couple of memorable decades in his later career Ofek was able at last to realize those large-scale mural projects that eluded Bezem.[41] While some of his murals are in remote Kibbutzim, several of them are

131 Mordecai Ardon, *Valley of the Cross*, 1939, oil on canvas.

in public sites in the country: the Central Post Office of Jerusalem (1972), Tel Aviv University Library (*Return to Zion*, 1976), and finally a climactic entrance mural (6 × 41 m; approx. 19 × 134 ft) for the new campus of Haifa University (illus. 132–3), his masterwork, entitled *Israel – Dream and Reality* (originally titled 'The Dream and its Meaning' in Hebrew).[42] Ofek's retrospective Haifa mural encompasses both

his four decades in his adopted country as well as its own four decades of independent statehood. In a continuous frieze, as the title suggests, the mural has two main divisions, within which it presents highly distilled, symbolic figure groups for viewer interpretation.

Beginning at the right, the direction from which Hebrew is read, 'the Israeli Dream' starts the immigrant experience with a boat. Moving

into the mural, a group of figures represents the new immigrants with a hybrid animal, both lamb and donkey, quintessential practical beasts of the region (and also perhaps an allusion to an all-important theme in Israeli imagery, the Sacrifice of Isaac – see Conclusions). Reclining in the countryside a large, female figure, an earth-mother, resembles allegories of the land painted by Diego Rivera in his Mexican murals. Thereafter farming scenes of work feature foreground symbols redolent of fertile harvest and the fall festival of Sukkot. A plowman with oxen labours before a well laid out settlement of houses, trees and fields. This warmer, more positive half of the mural returns to the *chalutz* ideal of pioneer labour on the land.

On the opposite wall, Ofek's Haifa University mural paints a different, darker picture. It begins powerfully, with a massive, standing, red-bearded figure, backed by the *sabra* cactus. This man is identifiable: the important Hebrew author, Yosef Haim Brenner, a Ukrainian immigrant of the Zionist Second Aliyah, noted pioneer author of Hebrew novels but also remembered as a martyr at the hands of Arabs during a 1921 riot in Jaffa.[43] Representing the call to Zionist labour, Brenner's body is adorned with building construction; he literally embodies 'Hebrew work' in the Land of Israel. Not defined by prayer, this Jewish state-in-formation pursues idealistic labour politics as its core value. Brenner thus personifies a vision of the new nation, to be

built in the region through a new, vigorous, human presence.

Beside Brenner's frontal figure appear helmeted military troops pointing their weapons leftward in profile. Continuing in the same direction, Ofek next introduces explicit allegory in the form of an aged, angry, bare-breasted woman, clearly a negative image, like an avenging Greek fury, who accompanies that army along with a trio of rapacious birds. They drop pebbles like bombs, labelled in preparatory drawings with the Latin terms for curses, bloodshed and punishment, as they approach a barren hillside, an upland of destruction, painted in ashen colours. That hill comprises a realm of death, vices and sins, captioned with their traditional Latin names; it is littered with fragments of heads and body parts (many expressly derived from Picasso's carnage of *Guernica*). Atop this horrific mound stands an artificial animal statue, seemingly constructed out of wood; in his preparatory drawing Ofek seems to conflate the Golden Calf idol and the mythic red heifer that supposedly will herald the coming of the Messiah, according to Orthodox legend.[44] That beast appears with a half-length, cut-off human figure without facial features but with arms outstretched as if in supplication. Although this faceless figure has been seen as either Moses or Aaron in conjunction with the Golden Calf at Mount Sinai, its curious triangular halo and arms in the form of a cross

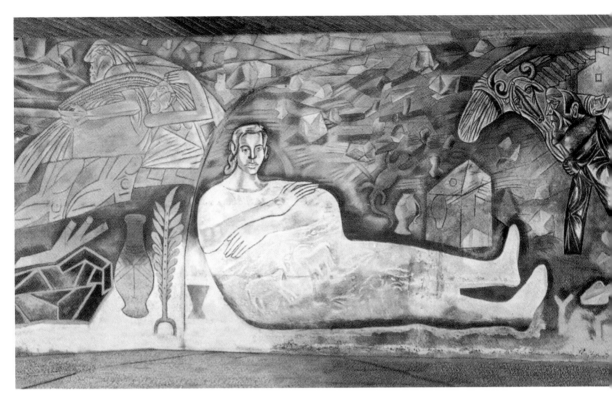

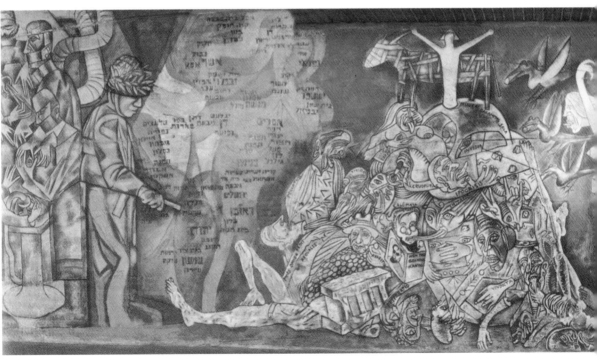

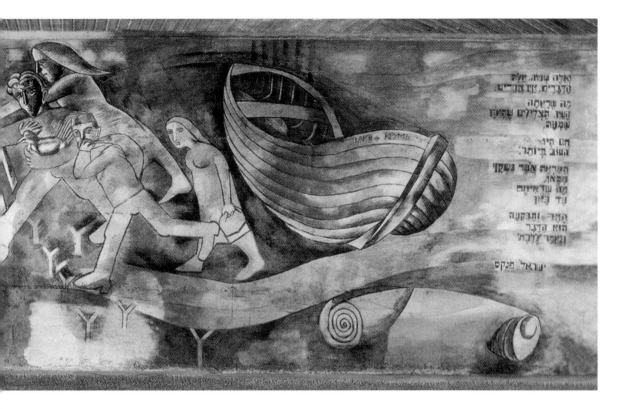

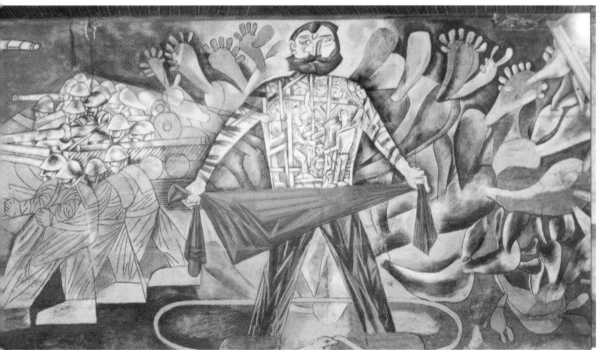

132, 133 Avraham Ofek, *Israel – Dream and Reality*, 1986–7, acrylic on concrete.

suggest instead the Trinitarian aura around Jesus during his mountaintop Transfiguration. Ofek's truncated figure surely remains parodic, utterly incapable of redeeming the sins below. Despite this pair of futile messianic dreams, the massive accumulation of sins clearly displays the faults of Israelis, both materialism and hypocrisy. Beside the pile stands a map of the nation, inscribed with the names of the biblical twelve tribes; however, it too is guarded by a giant soldier.

The remaining quarter of the mural features various forms of education, the life of the mind and of creative arts, which complement active labour on the land from the first half of the mural. A final image, closest to the gateway of the university, shows a scene of childhood education. But the main focus at left depicts adult education, appropriate to the University of Haifa, in the form of an academic art lecture, which even includes among its listeners a self-portrait of Ofek, seemingly absorbed in thought. The central lecturer[45] presents a contrasting pair of celebrated artworks: Danziger's *Nimrod* sculpture (see illus. 127), to which he is pointing, versus Chagall's *Rabbi of Vitebsk*, a quintessential image of European Jewish art, steeped in stereotypes of tradition and the shtetl. Essentially, this contrast underscores the polarities within Israeli art of Zion and diaspora: the hunter hero of the Canaanites, ultimately a nativist movement versus the

traditional religious leader, symbolizing imported, European, Ashkenazic art. Ofek's own preference in the mural favours the indigenous, echoing his earlier emphasis on Brenner's personal campaign to revive ancient Hebrew over the hybrid, imported language of Yiddish.

Ofek's retrospective look at the nation of Israel suggests that modernity has brought the nation its own discontents, vices and punishments as well as the self-fulfilling threat of militarism. His mural's title issue, *Israel – Dream and Reality*, has continued to preoccupy the most recent, native-born generations of Israeli artists up to the present, who increasingly have engaged with the current social conditions of their nation. Of late, younger artists have experimented fully with the entire range of newer media available to contemporary art, including video, installations and multi-media composites, and they have also embraced new subjects. Issues of identity – especially gender, politics and religion – have surfaced as critical concerns within a shifting, increasingly multi-national, multi-ethnic nation. In essence, Israel continues to re-examine, to redefine, its complex founding mandate: to become a 'Jewish state' (though Herzl's own term, *Judenstaat*, can also be translated as 'state of Jews').

The 1970s witnessed a period of transition, when a younger generation of artists surfaced, using vividly graphic representational media,

especially photography and video. They explored intensely personal concerns about the body and gender identity, particularly nascent feminism, ably summed up in Mordechai Omer's title of the retrospective exhibition of 2008, 'My Own Body'.[46] But thereafter a crucially important historical change in Israel's national identity and self-consciousness occurred in the 1980s, in the wake of the country's preemptive invasion of Lebanon and the subsequent massacres that occurred during Israeli occupation (events famously chronicled and revisited in both Thomas Friedman's 1989 book, *From Beirut to Jerusalem* as well as Ari Folman's 2008 animated cinema, *Waltzing with Bashir*). Previously the country had viewed itself as united by political consensus, confident in its military policies and its leadership, viewing itself as a heroic, democratic, Jewish David, threatened on all sides by a collective Goliath of Arab neighbours. But that consensus was broken by the sequence of events unleashed by Lebanon, leading to political factions, often organized according to religious ideology and splintered across the basic fault line of Sephardic and Orthodox religious resistance to earlier dominance by secular Zionists, chiefly Ashkenazic Europeans and their Labour Party.[47] Massive new immigration, particularly by Russians after the end of the Cold War, has further altered Israeli demographics and politics and rendered more

problematic the question of Israel's relation to/dependence on the West. Today in Israel the very identity of the Jewish state – and inherent, intensified tension between religion and nationalism, especially in a pluralistic democracy – is contested as never before, exacerbated by the enduring societal problem of occupation in the West Bank/Palestine and its concomitant demands for military security. No public act held more power to underscore divisions within Israeli society than the sudden, shocking assassination of Prime Minister Yitzhak Rabin by a Jewish zealot in November, 1995, even before the fiftieth anniversary of Israel's independence.

Much of the art of the past three decades has critically engaged these abiding social concerns, often with the military as a thematic fulcrum. For example, the primal subject of Death, in the form of a skull (or a candle), inflects the neutral, framed constructions by Arnon Ben-David (*b.* 1950), whose *Judgment Day* (1990) also uses a contrasting word, 'God' (unutterable, but conveyed through the fifth Hebrew letter, *hey*), to provide a visual dialectic to the viewer.[48] Another work, entitled *Jewish Art* (1988), also juxtaposes word and image; it uses a concrete object, an Israeli submachine gun (fake, plastic), to insert death and force and to pose the basic problem of how to relate life's harshness with art (not to mention the vexed issue of defining 'Jewish art' itself). The artist's alternate choices of

Hebrew and English also exemplify the basic, multi-cultural choices of Israelis, at once both national and international.

An older, more celebrated artist, Moshe Gershuni, still utilizing the detached vocabulary of abstraction, produced a set of etchings, *Kaddish* (1984), explicitly referencing the Jewish ritual of mourning, with fragments of the prayer's words. His *After the Shiv'ah* (illus. 134) still uses abstraction in the form of two, irregular, dark voids (eerily suggestive of the dark hollows of a skull) within roughly textured earth tones on a canvas; its title revisits the process of mourning, specifically the seven-day period of mourning in the home(land). In 1990 Gershuni made a series of broadly brushed paintings of laurel wreaths, traditional symbols of military (or artistic) victory, easily taken as ironic.[49]

Particularly striking in contemporary Israel is photography's power to capture current conditions through representations of both places and figures.[50] Barry Frydlender (*b.* 1954) has photographed some of the most striking representations of settings in Israel with his panoramic views, both of city and country.[51] His individual colour images, assembled from separate images into wide-format, digital composites on a computer, are filled with figures (sometimes repeated in the melding process), and they offer richly detailed surveys of place with multiple perspectives. The very construction of his images

out of component parts defies traditional notions of photographs as documentary. Frydlender's works also span the entire range of Israeli society: devout Orthodox Jews on a pilgrimage, young adults on a busy Tel Aviv street (*Friday*, 2002), a rock concert on a beach (*Bombamela*, 2000), or a group of Israeli soldiers on the shore (*Shirat Hayam*, 2005). All ages and social groups seem represented in his output. One of his most poignant images, *Waiting, 38 Years* (2005; from the provocatively titled series, 'End of Occupation?'), surveys a gathering of Palestinian Arab men and boys along a dusty road, while they watch and wait, seemingly for their own land, prior to Israel's evacuation from the Gaza Strip.

In a trio of photographs of the same place, Café Bialik in Tel Aviv, Frydlender manages not only to suggest the passage of time but also to capture the trauma of the Second Intifada, or Arab uprising, which began in late September 2000. The first of the images (*Café Bialik*, 2000) shows the bustling café, filled with customers both inside and outside along a busy street (again, comprising exposures over multiple moments in their own right). However, *Café Bialik, After* (illus. 135) – consisting of two stacked photographs – captures the painful consequences after the terrorist bombing of that same place, blasted out and cordoned off in different views. The bottom image shows

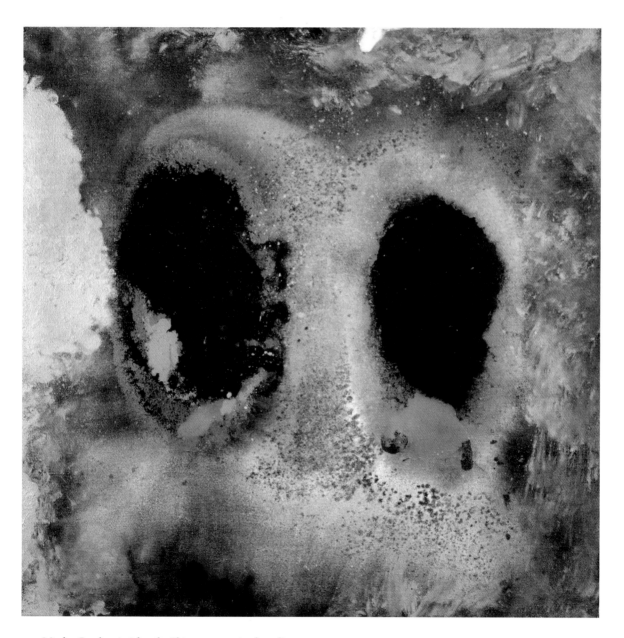

134 Moshe Gershuni, *After the Shiva*, 1995, mixed media on canvas.

135 Barry Frydlender, *Café Bialik, After*, 2002, chromogenic colour print.

the café at the right edge, and onlooking bystanders, including security soldiers, who populate the street while surveying the damage. Thus, even within the spectrum of attitudes toward Israeli-Arab conflicts, Frydlender manages to use on-site imagery and participants in events to convey each side and to show their shifting fortunes over time.

Several figural photographs can serve in conclusion as a complex index of altered Israeli consciousness in the latter part of the twentieth century. The first of these is an iconic Israeli image, *Paratroopers at the Western Wall* (illus. 136), by David Rubinger (*b*. 1924).[52] This documentary work, Israel's equivalent to the American flag-raising image on Iwo Jima from the Second World War, records the heroic sense of liberation of Old Jerusalem, achieved at the culmination of the nation's swift victory during the Six Day

War. This climax is viewed through the emotion-filled, awed faces of a sextet of soldiers, seen from below, with the Western Wall looming up behind them. The youngest of the six men, in the centre, has removed his helmet in respect for the holy site. Even the photographer's own biography provides the national story of Israel in microcosm: born in Vienna, he lost his parents in the Nazi death camps, but still managed to join the Jewish Brigade of the British army when he emigrated to Palestine. There he enjoyed a distinguished career as a photojournalist, starting with the War of Independence in 1948.

During the 1980s, however, Micha Kirshner (*b*. 1947) produced another photo with landmark status but with the opposite valence – an image not of victory, but rather of a suffering mother and child who are casualties of war.

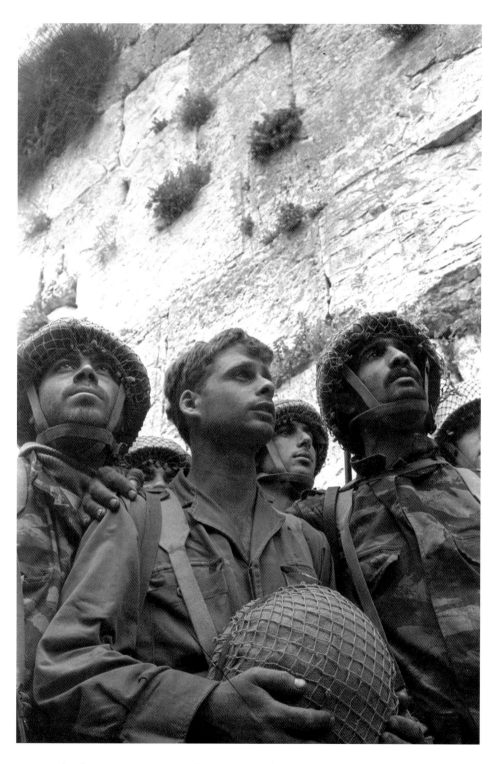

136 David Rubinger, *Paratroopers at the Western Wall*, 10 June 1967, photograph.

Yet in this case, crucially, the compassion of the photographer extends not to an Israeli mother, but to a black-shrouded Palestinian woman, whose silhouette enfolds the sleeping child on her lap. The image, *Aisha El-Kord, Khan Younis Refugee Camp* (1988), recalls traditional Madonna and Child imagery, where intimations of death preoccupy a pensive parent. The profound pathos in this picture also suggests classic Depression-era American photographs of Ben Shahn or Dorothea Lange's iconic suffering migrant farmworker mother. By choosing his subject from the population usually demonized as Israel's implacable enemy, Kirshner crystallizes the nation's intense self-consciousness and divided sentiments aroused by the invasion of Lebanon.

Even the heroic images of the military, epitomized in Rubinger's triumph at the Western Wall, gave way at the end of the century to revised portrayals of soldiers. During the 1990s Adi Nes (*b*. 1966) recast the inherited images of masculinity, extending in Israeli art back to the early Zionist images of pioneer farmers, through his photographic series 'Soldiers' (1994–2000). One of the most reproduced of those soldier images restages Leonardo da Vinci's *The Last Supper* mural with a military group that extends along a table; however, most of Nes's images are quieter, though never without a strong suggestion of self-conscious posing and

137 Adi Nes, *Untitled* from *Soldiers*, 1996, chromogenic print.

a challenge to the usual esprit de corps of a military unit.

A good example of his work is one untitled group (illus. 137), at rest on a dusty hillside. Nes shows these soldiers under sharp artificial side lighting, so this is anything but a candid shot; however, their uniforms are partially unbuttoned, a relaxed state of dress that suggests collective camaraderie at the end of the day. Several soldiers are clapping their hands, like spectators at a performance. But this gesture underscores the one anomalous figure at the left side, prominent in his white undershirt, whose left arm is missing. Despite all the relaxation and equality of this vignette, then, scars also remain in the human landscape of the army. In the twenty-first century,

Nes has returned to his recasting of traditional imagery, this time in the form of biblical subjects enacted by contemporary figures, who raise explicit questions about hot-topic social issues, including gender (*David and Jonathan*, 2006) and social welfare (*Abraham and Isaac*, 2006, see illus. 145).[53]

The harshest realities of Israel's occupation for its military are explored through vivid vignettes by photographers, whose sense of places and people offers a dark counterpoint to the celebratory landscapes with figures of pioneering artists, such as Rubin and Gutman. Two photographers, Roi Kuper (*b.* 1956) and Gilad Ophir (*b.* 1957), have documented abandoned sites, chiefly former military installations, desolate settings with the overall title *Necropolis*, or 'city of the dead'. In similar fashion, Igael Shemtov (*b.* 1952) juxtaposes the natural landscapes with intrusive development or industrialization within their midst. Several photographers and filmmakers have used the defence wall installed in the new century as their primary subject, for meditation on political and cultural separation between contemporary Israel and Palestine.[54]

Beyond such gallery photographs, leading photojournalists have also produced images that cross over art, capturing the immediacy of occupation tensions and conflict.[55] One of them, Pavel Wolberg (*b.* 1966), an immigrant in the wave of Russians from Leningrad, has recorded some of the most fiercely contested grounds of the West Bank (Hebron, Jenin) from the new century. Following up on the precedent of Kirshner for Hebron (for example, his image of a large Palestinian family that lost its house), Wolberg in 2004 records images from the same West Bank site, showing armed soldiers or tanks before defenceless Palestinians. For example, one photo depicts a trio of soldiers with rifles behind a little girl in the foreground, dressed in a wedding costume.

Perhaps the most unequal of his images of Occupation security forces (*Jenin*, 2001) presents a tank at left confronting a Palestinian woman, seen from behind in the right corner; she gestures imploringly with her right hand against an open landscape, the object of contention, even while it still remains the same basic landscape of Palestine first celebrated by Jewish painters in the Land of Israel. Yet Jenin is now the site a Palestinian refugee camp, cleared with bulldozers by Israeli Defence Forces in April 2002, amidst charges of massacres, soon after it was charged with being a source of terrorist attacks during the Second Intifada. As is so often the case in contemporary Israel, both sides claim priority as suffering victims.

The most recent Israeli military venture, its incursion to Gaza after ceding the territory to Palestinians in 2008, also generated powerful images of photojournalism by Rina Castelnuovo (*b.* 1956), also noted for her

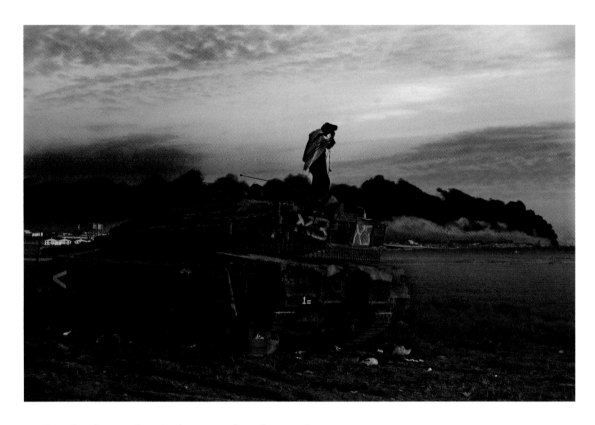

138 Rina Castelnuovo, *Gaza Border*, 2009, colour photograph.

quiet, reflective imagery of religious life. Not only did she record the bombed-out house of an Israeli border town (*Sderot*, 2008), whose missile attacks by Hamas prompted the counter-attack; she also produced some of the most powerful images of the conflict itself. *Gaza Border* (illus. 138), shows an Israeli tank parked in the foreground of the rocky desert plain; at the right horizon a streaming black cloud of smoke rises to record a distant burning building against the colourful glow of a dawn sky. Atop the tank stands an Israeli soldier, dressed in his *tallit* (prayer shawl) and *tefillin* (phylacteries) for morning prayers, which will include the Kaddish prayer of mourning as well as pious praise of God. Here Castelnuovo successfully melds her own two major strands of imagery, but she also manages to personify Israel's tensions between religion and nationalism, between military commands and individual choices, through this lone individual.

Seen against the Rubinger photo and across
the historical and social distance travelled
since the international glory and national
consensus of the Six Day War, Castelnuovo
shows how the former national unity and
consensus now lies smoking in ruins
before Gaza.

139 Alfred Nossig, *Wandering Jew,* 1899, sculpture.

Conclusions: Diaspora and Homeland(s)

And as for us, this is what I believe: even if the form wherein the old Jews were happy no longer offers us any shelter, something of the core, of the essence of this meaningful and life-affirming Judaism will not be absent from our home.
— LETTER FROM SIGMUND FREUD to his then-fiancée Martha Bernays, 23 July 1882

I think a Jew is defined by Diaspora, and not homeland.
— PETER EISENMAN, 2007

'You know I used to be a Jew', said Otto Kahn, an American convert to Christianity.
'And I used to be a hunchback', his companion, a hunchback, replied.
— APOCRYPHAL JOKE

Over the span of two centuries, the new field of Jewish art flourished, but within extremes – whether through self-conscious assertion of Jewish symbols and/or biblical subjects or else through willful denial by Jewish practitioners that their background and heritage even mattered in their creations. Despite the prevailing norm of toleration, during the secular era of modernity and within a Christian cultural majority, Jews were inevitably marked as a minority, never able (or for many never wanting) to disappear fully and assimilate.

Across this period, three paradigms of Jewishness stand out. The first model encompasses the diasporic condition, the role of the eternal migrant, epitomized by the legend of the Wandering Jew.[1] Based on a medieval tale of a Jew who mocked Jesus and was condemned as a result to wander the earth for all eternity, the Wandering Jew embodies restlessness. Both the landless urban merchants as well as the more wide-ranging emigrants appeared to be perpetual aliens when measured against the

fixed abodes of Western European homelands, those emerging nation-states that became established along modern lines during the nineteenth century. The Wandering Jew is regarded by Europeans as the exotic Other in their midst, reminiscent of the First Crusade mentality when medieval Jews were attacked as 'the enemy at home' before Christians departed to combat the infidel abroad in the Holy Land (1096).[2]

Two particularly potent renditions of the Wandering Jew were produced by Jewish artists in the late nineteenth century. The first, a large sculpture by the Zionist artist from Galicia, Alfred Nossig (1864–1943), has disappeared since its initial exposition (1899) but survives in photographs (illus. 139).[3] This heroic, bearded, standing figure, loosely derived from Michelangelo's muscular *Moses* (c. 1513–15), bears the Torah scroll (Books of Moses). That scroll is adorned with the Star of David, a latter-day symbol of Jewish identity (a derivation from the sixteenth-century Prague community),

self-consciously chosen to rival the Christian cross during the nineteenth century in order to define the Jews as a distinct 'nation'. Firmly, Nossig's Wandering Jew leans upon his massive staff, not only the traditional aid to pilgrims but also a reference to the great rod used by Moses in parting the Red Sea at the Exodus. Confident and defiant, the aged figure epitomizes assured leadership for a self-identified nation, whose Torah remains its enduring support, like the staff of Moses. Rather than representing a figure of weakness, this Wandering Jew thus proudly personifies the Jewish nation and strides forward boldly. Neither Moses nor the Wandering Jew ever came to rest in the Promised Land, but the promise remained present before him.

That very year Samuel Hirszenberg (chapter Two) painted his own over-life-sized *Wandering Jew* (illus. 140).[4] In complete contrast to Nossig, this figure rushes forwards in fright, wide-eyed and with arms outstretched, as if to emerge from the canvas into the viewer's space. Clad only in a loincloth, like Jesus on the cross, and lit only by a lunar glow under the lowering grey skies of the New Testament account (Matthew 27:45; Mark 15:33; Luke 23:44–5), this Wandering Jew emerges unsteadily from a Valley of Death beneath a towering forest of crosses, not just the three crosses of the Crucifixion on Golgotha. The lone survivor in a landscape of nude corpses – massacred Jews of pogroms (as a stray *tallit* reveals) – this single accursed man emerges into

a frightening and uncertain future from within the eternal struggle with the dominant Christian majority. When this picture was prominently hung at the new home of Bezalel in Jerusalem, Hirszenberg's masterpiece seemed to fulfill his own aspirations to find a final peaceful homeland, far from the suffering history of Jews in Europe (while Hirszenberg himself emigrated to Palestine to teach painting at Bezalel, he died within months of arriving).

Marc Chagall, an artist whose own career (chapters Three and Five) consists of numerous emigrations – from the Pale of Settlement to Paris to New York and back to Paris – also painted the Wandering Jew, as a bearded figure with a sack on his back or close by. This characteristic wanderer floats above Chagall's hometown in *Over Vitebsk* (1915–20). Rendered in a modernist, quasi-Cubist idiom and occasionally coloured with primary hues of green, yellow and red, Vitebsk – with its prominent Orthodox church dominating the skyline – appears lively compared to the snowy landscape and the shadowy, anonymous figure adrift. Chagall's own career echoed the path of this wanderer, including a new life in Paris but also another period of exile in New York during the Second World War.

Diasporic wandering still pervades the consciousness of self-aware Jewish artists of the late twentieth century, as exemplified by R. B. Kitaj's *The Jewish Rider* (illus. 103), another traveller, here on a European train.[5]

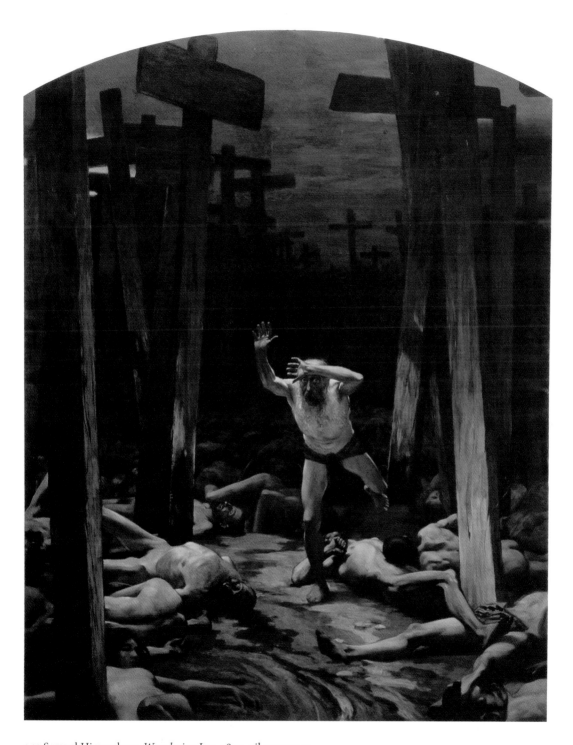

140 Samuel Hirszenberg, *Wandering Jew*, 1899, oil on canvas.

Kitaj, born in Cleveland, Ohio, but mostly active in England, epitomizes with his career the Jewish wanderer between America and Europe (although in the reverse direction of modern immigration). He also wrote a polemic on exile, *First Diasporist Manifesto* (1989), to refer to any art – not exclusively Jewish art – made 'in two or more societies at once'.[6] The solitary Jewish rider remains homeless and in constant movement, the characteristic modern condition. This man is a secular intellectual,[7] lost in thought with a book left on the window sill, through which one sees an ominous chimney that belches smoke, again evoking Holocaust deportation and extermination camp imagery. Thus this symbolic Jewish wanderer, albeit fashionably dressed and guided by an unidentified officer, will suffer the same horrible fate as victims of the Holo-caust, against the distant suggestion of a cross.

Just as Hirszenberg's *Wandering Jew* found its ultimate destination in Palestine, the Land of Israel, so did artists and other Zionist immigrants depart Europe to find their way to a new homeland that eventually became the nation of Israel. From the time of the original monotheist, Abraham, that land had formed the physical and spiritual centre of Jewish identity and national aspirations, cemented literally with the construction of the Temple on Mount Moriah.

Thus, the second model of Jewishness derives from the biblical covenant, at once a religious compact as well as a marker of peoplehood. In the land of Zion, the binding of Isaac (the Akeda) exemplifies this mutual commitment between God and the Jewish people, just as it provides the essential Torah portion every New Year when Jews gather in prayer. Jewish artists in the new Zion, Israel, naturally turned to that moment as the crucial event in Abraham's life, his test of faith through the aborted Sacrifice of Isaac, his favoured second son (see the earlier Jewish images of this subject at Dura Europos and Sepphoris). As Yael Feldman makes clear, Hebrew language literature in Israel up to the 1950s had presented this subject as an image of dedicated (self-) sacrifice and adherence to God's directives in the Promised Land.[8]

In early twentieth-century art in the Land of Israel, this local interpretation of the scene had been realized by Bezalel artist Abel Pann (1883–1963), first in a 1923 lithograph from his *Pentateuch* album, then in a painting of the 1950s, where the fearful, dark-skinned Isaac bears distinctly Middle Eastern features, as his brooding, white-haired father tightly embraces him. Pann's figures seem to docu-ment the regional character and enduring, living immediacy of such patriarchal figures in the Land of Israel. Indeed, the artist even depicts the ultimate cementing of God's covenant with Abraham in another remark-able pastel image (illus. 141) that represents an elderly Abraham's earlier response to the

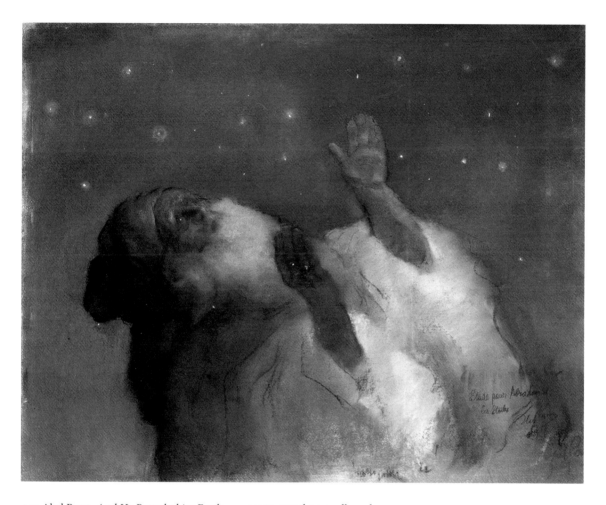

141 Abel Pann, *And He Brought him Forth . . . ,* 1930s, pastel on cardboard.

divine mandate (Genesis 15:5), when he turns towards the blue heavens to learn that his people will be as numerous as the stars themselves.[9] The patriarch gazes upwards, extending his arms in prayerful submission as he hears the voice of the Lord in the night. Emphasizing the origins of the Jewish people, their divine covenant and the sacrality of the landscape itself, this scene defines distinctly Jewish art –in and for the Promised Land – by narrating the foundation of the nation as an act of monotheistic faith.

During the interval between Pann's first and second narratives of the Sacrifice of Isaac, the

artist had lost his younger son Eldad in Israel's 1948 War of Independence. This ultimate sacrifice by parents of their sons, repeated in later wars, altered the new nation's associations of the Sacrifice of Isaac in both literature and art. Patriotism was replaced with an increasingly peace-oriented sympathy for the plight of the son.[10] Since its birth pangs, Israel has been a nation steeped in unwanted violence, often mobilized to danger in a state of emergency (*hamatzav*, literally 'the situation'). We saw the significance of such painful sacrifice of the young in the heroic war of independence in Israel, through the imagery of Marcel Janco and his painting *Death of the Soldier* (1949). Thus, the original notion in the Hebrew Bible episode of the 'binding' of Isaac and his near-sacrifice as a test of faith and loyalty gave way increasingly to a re-creation of the scene as a threat or even a realization of an actual child sacrifice, especially in the absence of any depicted intervening angel to stay Abraham's hand.[11]

Yet the general shift in Israeli sentiment after the Lebanon invasion of 1982, discussed in the last chapter, reshaped the vision of the Sacrifice of Isaac yet raised the pertinence of the subject in Israel as the primal theme of national identity. Some of this shifted mood is conveyed through the searing poem by Yehuda Amichai on this theme, 'The True Hero of the Akeda':

The true hero of the Akeda was the ram
Who did not know about the pact among
 the others.
It was as if he volunteered to die in place
 of Isaac.
I want to sing, for him, a memorial song,
About the curly wool and the mortal eyes
About the horns that stood silent on its
 living head.
After the slaughter, they were made into
 shofars
To sound the blast of their wars
And to sound the blast of their base
 celebrations . . .

The angel departed homewards
Isaac departed homewards
And Abraham and God had parted ways
 a while back.

But the true hero of the Akeda
Was the ram.[12]

As if to provide the visual equivalent of Amichai's poem and to focus on the actual sacrifice in the form of the substitute creature, a ram, Menashe Kadishman (*b.* 1932) repeatedly, even obsessively, returned to the Akeda, which he represented in various media – drawings, paintings and sculptures.[13] Kadishman began to focus on the Akeda in 1982, spurred by Israel's war in Lebanon, a time when his own son was inducted into the army. In his version of the

theme, the artist transformed his earlier, signature, naturalistic sheep and rams, a vivid synecdoche for nature in the Middle East; instead, he excerpted the figure of the ram to serve as an isolated symbol for the larger conflicts within the theme of the Sacrifice of Isaac. Eliminating the father, Abraham, from the event, Kadishman placed the ram at the centre of attention but presented it now as a living object, to confront and to challenge the viewer to act against it with violence. In one large, steel, sculptured relief multiple outside the Tel Aviv Museum (illus. 142) a towering, larger-than-life-size ram figure with voids for eyes looms above the viewer and also above a

relief oval face of Isaac, lying prone on the ground (a motif echoed later in the host of stamped out metal faces by Kadishman, *Fallen Leaves*, 1997–9, representing sacrificial victims of the Holocaust in Daniel Libeskind's Jewish Museum in Berlin).[14] Instead of the conventional biblical focus, chiefly on Abraham and his terrible dilemma in response to the divine command, with Isaac largely in an innocent and complicit supporting role, this sculpture juxtaposes Isaac and the ram in silent conflict. For the most part the upright ram dominates the prone or disembodied youth.

A decade earlier Menashe Kadishman and his son had already served as the models for a

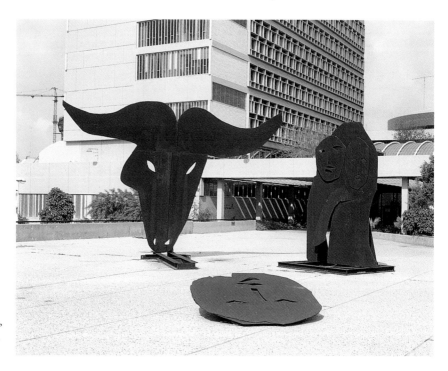

142 Menashe Kadishman,
Sacrifice of Isaac, 1982–5,
Cor-ten steel.

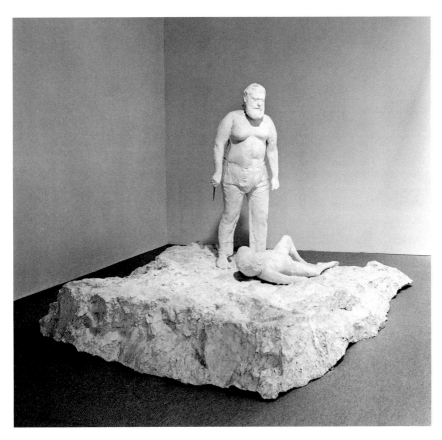

143 George Segal, *Sacrifice of Isaac*, 1973, plaster, height 190 cm.

realistic plaster cast sculpture of a *Sacrifice of Isaac* (illus. 143), created on commission in Israel by American artist George Segal (chapter Five), the son (ironically enough) of a kosher butcher from Eastern Europe. Like Israeli artists, including Kadishman, Segal also eliminated the saving angel from the scene. Certainly the contemporary dress of the figures invites application of the subject to current events; Kadishman/Abraham is shown as a heavy, shirtless, ordinary figure, dressed in jeans and standing above a prone Isaac laid out on a rock. Abraham clutches a real knife, the only element of the sculpture not cast in white plaster, adding a further note of presence and urgency to the scene. Neither a ram nor an angel intrudes upon this threatening moment.

When Segal's *Abraham and Isaac* was displayed in Tel Aviv, it stirred controversy and reaction from Israelis, who read this image of the unconstrained sacrifice of a son as an implicit criticism of the 1973 Yom Kippur War.

144 Moshe Gershuni,
Isaac! Isaac!, 1982,
mixed media on paper.

While Segal denied any connection between the subject and social commentary, he did repeat the theme for a commission in America for Kent State University (1978; rejected by Kent State, now at the Princeton University Art Museum), the site of a recent and tragic National Guard massacre (1970) of student protesters against the Vietnam War.[15] In his later version of the scene for Kent State, Segal shows Isaac as a fully-grown teen (like a college student), kneeling at the feet of his father with his hands bound with rope and looking up to meet his father's gaze. Clearly in the latter case, the implication concerning the sacrifice of youth to the violence of war is intentional, although the image participates far more in the American

vein, where a number of Jewish artists lobbied through their work for social justice.

That the Akeda theme continues to exercise power for Israeli artists in the late twentieth century is evident from an abstract image, *Isaac! Isaac!* (illus. 144) by Moshe Gershuni, whom we met already through his related work, pious meditations on the ritual process of mourning and the celebration of hollow victories (*After the Shiv'ah*, illus. 134).[16] Inspired by concern for his lover Isaac, a soldier in the Israeli army, the image also transcends the specifics of its subject to convey a larger social indictment of grief and sacrifice to the fatherland. This painting not only shows a dark pyre surmounted by a flaming torch, but it also

inscribes the name of Isaac twice, in Hebrew and with exclamation points, upon the outline of a superimposed flag, as if to indict the very display of patriotism through symbols. The sheet of paper is suffused with the glowing yellow-orange of flames, but neither human figures nor a ram can be seen any longer.

Finally, another Israeli artist from the previous chapter, photographer Adi Nes, has devoted his work of the past decade to the close-up realization of biblical subjects, including *(Untitled) Abraham and Isaac* (illus. 145).[17] In this case, the mythic dimensions of the subject are undercut by Nes's use of homeless street people: Abraham is an old, unshaven man who pushes a shopping cart, in which his mature adolescent son lies passive and asleep. On one level, this image indicts the state of Israel for its failure to keep faith, not with a divine covenant, but with a social compact –the obligation to meet the basic survival needs of all its citizens, summarized in the use of an empty grocery trolley as a form of transportation. This vivid contrast of ages between two real-life figures has been compared to the veristic realization of the subject in a canvas by Caravaggio from circa 1603, and Nes's prosaic presentation undermines any mythic or spiritual dimension in the tale. Certainly no suggestion of supernatural intervention or redemption (even literal redemption of deposits on bottle purchases) is evident in Nes's photographic vision. But the

bleakness of the situation as well as the urban setting further distance the Akeda subject in modern Israel from its earlier promise of national commitment and personal dedication to a larger Zionist cause. Moreover, these peripatetic mendicants comment on the eternal homelessness of the Jews, sometimes, sadly, even in the Promised Land.

The third model of Jewishness, particularly articulated by Jewish American artists has focused on the Jew's mission in the role of social betterment. In the later twentieth century this wider mission has been expressed by the phrase 'tikkun olam'. As described earlier, a significant number of Jewish American artists addressed issues of poverty and suffering when they worked as Social Realists during the 1930s, dedicating their art to that difficult time, when breadlines, the Dust Bowl and other ills challenged the nation. Crucially, this propensity to champion the downtrodden and to try to affect change with art continued through successive decades. Indeed, a number of ageing artists already active during the Great Depression turned their sensibilities toward the civil rights movement of the 1960s. Raphael Soyer's 1960s drawing, *Amos on Racial Equality*, depicts a white woman carrying a black infant, under which he inscribes the incisive biblical query from Amos (9:7) in Hebrew and English, 'Are you not as the children of the Ethiopians unto me, O children of Israel?' Ben Shahn's gouache *Thou Shalt Not Stand Idly By* (illus.

145 Adi Nes, *Abraham and Isaac*, 2006, chromogenic print.

146 Ben Shahn, *Thou Shalt Not Stand Idly By*, 1965, gouache on paper.

146) portrays an oversized interracial hand-shake; the title comes from Leviticus (19:16) and is also printed in Hebrew and in English at the top of the image. The design achieved widespread circulation as a lithograph published by the American Civil Liberties Union, part of a nine-work portfolio distributed for fund-raising purposes. Both Shahn and Soyer exploit a biblical source to strengthen their repudiation of repression and racism, and both punctuated their use of scripture by writing the biblical verse twice – in the holy

language of the Jews as well as the language of their adopted country. In their new homeland they did not create art about their own persecution, as did a number of European artists discussed in this book, but instead they elected to work toward the betterment of other oppressed peoples.

American Jewish artists of the next generation also engaged social issues. Leon Golub consistently pictured war and man's inhumanity to man, typically delineated in his cycles of thematic paintings, including series: *Combat* (1962–5), *Vietnam* (1972–3) and *Interrogation* (1981), all of which explored the condition of victims under tyrants through the successive wars and struggles of his era. Golub's enormous and disturbing canvas, *Interrogation II* (illus. 147), presents four oppressors torturing a naked, hooded man, bound to a chair. Two larger-than-life interrogators on the right side

147 Leon Golub, *Interrogation II*, 1981, acrylic on canvas.

148 Art Spiegelman,
New Yorker cover
(15 February 1993).

of the deep red canvas make direct eye contact with the viewer, posturing and smiling nonchalantly. Even when Golub portrays horrific actions, he tries, using the artist's words, 'to expose both victimizer and victim, the psychic circumstances'.[18]

Jewish-black relations became strained after the period of the civil rights movement,

a situation graphic artist Art Spiegelman tackled with his controversial cover design of a black woman kissing a Hasidic man for the 15 February 1993 issue of the *New Yorker* (illus. 148). Tensions between the two groups reached a climax in 1991, with the Crown Heights riots in Brooklyn, incited by the accidental death of a black boy hit by a car driven

by a Hasidic Jew. During three days of rioting – the first anti-Semitic riot in American history – blacks targeted Jews in a manner likened to a pogrom.[19] Spiegelman responded with a Valentine's Day cover, coloured deep red and trimmed with white lace, on top of which the naively rendered figures are locked in an embrace – a bearded, traditionally dressed Jew with *payot* presses his pink lips and white face against a skimpily and trendily dressed black woman's ruby lips. Commenting on the heated reactions to his provocative image, Spiegelman observed: 'I think this cover managed to unite that community like nothing else, which they both hated me for.'[20] Anti-Semitism, still easily inflamed years after both the Holocaust and the supposedly successful integration of Jews into American society, must have been just as attractive a subject to Spiegelman as the politics of the moment.

While contemporary art by Jewish artists ranges from an intense engagement with Jewish heritage to formal experimentation without any obvious Jewish content, some of the most singular creativity in an increasingly international network of art has been global in address and expressly political in its content. Particularly striking is the case of William Kentridge (*b.* 1955), a Jewish artist from South Africa. Using modern media, yet sometimes adopting a deliberately old-fashioned technique, Kentridge tackles issues of political and social conscience, most emphatically concerning

Apartheid and its aftermath.[21] Two Jewish characters, Soho Eckstein and Felix Teitelbaum, figure centrally in several of his signature animated films. Collectively titled '9 Drawings for Projection', these films are comprised of Kentridge's charcoal drawings with occasional blue or red pastel crayon accents, slowly erased and redrawn to allow the viewer access to the successive traces of each frame by the artist. Teitelbaum, a surrogate self-portrait, and Eckstein, physically based on the artist's grandfather, materialize and dematerialize in each frame of Kentridge's eight-minute, ironically titled and allegorical first film, *Johannesburg, 2nd Greatest City After Paris* (1989), made just before Apartheid was abolished. Eckstein and Teitelbaum represent differing poles of thought in the artist's birthplace: the ruthless, indifferent, pinstriped industrialist with huge appetites who owns black slaves, and the idealistic, naked artist, emotionally available and humane in outlook (illus. 149). In these painstakingly created movies, vestiges of memory remain after each drawing is changed, an effective technique for films exploring the erasure of identity and the subsequent recreation of a country that must deal with the memory of oppression and discrimination against its indigenous sons and daughters.

Kentridge remained in his native country and provided committed commentary in his work to better the society of his birthplace. But

149 William Kentridge, *Johannesburg, 2nd Greatest City After Paris*, 1989, film stills.

both the life experience and the ironic art of Vitaly Komar (*b.* 1943) and Alex Melamid (*b.* 1945) stand literally worlds apart from their origins.[22] Marginalized in Russia for being Jewish, Komar and Melamid became notorious dissidents. Once in America (via Israel), these Russian refusnik *émigrés* began to quote past Soviet artworks through the despised veristic style of Socialist Realism. The pair also created work tweaking their adopted country, using American clichés like the American flag, the bald eagle and George Washington. Against Kentridge's passionate, progressive art, Komar and Melamid's deadpan presentation appears coldly realistic and conservative, pandering to popular, public taste, whether Soviet or American. But these cosmopolitan ironists proudly stand outside any national tradition, including Jewish tradition. While their art does not consistently engage with any 'Jewish' issues, Komar and Melamid – who no longer work together – nevertheless take this critical approach to art and society precisely *because* they are Jews; specifically, they respond out of their lived experience as dissident Jews and as *émigrés*, making them paragons of diaspora consciousness.

Ultimately, both modernization and secularization made Jewish art possible in the first place, but some Jewish artists continued to find both their personal and professional identities within the framework of their religiocultural heritage. As noted earlier, Jewish identity is marked, set apart from the unexamined norms of dominant culture and often still religiously tinged for many immigrant artists due to their traditional upbringing. Even those artists who never overtly depict

Jewish subjects may find themselves singled out as Jewish, even if not victimized by discrimination. Further, in a complex modern society Jewish art does not distinguish itself through explicitly religious identifiers, whether biblical subjects or defined Jewish symbols. During the twentieth century both the foundation of a Jewish state in Israel (constantly undergoing self-definition and self-aware questioning of political and social identity) and the eventual absorption of Jews as real equals in American society have provided for almost unlimited creative possibilities today.

Yet even within a largely secular contemporary modernity, most Jews live under the shadow of a constant awareness of the Holocaust, as both a recent event, still in living memory, and as a potential threat (Israel, with many more survivors than any other location, surely has such historical fears reinforced by current political tensions). Today, both as artists and within the general population, Jews are freer yet also as self-aware as ever. Because of the unique blend of Jewish culture – in part a religion, in part a people and a community – modern Jews never fully succumbed to the larger processes of assimilation or secularization, in which society self-consciously split itself into a secular/religious polarity or dichotomy. Therein lies the dilemma of defining Jewishness – or a Jewish artist within that elusive category: Jews are not just members of a faith, not just members of a community, nor are they even primarily identifiable with a single modern nation-state. But their Jewish identity, however determined in all of its fluidity and variability, often impresses itself on their actions, including creative participation in the modern art world.

References

Introduction

1 A handful of illustrated books attempt to present a fairly comprehensive view of Jewish art. The earliest survey in English is Cecil Roth, ed., *Jewish Art: An Illustrated History* (New York, 1961). More recently, Gabrielle Sed-Rajna *et al., Jewish Art,* trans. Sara Friedman and Mira Reich (New York, 1997); Edward Van Voolen, *My Grandparents, My Parents and I: Jewish Art and Culture* (Munich, 2006), a slimmer volume with good plates, especially from the modern era. Also see Grace Cohen Grossman, *Jewish Art* (New York, 1995).

2 Romy Golan, 'The *Ecole Française* vs the *Ecole de Paris*: The Debate about the Status of Jewish Artists in Paris between the Wars', in *The Circle of Montparnasse: Jewish Artists in Paris (1905–1945)*, exh. cat., ed. Kenneth Silver and Golan, Jewish Museum, New York (1985), pp. 80–87.

3 Annabel Jane Wharton, 'JEWISH ART, Jewish art', *Images*, 1 (2007), esp. pp. 33–5.

4 Vivian B. Mann and Gordon Tucker, eds, *The Seminar on Jewish Art* (New York, 1985), p. 10. While the group's focus was to discuss the possibility of a graduate programme in Jewish art, it also debated the definition of the subject of study proposed.

5 Of late a number of essay compilations have focused on modern Jewish art: Ezra Mendelsohn and Richard I. Cohen, eds, *Art and Its Uses: The Visual Image and Modern Jewish Society* (New York, 1990); Catherine Soussloff, ed., *Jewish Identity and Modern Art History* (Berkeley, CA, 1999); Matthew Baigell and Milly Heyd, eds, *Complex Identities: Jewish Consciousness and Modern Art* (New Brunswick, NJ, 2001). See Nicholas Mirzoeff, ed., *Diaspora and Visual Culture: Representing Africans and Jews* (London, 2000), for essays on Jews and Blacks in the diaspora. See also Tamar Garb and Linda Nochlin, eds, *The Jew in the Text: Modernity and the Construction of Identity* (London, 1995), for visual and literary representations of the Jew. Two new journals focus on Jewish art as a whole: *Ars Judaica* (first published in 2005), housed at Bar Ilan University, Israel, and the US journal *Images: A Journal of Jewish Art and Visual Culture* (first published in 2007). *Jewish Art*, formerly the *Journal of Jewish Art* (1974–98), remains essential to the field.

6 For several insightful essays on Judaism as a religion and/or a culture/ethnicity/nationality, or as one essayist puts it, Judaicness versus Jewishness, see Gabriele Boccaccini 'What is Judaism?: Perspectives from Second Temple Jewish Studies', in *Religion or Ethnicity?: Jewish Identities in Evolution*, ed. Zvi Gitelman (New Brunswick, NJ, 2009), esp. pp. 30–32.

7 Ziva Amishai-Maisels, 'Ben Shahn and the Problem of Jewish Identity', *Jewish Art*, 12–13 (1986–7), pp. 304–19.

8 Samantha Baskind, *Raphael Soyer and the Search for Modern Jewish Art* (Chapel Hill, NC, 2004); Milly Heyd and Ezra Mendelsohn, '"Jewish" Art?: The Case of the Soyer Brothers', *Jewish Art*, 19–20 (1993–4), pp. 194–211.

9 Helen Frankenthaler quoted in Julia Brown, *After Mountains and Sea: Frankenthaler 1956–1959*, exh. cat., Guggenheim Museum, New York (1998), p. 28.

10 Steven Schwarzschild, 'The Legal Foundation of Jewish Aesthetics', in *The Pursuit of the Ideal: Jewish Writings of Steven Schwarzschild*, ed. Menachem Keller (Albany, NY, 1990), p. 109.

11 Michael Awkward, *Negotiating Difference: Race, Gender, and the Politics of Positionality* (Chicago, IL, 1995), p. 15.

12 Daniel Boyarin and Jonathan Boyarin, 'Diaspora: Generation and the Ground of Jewish Identity', *Critical Inquiry*, XVIV/4 (Summer 1993), pp. 693–725.

13 Stuart Hall, 'Cultural Identity and Diaspora', in *Identity: Community, Culture, Difference*, ed. Jonathan Rutherford (London, 1990), p. 235.

14 H. W. Janson defines the term 'Early Christian' as follows: '"Early Christian" does not, strictly speaking, designate a style; it refers, rather, to any work of art produced by or for Christians during the time prior to the splitting off of the Orthodox Church – or, roughly, the first five centuries of our era.' H. W. Janson, *History of Art*, 3rd edn, revised and expanded by Anthony F. Janson (New York, 1986), p. 198. Also, notice the Christian-centric prose: the first five centuries of *our* era.

15 The idea of markedness was first used by linguists, but the terms 'marked' and 'unmarked' have since become accepted by sociologists, who employ the distinction to highlight difference in social situations. The marked comprise the minority, accented by their identity of Otherness and held up in comparison to the unmarked, who are viewed as normal, or typical. For a discussion of the terms' usefulness in fields other than linguistics see Linda Waugh, 'Marked and Unmarked: A Choice Between Unequals in Semiotic Structure', *Semiotica*, 38 (1982), pp. 299–318.

16 Georg Simmel, *Conflict and the Web of Group-Affiliations*, trans. Kurt H. Wolff and Reinhard Bendix (New York, 1955), p. 141.

17 W.E.B. Du Bois, *The Souls of Black Folk*, ed. and intro. David W. Blight and Robert Gooding-Williams (1903; reprint, Boston, MA, 1997), p. 38.

18 David Biale, Michael Galchinsky and Susannah Heschel, 'Introduction: The Dialectic of Jewish Enlightenment', in *Insider/Outsider: American Jews and Multiculturalism*, ed. Biale, Galchinsky and Heschel (Berkeley, CA, 1998), pp. 5, 7.

19 Moshe Barasch, *Icon: Studies in the History of an Idea* (New York, 1992), pp. 13–22. For prohibited images described in original sources and Moses Maimonides on permitted imagery see Vivian B. Mann, ed., *Jewish Texts on the Visual Arts* (London, 2000), pp. 20–24.

20 For a critical examination of the effect of the Second Commandment on Jewish art see Joseph Gutmann's classic article, 'The "Second Commandment" and the Image in Judaism', *Hebrew Union College Annual*, 32 (1961), pp. 161–79.

21 Kalman P. Bland, *The Artless Jew: Medieval and Modern Affirmations and Denials of the Visual* (Princeton, NJ, 2000). See also Margaret Olin, *The Nation without Art: Examining Modern Discourses on Jewish Art* (Lincoln, NE, 2001).

22 Maurice Sterne quoted in Charlotte Leon Mayerson, ed., *Shadow and Light: The Life, Friends and Opinions of Maurice Sterne* (New York, 1965), p. 7.

23 Jack Levine, quoted in Stephen Robert Frankel, ed., *Jack Levine* (New York, 1989), p. 134.

24 Archie Rand, telephone conversation with Samantha Baskind, 7 July 2006.

25 Jack Levine, conversation with Samantha Baskind, New York, 14 January 2005.

26 Chaim Potok, *My Name is Asher Lev* (Greenwich, CT, 1972), p. 9. Emphasis in the original.

1 A Prequel to Modernity

1 As stated in the first sentence of the first systematic English language book on Jewish art. Cecil Roth, ed., *Jewish Art: An Illustrated History* (Greenwich, CT, 1961).

2 Carl Kraeling, *The Synagogue: The Excavations at Dura Europos* (New Haven, CT, 1956); Kurt Weitzmann and Herbert Kessler, *The Frescoes of the Dura Synagogue and Christian Art* (Washington, DC, 1990); Joseph Guttman, ed., *The Dura Europos Synagogue: A Re-evaluation (1932–1992)* (Atlanta, GA, 1992). For the reception of the Dura frescoes see Annabel Wharton, 'Good and Bad Images from the Synagogue of Dura Europos: Contexts, Subtexts, Intertexts', *Art History*, 17 (1994), pp. 1–25; Margaret Olin, '"Jewish Christians" and "Early Christian" Synagogues: The Discovery at Dura-Europos and its Aftermath', in *The Nation without Art: Examining Modern Discourses on Jewish Art* (Lincoln, NE, 2001), pp. 127–54.

3 Olin, *Nation without Art*; Kalman P. Bland, *The Artless Jew: Medieval and Modern Affirmations and Denials of the Visual* (Princeton, NJ, 2000), both pointing out that it was

Hegel who first contrasted Jews with Christians for their religious aniconism.

4 Vivian B. Mann, ed., *Jewish Texts on the Visual Arts* (London, 2000), pp. 20–24.

5 Summarized as 'ambivalent emancipation' in Howard Sachar, *A History of the Jews in the Modern World* (New York, 2005), pp. 34–50. On arguments about absorbing Jews into society, see Christian Wilhelm von Dohm, 'On the Civil Improvement of the Jews' (1781), pp. 28–9, and the quotation by Count Clermont-Tonnere, p. 38. David Myers and William Rowe, *From Ghetto to Emancipation* (Toronto, 1997).

6 For a translation of selections of the debate see Paul Mendes-Flohr and Jehuda Reinharz, eds, *The Jew in the Modern World: A Documentary History*, 2nd edn (New York, 1995), pp. 114–16, extract from p. 115.

7 David Sorkin, *The Religious Enlightenment: Protestants, Jews, and Catholics* (Princeton, NJ, 2008). For a comprehensive overview see Salo Baron, *A Social and Religious History of the Jews*, 18 vols (New York, 1952–83). On anti-Semitism see Léon Poliakoff, *The History of Anti-Semitism*, trans. George Klin, 4 vols (1977; reprint Philadelphia, PA, 2003).

8 The top of the southern and northern walls were damaged when the synagogue was abandoned six years later, and covered by an earthen wall erected by the Roman city for siege defence. About two-thirds of the images are preserved.

9 Carol Delaney, *Abraham on Trial* (Princeton, NJ, 1998), esp. pp. 111–32.

10 Yael Israeli, ed., *In the Light of the Menorah*, exh. cat., Israel Museum, Jerusalem (1999), esp. essays by Dan Barag (pp. 71–5) and Lee Levine (pp. 109–12).

11 Gabrielle Sed-Rajna, 'Images of the Tabernacle/Temple in Late Antique and Medieval Art: The State of Research', *Jewish Art*, 23–4 (1997–8), pp. 42–53. In subsequent related images, a shofar, connected to the Akedah in Rosh Hashanah ritual, or an incense shovel often appear in the roles of *lulav* and *etrog*; see the mosaic pavement of Beth Shean (sixth century CE; Israel Museum, Jerusalem). The menorah also appears in cemetery imagery to signify the hope of personal redemption through resurrection of the dead in the messianic age.

12 Lihi Habas, 'Identity and Hope: The Menorah in the Jewish Catacombs of Rome', in Israeli, *Light of the Menorah*, pp. 76–80.

13 A good overview of Jewish archaeology can be found in: Steven Fine, 'Jewish Art and Biblical Exegesis', in *Picturing the Bible: The Earliest Christian Art*, exh. cat., ed. Jeffrey Spier, Kimbell Museum, Fort Worth, TX (2007), pp. 25–49, esp. pp. 37–42 (on Dura Europos).

14 Zeev Weiss, *The Sepphoris Synagogue: Deciphering an Ancient Message through its Archaeological and Socio-Historical Contexts* (Jerusalem, 2005). On the subject of Jewish archaeology in general see Fine, 'Jewish Art and Biblical Exegesis', pp. 42–8. For other mosaics in the city see Rena Talgam and Zeev Weiss, *The Mosaics of the House of Dionysos at Sepphoris* (Jerusalem, 2004).

15 Mira Friedman, 'The Meaning of the Zodiac in Synagogues in the Land of Israel during the Byzantine Period', *Ars Judaica*, 1 (2005), pp. 51–62; Iris Fishof, *Written in the Stars: Art and Symbolism of the Zodiac*, exh. cat., Israel Museum, Jerusalem (2001); Fine, 'Jewish Art and Biblical Exegesis', pp. 45–8. Other zodiac images appear in synagogue mosaics at Beth Alpha (sixth century), Hammath Tiberias (late fourth century). Notably those works show a central Apollo as sun god in his chariot, whereas Sepphoris features a sun disk symbol and the names of the zodiac and seasons in Hebrew.

16 Weiss, *The Sepphoris Synagogue*, pp. 30–34.

17 Friedman, 'The Meaning of the Zodiac', pp. 54–57.

18 Steven Fine, 'Iconoclasm and the Art of Late-Antique Palestinian Synagogues', in *From Dura to Sepphoris: Studies in Jewish Art and Society in Late Antiquity*, ed. Levine and Weiss (Ann Arbor, MI, 2000), pp. 183–94; Levine, 'Figural Art in Ancient Judaism', *Ars Judaica*, 1 (2005), pp. 9–26, esp. pp. 23–5; Charles Barber, 'The Truth in Painting: Iconoclasm and Identity in Early-Medieval Art', *Speculum*, 72 (1997), pp. 1019–36. For a general overview on this subject see Alain Besançon, *The Forbidden Image* (Chicago, IL, 2000).

19 Bezalel Narkiss, *Hebrew Illuminated Manuscripts* (Jerusalem–New York, 1969); Joseph Gutmann, *Hebrew Manuscript Painting* (New York, 1978); Kurt and Ursula Schubert, *Jüdische Buchkunst* (Graz, 1984); David Goldstein, *Hebrew Manuscript Painting* (London, 1985).

20 On the history of the haggadah see Yosef Hayim
Yerushalmi, *Haggadah and History* (Philadelphia, PA,
1975); Katrin Kogman-Appel, *Illuminated Haggadot
from Medieval Spain* (University Park, PA, 2006). On
Jewish books in general, David Stern, *Chosen: Phila-
delphia's Great Hebraica*, exh. cat., Rosenbach Museum,
Philadelphia, PA (2008), which is a prelude to Stern's
in-progress *magnum opus* on the history of the
Jewish book.

21 Kogman-Appel, *Illuminated Haggadot from Medieval
Spain*, pp. 47–72, cites the Morgan Picture Bible (Pierpont
Morgan Library, New York, MS M. 683), and the *Bibles
moralisées*, especially Oxford (Bodleian Library MS 270B),
noteworthy for their anti-Jewish polemics; see Sara
Lipton, *Images of Intolerance: The Representations of Jews
and Judaism in the Bible Moralisée* (Berkeley, CA, 1999).
Facsimile, Bezalel Narkiss, ed., *Golden Haggadah*
(London, 1970).

22 Michael Batterman, 'Bread of Affliction, Emblem of
Power: The Passover Matzah in Haggadah Manuscripts
from Christian Spain', in *Imagining the Self, Imagining
the Other: Visual Representations and Jewish-Christian
Dynamics in the Middle Ages and Early Modern Period*,
ed. Eva Frojmovic (Leiden, 2002), pp. 53–90. For Jewish-
Christian exchanges in later panel paintings, see Vivian
Mann, ed., *Uneasy Communion: Jews, Christians, and
the Altarpieces of Medieval Spain*, exh. cat., Museum of
Biblical Art, New York (2010).

23 Bezalel Narkiss, 'The Menorah in Illuminated
Manuscripts of the Middle Ages', in Israeli, *Light of the
Menorah*, pp. 81–6; Avigdor Poseq, 'Toward a Semiotic
Approach to Jewish Art', *Ars Judaica*, 1 (2005), pp. 45–8.
In general on Hebrew Bibles see Gabrielle Sed-Rajna,
The Hebrew Bible (New York, 1987).

24 J.J.G. Alexander, *Italian Renaissance Illuminations*
(New York, 1977), pp. 24–5, plates 19–26; Alexander,
*The Painted Page: Italian Renaissance Illumination,
1450–1550* (Munich, 1994). Facsimile of *Rothschild
Miscellany*, ed. Iris Fishof (London, 1989); a recent
argument has asserted that the main illustrator of
the *Miscellany* was Leonardo Bellini, a nephew of
the famous Venetian artist, Jacopo Bellini: U. Bauer-
Eberhardt, 'Die Rothschild-Miscellanea in Jerusalem.

Hauptwerk des Leonardo-Bellini', *Pantheon*, 42 (1984),
pp. 229–37.

25 Miri Rubin, *Gentile Tales: The Narrative Assault on Late
Medieval Jews* (New Haven, CT, 1999); Dana Katz, *The
Jew in the Art of the Italian Renaissance* (Philadelphia,
PA, 2008).

26 Mitchell Merback, 'Fount of Mercy, City of Blood:
Cultic Anti-Judaism and the Pulkau Passion Altarpiece',
Art Bulletin, 87/4 (2005), pp. 589–642; Merback, 'Intro-
duction', *Beyond the Yellow Badge: Anti-Judaism and
Antisemitism in Medieval and Early Modern Visual
Culture* (Leiden, 2008).

27 Ruth Mellinkoff, *Outcasts: Signs of Otherness in Northern
European Art of the Late Middle Ages* (Berkeley, CA, 1993);
Debra Higgs Strickland, *Saracens, Demons, and Jews:
Making Monsters in Medieval Art* (Princeton, NJ, 2003),
esp. pp. 95–156.

28 Richard I. Cohen, *Jewish Icons: Art and Society in Modern
Europe* (Berkeley, CA, 1998), pp. 22–4; David Landau and
Peter Parshall, *The Renaissance Print, 1470–1550* (New
Haven, CT, 1994), pp. 337–42; Hans Mielke, *Albrecht
Altdorfer*, exh. cat., Kupferstichkabinett, Berlin, and
Museen der Stadt, Regensburg (1988), esp. pp. 224–5,
nos 116–17.

29 For the process of 'cleansing' a Jewish site by 'converting'
it into a shrine church of the Virgin Mary see Mitchell
Merback, 'Cleansing the Temple: The Munich Gruftkirche
as Converted Synagogue', in *Beyond the Yellow Badge*, ed.
Merback, pp. 305–45.

30 Yosef Kaplan, *Alternative Path to Modernity: The Sephardi
Diaspora in Western Europe* (Leiden, 2000); Henri
Méchoulan and Richard Popkin, *Menasseh ben Israel and
his World* (Leiden, 1989); Miriam Bodian, *Hebrews of the
Portuguese Nation: Conversos and Community in Early
Modern Amsterdam* (Bloomington, IN, 1997).

31 Ruth Levine and Susan Morgenstern, *The Jews in the Age
of Rembrandt*, exh. cat. (Rockville, MD, 1981), figs 5–6;
Adri Offenberg, 'De wijze stad aan de Amstel. De joodse
prenten', *Romeyn de Hooghe: De verbeelding van de late
Gouden Eeuw*, exh. cat., ed. Henk van Nierop *et al.*
(Amsterdam, 2008), pp. 112–25. It is not known whether
the Jewish community commissioned De Hooghe for
the etching of the synagogue dedication, but he surely

maintained contact, since he also produced thirteen prints and a finished drawing for the Amsterdam Sephardim.

32 Yosef Kaplan, 'For whom did Emanuel de Witte paint his three pictures of the Sephardic Synagogue in Amsterdam?', *Studia Rosenthaliana*, 32 (1998), pp. 133–54.

33 Michael Zell, *Reframing Rembrandt: Jews and the Christian Image in Seventeenth-Century Amsterdam* (Berkeley, CA, 2002), pp. 12–14; William Wilson, '"The Circumcision": A Drawing by Romeyn de Hooghe', *Master Drawings*, 13 (1975), pp. 250–58, which identifies the family as Jeronimo Nunes d' Acosta, alias Moses Curiel, agent of the king of Portugal, whose house is the subject of another de Hooghe etching (*c*. 1695).

34 Mirjam Alexander-Knotter, Jasper Hillegers and Edward van Voolen, *The 'Jewish' Rembrandt: The Myth Unravelled* (Amsterdam, 2008); Shelley Perlove and Larry Silver, *Rembrandt's Faith: Church and Temple in the Dutch Golden Age* (University Park, PA, 2009).

35 On Rembrandt and the Old Testament see Perlove and Silver, *Rembrandt's Faith*, pp. 69–159, 370, n. 10 for Dutch identification with the biblical Hebrews.

36 This is the conclusion of Alexander-Knotter *et al.*, *The 'Jewish" Rembrandt*, as well as Gary Schwartz, *The Rembrandt Book* (New York, 2006), pp. 299–305.

37 One of the best studies by a Jewish scholar imputing philo-Semitic sympathies to the artist is Franz Landsberger, *Rembrandt, the Jews, and the Bible* (Philadelphia, PA, 1946). For the harshest debunking of this 'myth' see Alexander-Knotter, *et al.*, *'Jewish" Rembrandt*, pp. 66–88, esp. pp. 87–8, for Berlin and Fort Worth images, arguing that such skullcaps not only were worn by some Christians but also that they were not required of Jews during the seventeenth century.

38 Zell, 'Rembrandt's Encounter with Menasseh ben Israel', *Reframing Rembrandt*, pp. 58–98, with references.

39 Italia also made another rabbi portrait of Jacob Jehuda Leon, known as 'Templo' and celebrated for its three-dimensional reconstruction of the Jerusalem Temple: Zell, *Reframing Rembrandt*, pp. 26–9, figs 13–15.

40 Zell, *Reframing Rembrandt*, 59–64; Shalom Sabar, 'Between Calvinists and Jews: Hebrew Script in Rembrandt's Art', in *Beyond the Yellow Badge* (Leiden, 2008), pp. 371–404; Mirjam Alexander-Knotter, 'An

Ingenious Device: Rembrandt's Use of Hebrew Inscriptions', *Studia Rosentaliana*, 33 (1999), pp. 131–59.

41 Jonathan Israel, *European Jewry in the Age of Mercantilism, 1550–1750* (Oxford, 1989), pp. 123–44; Vivian Mann and Richard Cohen, eds, *From Court Jews to the Rothschilds: Art, Patronage and Power, 1600–1800*, exh. cat., Jewish Museum, New York (1996); Cohen, *Jewish Icons*, pp. 69–89.

42 Shalom Sabar, 'The Beginnings of *Ketubbah* Decoration in Italy: Venice in the Late Sixteenth to the Early Seventeenth Centuries', *Jewish Art*, 12/13 (1986–7), pp. 96–110.

43 Shalom Sabar, *Ketubbah: Jewish Marriage Contracts of the Hebrew Union College Skirball Museum and Klau Library* (New York, 1990), p. 122; invaluable for its observations and copious reproductions; see also Sabar, *Ketubbah: The Art of the Jewish Marriage Contract*, exh. cat., Israel Museum, Jerusalem (2000).

44 Thomas C. Hubka, *Resplendent Synagogue: Architecture and Worship in an Eighteenth-Century Polish Community* (Hanover, NH, 2003), p. 86; Iris Fishof, *Jewish Art Masterpieces from the Israel Museum, Jerusalem* (Jerusalem, 1994), pp. 34–5; David Davidovitch, *Wandmalereien in alten Synagogen. Das Wirken des Malers Elieser Sussmann in Deutschland* (Hameln-Hannover, 1969). For a more general overview see Carol Herselle Krinsky, *Synagogues of Europe* (Cambridge, MA, 1985), pp. 56–9; a very useful resource for synagogue architecture.

45 Cohen, *Jewish Icons*, pp. 71–4; Rafi Grafman, *Crowning Glory: Silver Torah Ornaments of The Jewish Museum, New York*, exh. cat., Jewish Museum, New York (1996).

2 Inventing the Jewish Artist in Europe

1 Principally Shmuel Feiner, *The Jewish Enlightenment* (Philadelphia, PA, 2004); for the wider context see David Sorkin, *The Religious Enlightenment: Protestants, Jews, and Catholics from London to Vienna* (Princeton, NJ, 2008); also Sorkin, *The Berlin Haskalah and German Religious Thought* (London, 2000).

2 A conventional touchstone is Peter Gay: *The Enlightenment, an Interpretation: The Rise of Modern Paganism* (New York, 1996); Dorinda Outram, *The Enlightenment* (Cambridge, 1995); see also Kim Sloan, ed., *Enlightenment* (London, 2003).

3 Sorkin, *Moses Mendelssohn and the Religious Enlight-enment* (London, 1996); Allan Arkush, *Moses Mendelssohn and the Enlightenment* (Albany, 1994). The term 'public sphere' derives from Jürgen Habermas, *The Structural Transformation of the Public Sphere* (Cambridge, MA, 1998). For the essay James Schmidt, ed., *What is Enlightenment?: Eighteenth-Century Answers and Twentieth-Century Questions* (Berkeley, CA, 1996), pp. 53–7.

4 For the essay, sometimes also translated as 'Concerning the Amelioration of the Civil Status of the Jews', see Paul Mendes-Flohr and Jehuda Reinharz, eds, *The Jew in the Modern World: A Documentary History*, second edn (New York, 1995), pp. 28–36.

5 For this point of contention see Mendes-Flohr and Reinharz, *The Jew in the Modern World*, p. 35 (Dohm); for the response by Mendelssohan see ibid., pp. 44–7; Sorkin, *Mendelssohn*, pp. 114–15: 'We entrust our health . . . to a doctor without regard to religion; why not our property to a judge?'

6 Mendes-Flohr and Reinharz, *The Jew in the Modern World*, 97; trans. Allan Arkush (Hanover, NH, 1983), p. 85; Sorkin, *Mendelssohn*, pp. 120–46.

7 Howard Sachar, *A History of the Jews in the Modern World* (New York, 2005), pp. 34–50; For the French National Assembly's successive declarations see Mendes-Flohr and Reinharz, *The Jew in the Modern World*, pp. 114–18.

8 Mendes-Flohr and Reinharz, *The Jew in the Modern World*, pp. 123–41.

9 This term is not contemporary but is utilized by scholars to designate the reaction against Reform Judaism led by Rabbi Samuel Raphael Hirsch of Oldenburg, Germany. Mendes-Flohr and Reinharz, *The Jew in the Modern World*, p. 159, n. 5, pp. 197–202.

10 For dialectics in modern Judaism see Sorkin, 'Between Messianism and Survival. Secularization and Sacralization in Modern Judaism', *Journal of Modern Jewish Studies*, 3 (2004), pp. 73–86. Orthodoxy had its own visual culture, celebrating charismatic rabbinical leadership through portraits; Richard Cohen, *Jewish Icons* (Berkeley, CA, 1998), pp. 114–53.

11 Sachar, *Jews in the Modern World*, pp. 133–7; Ismar Schorsch, *From Text to Context: The Turn to History in Modern Judaism* (Hanover, NH, 1994); David Sorkin, *The Transformation of German Jewry (1780–1840)* (New York, 1987); Michael Meyer, *Response to Modernity: A History of the Reform Movement in Judaism* (New York, 1988).

12 Jeffrey Sammons, *Heinrich Heine: A Modern Biography* (Princeton, NJ, 1979); S. S. Prawer, *Heine's Jewish Comedy: A Study of his Portraits of Jews and Judaism* (Oxford, 1983).

13 Sachar, *Jews in the Modern World*, pp. 102–108; for other Jewish financiers of the nineteenth century, pp. 108–19. The quotation (chapter epigraph) is from Jost Hermand and Robert Holub, eds, *Heinrich Heine/Poetry and Prose* (New York, 1982), Introduction, p. x.

14 Generally, Susan Tumarkin Goodman, ed., *The Emergence of Jewish Artists in Nineteenth-Century Europe*, exh. cat., Jewish Museum, New York (2001); Elisheva Cohen, *Moritz Oppenheim: The First Jewish Painter*, exh. cat., Israel Museum, Jerusalem (1983), esp. the essay by Ismar Schorsch, 'Art as Social History: Oppenheim and the German Jewish Vision of Emancipation', pp. 31–61; Georg Heuberger and Anton Merk, eds, *Moritz Daniel Oppenheim: Jewish Identity in 19th Century Art*, exh. cat., Jüdisches Museum, Frankfurt (1999), esp. Annette Weber, 'Moritz Daniel Oppenheim and the Rothschilds', pp. 170–86 and Weber, 'The Portrait as Mirror: Moritz Daniel Oppenheim as Artist, Citoyen, and Jew', pp. 187–99.

15 Weber, 'Portrait as Mirror', pp. 196–7, notes that the portraits of both Mendelssohn and Lessing were based on contemporary likenesses, by Daniel Chodowiecki and Anton Graff, respectively. On Goethe and Oppenheim see Liliane Weissberg and Georg Heuberger, 'The Rothschild of Painters and the Prince of Poets', in *Moritz Daniel Oppenheim*, ed. Heuberger and Merk, pp. 131–52, esp. pp. 142–5. Oppenheim also portrayed Felix Mendelssohn's sister, Fanny Hensel (1842).

16 Norman Kleeblatt, 'Departures and Returns – Sources and Contexts for Moritz Oppenheim's Masterpiece *The Return of the Volunteer*', in *Moritz Daniel Oppenheim*, pp. 113–30.

17 The painting was presented as a gift by the grateful Jewish community of Baden to Gabriel Riesser in 1835 for his contributions in their defence of the rights to citizenship and equal rights as well as responsibilities to the state. A now-lost portrait of Riesser, editor of the periodical, *Der Jude*, was produced by Oppenheim: Weber, 'Portrait as Mirror', pp. 194–5.

18 Richard Cohen, *Jewish Icons* (Berkeley, CA, 1998), 43–67, also discussing precedents in Germany; Samantha Baskind, 'Bernard Picart's Etchings of Amsterdam's Jews', *Jewish Social Studies*, XIII/2 (Winter 2007), pp. 40–64.

19 Carol Herselle Krinsky, *Synagogues of Europe* (Cambridge, MA, 1985), esp. pp. 261–330 for Germany. Berlin's Oranienburgstrasse synagogue dates from 1866; the grandest of all was Budapest's Dohány Street, 1854–9. Frankfurt's Israelistische Religionsgesellschaft opened in 1852–3, enlarged 1874–5, rebuilt 1904–7.

20 Cohen, *Jewish Icons*, pp. 171–5; Tobias Natter, ed., *Rabbiner-Bocher-Talmudschüler: Bilder des Wiener Malers Isidor Kaufmann, 1853–1921*, exh. cat., Jüdisches Museum, Vienna (1995), including essays by Richard Cohen and Bernhard Purin.

21 Cohen, *Jewish Icons*, pp. 174–5.

22 Connection drawn by Gabriel Weisberg, 'Jewish Naturalist Painters: Understanding and Competing in the Mainstream', in Goodman, *Emergence of Jewish Artists*, p. 149.

23 Goodman, *Emergence of Jewish Artists*, pp. 18, 182–3.

24 Biographies and references ibid., pp. 180–82. Simeon Solomon has also been championed recently by scholars of gay artists, in part because of his imagery, in part because he was arrested for 'indecency' in 1873 – indecency meaning 'the love that dare not speak its name'.

25 Paula Hyman, 'Acculturation of the Jews in Nineteenth-Century Europe', in Goodman, *Emergence of Jewish Artists*, pp. 31–9, with references.

26 Weisberg, 'Jewish Naturalist Painters', pp. 144–7. Weisberg compares Brandon to a contemporary French painter of Catholic themes, Isidore Pils.

27 Cohen, *Jewish Icons*, pp. 175–8; Linda Nochlin, 'Starting with the Self: Jewish Identity and its Representation', in *The Jew in the Text: Modernity and the Construction of Identity*, ed. Linda Nochlin and Tamar Garb (London, 1995), pp. 12–18.

28 Exhibited in the Paris Salon of 1841; Cissy Grossman, 'The Real Meaning of Eugene Delacroix's *Noce Juive au Maroc*', *Journal of Jewish Art*, 14 (1988), pp. 64–73.

29 Israel Bartal, *The Jews of Eastern Europe, 1772–1881* (Philadelphia, PA, 2002).

30 Ezra Mendelsohn, *Painting a People: Maurycy Gottlieb and Jewish Art* (Hanover, NH, 2002); Larry Silver, 'Jewish Identity in Art and History: Maurycy Gottlieb as Early Jewish Artist', in *Jewish Identity in Modern Art History*, ed. Catherine Soussloff (Berkeley, CA, 1999), pp. 87–113; Nehama Guralnik, *In the Flower of Youth: Maurycy Gottlieb, 1856–1879*, exh. cat., Museum of Art, Tel Aviv (1991). For pictures of Jews in nineteenth-century Polish art, often the work of non-Jews, see Halina Nelkin, *Images of a Lost World: Jewish Motifs in Polish Painting 1770–1945* (New York, 1991).

31 Shelley Perlove, 'Perceptions of Otherness: Critical Responses to the Jews of Rembrandt's Art and Milieu (1836–1945)', *Dutch Crossing*, 25 (2001), pp. 243–90. An important small oil sketch by Gottlieb depicts a famous moment from Rembrandt's Amsterdam, the recantation from the synagogue *bima* by an excommunicated Jew, *Uriel D'Acosta Abjuring Beliefs* (1877); Mendelsohn, *Painting a People*, pp. 120–24.

32 Ziva Amishai-Maisels, 'Origins of the Jewish Jesus', in *Complex Identities: Jewish Consciousness and Modern Art*, ed. in Matthew Baigell and Milly Heyd (New Brunswick, NJ, 2001), pp. 62–5.

33 Quoted by Guralnik, *In the Flower of Youth*, p. 51, n. 40; Mendelsohn, *Painting a People*, p. 40, n. 147.

34 Guralnik, *In the Flower of Youth*, p. 183; Mendelsohn, *Painting a People*, pp. 128–9.

35 Mendelsohn, *Painting a People*, pp. 101–2; on self-portraits in varied guises, pp. 103–13; on portraits of a wider circle, pp. 115–17.

36 Sachar, *History of the Jews*, pp. 193–206, 284–309; Benjamin Nathans, *Beyond the Pale: The Jewish Encounter with Late Imperial Russia* (Berkeley, CA, 2002), esp. for St Petersburg.

37 Stefani Hoffman and Ezra Mendelsohn, eds, *The Revolution of 1905 and Russia's Jews* (Philadelphia, PA, 2008); Yuri Slezkine, *The Jewish Century* (Princeton, NJ, 2004), esp. pp. 105–65.

38 Cohen, *Jewish Icons*, 223–36; Goodman, *Emergence of Jewish Artists*, pp. 76–8, 134–5.

39 Weisberg, 'Jewish Naturalist Painters', pp. 143–51, esp. p. 144 for Hirszenberg.

40 Dieuwertje Dekkers, ed., *Jozef Israëls, 1824–1911*, exh. cat., Groninger Museum, Groningen, and Jewish Historical Museum, Amsterdam (1999); see also Ronald de Leeuw,

John Sillevis and Charles Dumas, *The Hague School: Dutch Masters of the Nineteenth Century*, exh. cat., Royal Academy of Arts, London (1985), pp. 20–22, 92–4, 186–99. For Israëls and Rembrandt see Ronald de Leeuw in *Jozef Israëls*, pp. 43–53. On the Bruegel peasant scene tradition, Larry Silver, *Peasant Scenes and Landscapes* (Philadelphia, PA, 2006).

41 The Philadelphia Museum of Art has another Israëls painting *Silent Dialogue/Old Friends* (1882; mentioned in Van Gogh's letter to his brother Theo) that shows an old peasant in a chair in his one-room cottage, accompanied by his faithful dog. Dekkers, *Jozef Israëls*, pp. 201–103, no. 36.

42 Dekkers, *Jozef Israëls*, p. 226, n. 7; see also Edward Van Voolen, 'Israëls: Son of the Ancient People', in Dekkers, *Jozef Israëls*, pp. 54–70.

43 John Sillevis, ed., *Jozef en Isaac Israëls, vader en zoon*, exh. cat., Gemeentemuseum, The Hague (2008).

44 Emily Braun, 'From Risorgimento to the Resistance: A Century of Jewish Artists in Italy', in *Gardens and Ghettos: The Art of Jewish Life in Italy*, exh. cat., ed. Vivian Mann, Jewish Museum, New York (1989), pp. 137–89, esp. pp. 137–53.

45 Joachim Pissarro, *Camille Pissarro* (New York, 1993); Ralph Shikes and Paula Harper, *Pissarro, His Life and Work* (New York, 1980); *Pissarro*, exh. cat. Museum of Fine Arts, Boston, MA (1980); Nicholas Mirzoeff, 'Pissarro's Passage: The Sensation of Caribbean Jewishness in Diaspora', in *Diaspora and Visual Culture: Representing Africans and Jews*, ed. Mirzoeff (New York, 2000), pp. 57–75.

46 Theodore Reff, 'Pissarro's Portrait of Cézanne', *Burlington Magazine*, 109 (1967), pp. 627–33.

47 Richard and Caroline Brettell, *Painters and Peasants in the Nineteenth Century* (New York, 1983).

48 Shikes and Harper, *Pissarro*, pp. 226–41; John Hutton, *Neo-Impressionism and the Search for Solid Ground* (Baton Rouge, LA, 1994), pp. 67–8, 181–9; Eugenia Herbert, *The Artist and Social Reform: France and Belgium 1885–98* (New Haven, CT, 1961).

49 Pissarro notes specific Jewish banking houses in a letter to his nieces: 'That statue is the golden calf, the God Capital. In a word it represents the divinity of the day in a portrait of a Fischoffheim, of an Oppenheim, of a Rothschild, of a Gould, whatever. It is without distinction, vulgar and ugly.' Shikes and Harper, *Pissarro*, pp. 232–4; also Linda Nochlin, 'Degas and the Dreyfus Affair: A Portrait of the Artist as an Anti-Semite', in *The Dreyfus Affair: Art, Truth and Justice*, exh. cat., ed. Norman Kleeblatt, Jewish Museum, New York (1987), pp. 97–9. For the historical background on Jews and banking, Sachar, *History of the Jews*, pp. 100–19.

50 Shikes and Harper, *Pissarro*, p. 221.

51 Ibid., *Pissarro*, p. 178; for the Caribbean background, Mirzoeff, 'Pissarro's Passage', pp. 64–7, who notes that in contemporary France an assimilated Jew might be termed an *Israélite* rather than the more pejorative, less refined, often Eastern European *juif*. Both of these ethnic distinctions stood apart from the designation of religion, often termed *hébraïque*.

52 Sachar, *History of the Jews*, pp. 229–41; Kleeblatt, *Dreyfus Affair*.

53 Nochlin, 'Dreyfus Affair', p. 96, noting that Degas was the most virulently anti-Semitic and quoting Renoir that Jews 'shouldn't be allowed to become so important in France'. He had protested against being associated with Pissarro, 'to exhibit with the Jew Pissarro means revolution'.

54 Richard Brettell and Joachim Pissarro, *The Impressionist and the City*, exh. cat., Royal Academy of Arts, London (1992).

55 Charles Baudelaire, 'The Painter of Modern Life', *Selected Writings on Art and Artists* (New York, 1972), p. 403.

56 Quoted by Brettell and Pissarro, *Impressionist and the City*, p. xlvi; see also p. 79.

57 Goodman, *Emergence of Jewish Artists*, pp. 22–3, 172; fig. 6 for the Gauguin portrait of de Haan, plate 60 for de Haan's contemporary self-portrait. A mural of Breton Women working with flax is plate 59. A retrospective of the artist was held late in 2009 at the Jewish Museum, Amsterdam, when this book was in preparation, *A Master Revealed: Meijer de Haan (1852–95)*.

58 Peter Paret, 'Modernism and the "Alien Element" in German Art', in *Berlin Metropolis: Jews and the New Culture 1890–1918*, exh. cat., ed. Emily Bilski, Jewish Museum, New York (1999), pp. 33–57; Peter Paret, 'Jüdische Kunstsammler, Stifter, und Kunsthändler', in *Stiften und Museen Sammler*, ed. Ekkehard Mai and Peter

Paret (Cologne, 1993), esp. pp. 181–4. On Liebermann: Chana Schütz, 'Max Liebermann as a "Jewish" Painter: The Artist's Reception in his Time', in *Berlin Metropolis*, pp. 146–63; Matthais Eberle, *Max Liebermann, 1847–1935* (Munich, 1995); Tobias Natter and Julias Schoeps, eds, *Max Liebermann und die französischen Impressionisten*, exh. cat., Jüdisches Museum, Vienna (1997).

59　Walter Cahn, 'Max Liebermann and the Amsterdam Jewish Quarter', in *Art of Being Jewish*, ed. Barbara Kirschenblatt-Gimblett and Jonathan Karp (Philadelphia, PA, 2008), pp. 208–27.

60　Amishai-Maisels, 'Origins of the Jewish Jesus', pp. 66–9; Schütz, 'Liebermann as "Jewish" Painter', pp. 153–6; Marion Deshmukh, 'Max Liebermann, ein Berliner Jude', in *Max Liebermann – Jahrhundertwende*, exh. cat., ed. Angelika Wesenberg, Alte Nationalgalerie, Berlin (1997), pp. 59–64; Deshmukh, '"Politics is an Art": The Cultural Politics of Max Liebermann in Wilhelmine Germany', in *Imagining Modern German Culture 1889–1910*, ed. Françoise Forster-Hahn (Washington, DC, 1996), pp. 165–85. Most recently, Barbara Gilbert, ed., *Max Liebermann: From Realism to Impressionism*, exh. cat., Skirball Museum, Los Angeles (2005), esp. Marion F. Deshmukh, 'Max Liebermann and the Politics of Painting in Germany, 1870–1935'; and Chana Schutz and Hermann Simon, 'Max Liebermann: German Painter and Berlin Jew', pp. 129–50, 151–67, respectively. The painting was created in Catholic Bavaria and was removed from exhibition; Maria Makela, *Munich Secession* (Princeton, NJ, 1990), pp. 33–4.

61　Paret, 'Modernism in German Art', pp. 36–42, 49–53; Peter Paret, *The Berlin Secession: Modernism and its Enemies in Imperial Germany* (Cambridge, MA, 1980); Nicolas Teewisse, *Vom Salon zur Secession* (Berlin, 1986). Robert Jensen, *Marketing Modern-ism in fin-de-siecle Europe* (Princeton, NJ, 1994), pp. 187–200, characterizing Liebermann, p. 191: 'He was the society's president, its most prominent artist, and its initial source of prestige and cohesiveness. He was as close to an art prince as Berlin had produced . . . Liebermann was the Secession.'

62　Paret, *Berlin Secession*, pp. 170–82; Jensen, *Marketing Modernism*, pp. 255–63. Particularly virulent was the attack in 1905 by Prof. Henry Thode of Heidelberg on the Jewish art critic, Julius Meier-Graefe, leading Liebermann himself to weigh in and accuse Thode of using 'fairly rusty weapons from the armory of anti-Semitism', only to be slurred in turn for being 'un-German'.

63　On anti-Semitism and racism see Sachar, *History of the Jews*, pp. 222–54; on early Zionism, pp. 255–83.

64　Key references include three volumes by David Vital, *The Origins of Zionism* (Oxford, 1975); *Zionism: The Formative Years* (Oxford, 1982); *Zionism: The Crucial Phase* (Oxford, 1987); plus: Jehuda Reinharz, *Fatherland or Promised Land* (Ann Arbor, MI, 1975); Michael Berkowitz, *Zionist Culture and West European Jewry before the First World War* (Cambridge, 1993). For documents, Arthur Hertzberg, ed., *The Zionist Idea* (Garden City, NY, 1959).

65　Quoted in Berkowitz, *Zionist Culture*, p. 91; Michael Brenner, *The Renaissance of Jewish Culture in Weimar Germany* (New Haven, CT, 1996), pp. 22–31, esp. pp. 24–5; Cohen, *Jewish Icons*, 208–12; Inka Bertz, 'Jewish Renaissance – Jewish Modernism', in *Berlin Metropolis*, pp. 165–87; Gilya Gerda Schmidt, *The Art and Artists of the Fifth Zionist Congress, 1901* (Syracuse, NY, 2003).

66　Schmidt, *Art and Artists*, pp. 151–89; Milly Heyd, 'Lilien and Beardsley', *Journal of Jewish Art*, 7 (1980), pp. 58–69.

67　On Zionist heroes and 'new men' see Berkowitz, *Zionist Culture*, pp. 99–118.

68　Quoted in Berkowitz, *Zionist Culture*, p. 37.

69　Originally published in Maxim Gorky's *Zbornik*. Its inscription in Hebrew reads: 'To Those Who Died Hallowing the Holy Name at Kishinev.'

70　Schmidt, *Art and Artists*, pp. 85–119; *Hermann Struck*, exh. cat., Open Museum, Tefen (2007).

71　Hermann Struck, 'As an Artist Saw Him: The Man of Sorrows and the Seer', in *Theodor Herzl: A Memorial*, ed. Meyer W. Weisgal (New York, 1929), p. 36.

72　Chana Schütz, 'Max Liebermann as a Jewish Painter: The Artist's Reception in his Time', in *Berlin Metropolis*, pp. 146–63.

73　Chana Schütz and Hermann Simon, 'Max Liebermann: German Painter and Berlin Jew', in *Max Liebermann: From Realism to Impressionism*, pp. 150–65, esp. pp. 161–2, n. 39.

3 Revolutions in Art and Politics

1 Susan Tumarkin Goodman, *Russian Jewish Artists*, exh. cat., Jewish Museum, New York (1995); for the history see Yuri Slezkine, *The Jewish Century* (Princeton, NJ, 2004); Benjamin Nathans, *Beyond the Pale: The Jewish Encounter with Late Imperial Russia* (Berkeley, CA, 2002).

2 Ziva Amishai-Maisels, 'Origins of the Jewish Jesus', in *Complex Identities: Jewish Consciousness and Modern Art*, ed. Matthew Baigell and Milly Heyd (New Brunswick, NJ, 2001), pp. 55–62; Olga Litvak, 'Rome and Jerusalem: The Figure of Jesus in the Creation of Mark Antokol'skii', in *The Art of Being Jewish in Modern Times*, ed. Barbara Kirshenblatt-Gimblett and Jonathan Karp (Philadelphia, PA, 2008), pp. 228–53.

3 Elizabeth Valkenier, *Ilya Repin and the World of Russian Art* (New York, 1990).

4 Stefani Hoffman and Ezra Mendelsohn, eds, *The Revolution of 1905 and Russia's Jews* (Philadelphia, PA, 2008).

5 Ruth Wisse, *The Modern Jewish Canon* (Chicago, IL, 2000); Sheila E. Jelen, Michael P. Kramer and L. Scott Lerner, 'Introduction: Intersections and Boundaries in Modern Jewish Literary Study', in *Modern Jewish Literatures: Intersections and Boundaries* (Philadelphia, PA, 2010), pp. 1–23.

6 Juliet Bellow, 'A Feminine Geography: Place and Displacement in Jewish Women's Art of the Twentieth Century', in *Transformation: Jews and Modernity*, exh. cat., ed. Larry Silver, Ross Gallery, Philadelphia, PA (2001), pp. 36–9, an important general consideration of pioneering Jewish women artists in multiple media. See also Stanley Baron, *Sonia Delaunay: The Life of an Artist* (London, 1995); *Sonia Delaunay: A Retrospective*, exh. cat., Albright-Knox Gallery, Buffalo, NY (1980). A thoughtful consideration of the Delaunay relationship is Whitney Chadwick, 'Living Simultaneously: Sonia and Robert Delaunay', in *Significant Others: Creativity and Intimate Partnership*, ed. Chadwick and Isabelle de Courtivon (London, 1993), esp. pp. 32–6.

7 Andreas Blühm and Louise Lippincott, *Light! The Industrial Age 1750–1900: Art & Science, Technology & Society*, exh. cat., Carnegie Museum, Pittsburgh, PA (2000), esp. pp. 158, 182–5, 196. The electric light globe was invented in 1879.

8 Chagall literature is vast. See Jackie Wullschlager, *Chagall: A Biography* (New York, 2009); Benjamin Harshav, *Marc Chagall and the Lost Jewish World* (New York, 2006); Monica Bohm-Duchen, *Chagall* (London, 1998); Jacob Baal-Teshuva, ed., *Chagall: A Retrospective* (Westport, CT, 1995).

9 Chagall is justly celebrated, particularly in his later career, for designing opera productions, such as Mozart's *Magic Flute* and for his ceiling decoration of the Paris Opera House (1964), as well as for his later stained-glass projects, which include not only the Hadassah Hospital in Jerusalem but also the Fraumünster in Zurich.

10 Kenneth Silver and Romy Golan, *The Circle of Montparnasse: Jewish Artists in Paris (1905–1945)*, exh. cat., Jewish Museum, New York, (1985). Jews were not the only experimental *émigré* artists in Paris; particularly notable is the Czech pioneer of abstraction, Frantisek Kupka as well as the Romanian sculptor, Constantin Brancusi.

11 Jean Leymarie, *Marc Chagall: The Jerusalem Windows*, 3rd edn (New York, 1996), p. viii.

12 A miniature blue fantasy figure of the artist also hovers above the background view of Paris, or even parachutes into the city, held aloft in a spotlight area by means of a triangle umbrella. This same image appears in a work of 1913, *Paris through the Window*.

13 Later elaborated but first discussed in Ziva Amishai-Maisels, 'Chagall's Jewish In-Jokes', *Journal of Jewish Art*, 5 (1978), pp. 76–93.

14 Ziva Amishai-Maisels, 'The Jewish Awakening: A Search for National Identity', in *Russian Jewish Artists*, pp. 54–70; Seth Wolitz, 'The Jewish National Art Renaissance in Russia', in *Tradition and Revolution: The Jewish Renaissance in Russian Avant-Garde Art 1912–1928*, exh. cat., ed. Ruth Apter Gabriel, Israel Museum, Jerusalem (1987), pp. 21–42; John Bowlt, 'From the Pale of Settlement to the Reconstruction of the World', ibid., pp. 43–60. The Jewish Kultur-Liga, founded after the Revolution in Kiev (1918) and adopted in Moscow (1922–4), where Chagall and Altman participated, drew heavily upon Jewish folk motifs and Yiddish, especially

for graphic design; Hillel Kasovsky, *The Artists of the Kultur-Liga* (Jerusalem, 2003).

15 Amishai-Maisels, 'The Jewish Awakening', pp. 55–8.

16 Avram Kampf, 'Art and Stage Design: The Jewish Theatres of Moscow in the Early Twenties', in *Tradition and Revolution*, pp. 125–42; Harshav, *Chagall and the Lost Jewish World*, pp. 149–61; Susan Tumarkin Goodman, ed., *Chagall and the Artists of the Russian Jewish Theater*, exh. cat., Jewish Museum, New York (2008).

17 Quoted by Kashovsky, *Kultur-Liga*, p. 66; see Harshav, *Chagall and the Lost Jewish World*, pp. 162–211.

18 Ziva Amishai-Maisels, 'Chagall's Murals at the State Jewish Chamber Theatre in Moscow', in *Marc Chagall, the Russian Years, 1906–1922*, exh. cat. Schirn Kunsthalle Frankfurt, Frankfurt, ed. Christoph Vitali (1991), pp. 107–27. Chagall had used this detached head in his picture of *The Poet* (1911); Yiddish phrase from Harshav, *Chagall and the Lost Jewish World*, p. 114.

19 Harshav, *Lost Jewish World*, p. 189, interprets this figure as a youthful surrogate for Chagall himself, proudly asserting himself in the wider Christian world.

20 Vladislav Ivanov, 'Habima and "Biblical Theater"', in *Russian Jewish Theater*, pp. 27–47, 90–105; Kampf, 'Art and Stage Design', esp. pp. 132–5 for Altman's 'Dybbuk'.

21 Martin Hammer, Naum Gabo and Christina Lodder, *Constructing Modernity: The Art and Career of Naum Gabo* (New Haven, CT, 2000).

22 Selim Khan-Magomedov, 'Early Constructivism: From Representation to Construction', *Art into Life*, exh. cat., Henry Art Gallery, Seattle (1990), pp. 49–59, 61–3 (document 1).

23 Amishai-Maisels, 'The Jewish Awakening', pp. 56–64; Ruth Apter-Gabriel, 'El Lissitzky's Jewish Works', in *Tradition and Revolution*, pp. 101–24; for a more general overview see Margarita Tupitsyn, *El Lissitzky – Beyond the Abstract Cabinet: Photography, Design, Collaboration* (New Haven, CT, 1999); *El Lissitzky (1890–1941)*, exh. cat., Busch-Reisinger Museum, Cambridge, MA (1987).

24 Apter-Gabriel, 'El Lissitzky's Jewish Works', pp. 111–18; Haya Friedman, 'Lissitzky's *Had Gadya*', *Jewish Art*, 12–13 (1986–7), pp. 294–303. Facsimile: Arnold Band, ed., *Had Gadya, The Only Kid* (Los Angeles, CA, 2004).

25 Khan-Magomedov, 'Early Constructivism', p. 50

26 T. J. Clark, 'God Is Not Cast Down', in *Farewell to an Idea: Episodes from a History of Modernism* (New Haven, CT, 1999), pp. 224–97.

27 El Lissitzky, 'The Victory over Art', quoted by Apter-Gabriel, *Tradition and Revolution*, p. 232.

28 Issachar Ryback and Boris Aronson, 'Paths of Jewish Painting' (1919), quoted in Apter-Gabriel, *Tradition and Revolution*, p. 229.

29 Avram Kampf, *Chagall to Kitaj: Jewish Experience in 20th Century Art* (Westport, CT, 1990), pp. 18–20, figs 12–14.

30 Silver and Golan, *The Circle of Montparnasse*; Romy Golan, *Modernity and Nostalgia: Art and Politics in France between the Wars* (New Haven, CT, 1995), pp. 137–54.

31 *Four Americans in Paris: The Collections of Gertrude Stein and her Family*, exh. cat., Museum of Modern Art, New York (1970); a 2011 exhibition on the Steins as collectors will open at the San Francisco Museum of Modern Art; Brenda Richardson, *Dr Claribel and Miss Etta: The Cone Collection of the Baltimore Museum of Art*, exh. cat. (Baltimore, MD, 1985), esp. pp. 82–119 for Gertrude Stein; Kenneth Silver, *Paris Portraits: Artists, Friends and Lovers*, exh. cat. Bruce Museum, Greenwich, CT (2008), pp. 107–8, 23. American Jo Davidson (1883–1952) also made a sculpture of his coreligionist Stein the same year as Lipchitz. Davidson captured what he deemed the 'eternal quality about her – she somehow symbolized wisdom'. Jo Davidson, *Between Sittings: An Informal Autobiography of Jo Davidson* (New York, 1951), p. 175.

32 Silver and Golan, *The Circle of Montparnasse*, pp. 22–4, 106–7; Michael Taylor, 'Jacques Lipchitz and Philadelphia', *Philadelphia Museum of Art Bulletin*, 92 (2004); Alan Wilkinson, *The Sculpture of Jacques Lipchitz: A Catalogue Raisonné I. The Paris Years, 1910–1940* (London, 1996).

33 William Rubin, ed., *'Primitivism' in Twentieth-Century Art*, exh. cat. (New York, 1984), esp. Alan Wilkinson, 'Paris and London: Modigliani, Lipchitz, Epstein and Gaudier-Brzeska', pp. 417–29.

34 Silver and Golan, *The Circle of Montparnasse*, pp. 18–20, 110–11; Kenneth Wayne, *Modigliani and the Artists of Montparnasse*, exh. cat., Albright-Knox Gallery, Buffalo, NY (2002), esp. pp. 16–47; Mason Klein, ed., *Modigliani: Beyond the Myth*, exh. cat., Jewish Museum, New York (2004).

35 Neal Benezra, 'A Study in Irony: Modigliani's *Jacques and Berthe Lipchitz*', *Museum Studies Art Institute of Chicago*, 12 (1986), pp. 188–99, emphasizing the set of preliminary drawings.

36 Silver, *Paris Portraits*, p. 120.

37 Norman Kleeblatt and Kenneth Silver, *An Expressionist in Paris: The Paintings of Chaim Soutine*, exh. cat. (New York, 1998); Donald Kuspit, 'Jewish Naivete? Soutine's Shudder', in *Complex Identities*, pp. 87–99.

38 Romy Golan, *Modernity and Nostalgia: Art and Politics in France between the Wars* (New Haven, CT, 1995), pp. 144–6.

39 Avigdor Poseq, 'The Hanging Carcass Motif and Jewish Artists', *Jewish Art*, 16–17 (1990–91), pp. 139–56; Alan Chong and Wouter Kloek, *Still-Life Painting from the Netherlands, 1550–1700*, exh. cat., Rijksmuseum, Amsterdam (1999); on Rembrandt's own painting of a slaughtered game bird see pp. 194–6, no. 40. A hanging ox carcass, signed by Rembrandt and a probable model for Soutine, hangs in the Louvre (1655).

40 Silver and Golan, *The Circle of Montparnasse*, pp. 39–41, 44–6, 112–13; Jean Cassou, *Chana Orloff (1888–1968)*, exh. cat., Tel Aviv Museum (1969); Felix Marcilhac, *Chana Orloff* (Paris, 1991).

41 Neil Baldwin, *Man Ray: American Artist* (Cambridge, MA, 2001).

42 In an interview with Pierre Cabanne, Duchamp revealed, 'I wanted to change my identity, and the first idea that came to me was to take a Jewish name . . . and suddenly I had an idea: why not change sex? It was much simpler. So the name Rrose Sélavy came from that.' Quoted in Hal Foster *et al.*, *Art since 1900* (New York, 2004), vol. 1, p. 159.

43 Milly Heyd, 'Man Ray/Emmanuel Radnitsky: Who is Behind *The Enigma of Isidore Ducasse*?', in *Complex Identities*, pp. 115–41.

44 Emily Bilski, 'Images of Identity and Urban Life: Jewish Artists in Turn-of-the-Century Berlin', in *Berlin Metropolis: Jews and the New Culture, 1890–1918*, exh. cat., ed. Bilski, Jewish Museum, New York (1999), pp. 106–23.

45 Gilya Gerda Schmidt, *The Art and Artists of the Fifth Zionist Congress, 1901* (Syracuse, NY, 2003), pp. 120–50.

46 Bilski, 'Images of Identity and Urban Life', pp. 103–45, esp. 123–40 for Meidner and Steinhardt; see also Freyda Spira, 'Marketing Identities: Works on Paper in Fin-de-Siecle

Berlin', in *Transformation*, pp. 56–67, esp. 62–5. Victor Meisel, *Ludwig Meidner: An Expressionist Master*, exh. cat., University of Michigan Museum, Ann Arbor (1978); Carol Eliel, *The Apocalyptic Landscapes of Ludwig Meidner*, exh. cat., Los Angeles County Museum of Art (1989).

47 On Walden, Sidrid Bauschinger, 'The Berlin Moderns: Else Lasker-Schüler and Café Culture', in *Berlin Metropolis*, pp. 67–72.

48 Michael Brenner, *The Renaissance of Jewish Culture in Weimar Germany* (New Haven, CT, 1996), esp. pp. 167–8.

49 Bilski, 'Images of Identity and Urban Life', pp. 127–31; Inka Bertz, 'Jewish Renaissance – Jewish Modernism', in *Berlin Metropolis*, pp. 183–4.

50 Brenner, *Jewish Culture in Weimar Germany*, esp. pp. 167–81.

51 Ziva Amishai-Maisels, *Jacob Steinhardt, Etchings and Lithographs* (Tel Aviv, 1981); Ziva Amishai-Maisels, 'Jacob Steinhardt's Call for Peace', *Journal of Jewish Art*, 3–4 (1976/77), pp. 90–102.

52 Brenner, *The Renaissance of Jewish Culture in Weimar Germany*, pp. 177–80.

53 Stephanie Barron, ed., *'Degenerate Art': The Fate of the Avant-Garde in Nazi Germany*, exh. cat., Los Angeles County Museum of Art (1997); see also Eric Michaud, *The Cult of Art in Nazi Germany* (Stanford, CA, 2004).

54 Saul Friedländer, *Nazi Germany and the Jews: The Years of Persecution, 1933–1939* (New York, 1997) is the standard work.

55 Howard Sachar, *A History of the Jews in the Modern World* (New York, 2005), pp. 452–3, citing an 1892 book, *Degeneration (Entartung)* by Max Nordau, a doctor in Vienna and close Zionist associate of Theodor Herzl as well as the late nineteenth-century psychology in France of Jean-Martin Charcot. For Nordau images in early Zionism see Michael Berkowitz, *The Jewish Self-Image in the West* (New York, 2000), pp. 26–7, 64–74.

56 Stephanie Barron, ed., *Exiles and Emigrés: The Flight of European Artists from Hitler* (Los Angeles, CA, 1997).

57 Jacques Lipchitz quoted in Martica Sawin, *Surrealism in Exile and the Beginning of the New York School* (Cambridge, MA, 1995), pp. 116–17.

58 Other celebrated non-Jewish artists include Léger, Mondrian, Ozenfant, Tanguy, Ernst, Masson and André Breton.

59 Ziva Amishai-Maisels, *Depiction and Interpretation: The Influence of the Holocaust on the Visual Arts* (New York, 1993), pp. 21–5.

60 Taylor, 'Jacques Lipchitz and Philadelphia', pp. 30–34. The 1937 sculpture on the Grand Palais was destroyed by right-wing political forces, but Lipchitz redesigned the subject in America (1944, cast 1953).

61 Ibid., pp. 23–8.

62 On Vichy, Michele Cone, *Artists under Vichy: A Case of Prejudice and Persecution* (Princeton, NJ, 1992).

63 Jerzy Ficowski, ed., *The Drawings of Bruno Schulz* (Evanston, IL, 1990).

64 David Grossman, 'The Age of Genius: The Legend of Bruno Schulz', *New Yorker* (8 June 2009), pp. 66–77; the murals aroused controversy about their ownership and patrimony, from both Poland and Ukraine, after their initial removal in 2001. See Ethan Bronner, 'Behind Fairy Tales, Walls Talk of Unspeakable Cruelty', *New York Times* (27 February 2009); http://www.nytimes.com/2009/02/28/arts/design/28wall.html. Accessed 1 February 2010.

4 Art, America and Acculturation

1 For a general overview of Jewish American art of this period see Norman L. Kleeblatt and Susan Chevlowe, eds, *Painting a Place in America: Jewish Artists in New York 1900–1945*, exh. cat., Jewish Museum, New York (1991); Samantha Baskind, *Encyclopedia of Jewish American Artists* (Westport, CT, 2007); Matthew Baigell, *Jewish Art in America: An Introduction* (Lanham, MD, 2007).

2 On Jewish population in America see Jacob R. Marcus, *To Count a People: American Jewish Population Data, 1585–1984* (Lanham, MD, 1990), pp. 237–40. Jonathan D. Sarna, *American Judaism: A New History* (New Haven, CT, 2004) provides a useful appendix with population totals over intermittent years from 1660–2000 (p. 375).

3 On early Jewish American art see Joseph Gutmann's pioneering essay 'Jewish Participation in the Visual Arts of Eighteenth- and Nineteenth-Century America', *American Jewish Archives*, XV/1 (April 1963), pp. 21–57.

4 Joan Sturhahn, *Carvalho, Artist-Photographer-Adventurer-Patriot: Portrait of a Forgotten American* (Merrick, NY, 1976), p. 11; Elizabeth Kessin Berman, 'Transcendentalism and Tradition: The Art of Solomon Nunes Carvalho', *Jewish Art*, 16–17 (1990–91), pp. 68–71.

5 Robert Shlaer, 'An Expeditionary Daguerrotype by Solomon Carvalho', *The Daguerrian Annual* (1999), pp. 151–9; Sturhahn, *Carvalho, Artist-Photographer-Adventurer-Patriot*, p. 85.

6 Solomon Nunes Carvalho, *Incidents of Travel and Adventure in the Far West with Colonel Fremont's Last Expedition* (1856; Reprint, Lincoln, NB, 2004).

7 Henry Mosler quoted in Barbara C. Gilbert, ed., *Henry Mosler Rediscovered: A Nineteenth-Century Jewish-American Artist* (Los Angeles, CA, 1995), p. 52. Originally quoted in 'New York Jews in Art: No. 11–Henry Mosler', *The Federation Review*, IV/4 (March 1910), p. 77.

8 Albert Boime, 'Henry Mosler's "Jewish" Breton and the Quest for Collective Identity', in *Henry Mosler Rediscovered*, ed. Gilbert, p. 113.

9 Ibid., p. 122.

10 Moses Jacob Ezekiel, *Moses Jacob Ezekiel: Memoirs from the Baths of Diocletian*, ed. Joseph Gutmann and Stanley F. Chyet (Detroit, MI, 1975), p. 281.

11 On Thomas Crawford's sculpture and Liberty imagery see Vivien Green Fryd, *Art and Empire: The Politics of Ethnicity in the US Capitol, 1815–1860* (New Haven, CT, 1992), pp. 177–208; see Nancy Jo Fox, *Liberties with Liberty: The Fascinating History of America's Proudest Symbol* (New York, 1985) for copious American folk images of the figure.

12 Ezekiel, *Moses Jacob Ezekiel*, p. 185.

13 David Philipson, 'Moses Jacob Ezekiel', *Publications of the American Jewish Historical Society*, 28 (1922), pp. 9–10.

14 On Jewish American history, Sarna, *American Judaism*; Hasia R. Diner, *The Jews of the United States, 1654–2000* (Berkeley, CA, 2004); on the immigration that brought so many artists to America see Gerald Sorin, *A Time for Building: The Third Migration, 1880–1920* (Baltimore, MD, 1992).

15 For the discourse in its time see Horace M. Kallen, 'Democracy Versus the Melting-Pot: Part I', *The Nation*, C/2,590 (18 February 1915), pp. 190–94 and 'Democracy Versus the Melting-Pot: Part II', *The Nation*, C/2,591 (25 February 1915), pp. 217–20; Randolph S. Bourne,

'Trans-National America', *The Atlantic Monthly*, 118 (July 1916), pp. 86–97.

16 On 5 October 1908, the playwright Zangwill introduced the phrase 'melting pot' with the premiere in Washington, DC, of his play of the same name. Israel Zangwill, *The Melting-Pot, Drama in Four Acts* (New York, 1909). For the shifting definition of the melting pot see Philip Gleason, 'The Melting Pot: Symbol of Fusion or Confusion?', *American Quarterly*, XVI/1 (Spring 1964), pp. 20–46.

17 Adam Bellow, *The Educational Alliance: A Centennial Celebration* (New York, 1990).

18 Allon Schoener, ed., *Portal to America: The Lower East Side, 1870–1925* (New York, 1967).

19 Jonathan Bober, *The Etchings of William Meyerowitz*, exh. cat., Archer Huntington Gallery, Austin, TX (1996).

20 Hutchins Hapgood, *The Spirit of the Ghetto* (1902; reprint, Cambridge, 1967), p. 255.

21 Jacob Epstein, *Let There Be Sculpture* (New York, 1940), p. 10.

22 Evelyn Silber, *The Sculpture of Epstein: With a Complete Catalogue* (Oxford, 1986), pp. 43, 115. For excellent essays on Epstein's art see Evelyn Silber and Terry Friedman, *et al.*, *Jacob Epstein: Sculpture and Drawings* (Leeds, England, 1989). Also Richard Cork, *Jacob Epstein* (Princeton, NJ, 1999).

23 John Betjeman, 'Jacob Epstein', in *Twelve Jews*, ed. Hector Bolitho (London, 1934), p. 85.

24 Ibid., pp. 85–6.

25 For example, Kleeblatt and Chevlowe, eds, *Painting a Place in America*; Jonathan N. Barron and Eric Murphy Selinger, eds, *Jewish American Poetry: Poems, Commentary, and Reflections* (Hanover, NH, 2000); Ezra Mendelsohn, *On Modern Jewish Politics* (New York, 1993). On Soyer's Jewish identity see Samantha Baskind, *Raphael Soyer and the Search for Modern Jewish Art* (Chapel Hill, NC, 2004) and Milly Heyd and Ezra Mendelsohn, "'Jewish' Art?: The Case of the Soyer Brothers', *Jewish Art*, 19–20 (1993–4), pp. 194–211.

26 Edward A. Steiner, *On the Trail of the Immigrant* (New York, 1906), p. 175.

27 Abraham Cahan, *The Rise of David Levinsky* (1917; reprint, New York, 1960), pp. 92–3.

28 Grace Cohen Grossman, *Jewish Art* (New York, 1995), p. 278.

29 Samantha Baskind, 'Midrash and the Jewish American Experience in Jack Levine's *Planning Solomon's Temple*', *Ars Judaica*, 3 (2007), pp. 73–90.

30 Jack Levine, conversation with Samantha Baskind, 14 January 2005.

31 Levine quoted in Stephen Robert Frankel, ed., *Jack Levine* (New York, 1989), p. 37.

32 Among the most informative sources on Weegee: Miles Barth, ed., *Weegee's World*, exh. cat., International Center of Photography, New York (Boston, MA, 1997); Judith Keller, *Weegee: Photographs from the J. Paul Getty Museum* (Los Angeles, CA, 2005), especially the transcribed conversation; and Weegee, *Weegee by Weegee: An Autobiography* (New York, 1961). On Jews and photography more generally see Max Kozloff, *New York: Capital of Photography*, exh. cat., Jewish Museum, New York (2002). See also Alan Trachtenberg's insightful article: 'The Claim of a Jewish Eye', *Pakn Treger*, 41 (Spring 2003), pp. 20–25.

33 Samantha Baskind, 'Weegee's Jewishness', *History of Photography* XXXIV/1 (2010), pp. 60–78.

34 Hasia R. Diner, Jeffrey Shandler and Beth S. Wenger, eds, 'Introduction: Remembering the Lower East Side: A Conversation', in *Remembering the Lower East Side: American Jewish Reflections* (Bloomington, IN, 2000), p. 2. In another discussion, Wenger notes, 'unlike the studies produced at the turn of the century, when the Lower East Side was filled with Jewish immigrants, the documentaries of the interwar years focused less on exposing the desperate conditions in the neighborhood and more on deciphering the meaning and recording the vestiges of a "disappearing" Jewish culture'. See Beth S. Wenger, 'Memory as Identity: The Invention of the Lower East Side', *American Jewish History*, LXXXV/1 (March 1997), pp. 14–15.

35 For more on the Lower East Side as an evolving site of Jewish heritage and collective memory (although sometimes constructed and imagined), see Diner, Shandler and Wenger, eds, *Remembering the Lower East Side* and the essays therein. On photographs of the Lower East Side throughout the twentieth century see Deborah Dash Moore and David Lobenstine, 'Photographing the Lower East Side: A Century's Work', in ibid., pp. 28–69.

36 Charles Spencer *et al.*, *The Immigrant Generations: Jewish Artists in Britain, 1900–1945*, exh. cat., Jewish Museum, New York (1983).

37 Richard Cork, *David Bomberg* (New Haven, CT, 1987), p. 135.

38 Juliet Steyn, 'Inside-Out: Assumptions of "English" Modernism in the Whitechapel Art Gallery, London, 1914', in *Art Apart: Art Institutions and Ideology Across England and North America*, ed. Marcia Pointon (Manchester, 1994), pp. 212–30. 53 works by fifteen Jews were shown, including art by Bomberg, Gertler, Wolmark and Kramer, and also Jews outside Britain, such as Modigliani and Jules Pascin.

39 Royal Cortissoz, *American Art* (New York, 1923), p. 18.

40 Alfred Stieglitz, *Stieglitz on Photography: His Selected Essays and Notes*, compiled and annotated by Richard Whelan (New York, 2000), pp. 194–5. On Stieglitz more broadly see Sarah Greenough, *Modern Art and America: Alfred Stieglitz and his New York Galleries*, exh. cat., National Gallery of Art, Washington, DC (2001).

41 Benita Eisler, *O'Keeffe and Stieglitz: An American Romance* (New York, 1991), p. 229.

42 Thomas Craven, *Modern Art: The Men, the Movements, the Meaning* (New York, 1934), p. 312.

43 Eisler, *O'Keeffe and Stieglitz*, p. 229. Original citation in a letter from Stieglitz to Waldo Frank, dated 3 April 1925.

44 'Max Weber Dies; Painter, Was 80' (obituary). *New York Times* (5 October 1961), p. 37.

45 Matthew Baigell, 'Max Weber's Jewish Paintings', *American Jewish History*, LXXXVIII/3 (September 2000), pp. 341–60.

46 Alfred Werner, *Max Weber* (New York, 1975), p. 23.

47 Louis Lozowick, *Survivor from a Dead Age: The Memoirs of Louis Lozowick*, ed. Virginia Hagelstein (Washington, DC, 1997), p. 14. Lozowick also made prints of the city landscape. See Janet Flint, *The Prints of Louis Lozowick: A Catalogue Raisonné* (New York, 1982). Lozowick was a prolific writer, particularly interested in Jewish art and artists. Among many publications, he wrote a monograph on William Gropper (see Reference 52 below) and penned the introductory essay for the first text to focus on Jewish American artists: *One Hundred Contemporary American Jewish Painters and*

Sculptors (New York, 1947), published by the Yiddisher Kultur Farband.

48 Quoted in Isabelle Dervaux, *The Ten: Birth of the American Avant-Garde*, exh. cat., Mercury Gallery, Boston, MA (1998), p. 7.

49 Matthew Baigell, *American Artists, Jewish Images* (Syracuse, NY, 2006); Baskind, *Raphael Soyer and the Search for Modern Jewish Art*; and Ori Z. Soltes, *Fixing The World: Jewish American Painters in the Twentieth Century* (Hanover, NH, 2003).

50 Maurice G. Hindus, 'The Jew as a Radical,' *The Menorah Journal*, XIII/4 (August 1927), p. 372. On the Jewish universalist instinct in art see Ezra Mendelsohn, *Painting a People: Maurycy Gottlieb and Jewish Art* (Hanover, NH, 2002), pp. 208–22.

51 James Thrall Soby, 'Peter Blume's Eternal City', *Bulletin of the Museum of Modern Art*, 10 (April 1943), pp. 2–6; Frank Anderson Trapp, *Peter Blume* (New York, 1987).

52 Louis Lozowick, *William Gropper* (Philadelphia, PA, 1983); August L. Freundlich, *William Gropper: Retrospective*, exh. cat., Lowe Art Gallery, University of Miami (Los Angeles, CA, 1968).

53 Frances K. Pohl, *Ben Shahn* (San Francisco, CA, 1993), p. 15. Further reading see Susan Chevlowe, *et al.*, *Common Man, Mythic Vision: The Paintings of Ben Shahn*, exh. cat., Jewish Museum, New York (1998); Howard Greenfeld, *Ben Shahn: An Artist's Life* (New York, 1998).

54 Davis Pratt, *The Photographic Eye of Ben Shahn* (Cambridge, MA, 1975), p. ix.

55 Susan Noyes Platt, 'The Jersey Homesteads Mural: Ben Shahn, Bernarda Bryson, and History Painting in the 1930s', in *Redefining American History Painting*, ed. Patricia M. Burnham and Lucretia Hoover Giese (Cambridge, 1995), pp. 294–309; Frances K. Pohl, 'Constructing History: A Mural by Ben Shahn', *Arts Magazine*, 62 (September 1987), pp. 11–21.

56 Harry Sternberg quoted in Lozowick, *One Hundred Contemporary American Jewish Painters and Sculptors*, p. 180.

57 Harry Sternberg, oral history interview with Sally Yard. Archives of American Art, Smithsonian Institution, Washington, DC (19 March 1999–7 January 2000). http://www.aaa.si.edu/collections/oralhistories/transcripts/sternb99.htm. Accessed 4 May 2009.

58 James C. Moore, *Harry Sternberg: A Catalog Raisonné of his Graphic Work* (Wichita, KS, 1975); Malcolm Warner, *The Prints of Harry Sternberg* (San Diego, CA, 1994).

59 Andrei Codrescu and Terence Pitts, *Reframing America*, exh. cat., Center for Creative Photography, Tucson, AZ (1995), p. 86.

60 Robert Frank, *The Americans* (1959; reprint New York, 1969).

61 Gail Levin, 'Beyond the Pale: Jewish Identity, Radical Politics and Feminist Art in the United States', *Journal of Modern Jewish Studies*, IV/2 (July 2005), pp. 205–32 for Chicago and Schapiro in relation to their Jewishness. For a broader discussion of women artists and Jewish identity see Simon Zalkind, *Upstarts and Matriarchs: Jewish Women Artists and the Transformation of American Art*, exh. cat., Mizel Center, Denver, CO (2005).

62 Miriam Schapiro, written correspondence with Samantha Baskind, 12 May 2006.

63 Richard Avedon quoted in Helen Whitney, dir., *Richard Avedon: Darkness and Light* (Chicago, IL, 1995).

64 Richard Avedon, *Richard Avedon Portraits* (New York, 2002), unpaged.

65 Richard Avedon, *An Autobiography* (New York, 1993), unpaged.

66 Sarna, *American Judaism*, p. 375.

67 Thomas Hess, *Barnett Newman*, exh. cat., Museum of Modern Art, New York (1971), p. 56; Matthew Baigell, 'Barnett Newman's Stripe Paintings and Kabbalah: A Jewish Take', *American Art*, VIII/2 (Spring 1994), pp. 32–43.

68 Mira Goldfarb, 'Sacred Signs and Symbols in Morris Louis: The *Charred Journal* Series, 1951', in *Complex Identities: Jewish Consciousness and Modern Art*, ed. Matthew Baigell and Milly Heyd (New Brunswick, NJ, 2001), p. 199. For another insightful examination see Mark Godfrey, 'Morris Louis's *Charred Journal: Firewritten* paintings, 1951', in *Abstraction and the Holocaust* (New Haven, CT, 2007), pp. 23–49.

69 'It's All Yours', *Seventeen* (September 1954), p. 161.

70 Lucy R. Lippard, *Eva Hesse* (New York, 1976), p. 104; Bill Barrette, *Eva Hesse, Sculpture: Catalogue Raisonné* (New York, 1989); Elisabeth Sussman and Fred Wasserman, *Eva Hesse: Sculpture*, exh. cat., Jewish Museum, New York (2006).

71 Norman L. Kleeblatt, *Larry Rivers' History of Matzah (The Story of the Jews)*, exh. cat., Jewish Museum, New York (1984); Samantha Baskind, '"Effacing Difference: Larry Rivers" *History of Matzah (The Story of the Jews)*', *Athanor*, 17 (Summer 1999), pp. 87–95; Larry Rivers, *Larry Rivers: Art and the Artist*, exh. cat., Corcoran Gallery of Art, Washington, DC (Boston, MA, 2002).

72 Susan Goodman, *Jewish Themes/Contemporary American Artists*, exh. cat., Jewish Museum, New York (1982) and Susan Goodman, *Jewish Themes/Contemporary American Artists II*, exh. cat. (New York, 1986).

73 Norman Kleeblatt, ed., *Too Jewish? Challenging Traditional Jewish Identities*, exh. cat., Jewish Museum, New York (1996).

74 Sander Gilman, *The Jew's Body* (New York, 1991).

75 Kleeblatt, *Too Jewish?*, p. ix.

76 Richard McBee, 'The 613: Paintings By Archie Rand', *The Jewish Press* (16 April 2008), http://www.jewishpress.com/pageroute.do/31344. Accessed 25 October 2009.

5 Art and the Holocaust . . .

1 Theodor Adorno, 'Meditations on Metaphysics: After Auschwitz', in *The Adorno Reader*, ed. Brian O'Connor (Oxford, 1966), p. 86.

2 On Holocaust imagery across national boundaries see Ziva Amishai-Maisels's magisterial *Depiction and Interpretation: The Influence of the Holocaust on the Visual Arts* (New York, 1993). Several anthologies offer essays on art and the Holocaust, including Stephen C. Feinstein, ed., *Absence/Presence: Critical Essays on the Artistic Memory of the Holocaust* (Syracuse, IN, 2005); Shelley Hornstein, Laura Levitt and Laurence J. Silberstein, eds., *Impossible Images: Contemporary Art after the Holocaust* (New York, 2003); Shelley Hornstein and Florence Jacobowitz, eds, *Image and Remembrance: Representation and the Holocaust* (Bloomington, IN, 2003); Monica Bohm-Duchen, ed., *After Auschwitz: Responses to the Holocaust in Contemporary Art* (London, 1995).

3 Avigdor W. G. Posèq, 'Jacques Lipchitz's *David and Goliath*', *Source*, 8 (Spring 1989), pp. 22–31.

4 Jacques Lipchitz with H. H. Arnason, *My Life in Sculpture* (New York, 1972), pp. 131–2.

References

5 Stephanie Barron, ed., *Exiles and Emigrés: The Flight of European Artists from Hitler* (Los Angeles, CA, 1997).

6 Ziva Amishai-Maisels, 'The Artist as Refugee', in *Art and Its Uses: The Visual Image and Modern Jewish Society*, ed. Ezra Mendelsohn and Richard Cohen (New York, 1990), pp. 127–31.

7 David G. Roskies, *Against the Apocalypse: Responses to Catastrophe in Modern Jewish Culture* (Syracuse, NY, 1984), p. 20. Matthew Baigell describes this reaction in relation to Ben Shahn's work after the Second World War in 'Ben Shahn's Postwar Jewish Paintings', *Artist and Identity in Twentieth-Century America* (Cambridge, 2001), pp. 213–31. On the recurrence of Jewish American artists' interest in the Bible, even in an unhospitable modern art world, see Samantha Baskind, 'Imaging the Book: Jewish Artists and the Bible in Twentieth-Century America', *Art Criticism*, XXIV/1 (2009), pp. 7–20.

8 Ziva Amishai-Maisels convincingly argues that Marc Chagall, and many other Jewish artists before and after him, employed the Crucifixion during periods of intense anti-Semitism as a symbol of Jewish martyrdom. See 'The Jewish Jesus', *Journal of Jewish Art*, 9 (1982), pp. 84–104. See also Ziva Amishai-Maisels, 'Origins of the Jewish Jesus', in *Complex Identities: Jewish Consciousness and Modern Art*, ed. Matthew Baigell and Milly Heyd (New Brunswick, NJ, 2001), pp. 55–62.

9 Ziva Amishai-Maisels, 'Chagall's *White Crucifixion*', *Art Institute of Chicago Museum Studies*, XVII/2 (1991), pp. 138–53, 180–81.

10 Amishai-Maisels, 'The Artist as Refugee', pp. 113–17.

11 Amishai-Maisels, 'Chagall's *White Crucifixion*', p. 140.

12 Deborah Schultz and Edward Timms, *Pictorial Narrative in the Nazi Period: Felix Nussbaum, Charlotte Salomon and Arnold Daghani* (London, 2009).

13 Emily Bilski, *Art and Exile: Felix Nussbaum, 1904–1944*, exh. cat., Jewish Museum, New York (1985), p. 19; Karl Georg Kaster, ed., *Felix Nussbaum – Art Defamed, Art in Exile, Art in Resistance: A Biography*, trans. Eileen Martin (Woodstock, NY, 1997). For a catalogue raisonée of Nussbaum's work, http://www.felix-nussbaum.de/werkverzeichnis/archiv.php?lang=en&. Accessed 10 December 2009.

14 Bilski, *Art and Exile*, p. 21.

15 Charlotte Salomon, *Charlotte: Life? or Theater? An Autobiographical Play by Charlotte Salomon*, trans. Leila Vennewitz (New York, 1981); Mary Lowenthal Felstiner, *To Paint Her Life: Charlotte Salomon in the Nazi Era* (New York, 1994); Michael P. Steinberg and Monica Bohm-Duchen, eds, *Reading Charlotte Salomon* (Ithaca, NY, 2006).

16 Translation from *Charlotte Salomon: Life? or Theater?*, p. 152.

17 Especially, Janet Blatter and Sybil Milton, *Art of the Holocaust* (New York, 1981). On non-portable art – drawings, graffiti and paintings left on the walls of Auschwitz – see Joseph P. Czarnecki, *Last Traces: The Lost Art of Auschwitz* (New York, 1989).

18 On the arts and culture in Theresienstadt (or Terezín) see Gerald Green, *The Artists of Terezín* (New York, 1978); *Seeing through 'Paradise': Artists and the Terezin Concentration Camp*, exh. cat., Massachusetts College of Art, Boston (1991) and Anne D. Dutlinger, ed., *Art, Music, and Education as Strategies for Survival: Theresienstadt, 1941–45*, exh. cat. (New York, 2001).

19 Ziva Amishai-Maisels, 'The Complexities of Witnessing', in *After Auschwitz: Responses to the Holocaust in Contemporary Art*, exh. cat., ed. Monica Bohm-Duchen, Royal Festival Hall, London (London, 1995), pp. 25–48.

20 David Mickenberg, Corinne Granof and Peter Hayes, *The Last Expression: Art and Auschwitz*, exh. cat., Block Gallery, Evanston, IL (2003), p. 64.

21 Morris Wyszogrod, *A Brush with Death: An Artist in the Death Camps* (Albany, NY, 1999).

22 Mickenberg, Granof and Hayes, *The Last Expression*, p. 173.

23 Stephanie Barron, ed., *'Degenerate Art': The Fate of the Avant-Garde in Nazi Germany*, exh. cat., Los Angeles County Museum of Art (1997), pp. 194–6.

24 Much of the literature on Adler is not in English. The most incisive English language analysis of Adler's work is by Ziva Amishai-Maisels, and this discussion is much influenced by her. See Amishai-Maisels, 'The Iconographic Use of Abstraction in Jankel Adler's Late Works', *Artibus et Historiae*, 17 (1988): pp. 55–70.

25 Ibid., p. 55.

26 For a brief description of Holocaust responses by Jewish American artists see Matthew Baigell, *Jewish-American*

Artists and the Holocaust (New Brunswick, NJ, 1997) and parts of Baigell's *Jewish Artists in New York: The Holocaust Years* (New Brunswick, NJ, 2002). See Deborah E. Lipstadt, *Beyond Belief: The American Press and the Coming of the Holocaust, 1933–1945* (New York, 1986) for a discussion of how and when the American public gained knowledge of the Nazi massacres.

27 Hans-Ulrich Obrist, ed., *Leon Golub: Do Paintings Bite? Selected Texts (1948–1996)* (Ostfildern, Germany, 1997), p. 49. Generally, Gerald Marzorati, *A Painter of Darkness: Leon Golub and Our Times* (New York, 1990); Jon Bird, *Leon Golub: Echoes of the Real* (London, 2000).

28 Albert Elsen, *Seymour Lipton* (New York, 1970), p. 27.

29 Amishai-Maisels, *Depiction and Interpretation*, pp. 82–3.

30 Chaim Gross, *Fantasy Drawings* (New York, 1956). See also Frank Getlein, *Chaim Gross* (New York, 1974).

31 Chaim Gross Papers, Archives of American Art, Smithsonian Institution, Washington, DC, reel 3197, frame 1234.

32 Abraham Rattner, oral history interview with Colette Roberts, 20 May 1968 and 21 June 1968. Transcript in the Archives of American Art, Smithsonian Institution, Washington, DC, p. 13.

33 Baigell, *Jewish Artists in New York*, pp. 98–151; Lisa Saltzman, 'Barnett Newman's Passion' in *The Passion Story: From Visual Representation to Social Drama*, ed. Marcia Kupfer (University Park, PA, 2008), pp. 203–15; and Mark Godfrey, *Abstraction and the Holocaust* (New Haven, CT, 2007), an especially interesting discussion, including chapters on Newman, Morris Louis and Peter Eisenman.

34 Quoted in Richard Morphet, *R. B. Kitaj* (New York, 1994), p. 22. Original citation R. B. Kitaj, 'Jewish Art – Indictment and Defence: A Personal Testimony,' *Jewish Chronicle Colour Magazine* (30 November 1994), pp. 42–6.

35 R. B. Kitaj, *Second Diasporist Manifesto* (New Haven, CT, 2007), aphorism 287.

36 Vivianne Barsky, '"Home is Where the Heart Is": Jewish Themes in the Art of R. B. Kitaj', in *Art and Its Uses: The Visual Image and Modern Jewish Society*, ed. Ezra Mendelsohn and Richard I. Cohen (New York, 1990), p. 171. See also Marco Livingstone, *R. B. Kitaj* (London, 1999); James Aulich and John Lynch, eds, *Critical Kitaj: Essays on the Work of R. B. Kitaj* (New Brunswick, NJ, 2001).

37 One example: *Germania (The Tunnel)* (1985). See Morphet, *R. B. Kitaj*, p. 154.

38 R. B. Kitaj file, Skirball Cultural Center, Los Angeles, CA. Comment for exhibition *R. B. Kitaj: Passion and Memory: Jewish Works from his Personal Collection* (11 January–30 March 2008).

39 Peter Novick, *The Holocaust in American Life* (Boston, MA, 1999), p. 202.

40 Samantha Baskind, '"Everybody thought I was Catholic": Audrey Flack's Jewish Identity', *American Art*, XXIII/1 (Spring 2009), pp. 104–15.

41 Audrey Flack, *Audrey Flack on Painting* (New York, 1981), p. 78. Exact transcription from original.

42 Ibid., p. 81.

43 Ibid., p. 78.

44 Audrey Flack, telephone conversation with Samantha Baskind, 10 May 2005.

45 Shimon Attie, *Sites Unseen: Shimon Attie – European Projects, Installations and Photographs*, intro. James Young (Burlington, VT, 1998); James E. Young, 'Sites Unseen: Shimon Attie's Acts of Remembrance, 1991–1996', in *At Memory's Edge: After-Images of the Holocaust in Contemporary Art and Architecture* (New Haven, CT, 2000), pp. 62–89.

46 Shimon Attie, *The Writing on the Wall: Projections in Berlin's Jewish Quarter, Shimon Attie – Photographs and Installations* (Heidelberg, 1994), p. 9.

47 Howard N. Fox, *Eleanor Antin*, exh. cat., Los Angeles County Museum of Art (1999). Focusing on Antin's Jewish identity: Lisa Bloom, 'Ethnic Notions and Feminist Strategies of the 1970s: Some Work by Judy Chicago and Eleanor Antin', in *Jewish Identity in Modern Art History*, ed. Catherine M. Soussloff (Berkeley, CA, 1999), pp. 135–63.

48 Eleanor Antin, email correspondence with Samantha Baskind, 9 January 2006.

49 Judy Chicago, *Holocaust Project: From Darkness into Light* (New York, 1993), p. 137.

50 Ibid., p. 88.

51 Art Spiegelman, *Maus: A Survivor's Tale* (New York, 1986 [vol. I], 1991 [vol. II]). Deborah R. Geis, ed., *Considering Maus: Approaches to Art Spiegelman's Survivor's Tale of the Holocaust* (Tuscaloosa, AL, 2003). Samantha Baskind

and Ranen Omer-Sherman, eds, *The Jewish Graphic Novel: Critical Approaches* (New Brunswick, NJ, 2008).

52 Among other graphic novels exploring the Holocaust are Joe Kubert's *Yossel, April 19, 1943: A Story of the Warsaw Ghetto Uprising* (New York, 2003), which presents a harrowing alternative history of his family's fate in Poland through the eyes of a boy during the final days of the Warsaw ghetto; Pascal Croci's stark and grimly effective *Auschwitz* (New York, 2003), based on interviews with concentration camp survivors; Bernice Eisenstein's *I Was a Child of Holocaust Survivors* (New York, 2006), addressing the transmission of traumatic memory embodied by an artist of the second generation; and Miriam Katin's poignant and haunting memoir *We Are On Our Own* (Montreal, 2006).

53 On the effects and aftermath of the Holocaust on children of survivors, often called second-generation witnesses see Aaron Hass, *In the Shadow of the Holocaust: The Second Generation* (Cambridge, 1996). See also Eva Hoffman, *After Such Knowledge: Memory, History, and the Legacy of the Holocaust* (New York, 2004), with personal reflections.

54 Marianne Hirsch, *Family Frames: Photography, Narrative, and Postmemory* (Cambridge, MA, 1997), p. 23. Marianne Hirsch, 'Family Pictures: *Maus*, Mourning, and Post-Memory', *Discourse: Journal for Theoretical Studies in Media and Culture*, XV/2 (Winter 1992–3), pp. 3–29.

55 Dalia Manor, 'From Rejection to Recognition: Israeli Art and the Holocaust', *Israel Affairs*, IV/3–4 (Spring–Summer 1998), pp. 253–77.

56 Tami Katz-Freiman summarizes these points well in 'Don't Touch My Holocaust', in *Impossible Images*, pp. 131–3.

57 José M. Sanchez, *Pius XII and the Holocaust: Understanding the Controversy* (Washington, DC, 2002).

58 For Ardon's transcribed poem and description of the painting see Ronald Alley, *Catalogue of The Tate Gallery's Collection of Modern Art Other Than Works by British Artists* (London, 1981), pp. 19–21. See also Michelle Vishny, *Mordecai Ardon* (New York, 1974).

59 Lawrence L. Langer, *Landscapes of Jewish Experience: Painting By Samuel Bak* (Boston, MA, 1997).

60 In 2002, New York's Jewish Museum exhibited these two works among imagery by eleven other artists from various countries engaging visual material that was not cathartic, memorializing or redemptive, and often focused on the perpetrators of the Holocaust rather than the victims. This highly controversial show elicited conflicting reactions from both viewers and critics, some arguing that it was sensationalizing and inappropriate for a Jewish museum. Norman L. Kleeblatt, ed., *Mirroring Evil: Nazi Imagery/Recent Art*, exh. cat., Jewish Museum, New York (2001). For an insightful discussion of Arad and Rosen's introduction of Hitler into Holocaust art see Ariella Azoulay, 'The Return of the Repressed', in *Impossible Images*, pp. 85–117.

61 Ernst van Alphen, 'Playing the Holocaust', in *Mirroring Evil*, p. 75.

62 Ibid., p. 77.

63 Essential to any discussion of memorials, Jewish and otherwise, is the work of James E. Young. In particular, *The Texture of Memory: Holocaust Memorials and Meaning* (New Haven, CT, 1993).

64 Yosef Hayim Yerushalmi, *Zakhor: Jewish History and Jewish Memory* (Seattle, WA, 1982).

65 Richard Yaffe, *Nathan Rapoport Sculptures and Monuments* (New York, 1980); James E. Young, 'The Biography of a Memorial Icon: Nathan Rapoport's Warsaw Ghetto Monument', *Representations*, 26 (Spring 1989), pp. 69–106.

66 Hanno Rauterberg, *Holocaust Memorial Berlin: Eisenman Architects* (Baden, Switzerland, 2005).

67 Peter Eisenman, *Memorial to the Murdered Jews of Europe* (New York, 2005), p. 11.

68 Ibid., p. 3.

69 Margaret Olin, 'The Stones of Memory: Peter Eisenman in Conversation', *Images*, 2 (2009), p. 131.

70 Hal Foster, ed., *Richard Serra* (Cambridge, MA, 2000), p. 190.

71 For more on Abraham and Isaac as a symbol in Holocaust imagery see Amishai-Maisels, *Depiction and Interpretation*, pp. 167–72.

72 Segal quoted in Pamela Cohen, 'George Segal: An Iconographic Study of Biblical Imagery' (PhD thesis, Rutgers University, 1996), p. 135.

73 Segal quoted in Phyllis Tuchman, *George Segal* (New York, 1983), p. 102. Quote originally from a talk presented at the Jewish Museum, New York, 7 April 1983.

6 Home to Israel

1 Mira Friedman, 'Chagall's Jerusalem', *Jewish Art*, 23/24 (1997/98), pp. 543–64; see also Ziva Amishai-Maisels, 'Chagall in the Holy Land: The Real and the Ideal', ibid., pp. 516–24, 536–40.

2 Recently Dalia Manor, *Art in Zion: The Genesis of Modern National Art in Jewish Palestine* (London, 2005), esp. pp. 9 73; Yigal Zalmona, *Boris Schatz: The Father of Israeli Art* (Jerusalem, 2006).

3 Nurit Shilo Cohen, 'The 'Hebrew Style' of Bezalel, 1906–1929', *The Journal of Decorative and Propaganda Arts*, 20 (1994), pp. 140–63.

4 Manor, *Art in Zion*, pp. 13–19; for a sense of the Jewish nation in the context of late nineteenth-century visual ideology see Margaret Olin, *The Nation without Art: Examining Modern Discourses on Jewish Art* (Lincoln, NB, 2001), esp. pp. 3–70; see also Richard Cohen, *Jewish Icons* (Berkeley, CA, 1998), esp. pp. 205–12. Schatz's views first appeared in an 1888 article in the Hebrew-language newspaper *Ha-Tzefirah*; Zalmona, *Boris Schatz*, pp. 8–9, and Manor, *Art in Zion*, pp. 16–17 credit the influence of a Russian nationalist, Vladimir Stasov, regarding art, including Jewish art: to 'place a sovereign national stamp upon their art . . . and to bring to fruition the distinctive-ness of Jewish . . . expression' (quoted by Cohen, *Jewish Icons*, p. 212).

5 Zalmona, *Boris Schatz*, pp. 17–18, cites an important 1902 article by Ahad Ha'am, 'The Renewal of the Spirit', in the Hebrew newspaper *Ha-Shiloah*; Manor, *Art in Zion*, pp. 26–7, notes the support by Ahad Ha'am for Bezalel after it opened. David Biale, *Not in the Heavens: The Tradition of Jewish Secular Thought* (Princeton, NJ, 2011), esp. 140–45 for Ahad Ha'am, 'the most important theoetician of secular Jewish culture'.

6 Ahad Ha'am, 'Ueber die Kultur', *Ost und West*, II/10 (October 1902), pp. 655–60; *Ost und West*, II/11(November 1902), pp. 721–28; translated as 'Zionism and Jewish Culture', in *Essays, Letters, Memoirs: Ahad Ha-Am*, ed. and trans. Leon Simon (Oxford, 1946), pp. 83–101.

7 Zalmana, *Boris Schatz*, pp. 29–30; Olin, *The Nation without Art*, pp. 101–26. For the cultural context in Europe see Michael Berkowitz, *Zionist Culture and West European Jewry before the First World War* (Cambridge, 1993); Michael Brenner, *The Renaissance of Jewish Culture in Weimar Germany* (New Haven, CT, 1996), pp. 24–35; Richard Cohen, 'Exhibiting Nineteenth-Century Artists of Jewish Origin in the Twentieth Century: Identity, Politics, and Culture', in *The Emergence of Jewish Artists in Nineteenth-Century Europe*, exh. cat., ed. Susan Tumarkin Goodman, Jewish Museum, New York (2001), pp. 153–57.

8 On the influence of Arts and Crafts ideals of William Morris, Walter Crane and John Ruskin on Schatz's 'social doctrine' see Zalmana, *Boris Schatz*, pp. 27–8.

9 Batsheva Goldman Ida, *Ze'ev Raban: A Hebrew Symbolist*, exh. cat., Tel Aviv Museum (2001), pp. 222–30 [English summary]; *Raban Remembered: Jerusalem's Forgotten Master*, exh. cat., Yeshiva U. Museum, New York (1982).

10 From Schatz's 'utopian novella', *Jerusalem Rebuilt – A Daydream* [Hebrew] (Jerusalem: Bezalel, 1923), p. 36; quoted by Zalmona, *Boris Schatz*, p. 27.

11 Gideon Ofrat, *One Hundred Years of Art in Israel*, trans. Peretz Kidron (Boulder, CO, 1998), p. 27; also Manor, *Art in Zion*, p. 39. For another general discussion of twentieth-century Israeli art in English see Ronald Fuhrer, *Israeli Painting: From Post-Impressionism to Post-Zionism* (Woodstock, NY, 1998).

12 Zalmona, *Boris Schatz*, p. 31.

13 Manor, *Art in Zion*, p. 111, n. 4.

14 Quoted in Ofrat, *One Hundred Years of Art in Israel*, p. 48.

15 Yigal Zalmona, 'The Tower of David Days: The Birth of Controversy in Israel Art in the Twenties', in *The Tower of David Days*, exh. cat., Tower of David Museum, Jerusalem (1991).

16 Anat Helman, 'Was There Anything Particularly Jewish about "The First Hebrew City?"', in *The Art of Being Jewish in Modern Times*, ed. Barbara Kirschenblatt-Gimblett and Jonathan Karp (Philadelphia, PA, 2008, pp. 116–27

17 *Reuven Rubin Dreamland*, exh. cat., Tel Aviv Museum (2006) offers the most recent retrospective; Manor, *Art in Zion*, pp. 75–110.

18 On the new adoption of the Star of David as a Jewish symbol, in contrast to the enduring symbol of the menorah, see Manor, *Art in Zion*, pp. 43–5. Gershom Scholem, 'The Star of David: History of a Symbol', in

The Messianic Idea in Judaism and Other Essays on Jewish Spirituality (New York, 1971), pp. 257–81.

19 For the 'call to order', a kind of visual retrenchment in French art of the 1920s, see Romy Golan, *Modernity and Nostalgia: Art and Politics in France between the Wars* (New Haven, 1995); Kenneth Silver, 'Matisse's *Retour a l'Ordre*', *Art in America*, LXXVI/6 (June 1987), pp. 111–23.

20 Haim Gamzu, *Painting and Sculpture in Israel* (Tel Aviv, 1951), p. 62; quoted by Galia Bar Or, '*Hebrew Work*': *The Disregarded Gaze in the Canon of Israeli Art*, exh. cat., Ein Harod Museum (1998), p. 140.

21 Manor, *Art in Zion*, pp. 93–8.

22 Manor, *Art in Zion*, pp. 160–61; see also Berkowitz, *Zionist Culture*, pp. 93–4, 99–109.

23 Reuven Rubin, 'I Find Myself', *Menorah Journal*, XII/5 (October/November, 1926), p. 499; quoted by Manor, *Art in Zion*, pp. 101–02, n. 38.

24 Dalia Manor, 'Biblical Zionism in Bezalel Art', *Israel Studies*, VI/1 (2001), pp. 55–75.

25 Another aspect of *First Fruits* that deserves attention is its idyllic element, whose nostalgia appears in *fin-de-siécle* European painting not only in the art of Gauguin, but also in constructed paradises by Puvis de Chavannes and Henri Matisse; Margaret Werth, *Joy of Life: The Idyllic in French art, circa 1900* (Berkeley, CA, 2002).

26 Manor, *Art in Zion*, pp. 144–48.

27 Zirka Filipczak, *Hot Dry Men Cold Wet Women: The Theory of Humors in Western European Art 1575–1700*, exh. cat. Williams College Museum, Williamstown, MA (1998). Two good examples: Picasso's *Three Women at the Spring*, or his ink drawing, *La Source* (both 1921).

28 Yigal Zalmona, 'History and Identity', in *Artists of Israel: 1920–1980*, exh. cat., ed. Susan Tumarkin Goodman, Jewish Museum, New York (1981), p. 31: 'Who is this Arab, this Oriental man, as depicted in the paintings of Modernist artists of the twenties? In the writings of Nachum Gutman, the image of the Arab is the antithesis of that of the displaced Jew of the Diaspora. He is a model of belonging, a human representative of the natural and sustaining tie to the land. He is the complete opposite of the stereotypic Jew – poor and wretched, yet clever and scheming – from whom Gutman's generation fought to free themselves . . . The image of the Arab thus becomes a variation of that earthy and instinctual Gentile who appears in the literature of the Diaspora writer as a desirable model.'

29 For the 'Canaanite' movement, see Zalmona, 'History and Identity', pp. 40–42.

30 Moshe Barasch, 'The Quest for Roots,' in *Artists of Israel*, pp. 21–5; more polemically, Moshe Zuckermann, 'Authenticity, Ideology and the Israeli Society', in *Hebrew Work*, pp. 94–106.

31 Cohen, *Jewish Icons*, pp. 216–17, 223–8. Manor, *Art in Zion*, pp. 35, 93, quotes a 1925 Yitzhak Katz article that praises Rubin at the expense of Hirszenberg's *Wandering Jew*: 'Rubin . . . has proven to us that one can be a Hebrew artist without painting the Mount of Olives or the Western Wall . . . [H]is well-known triptych "The Shepherd-The Fruits of the Land-Serenity" was suddenly revealed to the Jewry of *eretz yisrael* in its full contrast to the Jew in Exile by Hirszenberg and brought with it a sense of relief.'

32 See now the retrospective exhibition of the period 1948–1958, Bar Or and Ofrat, *The First Decade: A Hegemony and a Plurality*, exh. cat., Ein Harod Museum (2008), an explicit critique of the dominant progress narrative of Israeli art 'towards a distilled modernist utterance' (p. v). As an index of current progressive thought in Israel, this exhibition preface also notes that what for the Israelis was a 'War of Liberation' was for Palestinian Arabs a catastrophe (*Nakba*).

33 The desire for an Israeli *Guernica* was widespread as a goal in the independent nation after 1948; Ofrat, *One Hundred Years of Art in Israel*, pp. 127, 130, 136–7, noting that a reproduction of Picasso's work hung permanently at the request of director Mordecai Ardon in the drawing hall of Bezalel; Bar Or, '*Hebrew Work*', pp. 136–7, n. 47, quoting Bezem on the influence of the *Guernica* from the two-metre (6½ ft) reproduction.

34 Quoted by Ofrat, *One Hundred Years of Art in Israel*, p. 183, from Tzabar, 'On the Course of Israeli Art', *Massa*, 1 (July 1951).

35 Illustrated in Bar Or, '*Hebrew Work*', pp. 26–7, 30. For Bezem's ceiling mural, depicting the theme of immigration to Israel, at the Presidential Residence, Jerusalem (1972), Ofrat, *One Hundred Years of Art in Israel*, pp. 203–5, illus. 214.

36 Kafr Qasim is an Arab Israeli town near Tel Aviv but also near the Green Line separating Israel from the West Bank; the massacre occurred at the behest of Israeli border police because of curfew violations on 29 October 1956. Bar Or, 'Hebrew Work', pp. 143–4, is one of the few scholars to discuss or illustrate this Bezem painting. She recovered evidence, p. 144, n. 33, that when the work was exhibited in 1957, the other artists participating in the 'General Exhibition of Israel's Artists' threatened to turn their own works to the wall to avoid being shown with Bezem's image; see also Ofrat, *One Hundred Years of Art in Israel*, p. 183. For Bezem's prior engagement with the 1951 Haifa port strike, see *To the Aid of the Seamen* (1952), Ofrat, *One Hundred Years of Art in Israel*, p. 182, illus. 192; Bar Or, *ibid.*, pp. 147–8.

37 Bar Or, 'Hebrew Work', quoted pp. 131–2, n. 57.

38 For a critique of that standard account and the accompanying canon of featured Israeli artists, see the fascinating revisionist essay by Bar Or, '"Hebrew Work" The Disregarded Gaze in the Canon of Israeli Art', in 'Hebrew Work', pp. 125–60.

39 Fuhrer, *Israeli Painting*, pp. 16–17.

40 On Tumarkin as well as other artists critical of the Zionist agenda after the initial celebration of a Jewish state, see Avraham Levitt, 'Israeli Art on its Way to Somewhere Else', *Azure*, 3 (Winter 1998), pp. 120–45.

41 Ruthi Ofek, *Avraham Ofek Murals*, exh. cat., Open Museum, Tefen (2001).

42 Avraham Ronen, 'Avraham Ofek's Murals' in *Avraham Ofek Murals*, pp. 28–31, esp. pp. 28–9 for the title.

43 Ruth Wisse, *The Modern Jewish Canon* (Chicago, IL, 2000), pp. 87–98; Anita Schapira, 'Brenner: Between Hebrew and Yiddish', in *Modern Jewish Literatures: Intersections and Boundaries*, ed. Sheila Jelen, Michael Kramer and Scott Lerner (Philadelphia, PA, 2010), pp. 262–93.

44 Ofek's drawings and on-site activities in the late 1970s clearly document this animal as a *Red Heifer*.

45 Identified as the artist's friend, art historian Professor Avram Kampf, who also commissioned the mural for Haifa University; see bibliography.

46 Mordechai Omer, *My Own Body, Art in Israel, 1968–1978*, exh. cat., Tel Aviv Museum of Art (2008).

47 Baruch Kimmerling, *The Invention and Decline of Israeliness: State, Society, and the Military* (Berkeley, CA, 2001). For art and politics see Yaron Ezrahi, 'Reflections on Art, Power and Israeli Identity', in *After Rabin: New Art from Israel*, exh. cat., ed. Susan Tumarkin Goodman, Jewish Museum, New York (1998), pp. 29–33: '[E]specially during the 1990s, Israel has been slowly but steadily shifting from what might be described as the early epic phase of its history, the period of heroic nation-building, to the increasingly post-epic era of . . . internal controversies on policies concerning the Arab-Israeli conflict and by preoccupation with domestic conflicts between religious and secular Israelis.' (p. 29.)

48 Doreet LeVitté Harten, ed., *Israeli Art around 1990*, exh. cat., Städtische Kunstalle, Düsseldorf (1991), pp. 120–27; see Tali Tamir, 'Death's Face and Victim's Mask: The Death-Motif in Israeli Art of the 1980s', in ibid., pp. 66–71.

49 Harten, ibid., pp. 128–35.

50 Susan Tumarkin Goodman, ed., *Dateline: Israel. New Photography and Video Art*, exh. cat., Jewish Museum, New York (2007); Margo Crutchfield, *Hugging and Wrestling: Contemporary Israeli Photography and Video*, exh. cat., Cleveland Museum of Contemporary Art (Cleveland, OH, 2009).

51 Peter Gelassi, *Barry Frydlender: Place and Time*, exh. cat., Museum of Modern Art, New York (2007).

52 Nissan Perez, *Time Frame* (Jerusalem, 2000).

53 Mordechai Omer, *Adi Nes*, exh. cat., Tel Aviv Museum (2007).

54 Goodman, *Dateline: Israel*, pp. 30–32.

55 Ibid., pp. 32–4.

Conclusions

1 Crucially, Richard I. Cohen, 'The "Wandering Jew" from Medieval Legend to Modern Metaphor', in *The Art of Being Jewish in Modern Times*, ed. Barbara Kirshenblatt-Gimblett and Jonathan Karp (Philadelphia, PA, 2008), pp. 147–75; *Le Juif errant*, exh. cat., Musée d'Art et d'Histoire du Judaïsme, Paris (2001); for the image of the modern Jew as 'mercurial' and thus quintessentially modern see Yuri Slezkine, *The Jewish Century* (Princeton, NJ, 2004), pp. 4–104.

2 Most recently, Jeremy Cohen, *Sanctifying the Name of God:*

Jewish Martyrs and Jewish Memories of the First Crusade (Philadelphia, PA, 2004); Robert Chazan, *European Jewry and the First Crusade* (Berkeley, CA, 1987).

3 Ezra Mendelsohn, 'From Assimilation to Zionism in Lvov: The Case of Alfred Nossig', *Slavonic and East European Review*, 117 (1971), pp. 512–34; compare a similar (also lost) life-sized sculpture of another heroic leader, *Mattathias the Maccabee* (1894) by Boris Schatz (see chapter Six); Yigal Zalmona, *Boris Schatz: The Father of Israeli Art*, exh. cat., Israel Museum, Jerusalem (2006), pp. 11–12. For Nossig and related images of Maccabees and Moses see Richard I. Cohen, *Jewish Icons* (Berkeley, CA, 1998), pp. 227–9, 242–4.

4 Cohen, *Jewish Icons*, pp. 216–17, 224–7, noting that this work was the featured image in Boris Schatz's Bezalel, see also Zalmona, *Boris Schatz*, p. 125.

5 *Le Juif errant*, pp. 220–21, cat. no. 178; Cohen, 'The "Wandering Jew"', pp. 173–4; Carol Zemel, 'Diasporic Values in Contemporary Art: Kitaj, Katchor, Frenkel', in *The Art of Being Jewish in Modern Times*, pp. 176–82; Vivianne Barsky, '"Home is Where the Heart Is": Jewish Themes in the Art of R. B. Kitaj', in *Art and its Uses: The Visual Image and Modern Jewish Society*, ed. Ezra Mendelsohn and Richard I. Cohen (New York, 1990), pp. 149–85.

6 R. B. Kitaj, *First Diasporist Manifesto* (New York, 1989), p. 19.

7 He has been variously identified as one of a pair of British Jewish art theorists, either Michael Podro or Richard Wollheim; see Cohen, 'The "Wandering Jew"', p. 174, n. 59.

8 Jo Milgrom, *The Binding of Isaac: The Akeda – A Primary Symbol in Jewish Thought and Art* (Berkeley, CA, 1988); Carol Delaney, *Abraham on Trial: The Social Legacy of Biblical Myth* (Princeton, NJ, 1998); Yael S. Feldman, 'On the Cusp of Christianity: Virgin Sacrifice in Pseudo-Philo and Amos Oz', *Jewish Quarterly Review*, 97 (2007), pp. 379–415; Yael S. Feldman, *Glory and Agony: Isaac's Sacrifice and National Narrative* (Stanford, CA, 2010); thanks to Prof. Feldman for graciously sharing her work prior to publication.

9 Yigal Zalmona, *The Art of Abel Pann: From Montparnasse to the Land of the Bible*, exh. cat., Israel Museum, Jerusalem (2003), pp. 54–69, 100–101, 116; Milly Heyd, 'Isaac's Sacrifice in the Bible Illustrations of Lilien and Pann', *Jewish Book Annual*, 40 (1982–3), pp. 54–66. Like Chagall, Pann spent time in Paris after his origins in Russia; he worked at Bezalel between 1920 and 1924.

10 Feldman, 'On the Cusp of Christianity', pp. 390–93; Feldman, 'Introduction' in *Glory and Agony*.

11 Ziva Amishai-Maisels, 'Israeli Reactions to Independence and to the Arab-Israeli Conflict', in *Jewish Art*, by Gabrielle Sed-Rajna, *et al.*, trans. Sara Friedman and Mira Reich (New York, 1997), pp. 356–57, citing Aviva Uri (1927–1989), in her series *Who Are the Winners? Who Are the Defeated?* (1982), and her statement, 'We are losing that which is most dear to us – our sons. They are losing that which is most dear to them – their sons.'

12 Yehuda Amichai, *She'at ha-hesed*, trans. Ilana Kurshan, with permission (Jerusalem, 1982), p. 21.

13 Ulrich Schneider, Arturo Schwarz and Mordecai Omer, *Menashe Kadishman. Shalechet: Heads and Sacrifices*, exh. cat., Suermondt Ludwig Museum, Aachen (1999). Other significant Israeli artists who explored the Akeda include Naftali Bezem, Yitzhak Danziger, Moshe Castel, Avraham Ofek, Aharon Kahana and Shraga Weil.

14 A third group of two cowering figures stands opposite in the plaza, but their identity is undefined – perhaps Abraham's two attendants (22:3), although identified as 'mothers' by the artist in another relief. According to Avishai-Maisels, 'Israeli Reactions to Independence and to the Arab-Israeli Conflict', p. 356, this nondescript pair depicts 'his mourning parents [who] stand to one side, their faces expressionless'. Most other Kadishman reliefs of the Sacrifice of Isaac show only the ram and the sacrificial boy.

15 George Segal explained in Robin Cembalest, 'Second Skin', *ARTnews*, XCIV/7 (September 1995), p. 37.

16 Edward Van Voolen, *My Grandparents, My Parents and I: Jewish Art and Culture* (Munich, 2006), pp. 148–9; *Moshe Gershuni, 1980–1990*, exh. cat., Tel Aviv Museum (1990).

17 Mordechai Omer, *Adi Nes*, exh. cat., Tel Aviv Museum (2007), esp Susan Chevlowe, 'Adi Nes's Biblical Stories', pp. 116–26.

18 Leon Golub quoted in Katy Kline and Helaine Posner, *Leon Golub and Nancy Spero: War and Memory* (Cambridge, MA, 1994), p. 43.

19 Edward S. Shapiro, *Crown Heights: Blacks, Jews, and the
 1991 Brooklyn Riot* (Waltham, MA, 2006), p. xiii; more
 generally, and focusing on artistic representations see
 Milly Heyd, *Mutual Reflections: Jews and Blacks in
 American Art* (New Brunswick, NJ, 1999).

20 Art Spiegelman NPR interview, 15 July 2008.
 http://www.npr.org/blogs/newsandviews/from_farai/.
 Accessed 26 November 2009.

21 Dan Cameron, *et al.*, *William Kentridge* (London, 1999);
 Mark Rosenthal, ed., *William Kentridge: Five Themes*, exh.
 cat., San Francisco Museum of Modern Art (New Haven,
 CT, 2009).

22 Carter Ratcliff, *Komar & Melamid* (New York, 1988);
 Anthony Julius, *Idolizing Pictures: Idolatry, Iconoclasm,
 and Jewish Art* (New York, 2001).

Select Bibliography

Adorno, Theodor, 'Meditations on Metaphysics: After Auschwitz', in *The Adorno Reader*, ed. Brian O'Connor (Oxford, 1966), pp. 84–8

Alexander-Knotter, Mirjam, 'An Ingenious Device: Rembrandt's Use of Hebrew Inscriptions', *Studia Rosentaliana*, 33 (1999), pp. 131–59

——, Jasper Hillegers and Edward van Voolen, *The 'Jewish' Rembrandt: The Myth Unravelled* (Amsterdam, 2008)

Alley, Ronald, *Catalogue of The Tate Gallery's Collection of Modern Art Other Than Works by British Artists* (London, 1981)

Amichai, Yehuda, *She'at ha-hesed* (Jerusalem, 1982)

Amishai-Maisels, Ziva, 'Jacob Steinhardt's Call for Peace', *Journal of Jewish Art*, 3–4 (1976/77), pp. 90–102

——, 'Chagall's Jewish In-Jokes', *Journal of Jewish Art*, 5 (1978), pp. 76–93

——, *Jacob Steinhardt, Etchings and Lithographs* (Tel Aviv, 1981)

——, 'Ben Shahn and the Problem of Jewish Identity', *Jewish Art*, 12–13 (1986–7), pp. 304–19

——, 'The Iconographic Use of Abstraction in Jankel Adler's Late Works', *Artibus et Historiae*, 17 (1988), pp. 55–70

——, 'The Artist as Refugee', in *Art and Its Uses: The Visual Image and Modern Jewish Society*, ed. Ezra Mendelsohn and Richard I. Cohen (New York, 1990), pp. 111–48

——, 'Chagall's Murals at the State Jewish Chamber Theatre in Moscow', in *Marc Chagall, the Russian Years, 1906–1922*, exh. cat., Schirn Kunsthalle, Frankfurt, ed. Christoph Vitali (Frankfurt, 1991), p. 107–27

——, 'Chagall's *White Crucifixion*', *Art Institute of Chicago Museum Studies*, XVII/2 (1991), pp. 138–53, 180–81

——, *Depiction and Interpretation: The Influence of the Holocaust on the Visual Arts* (New York, 1993)

——, 'The Complexities of Witnessing', in *After Auschwitz: Responses to the Holocaust in Contemporary Art*, exh. cat., ed. Monica Bohm-Duchen (London, 1995), pp. 25–48

——, 'The Jewish Awakening: A Search for National Identity', in *Russian Jewish Artists in a Century of Change, 1890–1990*, exh. cat., ed. Susan Tumarkin Goodman (New York, 1995), pp. 54–70

——, 'Chagall in the Holy Land: The Real and the Ideal', *Jewish Art*, 23/24 (1997/98), pp. 516–24, 536–40

——, 'Origins of the Jewish Jesus', in *Complex Identities: Jewish Consciousness and Modern Art* ed. Matthew Baigell and Milly Heyd (New Brunswick, NJ, 2001), pp. 55–62

Antin, Eleanor, email correspondence with Samantha Baskind, 9 January 2006

Arkush, Allan, *Moses Mendelssohn and the Enlightenment* (Albany, 1994)

Attie, Shimon, *Sites Unseen: Shimon Attie – European Projects, Installations and Photographs*, intro. James Young (Burlington, VT, 1998)

Aulich, James and John Lynch, eds, *Critical Kitaj: Essays on the Work of R. B. Kitaj* (New Brunswick, NJ, 2001)

Avedon, Richard, *An Autobiography* (New York, 1993)

——, *Richard Avedon Portraits* (New York, 2002)

Awkward, Michael, *Negotiating Difference: Race, Gender, and the Politics of Positionality* (Chicago, IL, 1995)

Azoulay, Ariella, 'The Return of the Repressed', in *Impossible Images: Contemporary Art after the Holocaust*, ed. Shelley Hornstein, Laura Levitt and Laurence J. Silberstein (New York, 2003), pp. 85–117

Baal-Teshuva, Jacob, ed., *Chagall: A Retrospective* (Westport, CT, 1995)

Baigell, Matthew, 'Barnett Newman's Stripe Paintings and Kabbalah: A Jewish Take', *American Art*, VIII/2 (Spring 1994), pp. 32–43

——, *Jewish-American Artists and the Holocaust* (New Brunswick, NJ, 1997)

——, 'Max Weber's Jewish Paintings', *American Jewish History*, LXXX/3 (September 2000), pp. 341–60

——, 'Ben Shahn's Postwar Jewish Paintings', in *Artist and Identity in Twentieth-Century America* (Cambridge, 2001), pp. 213–31

——, *Jewish Artists in New York: The Holocaust Years* (New Brunswick, NJ, 2002)

——, *American Artists, Jewish Images* (Syracuse, NY, 2006)

——, *Jewish Art in America: An Introduction* (Lanham, MD, 2007).

—— and Milly Heyd, eds, *Complex Identities: Jewish Consciousness and Modern Art* (New Brunswick, NJ, 2001)

Baldwin, Neil, *Man Ray: American Artist* (Cambridge, MA, 2001)

Band, Arnold, ed., *Had Gadya, The Only Kid* (Los Angeles, CA, 2004).

Barasch, Moshe, *Icon: Studies in the History of an Idea* (New York, 1992)

——, 'The Quest for Roots', in *Artists of Israel: 1920–1980*, exh. cat., ed. Susan Tumarkin Goodman (New York, 1981), pp. 21–5

Barber, Charles, 'The Truth in Painting: Iconoclasm and Identity in Early-Medieval Art', *Speculum*, 72 (1997), pp. 1019–36

Bar Or, Galia, *Hebrew Work*, exh. cat. (Ein Harod, 1998)

——, and Gideon Ofrat, eds, *The First Decade: A Hegemony and a Plurality*, exh. cat. (Ein Harod, 2008)

Barrette, Bill, *Eva Hesse, Sculpture: Catalogue Raisonné* (New York, 1989)

Barron, Stephanie, ed., *Exiles and Emigrés: The Flight of European Artists from Hitler* (Los Angeles, CA, 1997)

——, ed., *'Degenerate Art:' The Fate of the Avant-garde in Nazi Germany*, exh. cat. (Los Angeles, CA, 1997)

Baron, Salo, *A Social and Religious History of the Jews*, 18 vols (New York, 1952–83)

Baron, Stanley, *Sonia Delaunay: A Retrospective*, exh. cat. (Buffalo, NY, 1980)

——, *Sonia Delaunay: The Life of an Artist* (London, 1995)

Barsky, Vivianne, '"Home is Where the Heart Is": Jewish Themes in the Art of R. B. Kitaj', in *Art and its Uses: The Visual Image and Modern Jewish Society*, ed. Ezra Mendelsohn and Richard I. Cohen (New York, 1990), pp. 149–85

Barth, Miles, ed., *Weegee's World*, exh. cat. (Boston, MA, 1997)

Baskin, Judith, and Kenneth Seeskin, eds, *The Cambridge Guide to Jewish History, Religion, and Culture* (Cambridge, 2010)

Baskind, Samantha, 'Effacing Difference: Larry Rivers' *History of Matzah (The Story of the Jews)*', *Athanor*, 17 (Summer 1999), pp. 87–95

——, *Raphael Soyer and the Search for Modern Jewish Art* (Chapel Hill, NC, 2004)

——, *Encyclopedia of Jewish American Artists* (Westport, CT, 2007)

——, 'Bernard Picart's Etchings of Amsterdam's Jews', *Jewish Social Studies*, XIII/2 (Winter 2007), pp. 40–64

——, 'Midrash and the Jewish American Experience in Jack Levine's *Planning Solomon's Temple*', *Ars Judaica*, 3 (2007), pp. 73–90

——, '"Everybody thought I was Catholic": Audrey Flack's Jewish Identity', *American Art*, XXIII/1 (Spring 2009), pp. 104–15

——, 'Imaging the Book: Jewish Artists and the Bible in Twentieth-Century America', *Art Criticism*, XXIV/1 (2009), pp. 7–20

——, 'Weegee's Jewishness', *History of Photography*, XXXIV/1 (2010), pp. 60–78

—— and Ranen Omer-Sherman, eds, *The Jewish Graphic Novel: Critical Approaches* (New Brunswick, NJ, 2008)

Batterman, Michael, 'Bread of Affliction, Emblem of Power: The Passover Matzah in Haggadah Manuscripts from Christian Spain', in *Imagining the Self, Imagining the Other: Visual Representations and Jewish-Christian Dynamics in the Middle Ages and Early Modern Period*, ed. Eva Frojmovic (Leiden, 2002), pp. 53–90

Bellow, Adam, *The Educational Alliance: A Centennial Celebration* (New York, 1990)

Bellow, Juliet, 'A Feminine Geography: Place and Displacement in Jewish Women's Art of the Twentieth Century', in *Transformation: Jews and Modernity*, exh. cat., ed. Larry Silver (Philadelphia, PA, 2001), pp. 35–55

Benezra, Neal, 'A Study in Irony: Modigliani's *Jacques and Berthe Lipchitz*', *Museum Studies Art Institute of Chicago*, 12 (1986), pp. 188–99

Berkowitz, Michael, *Zionist Culture and West European Jewry before the First World War* (Cambridge, 1993)

——, *The Jewish Self-Image in the West* (New York, 2000)

Berman, Elizabeth Kessin, 'Transcendentalism and Tradition: The Art of Solomon Nunes Carvalho', *Jewish Art*, 16–17 (1990–91), pp. 68–71

Bertz, Inka, 'Jewish Renaissance – Jewish Modernism', in *Berlin Metropolis*, exh. cat., ed. Emily Bilski (New York, 1999), pp. 165–87

Besançon, Alain, *The Forbidden Image* (Chicago, IL, 2000)

Betjeman, John, 'Jacob Epstein', in *Twelve Jews*, ed. Hector Bolitho (London, 1934), pp. 83–100

Biale, David, Michael Galchinsky and Susan Heschel, eds, *Insider/Outsider: American Jews and Multiculturalism* (Berkeley, CA, 1998)

Bilski, Emily, *Art and Exile: Felix Nussbaum, 1904–1944*, exh. cat. (New York, 1985)

——, *Berlin Metropolis: Jews and the New Culture, 1890–1918*, exh. cat. (New York, 1999)

——, 'Images of Identity and Urban Life: Jewish Artists in Turn-of-the-Century Berlin', in *Berlin Metropolis*, pp. 103–45

Bird, Jon, *Leon Golub: Echoes of the Real* (London, 2000)

Bland, Kalman P., *The Artless Jew: Medieval and Modern Affirmations and Denials of the Visual* (Princeton, NJ, 2000)

Blatter, Janet, and Sybil Milton, *Art of the Holocaust* (New York, 1981)

Bloom, Lisa, 'Ethnic Notions and Feminist Strategies of the 1970s: Some Work by Judy Chicago and Eleanor Antin', in *Jewish Identity in Modern Art History*, ed. Catherine M. Soussloff (Berkeley, CA, 1999), pp. 135–63

Bober, Jonathan, *The Etchings of William Meyerowitz*, exh. cat. (Austin, TX, 1996)

Boccaccini, Gabriele, 'What is Judaism?: Perspectives from Second Temple Jewish Studies', in *Religion or Ethnicity?: Jewish Identities in Evolution*, ed. Zvi Gitelman (New Brunswick, NJ, 2009), pp. 24–37

Bodian, Miriam, *Hebrews of the Portuguese Nation: Conversos and Community in Early Modern Amsterdam* (Bloomington, NJ, 1997)

Bohm-Duchen, Monica, ed., *After Auschwitz: Responses to the Holocaust in Contemporary Art* (London, 1995)

——, *Chagall* (London, 1998)

Boime, Albert 'Henry Mosler's "Jewish" Breton and the Quest for Collective Identity', in *Henry Mosler*

Rediscovered: A Nineteenth-Century Jewish-American Artist, exh. cat., ed. Barbara C. Gilbert (Los Angeles, CA, 1995), pp. 91–127

Bourne, Randolph S., 'Trans-National America', *The Atlantic Monthly*, 118 (July 1916), pp. 86–97

Bowlt, John, 'From the Pale of Settlement to the Reconstruction of the World', in *Tradition and Revolution: The Jewish Renaissance in Russian Avant-Garde Art, 1912–1928*, exh. cat., ed. Ruth Apter Gabriel (Jerusalem, 1987), pp. 43–60

Boyarin, Daniel, and Jonathan Boyarin, 'Diaspora: Generation and the Ground of Jewish Identity', *Critical Inquiry*, XIX/4 (Summer 1993), pp. 693–725

Braun, Emily, 'From Risorgimento to the Resistance: A Century of Jewish Artists in Italy', in *Gardens and Ghettos: The Art of Jewish Life in Italy*, exh. cat., ed. Vivian Mann (New York, 1989), pp. 137–89, esp. pp. 137–53

Brenner, Michael, *The Renaissance of Jewish Culture in Weimar Germany* (New Haven, CT, 1996)

——, *A Short History of the Jews* (Princeton, NJ, 2010)

Brown, Julia, *After Mountains and Sea: Frankenthaler 1956–1959*, exh. cat. (New York, 1998)

Cahan, Abraham, *The Rise of David Levinsky* (1917; reprint, New York, 1960)

Cahn, Walter, 'Max Liebermann and the Amsterdam Jewish Quarter', in *Art of Being Jewish*, ed. Barbara Kirschenblatt-Gimblett and Jonathan Karp (Philadelphia, PA, 2008), pp. 208–27

Cameron, Dan, *et al.*, *William Kentridge* (London, 1999)

Carvalho, Solomon Nunes, *Incidents of Travel and Adventure in the Far West with Colonel Fremont's Last Expedition* (1856; Reprint, Lincoln, NB, 2004)

Cassou, Jean, *Chana Orloff (1888–1968)*, exh. cat. (Tel Aviv, 1969)

Chadwick, Whitney, 'Living Simultaneously: Sonia and Robert Delaunay', in *Significant Others: Creativity and Intimate Partnership*, ed. Whitney Chadwick and Isabelle de Courtivon (London, 1993), pp. 31–49.

Chaim Gross Papers, Archives of American Art, Smithsonian Institution, Washington, DC

Chazan, Robert, *European Jewry and the First Crusade* (Berkeley, CA, 1987)

Chevlowe, Susan, *et al.*, *Common Man, Mythic Vision: The Paintings of Ben Shahn*, exh. cat. (New York, 1998)

——, 'Adi Nes's Biblical Stories', in *Adi Nes*, exh. cat., ed. Mordechai Omer (Tel Aviv, 2007), pp. 116–26

Chicago, Judy, *Holocaust Project: From Darkness into Light* (New York, 1993)

Cohen, Elisheva, *Moritz Oppenheim: The First Jewish Painter*, exh. cat. (Jerusalem, 1983)

Cohen, Jeremy, *Sanctifying the Name of God: Jewish Martyrs and Jewish Memories of the First Crusade* (Philadelphia, PA, 2004)

Cohen, Nurit Shilo, 'The "Hebrew Style" of Bezalel, 1906–1929', *The Journal of Decorative and Propaganda Arts*, 20 (1994), pp. 140–63

Cohen, Pamela, 'George Segal: An Iconographic Study of Biblical Imagery' (PhD thesis, Rutgers University, 1996)

Cohen, Richard I., *Jewish Icons: Art and Society in Modern Europe* (Berkeley, CA, 1998)

——, 'Exhibiting Nineteenth-Century Artists of Jewish Origin in the Twentieth Century: Identity, Politics, and Culture', in *The Emergence of Jewish Artists in Nineteenth-Century Europe*, exh. cat., ed. Susan Tumarkin Goodman (New York, 2001), pp. 153–63

——, 'Samuel Hirszenberg's Imagination: An Artist's Interpretation of the Jewish Dilemma at the Fin de Siècle', in Eli Lederhendler and Jack Wertheimer, eds, *Text and Context: Essays in Modern Jewish History and Historiography in Honor of Ismar Schorsch* (New York, 2005), pp. 219–55

——, 'The "Wandering Jew" from Medieval Legend to Modern Metaphor', in *The Art of Being Jewish in Modern Times*, ed. Barbara Kirshenblatt-Gimblett and Jonathan Karp (Philadelphia, PA, 2008), pp. 147–75

——, and Mirjam Rajner, 'The Return of the Wandering Jew(s) in Samuel Hirszenberg's Art', *Ars Judaica*, 7 (2011), pp. 33–56

Cortissoz, Royal, *American Art* (New York, 1923)

Cork, Richard, *David Bomberg* (New Haven, CT, 1987)

Craven, Thomas, *Modern Art: The Men, the Movements, the Meaning* (New York, 1934)

Czarnecki, Joseph P., *Last Traces: The Lost Art of Auschwitz* (New York, 1989)

Davidson, Jo, *Between Sittings: An Informal Autobiography of Jo Davidson* (New York, 1951)

Dekkers, Dieuwertje, ed., *Jozef Israëls, 1824–1911*, exh. cat. (Groningen-Amsterdam, 1999)

Delaney, Carol, *Abraham on Trial: The Social Legacy of Biblical Myth* (Princeton, NJ, 1998)

Dervaux, Isabelle, *The Ten: Birth of the American Avant-Garde*, exh. cat. (Boston, MA, 1998)

Deshmukh, Marion F., '"Politics is an Art": The Cultural Politics of Max Liebermann in Wilhelmine Germany', in *Imagining Modern German Culture, 1889–1910*, ed. Françoise Forster-Hahn (Washington, DC, 1996), pp. 165–85

——, 'Max Liebermann and the Politics of Painting in Germany: 1870–1935', in *Max Liebermann: From Realism to Impressionism*, exh. cat., ed. Barbara C. Gilbert (Los Angeles, CA, 2005), pp. 129–50

Diner, Hasia R., *The Jews of the United States, 1654–2000* (Berkeley, CA, 2004)

——, Jeffrey Shandler, and Beth S. Wenger, eds, *Remembering the Lower East Side: American Jewish Reflections* (Bloomington, NJ, 2000)

Du Bois, W.E.B., ed., *The Souls of Black Folk*, intro. David W. Blight and Robert Gooding-Williams (1903; reprint, Boston, MA, 1997)

Dutlinger, Anne D., ed., *Art, Music, and Education as Strategies for Survival: Theresienstadt, 1941–45*, exh. cat. (New York, 2001)

Eberle, Matthais, *Max Liebermann, 1847–1935* (Munich, 1995)

Eisenman, Peter, *Memorial to the Murdered Jews of Europe* (New York, 2005)

Eisler, Benita, *O'Keeffe and Stieglitz: An American Romance* (New York, 1991)

Eliel, Carol, *The Apocalyptic Landscapes of Ludwig Meidner*, exh. cat. (Los Angeles, CA, 1989)

Elsen, Albert, *Seymour Lipton* (New York, 1970)

Epstein, Jacob, *Let There Be Sculpture* (New York, 1940)

Ezekiel, Moses Jacob, *Moses Jacob Ezekiel: Memoirs from the Baths of Diocletian*, ed. Joseph Gutmann and Stanley F. Chyet (Detroit, MI, 1975)

Feiner, Shmuel, *The Jewish Enlightenment* (Philadelphia, PA, 2004)

Feinstein, Stephen C., ed., *Absence/Presence: Critical Essays on the Artistic Memory of the Holocaust* (Syracuse, NY, 2005)

Feldman, Yael S., 'On the Cusp of Christianity: Virgin Sacrifice in Pseudo-Philo and Amos Oz', *Jewish Quarterly Review*, 97 (2007), pp. 379–415

——, *Glory and Agony: Isaac's Sacrifice and National Narrative* (Stanford, CA, 2010)

Felstiner, Mary Lowenthal, *To Paint Her Life: Charlotte Salomon in the Nazi Era* (New York, 1994)

Ficowski, Jerzy, ed., *The Drawings of Bruno Schulz* (Evanston, IL, 1990)

Fine, Steven, 'Iconoclasm and the Art of Late-Antique Palestinian Synagogues', in *From Dura to Sepphoris: Studies in Jewish Art and Society in Late Antiquity*, ed. Lee Levine and Zeev Weiss (Ann Arbor, MI, 2000), pp. 183–94

——, 'Jewish Art and Biblical Exegesis', in *Picturing the Bible: The Earliest Christian Art*, exh. cat., ed. Jeffrey Spier (Fort Worth, TX, 2007), pp. 25–49

Fishof, Iris, *Jewish Art Masterpieces from the Israel Museum, Jerusalem* (Jerusalem, 1994)

——, *Written in the Stars: Art and Symbolism of the Zodiac*, exh. cat. (Jerusalem, 2001)

Flack, Audrey, *Audrey Flack on Painting* (New York, 1981)

——, telephone conversation with Samantha Baskind, 10 May 2005

Flint, Janet, *The Prints of Louis Lozowick: A Catalogue Raisonné* (New York, 1982)

Foster, Hal, ed., *Richard Serra* (Cambridge, MA, 2000)

Fox, Howard, *Eleanor Antin*, exh. cat. (Los Angeles, CA, 1999)

Frank, Robert, *The Americans* (1959; reprint New York, 1969)

Frankel, Stephen Robert, ed., *Jack Levine* (New York, 1989)

Freundlich, August L., *William Gropper: Retrospective*, exh. cat. (Los Angeles, CA, 1968)

Friedman, Mira, 'Chagall's Jerusalem', *Jewish Art*, 23/24 (1997/98), pp. 543–64

——, 'The Meaning of the Zodiac in Synagogues in the Land of Israel during the Byzantine Period', *Ars Judaica*, 1 (2005), pp. 51–62

Friedländer, Saul, *Nazi Germany and the Jews: The Years of Persecution, 1933–1939* (New York, 1997)

Friedman, Haya, 'Lissitzky's *Had Gadya*', *Jewish Art*, 12–13 (1986–7), pp. 294–303

Frojmovic, Eva, ed., *Imagining the Self, Imagining the Other: Visual Representations and Jewish-Christian Dynamics in the Middle Ages and Early Modern Period* (Leiden, 2002)

Fuhrer, Ronald, *Israeli Painting: From Post-Impressionism to Post-Zionism* (Woodstock, NY, 1998)

Gabriel, Ruth Apter, ed., *Tradition and Revolution: The Jewish Renaissance in Russian Avant-Garde Art 1912–1928*, exh. cat. (Jerusalem, 1987)

——, 'El Lissitzky's Jewish Works', in *Tradition and Revolution*, exh. cat., ed. Ruth Apter Gabriel (Jerusalem, 1987), pp. 101–24

Gay, Peter, *The Enlightenment, an Interpretation: The Rise of Modern Paganism* (New York, 1996)

Geis, Deborah, ed., *Considering Maus: Approaches to Art Spiegelman's Survivor's Tale of the Holocaust* (Tuscaloosa, AL, 2003)

Gelassi, Peter, *Barry Frydlender: Place and Time*, exh. cat. (New York, 2007)

Getlein, Frank, *Chaim Gross* (New York, 1974)

Gilbert, Barbara C., *Henry Mosler Rediscovered: A Nineteenth-Century Jewish-American Artist*, exh. cat. (Los Angeles, CA, 1995)

——, ed., *Max Liebermann: From Realism to Impressionism*, exh. cat. (Los Angeles, CA, 2005)

Gilman, Sander, *The Jew's Body* (New York, 1991)

Gleason, Philip, 'The Melting Pot: Symbol of Fusion or Confusion?', *American Quarterly*, XVI/1 (Spring 1964), pp. 20–46

Godfrey, Mark, *Abstraction and the Holocaust* (New Haven, CT, 2007)

Golan, Romy, 'The *Ecole Française* vs the *Ecole de Paris*: The Debate about the Status of Jewish Artists in Paris between the Wars', in *The Circle of Montparnasse: Jewish Artists in Paris (1905–1945)*, exh. cat., ed. Kenneth Silver and Romy Golan (New York, 1985), pp. 80–87

Goldfarb, Mira, 'Sacred Signs and Symbols in Morris Louis: The *Charred Journal* Series, 1951', in *Complex Identities: Jewish Consciousness and Modern Art*, ed. Matthew Baigell and Milly Heyd, (New Brunswick, NJ, 2001), pp. 193–205

Goldstein, David, *Hebrew Manuscript Painting* (London, 1985).

Goodman, Susan Tumarkin, ed., *Artists of Israel: 1920–1980*, exh. cat. (New York, 1981)

——, ed., *Jewish Themes/Contemporary American Artists*, exh. cat. (New York, 1982)

——, ed., *Jewish Themes/Contemporary American Artists II*, exh. cat. (New York, 1986)

——, ed., *Russian Jewish Artists in a Century of Change, 1890–1990*, exh. cat. (New York, 1995)

——, ed., *After Rabin: New Art from Israel*, exh. cat. (New York, 1998)

——, ed., *The Emergence of Jewish Artists in Nineteenth-Century Europe*, exh. cat. (New York, 2001)

——, ed., *Dateline: Israel. New Photography and Video Art*, exh. cat. (New York, 2007)

——, ed., *Chagall and the Artists of the Russian Jewish Theater*, exh. cat. (New York, 2008)

Grafman, Rafi, *Crowning Glory: Silver Torah Ornaments of The Jewish Museum, New York*, exh. cat. (New York, 1996)

Green, Gerald, *The Artists of Terezín* (New York, 1978)

Greenfeld, Howard, *Ben Shahn: An Artist's Life* (New York, 1998)

Greenough, Sarah, *Modern Art and America: Alfred Stieglitz and his New York Galleries*, exh. cat. (Washington, DC, 2001)

Gross, Chaim, *Fantasy Drawings* (New York, 1956)

Grossman, Cissy, 'The Real Meaning of Eugene Delacroix's *Noce Juive au Maroc*', *Journal of Jewish Art*, 14 (1988), pp. 64–73

Grossman, David, 'The Age of Genius: The Legend of Bruno Schulz', *New Yorker* (8 June 2009), pp. 66–77

Grossman, Grace Cohen, *Jewish Art* (New York, 1995)

Guralnik, Nehama, *In the Flower of Youth: Maurycy Gottlieb, 1856–1879*, exh. cat. (Tel Aviv, 1991)

Gutmann, Joseph, 'The "Second Commandment" and the Image in Judaism', *Hebrew Union College Annual*, 32 (1961), pp. 161–79

——, 'Jewish Participation in the Visual Arts of Eighteenth- and Nineteenth-Century America', *American Jewish Archives*, xv/1 (April 1963), pp. 21–57

——, *Hebrew Manuscript Painting* (New York, 1978)

——, ed., *The Dura Europos Synagogue: A Re-evaluation (1932–1992)* (Atlanta, GA, 1992)

Hall, Stuart, 'Cultural Identity and Diaspora', in *Identity: Community, Culture, Difference*, ed. Jonathan Rutherford (London, 1990)

Hammer, Martin, Naum Gabo and Christina Lodder, *Constructing Modernity: The Art and Career of Naum Gabo* (New Haven, CT, 2000)

Hapgood, Hutchins, *The Spirit of the Ghetto* (1902; reprint, Cambridge, 1967)

Harshav, Benjamin, *Marc Chagall and the Lost Jewish World* (New York, 2006)

Harten, Doreet LeVitté, ed., *Israeli Art around 1990*, exh. cat. (Düsseldorf, 1991)

Hass, Aaron, *In the Shadow of the Holocaust: The Second Generation* (Cambridge, 1996)

Hermand, Jost and Robert Holub, eds, *Heinrich Heine/Poetry and Prose* (New York, 1982)

Hertzberg, Arthur, ed., *The Zionist Idea* (Garden City, NY, 1959)

Hess, Thomas, *Barnett Newman*, exh. cat. (New York, 1971)

Heuberger Georg and Anton Merk, eds, *Moritz Daniel Oppenheim: Jewish Identity in 19th Century Art*, exh. cat. (Frankfurt, 1999)

Heyd, Milly, 'Lilien and Beardsley', *Journal of Jewish Art*, 7 (1980), pp. 58–69

——, 'Isaac's Sacrifice in the Bible Illustrations of Lilien and Pann', *Jewish Book Annual*, 40 (1982–3), pp. 54–66

——, *Mutual Reflections: Jews and Blacks in American Art* (New Brunswick, NJ, 1999)

——, 'Man Ray/Emmanuel Radnitsky: Who is Behind *The Enigma of Isidore Ducasse*?', in *Complex Identities: Jewish Consciousness and Modern Art*, ed. Matthew Baigell and Milly Heyd (New Brunswick, NJ, 2001), pp. 115–41

——, and Ezra Mendelsohn, '"Jewish" Art?: The Case of the Soyer Brothers', *Jewish Art*, 19–20 (1993–4), pp. 194–211

Hindus, Maurice G., 'The Jew as a Radical', *The Menorah Journal*, xiii/ 4 (August 1927), pp. 367–79

Hirsch, Marianne, *Family Frames: Photography, Narrative, and Postmemory* (Cambridge, MA, 1997)

——, 'Family Pictures: *Maus*, Mourning, and Post-Memory', *Discourse: Journal for Theoretical Studies in Media and Culture*, xv/2 (Winter 1992–3), pp. 3–29

Hoffman, Eva, *After Such Knowledge: Memory, History, and the Legacy of the Holocaust* (New York, 2004)

Hoffman, Stefani and Ezra Mendelsohn, eds, *The Revolution of 1905 and Russia's Jews* (Philadelphia, PA, 2008)

Hornstein, Shelley, and Florence Jacobowitz, eds, *Image and Remembrance: Representation and the Holocaust* (Bloomington, IN, 2003)

——, Laura Levitt and Laurence J. Silberstein, eds, *Impossible Images: Contemporary Art after the Holocaust* (New York, 2003)

Hubka, Thomas C., *Resplendent Synagogue: Architecture and Worship in an Eighteenth-Century Polish Community* (Hanover, NH, 2003)

Hyman, Paula, 'Acculturation of the Jews in Nineteenth-Century Europe', in *The Emergence of Jewish Artists in Nineteenth-Century Europe*, exh. cat., ed. Susan Tumarkin Goodman (New York, 2001), pp. 31–9

Ida, Batsheva Goldman, *Ze'ev Raban: A Hebrew Symbolist*, exh. cat. (Tel Aviv Museum, 2001)

Israel, Jonathan, *European Jewry in the Age of Mercantilism, 1550–1750* (Oxford, 1989)

Israeli, Yael, ed., *In the Light of the Menorah*, exh. cat. (Jerusalem, 1999)

'It's All Yours', *Seventeen* (September 1954), pp. 140–41, 161

Ivanov, Vladislav, 'Habima and "Biblical Theater"', in *Russian Jewish Theater*, exh. cat. (New York, 2008), pp. 27–47, 90–105

Julius, Anthony, *Idolizing Pictures: Idolatry, Iconoclasm, and Jewish Art* (New York, 2001).

Le Juif errant, exh. cat. (Paris, 2001)

Lozowick, Louis, *One Hundred Contemporary American Jewish Painters and Sculptors* (New York, 1947)

——, *William Gropper* (Philadelphia, PA, 1983)

——, *Survivor from a Dead Age: The Memoirs of Louis Lozowick*, ed. Virginia Hagelstein (Washington, DC, 1997)

Julius, Anthony, *Idolizing Pictures: Idolatry, Iconoclasm, and Jewish Art* (New York, 2001)

Kallen, Horace M., 'Democracy Versus the Melting-Pot: Part I', *The Nation*, C/2,590 (18 February 1915), pp. 190–94

——, 'Democracy Versus the Melting-Pot: Part II', *The Nation*, C/2,590 (25 February 1915), pp. 217–20

Kampf, Avram, 'Art and Stage Design: The Jewish Theatres of Moscow in the Early Twenties', in *Tradition and Revolution*, exh. cat., ed. Ruth Apter-Gabriel (Jerusalem, 1987), pp. 125–42

——, *Chagall to Kitaj: Jewish Experience in 20th Century Art* (Westport, CT, 1990)

Kaplan, Yosef, 'For whom did Emanuel de Witte paint his three pictures of the Sephardic Synagogue in Amsterdam?', *Studia Rosenthaliana*, 32 (1998), pp. 133–54

——, *Alternative Path to Modernity: The Sephardi Diaspora in Western Europe* (Leiden, 2000)

Kasovsky, Hillel, *The Artists of the Kultur-Liga* (Jerusalem, 2003)

Kaster, Karl Georg, ed., *Felix Nussbaum – Art Defamed, Art in Exile, Art in Resistance: A Biography*, trans. Eileen Martin (Woodstock, NY, 1997)

Katz, Dana, *The Jew in the Art of the Italian Renaissance* (Philadelphia, PA, 2008)

Keller, Judith, *Weegee: Photographs from the J. Paul Getty Museum* (Los Angeles, CA, 2005)

Kimmerling, Baruch, *The Invention and Decline of Israeliness: State, Society, and the Military* (Berkeley, CA, 2001)

Kirshenblatt-Gimblett, Barbara, and Jonathan Karp, eds, *The Art of Being Jewish in Modern Times* (Philadelphia, PA, 2008)

Kitaj, R. B., *First Diasporist Manifesto* (New York, 1989)

——, *Second Diasporist Manifesto* (New Haven, CT, 2007)

Kleeblatt, Norman, *Larry Rivers' History of Matzah (The Story of the Jews)* exh. cat. (New York, 1984)

——, ed., *The Dreyfus Affair: Art, Truth and Justice*, exh. cat. (New York, 1987)

——, ed., *Too Jewish?: Challenging Traditional Jewish Identities*, exh. cat. (New York, 1996)

——, ed., *Mirroring Evil: Nazi Imagery/Recent Art*, exh. cat. (New York, 2001)

——, and Susan Chevlowe, eds, *Painting a Place in America: Jewish Artists in New York 1900–1945*, exh. cat. (New York, 1991)

——, and Vivian B. Mann, *Treasures of the Jewish Museum* (New York, 1986)

——, and Kenneth Silver, *An Expressionist in Paris: The Paintings of Chaim Soutine*, exh. cat. (New York, 1998)

——, 'Departures and Returns – Sources and Contexts for Moritz Oppenheim's Masterpiece *The Return of the Volunteer*', in *Moritz Daniel Oppenheim: Jewish Identity in 19th Century Art*, exh. cat., ed. Georg Heuberger and Anton Merk (Frankfurt, 1999), pp. 113–30

Klein, Mason, ed., *Modigliani: Beyond the Myth*, exh. cat. (New York, 2004)

——, ed., *Alias Man Ray: The Art of Reinvention*, exh. cat. (New York, 2009)

Kline, Katy, and Helaine Posner, *Leon Golub and Nancy Spero: War and Memory* (Cambridge, MA, 1994)

Kozloff, Max, *New York: Capital of Photography*, exh. cat. (New York, 2002)

Kraeling, Carl, *The Synagogue: The Excavations at Dura Europos* (New Haven, CT, 1956)

Krinsky, Carol Herselle, *Synagogues of Europe* (Cambridge, MA, 1985)

Kogman-Appel, Katrin, *Illuminated Haggadot from Medieval Spain* (University Park, PA, 2006)

Kuspit, Donald, 'Jewish Naivete? Soutine's Shudder', in *Complex Identities: Jewish Consciousness and Modern Art*, ed.

Matthew Baigell and Milly Heyd (New Brunswick, NJ, 2001), pp. 87–99

Landsberger, Franz, *Rembrandt, the Jews, and the Bible* (Philadelphia, PA, 1946)

Langer, Lawrence, *Landscapes of Jewish Experience: Painting By Samuel Bak* (Boston, MA, 1997)

Levin, Gail, 'Beyond the Pale: Jewish Identity, Radical Politics and Feminist Art in the United States', *Journal of Modern Jewish Studies*, IV/2 (July 2005), pp. 205–32

Levine, Jack, conversation with Samantha Baskind, New York, 14 January 2005

Levine, Lee, 'Figural Art in Ancient Judaism', *Ars Judaica*, 1 (2005), pp. 9–26

Levine, Ruth, and Susan Morgenstern, *The Jews in the Age of Rembrandt*, exh. cat. (Rockville, MD, 1981)

Levitt, Avraham, 'Israeli Art on its Way to Somewhere Else', *Azure*, 3 (Winter 1998), pp. 120–45

Leymarie, Jean, *Marc Chagall: The Jerusalem Windows*, 3rd edn (New York, 1996)

Lipchitz, Jacques, with H. H. Arnason, *My Life in Sculpture* (New York, 1972)

Lippard, Lucy R., *Eva Hesse* (New York, 1976)

Lipstadt, Deborah E., *Beyond Belief: The American Press and the Coming of the Holocaust, 1933–1945* (New York, 1986)

Lipton, Sara, *Images of Intolerance: The Representations of Jews and Judaism in the Bible Moralisée* (Berkeley, CA, 1999)

Litvak, Olga, 'Rome and Jerusalem: The Figure of Jesus in the Creation of Mark Antokol'skii', in *The Art of Being Jewish in Modern Times*, ed. Barbara Kirshenblatt-Gimblett and Jonathan Karp (Philadelphia, PA, 2008), pp. 228–53

Livingstone, Marco, *R. B. Kitaj* (London, 1999)

Mann, Vivian, ed., *Uneasy Communion: Jews, Christians, and the Altarpieces of Medieval Spain*, exh. cat. (New York, 2010)

——, ed., *Jewish Texts on the Visual Arts* (London, 2000)

——, and Richard I. Cohen, eds, *From Court Jews to the Rothschilds: Art, Patronage and Power, 1600–1800*, exh. cat. (New York, 1996)

——, and Gordon Tucker, eds, *The Seminar on Jewish Art* (New York, 1985)

Manor, Dalia, 'From Rejection to Recognition: Israeli Art and the Holocaust', *Israel Affairs*, IV/3–4 (Spring/Summer 1998), pp. 253–77

——, *Art in Zion: The Genesis of Modern National Art in Jewish Palestine* (London, 2005)

Marcilhac, Felix, *Chana Orloff* (Paris, 1991)

Marcus, Jacob R., *To Count a People: American Jewish Population Data, 1585–1984* (Lanham, MD, 1990)

Marzorati, Gerald, *A Painter of Darkness: Leon Golub and Our Times* (New York, 1990)

'Max Weber Dies; Painter, Was 80' (obituary), *New York Times* (5 October 1961), p. 37

Mayerson, Charlotte Leon, ed., *Shadow and Light: The Life, Friends and Opinions of Maurice Sterne* (New York, 1965)

McBee, Richard, 'The 613: Paintings By Archie Rand', *The Jewish Press* (16 April 2008), http://www.jewishpress.com/pager-oute.do/31344

Méchoulan, Henri, and Richard Popkin, *Menasseh ben Israel and his World* (Leiden, 1989)

Meisel, Victor, *Ludwig Meidner: An Expressionist Master*, exh. cat. (Ann Arbor, MI, 1978)

Mellinkoff, Ruth, *Outcasts: Signs of Otherness in Northern European Art of the Late Middle Ages* (Berkeley, CA, 1993)

Mendelsohn, Amitai, 'The End of Days and New Beginnings', in *Real Time: Art in Israel, 1998–2008*, exh. cat. (Jerusalem, 2008), pp. 74–86

Mendelsohn, Ezra, 'From Assimilation to Zionism in Lvov: The Case of Alfred Nossig', *Slavonic and East European Review*, 117 (1971), pp. 512–34

——, *On Modern Jewish Politics* (New York, 1993)

——, *Painting a People: Maurycy Gottlieb and Jewish Art* (Hanover, NH, 2002)

——, and Richard I. Cohen, eds, *Art and its Uses: The Visual Image and Modern Jewish Society* (New York, 1990)

Mendes-Flohr, Paul, and Jehuda Reinharz, eds, *The Jew in the Modern World: A Documentary History*, second edn (New York, 1995)

Merback, Mitchell, 'Fount of Mercy, City of Blood: Cultic Anti-Judaism and the Pulkau Passion Altarpiece', *Art Bulletin*, 87/4 (2005), pp. 589–642

——, *Beyond the Yellow Badge: Anti-Judaism and Antisemitism in Medieval and Early Modern Visual Culture* (Leiden, 2008)

Meyer, Michael, *Response to Modernity: A History of the Reform Movement in Judaism* (New York, 1988)

Michaud, Eric, *The Cult of Art in Nazi Germany* (Stanford, CA, 2004)

Mickenberg, David, Corinne Granof, and Peter Hayes, *The Last Expression: Art and Auschwitz*, exh. cat. (Evanston, IL, 2003)

Milgrom, Jo, *The Binding of Isaac: The Akeda – A Primary Symbol in Jewish Thought and Art* (Berkeley, CA, 1988)

Mirzoeff, Nicholas, 'Pissarro's Passage: The Sensation of Caribbean Jewishness in Diaspora', in *Diaspora and Visual Culture: Representing Africans and Jews*, ed. Mirzoeff (New York, 2000), pp. 57–75

Moore, Deborah Dash, and David Lobenstine, 'Photographing the Lower East Side: A Century's Work', in *Remembering the Lower East Side: American Jewish Reflections*, ed. Jeffrey Shandler, and Beth S. Wenger (Bloomington, NJ, 2000), pp. 28–69

Moore, James C., *Harry Sternberg: A Catalog Raisonné of his Graphic Work* (Wichita, KS, 1975)

Morphet, Richard, *R. B. Kitaj* (New York, 1994)

Myers, David, and William Rowe, *From Ghetto to Emancipation* (Toronto, ON, 1997)

Nadler, Steven, *Rembrandt's Jews* (Chicago, IL, 2003)

Narkiss, Bezalel, *Hebrew Illuminated Manuscripts* (Jerusalem; New York, 1969)

——, 'The Menorah in Illuminated Manuscripts of the Middle Ages', in *In the Light of the Menorah*, exh. cat., ed. Yael Israeli (Jerusalem, 1999), pp. 81–6

Nathans, Benjamin, *Beyond the Pale: The Jewish Encounter with Late Imperial Russia* (Berkeley, CA, 2002)

Natter, Tobias, ed., *Rabbiner-Bocher-Talmudschüler. Bilder des Wiener Malers Isidor Kaufmann, 1853–1921*, exh. cat. (Vienna, 1995)

Nelkin, Halina, *Images of a Lost World: Jewish Motifs in Polish Painting, 1770–1945* (New York, 1991)

Nochlin, Linda, 'Degas and the Dreyfus Affair: A Portrait of the Artist as an Anti-Semite', in *The Dreyfus Affair: Art, Truth and Justice*, exh. cat., ed. Norman Kleeblatt (New York, 1987), pp. 96–116

——, 'Starting with the Self: Jewish Identity and its Representation', in *The Jew in the Text: Modernity and the Construction of Identity*, ed. Nochlin and Tamar Garb (London, 1995), pp. 12–18

Novick, Peter, *The Holocaust in American Life* (Boston, MA, 1999)

Obrist, Hans-Ulrich, ed., *Leon Golub: Do Paintings Bite? Selected Texts (1948–1996)* (Ostfildern, Germany, 1997),

Ofek, Ruthi, ed., *Avraham Ofek Murals*, exh. cat. (Tefen, 2001)

Ofrat, Gideon, *One Hundred Years of Art in Israel*, trans. Peretz Kidron (Boulder, CO, 1998)

Olin, Margaret, *The Nation without Art: Examining Modern Discourses on Jewish Art* (Lincoln, NE, 2001)

——, 'The Stones of Memory: Peter Eisenman in Conversation', *Images*, 2 (2009), pp. 129–35

Omer, Mordechai, *Adi Nes*, exh. cat. (Tel Aviv, 2007)

——, *My Own Body: Art in Israel, 1968–1978*, exh. cat. (Tel Aviv, 2008)

Paret, Peter, 'Modernism and the "Alien Element" in German Art', in *Berlin Metropolis: Jews and the New Culture 1890–1918*, exh. cat., ed. Emily Bilski (New York, 1999), pp. 33–57

Perez, Nissan, *Time Frame* (Jerusalem, 2000)

Perlove, Shelley, 'Perceptions of Otherness: Critical Responses to the Jews of Rembrandt's Art and Milieu (1836–1945)', *Dutch Crossing*, 25 (2001), pp. 243–90

——, and Larry Silver, *Rembrandt's Faith: Church and Temple in the Dutch Golden Age* (University Park, PA, 2009)

Philipson, David, 'Moses Jacob Ezekiel', *Publications of the American Jewish Historical Society*, 28 (1922), pp. 1–62

Pissarro, Joachim, *Camille Pissarro* (New York, 1993)

Platt, Susan Noyes, 'The Jersey Homesteads Mural: Ben Shahn, Bernarda Bryson, and History Painting in the 1930s', in *Redefining American History Painting*, ed. Patricia M. Burnham and Lucretia Hoover Giese (Cambridge, 1995), pp. 294–309

Pohl, Frances K., 'Constructing History: A Mural by Ben Shahn', *Arts Magazine*, 62 (September 1987), pp. 11–21

——, *Ben Shahn* (San Francisco, CA, 1993)

Poliakoff, Léon, *The History of Anti-Semitism*, trans. George Klin, 4 vols (1977; Philadelphia, PA, 2003)

Posèq, Avigdor W. G., 'Jacques Lipchitz's *David and Goliath*', *Source*, 8 (Spring 1989), pp. 22–31

——, 'The Hanging Carcass Motif and Jewish Artists', *Jewish Art*, 16–17 (1990–91), pp. 139–56

——, 'Toward a Semiotic Approach to Jewish Art', *Ars Judaica*, 1 (2005), pp. 45–8

Potok, Chaim, *My Name is Asher Lev* (Greenwich, CT, 1972)

Pratt, Davis, *The Photographic Eye of Ben Shahn* (Cambridge, MA, 1975)

Prawer, S. S., *Heine's Jewish Comedy: A Study of his Portraits of Jews and Judaism* (Oxford, 1983)

Raban Remembered: Jerusalem's Forgotten Master, exh. cat. (New York, 1982)

Rand, Archie, telephone conversation with Samantha Baskind, 7 July 2006

Ratcliff, Carter, *Komar and Melamid* (New York, 1988)

Rattner, Abraham, oral history interview with Colette Roberts, 20 May 1968 and 21 June 1968, Archives of American Art, Smithsonian Institution, Washington, DC

Rauterberg, Hanno, *Holocaust Memorial Berlin: Eisenman Architects* (Baden, Switzerland, 2005)

R. B. Kitaj file, Skirball Cultural Center, Los Angeles

Reinharz, Jehuda, *Fatherland or Promised Land* (Ann Arbor, MI, 1975)

Reuven Rubin Dreamland, exh. cat. (Tel Aviv, 2006)

Rivers, Larry, *Larry Rivers: Art and the Artist*, exh. cat. (Boston, MA, 2002)

Rosen, Jochai, 'The End of Consensus: The Crisis of the 1980s and the Turning-point in Israeli Photography', *Journal of Modern Jewish Studies*, IX/3 (2010), pp. 327–47

Rosenberg, Harold, 'Is There a Jewish Art?', *Commentary*, XLII/1 (July 1966), pp. 57–60

Roskies, David G., *Against the Apocalypse: Responses to Catastrophe in Modern Jewish Culture* (Syracuse, NY, 1984)

Roth, Cecil, ed., *Jewish Art: An illustrated History* (Greenwich, CT, 1961)

Rubin, Miri, *Gentile Tales: The Narrative Assault on Late Medieval Jews* (New Haven, CT, 1999)

Sabar, Shalom, 'The Beginnings of *Ketubbah* Decoration in Italy: Venice in the Late Sixteenth to the Early Seventeenth Centuries', *Jewish Art*, 12/13 (1986–7), pp. 96–110

——, *Ketubbah: Jewish Marriage Contracts of the Hebrew Union College Skirball Museum and Klau Library* (New York, 1990)

——, *Ketubbah: The Art of the Jewish Marriage Contract*, exh. cat. (Jerusalem, 2000)

——, 'Between Calvinists and Jews: Hebrew Script in Rembrandt's Art', in *Beyond the Yellow Badge: New Approaches to Anti-Judaism and Anti-Semitism in Medieval and Early Modern Visual Culture*, ed. Mitchell Merback (Leiden, 2008), pp. 371–404

Sachar, Howard, *A History of the Jews in the Modern World* (New York, 2005)

Salomon, Charlotte, *Charlotte Salomon: Life? or Theater? An Autobiographical Play by Charlotte Salomon*, trans. Leila Vennewitz (New York, 1981)

Saltzman, Lisa, 'Barnett Newman's Passion', in *The Passion Story: From Visual Representation to Social Drama*, ed. Marcia Kupfer (University Park, PA, 2008), pp. 203–15

Sammons, Jeffrey, *Heinrich Heine: A Modern Biography* (Princeton, NJ, 1979)

Sarna, Jonathan D., *American Judaism: A New History* (New Haven, CT, 2004)

Schapiro, Miriam, written correspondence with Samantha Baskind, 12 May 2006

Schmidt, Gilya Gerda, *The Art and Artists of the Fifth Zionist Congress, 1901* (Syracuse, NY, 2003)

Schneider, Ulrich, Arturo Schwarz and Mordecai Omer, *Menashe Kadishman. Shalechet: Heads and Sacrifices*, exh. cat. (Aachen, 1999)

Schoener, Allon, ed., *Portal to America: The Lower East Side, 1870–1925* (New York, 1967)

Scholem, Gershom, 'The Star of David: History of a Symbol', in *The Messianic Idea in Judaism and Other Essays on Jewish Spirituality* (London, 1971), pp. 257–81

Schorsch, Ismar, 'Art as Social History: Oppenheim and the German Jewish Vision of Emancipation', in *Moritz Oppenheim: The First Jewish Painter*, exh. cat., ed. Elisheva Cohen (Jerusalem, 1983), pp. 31–61

——, *From Text to Context: The Turn to History in Modern Judaism* (Hanover, NH, 1994)

Schultz, Deborah, and Edward Timms, *Pictorial Narrative in the Nazi Period: Felix Nussbaum, Charlotte Salomon and Arnold Daghani* (London, 2009)

Schütz, Chana, 'Max Liebermann as a "Jewish" Painter: The Artist's Reception in his Time', in *Berlin Metropolis*, exh cat., ed. Emily Bilski (New York, 1999), pp. 146–63

——, and Hermann Simon, 'Max Liebermann: German Painter and Berlin Jew', in *Max Liebermann: From Realism to Impressionism*, exh. cat., ed. Barbara C. Gilbert (Los Angeles, CA, 2005), pp. 151–65

Schwarzschild, Steven, 'The Legal Foundation of Jewish Aesthetics', in *The Pursuit of the Ideal: Jewish Writings of Steven Schwarzschild*, ed. Menachem Keller (Albany, NY, 1990), pp. 109–16

——, 'Aesthetics', in *Contemporary Jewish Religious Thought: Original Essays on Critical Concepts, Movements, and Beliefs*, ed. Arthur A. Cohen and Paul Mendes-Flohr (New York, 1987)

Sed-Rajna, Gabrielle, *The Hebrew Bible* (New York, 1997)

——, *et al.*, *Jewish Art*, trans. Sara Friedman and Mira Reich (New York, 1997)

——, 'Images of the Tabernacle/Temple in Late Antique and Medieval Art: The State of Research', *Jewish Art*, 23–24 (1997–8), pp. 42–53

Seeing through 'Paradise': Artists and the Terezin Concentration Camp, exh. cat. (Boston, MA, 1991)

Shapiro Edward S., *Crown Heights: Blacks, Jews, and the 1991 Brooklyn Riot* (Waltham, MA, 2006)

Shikes, Ralph, and Paula Harper, *Pissarro, His Life and Work* (New York, 1980)

Shlaer, Robert, 'An Expeditionary Daguerrotype by Solomon Carvalho', *The Daguerrian Annual* (1999), pp. 151–9

Silber, Evelyn, *The Sculpture of Epstein: With a Complete Catalogue* (Lewisburg, PA, 1986)

——, and Terry Friedman, *et al.*, *Jacob Epstein: Sculpture and Drawings* (Leeds, England, 1989)

Silver, Ken, *Paris Portraits: Artists, Friends, and Lovers*, exh. cat. (Greenwich, CT, 2008)

——, and Romy Golan, *The Circle of Montparnasse: Jewish Artists in Paris (1905–1945)*, exh. cat. (New York, 1985)

Silver, Larry, 'Jewish Identity in Art and History: Maurycy Gottlieb as Early Jewish Artist', in Catherine Soussloff, ed., *Jewish Identity in Modern Art History* (Berkeley, 1999), pp. 87–113

——, 'Between Tradition and Acculturation: Jewish Painters in Nineteenth Century Europe', in *The Experience of Emancipation: Nineteenth-Century Jewish Artists Confront Modernity*, exh. cat., ed. Susan Goodman (New York, 2001), pp. 123–41

——, 'Diaspora, Nostalgia, and the Universal: Conditions of Modern Jewish Artists', in *Transformation: Jews and Modernity*, exh. cat., ed. Larry Silver (Philadelphia, PA, 2001), pp. 13–33

——, ed., *Transformation: Jews and Modernity*, exh. cat. (Philadelphia, PA, 2001)

Simmel, Georg, *Conflict and the Web of Group-Affiliations*, trans. Kurt H. Wolff and Reinhard Bendix (New York, 1955)

Slezkine, Yuri, *The Jewish Century* (Princeton, NJ, 2004)

Soby, James Thrall, 'Peter Blume's Eternal City', *Bulletin of the Museum of Modern Art*, 10 (April 1943), pp. 2–6

Soltes, Ori, *Fixing The World: Jewish American Painters in the Twentieth Century* (Hanover, NH, 2003).

Sorin, Gerald, *A Time for Building: The Third Migration, 1880–1920* (Baltimore, MD, 1992)

Sorkin, David, *The Transformation of German Jewry (1780–1840)* (New York, 1987)

——, *Moses Mendelssohn and the Religious Enlightenment* (London, 1996)

——, *The Berlin Haskalah and German Religious Thought* (London, 2000)

——, 'Between Messianism and Survival. Secularization and Sacralization in Modern Judaism', *Journal of Modern Jewish Studies*, 3 (2004), pp. 73–86

——, *The Religious Enlightenment: Protestants, Jews, and Catholics from London to Vienna* (Princeton, NJ, 2008)

Soussloff, Catherine, ed., *Jewish Identity in Modern Art History* (Berkeley, CA, 1999)

Spencer, Charles, *et al.*, *The Immigrant Generations: Jewish Artists in Britain, 1900–1945*, exh. cat. (New York, 1983)

Spiegelman, Art, *Maus: A Survivor's Tale* (New York, 1986 [vol. I], 1991 [vol. II])

——, NPR interview, 15 July 2008. http://www.npr.org/blogs/newsandviews/from_farai/

Spira, Freyda, 'Marketing Identities: Works on Paper in Fin-de-Siecle Berlin', in *Transformation: Jews and Modernity*, exh. cat., ed. Larry Silver (Philadelphia, PA, 2001), pp. 56–67

Steinberg, Michael, and Monica Bohm-Duchen, eds, *Reading Charlotte Salomon* (Ithaca, NY, 2006)

Steiner, Edward A., *On the Trail of the Immigrant* (New York, 1906)

Stern, David, *Chosen: Philadelphia's Great Hebraica*, exh. cat. (Philadelphia, PA, 2008)

Sternberg, Harry, oral history interview with Sally Yard. Archives of American Art, Smithsonian Institution, Washington, DC, 19 March 1999–7 January 2000). http://www.aaa.si.edu/collections/oralhistories/transcripts/sternb99.htm

Steyn, Juliet, 'Inside-Out: Assumptions of "English" Modernism in the Whitechapel Art Gallery, London, 1914', in *Art Apart:*

Art Institutions and Ideology Across England and North America, ed. Marcia Pointon (Manchester, 1994), pp. 212–30

Stieglitz, Alfred, *Stieglitz on Photography: His Selected Essays and Notes*, compiled and annotated by Richard Whelan (New York, 2000)

Strickland, Debra Higgs, *Saracens, Demons, and Jews: Making Monsters in Medieval Art* (Princeton, NJ, 2003)

Struck, Hermann, 'As an Artist Saw Him: The Man of Sorrows and the Seer', in *Theodor Herzl: A Memorial*, ed. Meyer W. Weisgal (New York, 1929), p. 36

Sturhahn, Joan, *Carvalho, Artist-Photographer-Adventurer-Patriot: Portrait of a Forgotten American* (Merrick, NY, 1976)

Sussman, Elisabeth, and Fred Wasserman, *Eva Hesse: Sculpture*, exh. cat. (New York, 2006)

Talgam, Rena, and Zeev Weiss, *The Mosaics of the House of Dionysos at Sepphoris* (Jerusalem, 2004)

Taylor, Michael, 'Jacques Lipchitz and Philadelphia', *Philadelphia Museum of Art Bulletin*, 92 (2004), pp. 3–52

Trachtenberg, Alan, 'The Claim of a Jewish Eye', *Pakn Treger*, 41 (Spring 2003), pp. 20–5

Trapp, Frank Anderson, *Peter Blume* (New York, 1987).

Tuchman, Phyllis, *George Segal* (New York, 1983)

Van Voolen, Edward, 'Israëls: Son of the Ancient People', in *Jozef Israëls*, exh. cat., ed. Dieuwertje Dekkers (Groningen-Amsterdam, 1999), pp. 54–70

——, *My Grandparents, My Parents and I: Jewish Art and Culture* (Munich, 2006)

Vishny, Michelle, *Mordecai Ardon* (New York, 1974)

Vital, David, *The Origins of Zionism* (Oxford, 1975)

——, *Zionism: The Formative Years* (Oxford, 1982)

——, *Zionism: The Crucial Phase* (Oxford, 1987)

Warner, Malcolm, *The Prints of Harry Sternberg* (San Diego, CA, 1994)

Waugh, Linda, 'Marked and Unmarked: A Choice Between Unequals in Semiotic Structure', *Semiotica*, 38 (1982), pp. 299–318

Wayne, Kenneth, *Modigliani and the Artists of Montparnasse*, exh. cat. (Buffalo, NY, 2002)

Weber, Annette, 'Moritz Daniel Oppenheim and the Rothschilds', in *Moritz Daniel Oppenheim: Jewish Identity in 19th Century Art*, exh. cat., ed. Georg Heuberger and Anton Merk (Frankfurt, 1999), pp. 170–86

——, 'The Portrait as Mirror: Moritz Daniel Oppenheim as Artist, Citoyen, and Jew', in *Moritz Daniel Oppenheim: Jewish Identity in 19th Century Art*, exh. cat., ed. Georg Heuberger and Anton Merk (Frankfurt, 1999), pp. 187–99

Weegee, *Weegee by Weegee: An Autobiography* (New York, 1961)

Weisberg, Gabriel, 'Jewish Naturalist Painters', in *The Emergence of Jewish Artists in Nineteenth-Century Europe,* exh. cat., ed. Susan Tumarkin Goodman (New York, 2001), pp. 143–51

Weiss, Zeev, *The Sepphoris Synagogue: Deciphering an Ancient Message through its Archaeological and Socio-Historical Contexts* (Jerusalem, 2005)

Weissberg, Liliane, and Georg Heuberger, 'The Rothschild of Painters and the Prince of Poets', in *Moritz Daniel Oppenheim: Jewish Identity in 19th Century Art*, exh. cat., ed. Georg Heuberger and Anton Merk (Frankfurt, 1999), pp. 131–52

Weitzmann, Kurt and Herbert Kessler, *The Frescoes of the Dura Synagogue and Christian Art* (Washington, DC, 1990)

Wenger, Beth S., 'Memory as Identity: The Invention of the Lower East Side', *American Jewish History*, LXXXV/1 (March 1997), pp. 3–27

Werner, Alfred, *Max Weber* (New York, 1975)

Wharton, Annabel Jane, 'Good and Bad Images from the Synagogue of Dura Europos: Contexts, Subtexts, Intertexts', *Art History*, 17 (1994), pp. 1–25

——, 'JEWISH ART, Jewish art', *Images*, 1 (2007), pp. 29–35

Whitney, Helen, dir., *Richard Avedon: Darkness and Light* (Chicago, IL 1995)

Wilkinson, Alan, *The Sculpture of Jacques Lipchitz: A Catalogue Raisonné I: The Paris Years, 1910–1940* (London, 1996)

——, 'Paris and London: Modigliani, Lipchitz, Epstein, and Gaudier-Brzeska', in *'Primitivism' in Twentieth-Century Art*, exh. cat., ed. William Rubin (New York, 1984), pp. 417–29

Wilson, William, '"The Circumcision": A Drawing by Romeyn de Hooghe', *Master Drawings*, 13 (1975), pp. 250–58

Wisse, Ruth, *The Modern Jewish Canon* (Chicago, IL, 2000)

Wolitz, Seth, 'The Jewish National Art Renaissance in Russia', in *Traditions and Revolution: The Jewish Renaissance in Russian Avant-Garde Art 1912–1928*, exh. cat., ed. Ruth Apter Gabriel (Jerusalem, 1987), pp. 21–42

Wullschlager, Jackie, *Chagall: A Biography* (New York, 2009)

Wyszogrod, Morris, *A Brush with Death: An Artist in the Death Camps* (Albany, NY, 1999)

Yaffe, Richard, *Nathan Rapoport Sculptures and Monuments* (New York, 1980)

Yerushalmi, Yosef Hayim, *Haggadah and History* (Philadelphia, PA, 1975)

——, *Zakhor: Jewish History and Jewish Memory* (Seattle, WA, 1982)

Young, James E., 'The Biography of a Memorial Icon: Nathan Rapoport's Warsaw Ghetto Monument', *Representations*, 26 (Spring 1989), pp. 69–106

——, *The Texture of Memory: Holocaust Memorials and Meaning* (New Haven, CT, 1993)

——, 'Sites Unseen: Shimon Attie's Acts of Remembrance, 1991–1996', in *At Memory's Edge: After-Images of the Holocaust in Contemporary Art and Architecture* (New Haven, CT, 2000), pp. 62–89

Zalkind, Simon, *Upstarts and Matriarchs: Jewish Women Artists and the Transformation of American Art*, exh. cat. (Denver, CO, 2005)

Zalmona, Yigal, 'History and Identity', in *Artists of Israel: 1920–1980*, exh. cat., ed. Susan Tumarkin Goodman (New York, 1981), pp. 26–46

——, *The Art of Abel Pann: From Montparnasse to the Land of the Bible*, exh. cat. (Jerusalem, 2003)

——, *Boris Schatz: The Father of Israeli Art*, exh. cat. (Jerusalem, 2006)

Zangwill, Israel, *The Melting-Pot, Drama in Four Acts* (New York, 1909)

Zell, Michael, *Reframing Rembrandt: Jews and the Christian Image in Seventeenth-Century Amsterdam* (Berkeley, CA, 2002)

Zemel, Carol, 'Diasporic Values in Contemporary Art: Kitaj, Katchor, Frenkel', in *The Art of Being Jewish in Modern Times*, ed. Barbara Kirshenblatt-Gimblett and Jonathan Karp (Philadelphia, PA, 2008), pp. 176–82

Zuckermann, Moshe, 'Authenticity, Ideology and the Israeli Society', in '*Hebrew Work*', exh. cat., ed. Galia Bar Or (Ein Harod, 1998), pp. 94–106

Acknowledgements

We offer our deepest gratitude to two pioneers of the still young field of modern Jewish art: Ziva Amishai-Maisels and Richard Cohen. Both have provided encouragement through the years, and in the present case each read carefully through this entire manuscript, making invaluable suggestions that helped us refine and shape the material. Other individuals working in Jewish studies have offered much appreciated support: Emily Bilski, Juliet Bellow, Sander Gilman, Harry Rand, Jonathan Sarna and Freyda Spira. We are most fortunate to have them as colleagues and friends.

Although there are too many to name specifically, we are grateful to all the galleries, artists' estates and museums that waived or reduced fees so that image reproductions could appear in the book. We especially thank those artists who provided images and waived fees: Eleanor Antin, Shimon Attie, Samuel Bak, Rina Castelnuovo, Audrey Flack, Barry Frydlender, William Kentridge, Jack Levine, Adi Nes, Archie Rand, Miriam Schapiro and Art Spiegelman. Generous publication subventions from the Lucius N. Littauer Foundation, the CLASS Dean's office at Cleveland State University, as well as the CSU Art Department and the James and Nan Farquhar Professorship at the University of Pennsylvania have enhanced our book considerably, and we extend our heartfelt thanks for these contributions.

As collaborators on this project, the authors realize the importance of teachers and family in the ultimate foundations of such a study of traditions, even modern ones. This book, in turn, is dedicated to the next generation: that of our own children.

Photo Acknowledgements

Courtesy Andrea Meislin Gallery, New York: p. 234 (© Barry Frydlender), p. 238; Art Institute of Chicago: p. 99 (Helen Birch Bartlett Memorial Collection, 1926.221, photo © The Art Institute of Chicago), p. 165 (gift of Alfred S. Alshuler, 1946.925, photo © The Art Institute of Chicago, painting © 2010 Artists Rights Society (ARS), New York / ADAGP, Paris), p. 176 (gift of the Estate of Mary MacDonald Ludgin, 1964.34, photo © The Art Institute of Chicago), p. 253 (gift of Society for Contemporary Art, 1983.264, photo © The Art Institute of Chicago); Art Resource, New York: p. 32 (Gemäldegalerie, Staatliche Museen, Berlin, photo Jörg P. Anders, Bildarchiv Preussischer Kulturbesitz), p. 42 (Hamburger Kunsthalle, Hamburg, photo Elke Walford, Bildarchiv Preussischer), p. 43 (The Jewish Museum, New York, gift of Richard and Beatrice Levy 1984–61, photo John Parnell), p. 45 (The Jewish Museum, New York, gift of the Oscar and Regina Gruss Charitable and Educational Foundation, Inc., 1999–91, photo John Parnell), p. 46 (private collection, MD, photo The Jewish Museum, New York), p. 47 (The Jewish Museum, New York, gift of Mr and Mrs Oscar Gruss, JM 28-55, photo Richard Goodbody, Inc.), p. 48 (The Jewish Museum, New York, gift of J. Sovatkin, JM 91-55, photo by John Parnell), p. 51 (The Jewish Museum, New York, gift of Brigadier-General Morris C. Troper in memory of his wife, Ethel G. Troper, and his son, Murray H. Troper, JM 78-61), p. 53 (Réunion des Musées Nationaux), p. 57 (The Jewish Museum, New York, gift of the Estate of Rose Mintz, JM 63.67a, photo Richard Goodbody Inc.), p. 58 (Musée d'Art et d'Histoire du Judaïsme, Paris, gift of Mr and Mrs Lenemann and Mr C. P. Kelman, photo Hervé Lewandowski, Réunion des Musées Nationaux), p. 60 (The Jewish Museum, New York, purchase The Eva and Morris Feld Fund, 1985-123), p. 73 (photo Erich Lessing), p. 87 (Tretyakov Gallery, Moscow, photo The Jewish Museum, New York / painting © 2010 Artists Rights Society (ARS), New York / ADAGP, Paris), p. 107 (Los Angeles County Museum of Art, digital image © 2009 Museum Associates / LACMA), p. 122 (The Jewish Museum, New York), p. 128 (The Jewish Museum, New York, © The Estate of Raphael Soyer, Courtesy of Forum Gallery, New York, photo Richard Goodbody, Inc.), p. 138 (The Jewish Museum, New York, gift of Mrs Nathan Miller, JM 51-58, photo by John Parnell), p. 149 (purchase Mr and Mrs George Jaffin Fund, Fine Arts Acquisition Committee Fund, and Lillian Gordon Bequest, 2001-12, The Jewish Museum, New York), p. 152 (The Jewish Museum, New York, gift of Ruth Bocour in memory of Leonard Bocour, 1997-126, photo John Parnell. Courtesy The Jewish Museum / Art Resource, NY © 1951 Morris Louis), p. 159 (The Jewish Museum, New York, gift of Seth Cohen, 2004-10, photo by Richard Goodbody, Inc.), p. 165 (The Jewish Museum, New York), p. 185 bottom left (The Jewish Museum, New York, gift through the Estate of Francis A. Jennings, in memory of his wife, Gertrude Feder Jennings, and an anonymous donor, 1997-130), p. 204 (The Jewish Museum, New York, gift of Dr Harry G. Friedman, F4537, photo by Richard Goodbody, Inc.); The Baltimore Museum of Art: p. 96 (The Cone Collection, formed by Dr Claribel Cone and Miss Etta Cone of Baltimore, MD, BMA 1950.396, photo by Mitro Hood); Rose Art Museum, Brandeis University, Waltham, MA: p. 175 (gift of Mr Henry Crapo, Hull, MA); © The British Library Board: p. 22; © The Trustees of The British Museum: pp. 26, 31; © Condé-Nast: p. 254; Delaware Art Museum, Wilmington: p. 50 (bequest of Robert Louis Isaacson, 1999); Photo © 1998 The Detroit Institute of Arts, MI: p. 153 (The Detroit Institute of Arts, Founders Society Purchase, Friends of Modern Art and

Miscellaneous Gifts Fund © The Estate of Eva Hesse. Hauser & Wirth, Zürich and London); Deutsche Bank Collection, Frankfurt: p. 69; Collection Eleanor and Leonard Flomenhaft, Long Island, New York: p. 150 (photo courtesy of Miriam Schapiro); Courtesy of Audrey Flack: p. 181; The Emanuel Ringelblum Jewish Historical Institute, Warsaw: p. 113; Felix Nussbaum Haus, Osnabrück: p. 168 (© DACS, 2010); Photo courtesy George Krevsky Gallery, San Francisco: p. 252 (Art © Estate of Ben Shahn/Licensed by VAGA, New York, NY); George Washington University: p. 71 (by courtesy of The I. Edward Kiev Collection, Melvin Gelman Library); Getty Images: p. 130 (© Weegee/International Center of Photography); Courtesy Government Press Office, Israel: p. 235; The Hebrew University of Jerusalem: p. 21 (courtesy Prof. Zeev Weiss, The Sepphoris Excavations, photo Gabi Laron); Israel Museum, Jerusalem: p. 18 (Photograph David Harris), p. 25 (gift of James A. de Rothschild, London, photo © The Israel Museum, by Ardon Bar-Hama), p. 36 (Shalom Ash Collection on permanent loan from The Jerusalem Foundation, photo ©The Israel Museum), p. 68 (Gift of Rebecca Shulman, New York. Collection, The Israel Museum, Photo © The Israel Museum, by Avshalom Avital. Art © Jack Levine/Licensed by VAGA, New York, NY), pp. 79, 93 (B71.183. Photo © The Israel Museum by Yoram Lehmann), p. 105 (The Vera and Arturo Schwarz Collection of Dada and Surrealist Art B98.0532, photo © The Israel Museum by Avshalom Avital, © 2010 Man Ray Trust / Artist Rights Society (ARS), NY/ADAGP, Paris), p. 208 (B02.0801, photo © The Israel Museum, by Meidad Suchowolski), p. 215 (B02.0801, photo © The Israel Museum, by Meidad Suchowolski), p. 216 (gift of Lola and Adolf (Dolfi) Ebner, photo © The Israel Museum), p. 217 (gift of Lola and Adolf (Dolfi) Ebner, photo © The Israel Museum), p. 219 (600.81, Collection The Israel Museum, photo © The Israel Museum, by Elie Posner), p. 234 (purchase, the Dov and Rachel Gottesmann Fund, Tel Aviv and Geneva, and the America-Israel Cultural Foundation, photo © The Israel Museum), p. 243 (B04.1484, photo © The Israel Museum by David Harris), p. 245 (bequest of Robert Veith, Jerusalem, Collection The Israel Museum, photo © The Israel Museum by Avshalom Avital); Jane Voorhees Zimmerli Art Museum, Rutgers, The State University of New Jersey: p. 82 (gift of Herbert D. and Ruth Schimmel, 2003.0856.026, photo by Bryan Whitney); Courtesy of Shimon Attie and Jack Shainman Gallery, New York: p. 184; Courtesy of Adi Ness and Jack

Shainman Gallery, New York: pp. 236, 251; Collection Jewish Historical Museum, Amsterdam: p. 169 (© Charlotte Salomon Foundation); Ben Uri Collection, The London Jewish Museum of Art: p. 136; Jewish Museum, Berlin: pp. 6, 111; Judah L. Magnes Museum, Berkeley, CA: p. 38 (gift of Vernon Stroud, Eva Linker, Gerda Mathan, Ilse Feiger and Irwin Straus in memory of Frederick and Edith Straus); Photo courtesy of Herbert Kessler: pp. 17, 19; Courtesy Marlborough Gallery, New York: p. 162 (© Estate of Jacques Lipchitz), p. 178 (Astrup Fearnley Collection, Oslo, Norway, photo Tore H. Royneland © Estate of R. B. Kitaj), p. 180 (University of California Los Angeles, Archive of Jewish Culture © Estate of R. B. Kitaj); The Metropolitan Museum of Art, New York: p. 139 (Edith and Milton Lowenthal Collection, bequest of Edith Abrahamson Lowenthal, 1991 (1992.24.6), image © The Metropolitan Museum of Art); Courtesy of Milestone Film & Video (www.milestonefilms.com): p. 185 top right; Minneapolis Institute of Arts; p. 66 (The William Hood Dunwoody Fund), p. 102 (gift of Mr and Mrs Donald Winston and an anonymous donor, 57.12 © 2010 Artist Rights Society (ARS), New York / ADAGP, Paris); Image Courtesy of National Gallery of Art, Washington, DC, 1960: p. 177 (Robert and Jane Meyerhoff Collection, painting © 2010 Barnett Newman Foundation / Artists Rights Society (ARS), New York); National Gallery of Modern Art, Rome: p. 62 (by permission of Ministero per i Beni e le Attività Culturali); Photo Susannah Lake: p. 119; National Museum of Bosnia and Herzegovina: p. 23; National Museum, Warsaw: p. 54 (photo Piotr Ligier, MP 431); Open Museum, Tefen, Israel: pp. 228–9 (photo by Avi Hay); Palace of the Legion of Honor, San Francisco: p. 201 (photo Samantha Baskind, Art © The George and Helen Segal Foundation / Licensed by VAGA, New York, NY); Philadelphia Museum of Art: p. 59 (gift of Ellen Harrison McMichael in memory of C. Emory McMichael, 1942), p. 97 (bequest of Mrs Irving R. Segal, 2006), p. 101 (gift of Arthur Wiesenberger, 1943 © 2010 Artists Rights Society (ARS), New York / ADAGP, Paris); Private collection: p. 181; Private collection, © The Estate of Seymour Lipton, courtesy of Michael Rosenfeld Gallery, LLC, New York, NY: p. 174; Private collection on permanent loan to the Tel Aviv Museum of Art: p. 226; Pucker Art Gallery, Boston, MA: p. 193; Collection of Archie Rand: p. 160 (Photo Sebastian Kahnert), p. 161 (photos Mary Faith O'Neill); Rijksmuseum Prentenkabinet, Amsterdam: pp. 28, 29; Rubin Museum, Tel Aviv: p. 213; Russian Museum, St Petersburg: p. 77 (photo Laura Silver); Scala / Art

Photo Acknowledgements

Resource: p. 122 (The Museum of Modern Art, New York. digital image © The Museum of Modern Art / Licensed by SCALA / Art Resource, New York), p. 137 (The Museum of Modern Art, New York. digital image © The Museum of Modern Art / Licensed by SCALA / Art © The Georgia O'Keeffe Museum / Artists Rights Society (ARS), New York); p. 142 (The Museum of Modern Art, New York, Mrs Simon Guggenheim Fund, digital image © The Museum of Modern Art / Licensed by SCALA / Art Resource, New York, Art © The Educational Alliance, Inc. / Estate of Peter Blume / Licensed by VAGA, New York, NY), p. 144 (Jersey Home-steads Community Center, Roosevelt, NJ, photo Scala / Art Resource, New York, Art © Estate of Ben Shahn/Licensed by VAGA, New York, NY), p. 151 (The Museum of Modern Art, New York, gift of Annalee Newman (390.1992), digital image © The Museum of Modern Art / Licensed by SCALA / Art Resource, New York, painting © 2010 Barnett Newman Foundation / Artists Rights Society (ARS), New York), p. 211 (The Museum of Modern Art, New York, digital image © The Museum of Modern Art / Licensed by Scala / Art Resource); Photo Sean Martin: pp. 194, 196 top right; Hebrew Union College Collection, Skirball Museum, Cincinnati, OH: pp. 117, 120; Courtesy of Skirball Museum, Skirball Cultural Center, Los Angeles: p. 35 (From the Collection of Salli Kirschstein, photo by Marvin Rand, HUCSM 34.66), p. 104 (photo by John Elder, HUCSM 67.47 © 2010 Artist Rights Society (ARS), New York / ADAGP, Paris); The Solomon R. Guggenheim Foundation, New York: p. 98 (55.1421, photo by David Heald); Sosland family collection, photo courtesy of the Sosland family: p. 140; Städel Museum, Frankfurt am Main / Artothek: p. 67 (U. Edelmann), p. 90 (U. Edelmann); Stedelijk Museum, Amsterdam: p. 86 (painting © 2010 Artists Rights Society (ARS), New York / ADAGP, Paris); © Sterling and Francine Clark Art Institute, Williamstown, MA: p. 63 (1955.554, photo by Michael Agee ©); © Tate, London 2010: pp. 133, 172; © 2010 Artist Rights Society (ARS), New York / VG Bild-Kunst, Bonn), pp. 192, 195 top left; Collection of the Tel Aviv Museum of Art, Tel Aviv: p. 56 (gift of Sidney Lamon, New York, 1955), pp. 89, 91 (gift of Mr Israel Pollack, Tel Aviv, 1979 with assistance from the British Friends of the Art Museum of Israel, London, © 2010 Artist Rights Society (ARS), New York / VG Bild-Kunst, Bonn), p. 221 (Dizengof Prize, 1957), p. 224 (acquisition through a donation from Joseph and Rebecca Meyerhoff, Baltimore, MD, 1975), p. 225 (acquisition through a contribution from the Joshua Rabinowitz Tel Aviv Foundation for the Arts), p. 247 (gift of Rachel and Dov Gottesman, 1988), p. 248 (gift of the Tel Aviv Foundation for Literature and Art, 1977, Art © The George and Helen Segal Foundation / Licensed by VAGA, New York, NY), p. 249; Photo Thom Davies: p. 196 bottom; Collection of the artists and Through the Flower Corporation: p. 188 (Art © 2010 Judy Chicago / Artists Rights Society (ARS), New York, photo courtesy of Through the Flower Corporation); Tretyakov Gallery, Moscow: p. 78; The University of Manchester: p. 49 (Whitworth Art Gallery); United States Holocaust Memorial Museum, Washington, DC, p. 198 (photo by Edward Owen, © 2010 Richard Serra / Artists Rights Society (ARS), New York); Photo © Davis Museum and Cultural Center, Wellesley College, Wellesley, MA: p. 83 (gift of Mr. Theodore Racoosin,1956.16); Whitney Museum of American Art, New York: p. 147 (purchase with funds from The Lauder Foundation: Leonard and Evelyn Lauder Fund 96.68.292, photo Geoffrey Clements; Courtesy of the Estate of the Artist and the Susan Teller Gallery, New York, NY); Yad Vashem Art Museum, Jerusalem: p. 171 (gift of the Prague Committee for Documentation, courtesy of Alisa Shek, Caesarea); Yale University Art Gallery, New Haven, CT: p. 93 (gift of Collection Société Anonyme © 2010 Artist Rights Society (ARS), New York / VG Bild-Kunst, Bonn), pp. 155 156, 157 (gift of Jeffrey H. Loria, BA, 1962, in memory of Harriet Loria Popowitz, photo courtesy Yale University Art Gallery, Art © Estate of Larry Rivers / Licensed by VAGA, New York, NY).

Index

All works of art and books are indexed by artist or author.
Page numbers in *italics* refer to illustrations.

Index